SPEED DUEL

SPEED DUEL

The Inside Story of the Land Speed Record in the Sixties

SAM HAWLEY

FIREFLY BOOKS

A FIREFLY BOOK

Published by Firefly Books Ltd. 2010

First printing

Publisher Cataloging-in-Publication Data (U.S.)

Hawley, Samuel.
 Speed duel : the inside story of the land speed record in the sixties / Samuel Hawley.
[360] p. : photos. ; cm.
Includes bibliographical references and index.
Summary: In the 1960s American hot-rodders took over the land speed record, long the preserve of the British. In the intense contest that followed, Craig Breedlove and Art Arfons at the forefront, the record was pushed from 394 to 600 mph.
ISBN-13: 978-1-55407-633-8 (pbk.) ISBN-10: 1-55407-633-1 (pbk.)
1. Breedlove, Craig. 2. Arfons, Art. 3. Automobiles, Racing – Speed records – History. 4. Automobile racing drivers. I. Title.
629.2 dc22 GV1030.H395 2010

Library and Archives Canada Cataloguing in Publication

Hawley, Samuel Jay, 1960-
 Speed duel : the inside story of the land speed record in the sixties / by Samuel Hawley.
Includes bibliographical references and index.
ISBN-13: 978-1-55407-633-8 (pbk.) ISBN-10: 1-55407-633-1 (pbk.)
 1. Breedlove, Craig. 2. Arfons, Art. 3. Automobiles, Racing--Speed records--United States--History--20th century. 4. Automobile racing drivers--United States--History--20th century. I. Title.
GV1033.H39 2010 796.72097309'046 C2010-902718-3

Published in the United States by
Firefly Books (U.S.) Inc.
P.O. Box 1338, Ellicott Station
Buffalo, New York 14205

Published in Canada by
Firefly Books Ltd.
66 Leek Crescent
Richmond Hill, Ontario L4B 1H1

Printed in China

The publisher gratefully acknowledges the financial support for our publishing program by the Government of Canada through the Canada Book Fund as administered by the Department of Canadian Heritage.

Contents

Prologue

The first cars were built in the 1880s. Within a decade, men had started to race them. Some raced against each other, sputtering down country lanes in head-to-head contests that would eventually evolve into competitions such as Le Mans, Daytona, Indianapolis and Formula One. Others raced against the clock. For these men, the goal was to push their machines to the limits of speed—to set what would come to be known as the World Land Speed Record.

The first official land speed mark, set by Frenchman Gaston de Chasseloup-Laubat in 1898, was just over 39 mph, about the speed of a galloping horse. After that, the record rose quickly: 65 mph by Camille Jenatzy in 1899; 91 mph by Henry Ford in 1904; 103 mph later that same year by Louis Rigolly; 116 mph by Victor Hémery in 1909; and 124 mph by L. G. Hornstead in 1914.

Following the First World War, as the record climbed beyond 150 mph, space for land racing became a critical factor: space to accelerate to maximum speed and, just as essential, space to slow down. By this time, the British had come to dominate the field as a matter of personal glory and national pride, land speed giants Malcolm Campbell and Henry Segrave foremost among them. The British looked overseas for an ideal race course on which to test their mettle and chose a stretch of Florida beach known as Daytona,

already a favorite location among American racers. Here, Campbell and Segrave took the record up past 200 mph. Then, as 300 mph hove into view, Daytona's space limitations in turn became problematic. A better site was needed—one that was enormously wide, long and flat.

The British land speed fraternity settled on the Bonneville Salt Flats in Utah. In 1935, Malcolm Campbell broke through 300 mph here before calling it quits. Fellow Englishman George Eyston then pushed the record up past 350. Yet another Brit, John Cobb, took it to 369 mph on the eve of the Second World War, then returned to the salt in 1947 to raise it yet again to 394. And there it remained for more than a decade.

John Cobb's 1947 record marked the end of Britain's golden age of land speed racing. In the decade that followed, the energy that would drive the record upward shifted to the United States, to a new breed of speed aficionados who called themselves hot-rodders and drag racers. These backyard builders had been souping up cars for years to see what they could do on nearby roads and runways and dry lakebeds. Now they started eying the land speed record, the LSR. The goal that had previously seemed unattainable, the preserve of big companies and wealthy gentlemen racers, began to loom large for an intrepid few as the ultimate challenge to their ingenuity, determination and daring.

And so they started building their own land speed cars. Some went the traditional route, using automobile engines, as many as four linked together; some used surplus piston engines from Second World War airplanes. Others wanted even more power and turned to jet engines, the thrust monsters that pushed military aircraft to Mach 2 and beyond.

The contest got well and truly underway at Bonneville in 1960 and continued on through the middle of the decade. A total of eight men eventually stepped forward to compete for the record: Mickey Thompson, Athol Graham, Donald Campbell, Nathan Ostich, Glenn Leasher, Craig Breedlove, and Art and Walt Arfons. The

game they would play would prove more dangerous than anything that had gone before, one in which nearly all of them would suffer high-speed crashes and two would be killed. By the middle of the decade, only two men would be left standing, locked in a deadly speed duel from which neither would back down. The first was Craig Breedlove, a handsome young Los Angeles hot-rodder who'd been obsessed since childhood with visions of speed. The second was Art Arfons of Akron, Ohio, a shy mechanical genius and professional drag racer who welded world-class speed machines together from junk.

During the first half of the 1960s, Craig Breedlove and Art Arfons and the other challengers for the record would create the most powerful cars ever seen and live the most exciting chapter in the story of land speed, one that would see the LSR pushed up through 400, 500 and 600 mph. They would pour their souls into their machines and risk their lives driving them out on the salt flats, experiencing some of the most spectacular crashes in motor sport history. They would do it for glory, for money, to make history—and because they loved speed.

This is their story.

The L.A. Hot-Rodder

The Clock was a drive-in joint at the corner of Sepulveda and Venice Boulevards in Culver City, California. Its cheap burgers, fries and shakes made it a favorite with local teenagers. Its big parking lot made it a hangout for West L.A. County hot-rodders. It was a good place to get together in the afternoon to talk cars and check out each others' souped-up creations—and to set up illegal street races for when it became dark.

In the early 1950s, 16-year-old Craig Bowman was a regular at the Clock. He was a good-looking kid, auburn hair carefully swept back, slim, a bit on the short side, wearing a white T-shirt and blue jeans with a brand-new driver's license in his wallet. And he had an even better-looking hot rod, a gleaming '34 Ford coupe upon which he had lavished three years of hard work. He hadn't done much racing with it yet—he was still basking in the warm glow of possession— but he had big plans. Racing was something he was meant for. Hadn't he gone 127 mph at the Saugus Drag Strip the year before in Bill Adair's dragster? Hadn't he probably been the fastest 15-year-old in the state? Oh yes, he was going to race his coupe.

But not tonight. Tonight, something else was cooking. Tonight, Craig was going to race his friend Stan Burnelay's hot rod, a '32 coupe he had worked on. Stan had set up the contest with another hot-rodder and he wanted Craig, with his Saugus experience,

to drive for him. They would have to be careful. The California Highway Patrol, spurred by public complaints, had started to crack down on night racing. Just the previous September they had busted a gathering in Compton and swept up 17 people, charging the drivers with illegal road racing and the spectators, at least the ones who hadn't "scattered like quail," with abetting.

The contest was held just outside town on Culver Boulevard, down by the train tracks. It was getting late and traffic had dwindled to nothing. After the betting was settled, Craig and the other driver lined up side by side on a straight stretch of the road, their headlights illuminating the starter and the spectators beyond. The signal—a slashing arm—was given, the cars took off with a scream of wheels—and Craig had his first brush with death.

"When I hit the railroad tracks," he recalls, "I ended up in a flip crash and went through the roof. The '32 coupe had this soft patch in the center and I was thrown right through it. I wrapped the steering wheel into kind of a pretzel design as I departed the vehicle. It knocked me out of my shoes and split my head wide open, and I also broke my neck. I didn't find out about the neck fracture until years later, when I started having trouble with it."

It was Stan Burnelay, shaken by the mishap, who called the ambulance. That brought in the police. They didn't bother making any arrests. Because Craig was underage, the dreaded call was made to his parents. His stepfather Ken Bowman came down to the hospital to pick him up after the doctors had stitched up his head.

You see, Ken said to Craig on the way home, this is the kind of trouble you can get into with hot rods. This is what happens when you start racing these things.

Craig was the product of quite literally a Hollywood wedding. His mother, a Maureen O'Hara look-alike named Portia Champion, had come to Los Angeles in the early 1930s to work as a chorus dancer in the musicals then all the rage, notably such Fred Astaire and

Ginger Rogers classics as *Flying Down to Rio* and *The Gay Divorcee*. It was there on the RKO lot that she'd met Craig's father, Norman Breedlove, a cameraman who later went into special effects and worked on a string of John Wayne and Tarzan pictures. They married in 1934. Their first and only child, Craig, came in 1937.

The marriage didn't last. The couple split up when Craig was seven or eight years old, and in 1946 Portia married Ken Bowman, an employee of UCLA's ornamental horticulture department. They settled into a bungalow on Marcassel Avenue, and Ken formally adopted Craig, giving him the new surname Bowman. Craig's half-sister, Cynthia, came along a year later.

Like most kids growing up, Craig went through phases. There was the bicycle phase and the model airplane phase and the time he fell in love with professional wrestling. For that one, Portia and Ken built a ring in the backyard where Craig and his friends could hold matches. Craig would be "Courageous Craig," resplendent in a Gorgeous George–style robe that his grandmother, a Hollywood costume maker, did up. It was fun wearing his outfit and being outrageous, casting a withering gaze at his classmate and arch-nemesis Bill Moore, "The Golden Terror," before going into the clinch.

But it wasn't all happiness and contentment for young Craig Bowman. He never developed a close relationship with his stepfather and that left him feeling vaguely unaccepted. Ken was just too different, an intellectual sort of man who would sooner read and listen to classical music than watch a wrestling match or fool around with models. "To be really honest," says Craig now, "when you're in a home with a stepfather and he's married to your mother and he has his own child by your mother—well, I was sleeping in the den and felt like a third wheel. That's kind of why I got into hot rods. I gravitated to the older kids who lived across the street and had a bunch of hot rods. I used to go over there and hang out, because basically, I didn't have a male role model in the home that I could relate to."

The older boys who congregated across the street at the Rourkes' place called themselves the Igniters, one of hundreds of hot-rod

clubs that were springing up along the West Coast. Portia was an indulgent mother and had no desire to rein in her son. It'll be all right, she said to soothe her husband. At least the boy's keeping up his grades. And I can keep an eye on him out the kitchen window.

Although only 12, Craig soon won the Igniters over with his rapidly expanding mechanical knowledge and his willingness to do any dirty job they threw at him. Within a year he was ready to become a hot-rodder himself and bought the old Ford coupe to work on, promising his parents that he wouldn't drive it on the street until he turned 16 and had his license. The broken-down hulk cost him $75. He came up with part of it from birthday and Christmas money and by working after school at a local garage as a sander. His stepfather kicked in the rest. Ken Bowman saw one good thing about hot-rodding: it was turning the boy into a very hard worker. It seemed to be all about slaving over cars and studying schematics and holding down part-time jobs to buy parts.

So why was Craig fixing up the old coupe? To race it, of course. He didn't spell that out to his parents, but he was itching to finish it and see what it could do. Maximum speed, after all, was what it was about. As for breaking the law and racing on streets—well, what else were hot-rodders to do? They couldn't drive all the way out to the dusty Mojave Desert every time they wanted to test their machines. Fortunately, just as Craig was coming of age, the idea of legal racing at places called drag strips was starting to catch on in Southern California. It started with the Santa Ana Drags in 1950 on an unused runway at Orange County Airport; the next year, it was the Saugus Drag Strip in the dry hills north of Los Angeles.

It was at Saugus in 1952 that Craig, 15, with his own coupe still a year from completion, had his first real taste of speed. He was a regular there with his fellow Igniters and had been noticed by Bill Adair, who had the track's fastest dragster. "Want to run it down the strip?" Bill nonchalantly asked him one Saturday afternoon. Craig could hardly believe it. To drive the first race of his life and in Bill's rod too, a supercharged beauty that ran on alcohol and nitromethane rather than plain old gasoline.

"I'll never forget the thrill that accompanied that first run," Craig would later write in his autobiography *Spirit of America*, "the feeling in the pit of my stomach when I let the clutch out, tramped the accelerator and felt the power pulling me down the racetrack. It made my chest throb and my fingers tingle. It was injecting the booster shot of racing fever in my veins. No more kid stuff—this was the real thing." He punched Bill's car to 127 mph . . . and never told his parents.

Craig returned to Saugus the next year to race his own car, the blue Ford coupe he had just completed. "Absolutely not," Ken had said when Craig announced that the car was finished and he was going to race it. "You spent about four or five hundred dollars on the engine alone and you're not going to take it up there and ruin it." Craig went anyway and won first place in his class. Ken was not happy.

Then came the accident on Culver. That made things worse.

In 1954 Craig was a senior at Venice High School, drifting toward inglorious graduation in all his courses except machine shop, where he stood out. "He was making all kinds of superchargers and advanced things like that," recalls Art Russell, "while the rest of us were making cold chisels and little stuff. He was so far ahead in developing and making things that it was like he was at the college level while we were down in junior high." In the meantime Craig was working part-time at Quincy's Speed Shop on Wilshire Boulevard—"One Shop, One Stop for all Automotive Needs"—and yearning for the day he would be done with school and could devote all his time to building and racing fast cars. His attitude was a big disappointment to Ken, who had hoped that Craig would go on to college.

After finishing high school Craig immediately broke free from his parents. He got a full-time job and a place of his own, married his classmate Marge Toombs and changed his name back to Craig Breedlove. For the next year it was wedded bliss, with Craig's new bride accompanying him to the drag strips at Saugus and Fontana.

On one memorable weekend they drove out into the Mojave Desert to the dry lake bed at El Mirage, where Craig and his coupe set the course record of 148 mph. Still, it bothered him that Marge never got too excited about his racing. And then a baby was on the way, then another, then a third, and it became increasingly difficult for Craig to support his family and still find time for his racing. Life was crowding in.

To bring home a bigger paycheck, Craig quit his job as a mechanic at Quincy's and joined the staff of a local Buick dealership, first as assistant manager and then as the manager of new car prep. Then he moved on to Douglas Aircraft, working in the material and process engineering department. Craig was earning better money now, but he still wasn't content. His day job was taking up too much time, leaving only occasional evenings and weekends for car building and racing and no time at all for his wife and his kids. When he had a chance to join the Costa Mesa Fire Department, he jumped at it. Paying a decent full-time wage for roughly 13 days of work a month, firefighting was a popular career choice among serious hot-rodders.

By then, Craig had moved up the speed ranks to a belly-tank lakester, a racer built out of the external fuel drop tank of a Second World War aircraft. The tanks were low, light and streamlined, and best of all, they were cheap. In 1957 Craig and his old neighbors Roger and Gene Rourke purchased a surplus tank for a song and shoehorned a V-8 Oldsmobile engine inside it. When they hauled it to the Bonneville Salt Flats for Speed Week the following summer, Craig took it to 236 mph in a qualifying run before losing the clutch.

And then it was back to the fire hall, thinking and dreaming. Craig had loved running on the salt flats in the lakester, striving for a whole new level of speed, and he was determined to return the next summer. But at the back of his mind was the nagging realization that racing was nothing more than a hobby, something fun to do on weekends while he worked his life away in some boring profession. He wanted more than that. He wanted to make a name for himself as a driver. He was 22 years old and wanted to be *somebody*.

As Craig would later tell it, the way ahead came to him in a moment of clarity at the fire station one evening. The firemen on duty had finished dinner and washed the dishes and were sitting around in the lounge, Craig feeling listless, an older fellow named Ray studying up on knots in the fireman's handbook. Craig watched Ray for a while and saw himself in 25 years, sitting on that same tattered sofa, his graying head bent over the same handbook.

"Ray," he said, "I'm going to break the world's land speed record."

Ray looked up skeptically and said: "Sure Craig. Sure."

Craig had known about the land speed record since junior high, when he'd seen a picture in a textbook of record holder John Cobb and his *Railton Special*. Later, he'd learned more of the LSR story: about the rivalry between Henry Segrave and Malcolm Campbell and George Eyston; about the time in the early 1930s when Campbell set and reset the record five times in succession; about the speed duel at Bonneville in 1938–39 between Eyston and Cobb; about Cobb's return to the salt in 1947 to set the record at 394 mph. It was a tale of mechanical ingenuity coupled with daring and glory—glory that was heightened by the dramatic deaths of challengers who fell by the wayside.

There was the demise of Englishman J.G. Parry-Thomas on Pendine Sands in Wales in 1927, when the drive chain broke off his racer *Babs* during a run for the record. The flailing whip of steel sheered off the top of his head; the fire half incinerated his body. Twenty-five-year-old American Frank Lockhart was killed at Daytona Beach the following year when his *Black Hawk* racer somersaulted at 200 mph and threw his body a terrible distance. Like most LSR drivers at the time, Lockhart had no harness to hold him into the cockpit. The same strip of sand claimed Lee Bible in 1929, his *White Triplex* veering into the dunes and tossing him out like a rag doll. He was past saving when rescuers got to him, his neck broken and his arms and legs shattered. An RKO cameraman was

also killed, cut in two by the hurtling racer while his camera kept filming. Bible's wife saw it all and was reduced to hysterics.

It was all very stirring stuff, stories of racing giants that could make a boy dream. As the 1950s unfolded, however, and West Coast hot rodding developed, the LSR for an intrepid few started to appear within reach. Maybe you didn't have to be a pedigreed Englishman to mount a challenge for the record. Maybe you didn't need a personal fortune or big-time industrial backing. Maybe a hot-rodder, a little guy in greasy jeans, could do it on his own.

Mickey Thompson, the son of a tough-as-nails California policeman, was the first to try it. A bull-headed dynamo with a crew cut, Mickey had done it all in the drag world since the late 1940s: built cutting-edge cars, set speed records, crashed, survived. Few could match him for ambition and drive and colorful exploits, and unlike the malarkey artists, he had the scars to prove it. There was that race down in Mexico in 1953, for example, when he crashed his Ford and took out six spectators, killing them stone dead. And then there were the fights that he'd sometimes get into.

"*Sometimes*?" exclaims Mickey's partner and chief mechanic Fritz Voigt. "Shit, he loved that stuff. You remember Clint Eastwood saying, 'Go ahead, make my day'? That was what Mickey was like. He would get into a fight at the drop of a hat. If the other guy was way bigger or if there were two of them, it didn't mean shit to him. It wasn't that he was hard to get along with. It was just that if you thought you were going to screw him over, you had another thing coming."

It all made Mickey the closest thing to an idol that hot-rodders had—the guy who'd clawed his way to the top of the drag game, starting a parts company and managing a drag strip and achieving enough success to allow him to quit his night job manning the *Los Angeles Times* presses to pursue his passion for speed—a passion that by 1958 was focused on the land speed record.

That year, Mickey pushed his first LSR car, built with Fritz, to nearly 300 mph. It made him the fastest American in history. The way Mickey figured it, he had come three-quarters of the way to the

record on two beefed-up car engines kicking out 1,000 horsepower. To ensure that his next car, which he named *Challenger*, could take him the rest of the way, he equipped it with four car engines. He would have preferred Chryslers, but the only engine sponsorship he could find was with GM's Pontiac division, which obliged him to use their V8s. Goodyear would kick in the tires and $10,000.

"Only an asshole would go racing with a Pontiac if you had an opportunity to go with a Chrysler," says Fritz. "But Mickey asked Chrysler and they said no. So we were kind of stuck with Pontiacs, because Pontiac was the only company that would even talk to him. And then they go and send us four stock engines out of test cars, not even brand-new ones. They shipped them to us in El Monte, and Mickey just laid them down on the floor and drew a chalk mark around them to show how much room we'd need, and we started building the frame."

The waist-high racer that Mickey and Fritz built, painted Pontiac Blue, was one of the most claustrophobic cars in history. The fit in the cockpit was so tight that Mickey had to be shoved down into the recumbent seat and his helmeted head pressed back into the pocket formed by the roll bar. Once loaded in, he could move his body only enough to steer and work the pedals, and he couldn't turn his head at all. He was effectively locked in, staring straight ahead through a windshield that was just four inches square. It was the way it had to be, he figured. The car had to be shrunk around his body to keep its profile small to reduce drag. The tight fit would also hold him in place if he crashed.

Wedged inside the racer, Mickey's biggest worry was fire. With all that fuel and heat, a blaze could easily start. The only protection he had was a black leather motorcycle outfit, jacket, pants and gloves; his wife Judy sealed the cuffs around his ankles with tape. If a fire started during a run, he would have to stop the car—no doubt under extreme duress—get the canopy off and somehow extract himself from the cockpit, which he could barely do on his own, and . . . well, it scarcely bore thinking about.

As a piece of machinery, *Challenger* was extremely complex. It had multiple engines and superchargers and clutches and fuel lines and cables that all added up to a blizzard of problems. By October 1959, however, most of the bugs had been worked out and Mickey pushed it to 363 mph, breaking his own American record and coming to within 31 miles of Cobb's mark. Suddenly, he was no longer an upstart hot-rodder with overblown LSR dreams. He had become a serious contender.

He might have done even better than 363 mph had he not nearly died on a subsequent run.

Fritz was always the one to get Mickey loaded into the cockpit, shoving him down and pushing his head back, all the while being careful to keep his oxygen line free. "You had to have oxygen," says Fritz, "because that son of a bitch had exhaust leaks all over. You're running four engines and you couldn't get the middle part of all the engines to exhaust outside the car. So you had exhaust everywhere." On this particular run, for the first and only time, Fritz relinquished the task of loading Mickey to someone else—and the oxygen hose was left in the wrong position, tight against Mickey's arm. In the confines of the cockpit, accelerating toward the clocks, it took only a slight movement for Mickey to inadvertently pull the line out of the bottle.

The toxic fumes from the burning fuel, which were 40 percent nitromethane, were so overpowering that he knew right away he was in trouble. Mickey held his breath and tried to lift the canopy up for fresh air, but couldn't. He was soon gasping, and then the black line marking the center of the course started to blur and he could feel his consciousness slipping away. He was doing over 200 mph when he blacked out completely. "Boy, you've got to pop that chute" was the last thing that drifted through his mind.

Somehow the chute deployed and *Challenger* slowed to a stop. Fritz, the first to reach the car, didn't realize that something was seriously wrong and walked forward expecting to see the canopy thrown open. Then he saw smoke seeping out of the cockpit and broke into a run. When he got the canopy open and Mickey's helmet

off, his friend looked dead, his face covered with mucus. Not knowing anything else to do, Fritz reconnected the oxygen tube and shoved the other end directly into Mickey's mouth and cranked open the bottle and began slapping his face while Judy looked on in horror. Mickey quickly revived and was soon struggling to his feet, head pounding. His only concern was that no one see him laid out on his back like a weakling. "He had balls as big as basketballs when it came to shit like that," Fritz remembers.

That was it for Mickey in the 1959 LSR season. But he wasn't finished. After spending a winter fine-tuning and further streamlining *Challenger*, he planned to return to Bonneville in the summer of 1960 to claim the record, the world record, once and for all.

It was Mickey's assault on the land speed record that got Craig Breedlove seriously thinking. Craig knew Mickey. He was just a regular guy, a working stiff with no money who hadn't made it past high school. And yet here he was, building a land speed car, raising himself up, making a career out of racing. If Mickey could do it, why couldn't he?

For the first several weeks after deciding to go after the record, Craig immersed himself in the study of aerodynamics and started to sketch a number of different designs. His earliest concept was of a streamliner powered by one or two bulky Allison aircraft engines, something he could piece together from parts he could buy cheap at the military surplus stores on Alameda Boulevard. He soon realized, however, that a narrow profile generating minimal drag would be better, something like an airplane fuselage on wheels. That led him to consider using a jet engine. It would be long and slender and generate even more power than the four car engines Mickey had been able to squeeze under *Challenger*'s hood.

Craig initially planned on a J-35 jet from a scrapped navy fighter, an engine that dated back to the late 1940s and could be picked up surplus for cheap. That changed when he stopped by Jessie's Barber

Shop for a haircut. He was waiting his turn when Mike Freebairn, a friend from high school, dropped in. Mike was just back in town from flying F-86s in the Air National Guard and became intrigued when the conversation turned to Craig's idea for a jet car. You really should consider the J-47 engine, Mike suggested. It's the same size as the J-35 and weighs only a bit more, and you'll get 5,000 pounds of thrust out of it instead of only 3,500. It's just more advanced.

It didn't take much to sell Craig on the idea. With Mike's help, he got an introduction to a group of jet technicians at the Air National Guard. They had the expertise on J-47s he needed and helped him locate one at the Northrop Institute of Technology. After the Northrop students had finished practicing on it, taking it apart and putting it back together, Craig would be allowed to buy it for $500.

The next step forward came in the form of a napkin in the pocket of Bill Moore, Craig's old wrestling nemesis, "The Golden Terror." Bill had been having lunch in the cafeteria at Hughes Aircraft, where he worked as a commercial artist, and was telling a Hughes engineer about this crazy car his old school buddy was going to build. Here's your optimal design, the engineer said, sketching an outline on a cafeteria napkin. See, you put only one wheel in the front. That way you keep the frontal profile small and minimize drag.

As with Mike Freebairn's J-47 idea, Craig adopted the sketch on the napkin, using it as the basis for a pointy-nosed, wingless-jet-fighter design that had only three wheels. It was impressive, a supersonic racer that looked like it was streaking past even as it sat there on paper. Now he just needed to scrape up the money to build it.

He had found it by early 1960. His benefactor was Ed Perkins, the owner of a local machine company who had backed Craig's '34 coupe and the Breedlove-Rourke belly-tank lakester the previous year. That had been a relatively minor investment. Now Craig hit Ed up for a heftier sum. "The conditions look right to bring the land speed record back to the United States," Craig pitched him, a reference to when Ray Keech of Pennsylvania had held the record back in 1928–29, between Campbell and Segrave. "There's a golden opportunity just

sitting there. With $10,000 I could get the design completed, buy the engine, and enough material to get the thing off the ground and organized to the point that we could interest the big companies in it."

Ed Perkins was impressed. He promised Craig the money and shop space to work on the 40-foot racer. Craig immediately spent $500 to buy the J-47 from Northrop and began assembling a wooden mock-up of the car.

Craig's next hurdle—and it was a big one—was to get free tires. You didn't go after the land speed record on a set of white walls off the family sedan. The centrifugal forces alone would blow conventional tires to pieces long before you got to 300 mph. You needed custom-crafted, very costly high-speed racing tires for the job, and in the States there were only two places to get them: from Firestone or from Goodyear, both based in Akron, Ohio. Craig decided to appeal to Goodyear and sent off a letter with his request in May. Shortly after, he received a phone call saying that a company representative would stop in Los Angeles to look over his plans.

For the next two weeks Craig was hardly able to sleep, he was so busy working and running around trying to get everything ready. He pushed ahead with the wooden mock-up and prepared a set of blueprints. He contacted another high school friend, Art Russell, now a model builder for Revell Toys, and asked him to make a model of the finished racer, something the Goodyear rep could hold in his hands. He got Bill Moore to do a set of full-color artwork. He persuaded an engineer at Lockheed Aircraft, Walt Sheehan, to help with the highly technical job of designing the jet engine's air ducts and in turn lending an impressive degree of professionalism to the project. It was a rushed job, but the end result looked good. The Goodyear rep liked what he saw and Craig was promised the tires.

Everything was set. Craig had a design and an engine and the promise of work space and tires and $10,000. He quit his job at the fire department to devote himself full time to building the car.

That's when everything fell to pieces. The first thing to go was his marriage. Things had been rocky with Marge for some time, going

back to the dragster days and getting worse as Craig became increasingly obsessed with the jet car. He knew he wasn't spending enough time with his family, but he couldn't help it. His drive to succeed, to make a name for himself, was too strong. Well, said Marge, if that's what you're going to do, then it'll be without me and the kids. Craig pleaded with her. He told her it was the biggest opportunity of his life; that if she would just hang on a bit longer, he would make it big and they would all be happy. Marge wouldn't listen. Craig had put his car ahead of his wife and family, so he had to go. He packed up a few things and moved in with his dad, Norman. He didn't know where else to go. "I felt alone and dejected."

Not long after that he had call from Goodyear. The company was instituting an austerity program, the man on the other end of the phone told him, and was no longer able to provide the tires it had promised. It might be able to do something later, but not just now, not with the company struggling.

Then Ed Perkins backed out as well. Business had turned bad, Ed said, and the $10,000 he had promised was suddenly more than he could afford. Craig could keep the engine he had already bought with Ed's' money, but that was it. There would be no more financial backing.

In the space of two months Craig's life and dreams crumbled to nothing. He had no job, no wife, no sponsor, no tires, just a sheaf of drawings, a two-foot-long model and a huge wooden mock-up that had to be moved out of Ed's shop.

It was at this point that Craig Breedlove started to show the depth of his determination. He began rebuilding his life from a spare room in his dad's house. He enlarged the garage to serve as a workshop and hauled in the mock-up. He looked around for alternate sponsors. He just kept going.

He was *going* to build a jet car. And he was *going* to break the land speed record.

Bonneville 1960

Great things were expected in land speed circles in 1960. With at least four record contenders booked to run on the Bonneville Salt Flats—an unprecedented number—this would be the year in which the record would almost certainly be broken. Mickey Thompson would be returning with his four-engined *Challenger*, new and improved after the 363-mph American record he had set in 1959. A Los Angeles physician named Nathan Ostich, a newcomer to the game, would also be racing, driving something that had never been tried in land speed racing: a jet car. It generated somewhere in the neighborhood of 5,000 horsepower, two and a half times the power of Mickey's racer. If it worked, it might just blow John Cobb's 13-year-old record to pieces.

On the other side of the Atlantic, meanwhile, the British had been stirred to action by the rising American threat to the record, which had been a British institution since the 1920s. The project to keep the Big Number in British hands was headed by Donald Campbell, son of racing legend Malcolm Campbell, who had broken the record nine times back in the 1920s and '30s before having the good fortune to die at home in his bed. Donald Campbell didn't have any land speed experience. His forte was racing on water, where he held the record of 260 mph. He had the pedigree, though, to call British industry and automotive experts to arms against what

he jokingly called those "wretched American chaps." By 1960 a car resembling Cobb's *Railton Special* had been designed and built at an estimated cost of three million dollars and nearly a million hours of labor, a great hulking thing with a double-humped back enclosing chest-high wheels. Donald called it *Bluebird*, the name his sainted father had used for his racers. Its builders estimated it would do a top speed of close to 500 mph.

Finally, a fourth aspirant to the speed crown that summer was Utah auto mechanic Athol Graham. If Donald Campbell represented the glamorous high end of land speed racing, where teams of paid specialists roamed and money flowed freely, Athol represented the bottom, where the name of the game was do-it-yourself and making do with junk parts. He had booked Bonneville's land speed track, the so-called International Course, for four days starting August 1, 1960. He would be the first up.

Athol Graham was the owner and operator of Canyon Motor Company, a seven-bay cinderblock auto repair shop in the east end of Salt Lake City, not far from his house. He was a decent, hardworking man in his mid-30s, a devout Mormon, married to a young nurse named Zeldine, with whom he had four kids. He had a pleasant oval face, kept his hair short in a crew cut, was of middling height and thickening a bit in the mid-section, all in all a pretty average guy—until you looked in his garage at the car that he'd built.

It started back when Athol was a teenager, when he'd first heard about Campbell and Eyston and Cobb racing at Bonneville for the record. "I'd get goose pimples reading about them," he said, "and I always imagined myself out there driving one of those beautiful cars across the salt." By the time he'd finished high school he was a self-taught mechanic, good enough to serve in a U.S. Army motor pool in Europe during the Second World War. After his discharge Athol did two years of Mormon missionary work in New Zealand, then returned to Salt Lake City to open his own garage. He built

Canyon Motors himself, trading auto servicing for lumber and blocks and roofing from local suppliers. All this time his land speed dream continued to percolate in the back of his mind, until finally he decided to do something about it. He knew he couldn't go the way of his British heroes, with big-time national support, industrial sponsors and personal fortunes. As a little guy without influence or reputation or money, he would have to rely on his own ingenuity and build a car on his own.

Athol's first attempt at a land speed racer, completed in 1958, was a failure. "Everything was off," he said. "We couldn't get much more than 100 mph out of it." He tore the machine apart and started over. He began with a Cadillac frame, the cockpit out of a scrapped P-51 fighter and a 2,200-horsepower Allison aircraft engine that he acquired through a series of trades. Over this he placed an aerodynamic shell fabricated from the split-apart drop tank off a B-29, one of the behemoths that had been used in the war to flatten Japan. For high-speed tires, he contacted Firestone Tire and Rubber. They recommended custom-made tires four feet in diameter that would be "a costly undertaking" and would thus "require a bona-fide order and approval of our top management." Athol settled on off-the-shelf, 33-inch-diameter Bonneville tires instead. He did it all with his own money, a total of $2,000, assisted by a neighborhood teen named Otto Anzjon, the son of Norwegian parents who had immigrated to the States in 1947. Otto, one of Athol's seven employees, had started working at Canyon Motors as part of a program to finish his last year of high school. He would put in countless unpaid hours in the evening and on weekends helping Athol fabricate the car.

For Athol, work was all-consuming. "He was a hard neighbor to get to know," said Bill Card, who lived across the street. "Not because he was aloof. Just because he spent so much time trying to run the garage and build that car. He wasn't around much." It made things hard for Zeldine, who ran the office at the garage in the daytime, worked as a nurse several nights a week at the LDS Hospital and in between raised the kids on her own. Athol was gone

so much that he rarely saw them. He was off to the garage before they were out of bed in the morning; when he got home at night, they were already asleep. There was no point in Zeldine complaining. Athol was going to build the car no matter what she said. And if she expressed concern for his safety, he brushed it aside. Don't worry honey, he'd say. I'll be as safe on the salt flats as I'd be driving in traffic down 33rd Street. He was so confident and so determined that it was contagious. In time, he made Zeldine believe.

Athol and Otto finished the new and improved version of the car in the fall of 1959. They painted it red and initially called it *Rangi-Toto*, a Maori term Athol had learned in New Zealand that meant "red sunset." Athol would soon rechristen it the *City of Salt Lake*. It was a homemade-looking affair and attracted some scoffing. That stopped during a remarkably snow-free December when Athol took the car out to Bonneville and pushed it to 344 mph. Only John Cobb and Mickey Thompson had gone faster than that. Suddenly, Athol's name was in the newspapers as "Utah's Cinderella racing pilot."

The high-speed run, however, had revealed a host of problems. The wheels turned at different speeds and were prone to losing traction. The off-the-shelf Firestone racing tires wore out too quickly. The front end caved in from wind pressure. There wasn't enough air in the cockpit. During his 344-mph run, Athol had been forced to ease up the canopy to breathe and the wind blast had torn it off. And so he and Otto went back to work, spending another $500 "and a whale of a lot of time," as Athol put it, on modifying and strengthening, adding ventilation holes to the cockpit, installing an oxygen mask. "I feel this is my year," he announced when work was completed in July 1960. "This is it, if ever." Athol was confident he could push the *City of Salt Lake* to a record-setting 410 mph.

Chasing the ultimate speed record out on the salt flats was expensive. First, there was the daily usage fee charged by the Bonneville Speedway Association, a hefty sum that helped offset what the Utah

Highway Department charged to grade the International Course. Then there was the cost of having the United States Auto Club (USAC) set up its timing equipment and send out a team of observers, the only way to make a record official. It all added up to something like $1,000 a day.

It was money Athol didn't have. He had gone deeply into debt building his car and was at the point where just paying his life insurance premiums, $20 or $30, was a problem. Getting involved in the LSR game had initially been a matter of personal ambition. Now, having sunk everything in it, he needed the land speed record to set him back on his feet financially. "If I break the record, I'll be able to get myself out of the hole," he confided to the bishop of the temple he attended. "If I don't, I don't know what I'll do."

Before he could even get out to Bonneville, however, he had to scrounge up a sponsor. There was no way he could afford to book the salt on his own for even one day. Fortunately, two years of letter-writing by Zeldine combined with Athol's 344-mph run had finally attracted some backing, a total of $3,500 from STP Oil Treatment and Firestone.

It also unleashed what to Athol, laboring in obscurity, must have seemed like a whirlwind. "Planning press conference re. your record attempt," read the telegram he received from Firestone's head office on July 12. "Would appreciate your air mailing to me fact sheet on your machine as soon as possible so that we can make it available to the press." The press conference took place in a hotel room in downtown Salt Lake City, with drinks and hors d'oeuvres and sportswriters and cameras. Athol showed up in a blue suit and a polka-dotted bow tie and for the most part came across as quietly upbeat. When it was over and the reporters were filtering out, he wandered to the window and gazed out over the city. "Gosh, Salt Lake's getting to be a big city," he mused. "I keep forgetting. But it's really big."

Marion Dunn of the *Tribune* would report afterward that he sensed apprehension in Athol. He would get confirmation of that in an informal chat with him the evening before his attempt at the

record. "Marion," Athol said, "I have a lot to tell you about my feelings toward this whole thing. I think a lot of it will shock you." They made plans for a get-together after Athol's return, when he would tell Dunn the whole story. Dunn left feeling that Athol was troubled and possibly fearful; that he wanted to slow things down, but couldn't. Everything—his ambition, the publicity flurry, his desire not to disappoint, the anxiety that a competitor would snatch the record before him—all of it was pushing him inexorably forward.

Athol returned to Bonneville on Monday, August 1, 1960. He drove out to the salt before daybreak, hauling the *City of Salt Lake* on its specially modified truck. Zeldine and Otto went with him. His four children did not. They were staying with Zeldine's parents in Arizona. By 7 a.m. they had the bright red racer unloaded at the southwest end of the course. In addition to its name in cursive letters, the racer was adorned with three logos: STP and Firestone on the nose and a big sign on the side that read, "Let's All Buy Bonds." Ted Gillette and his ambulance were on hand, but a doctor wasn't. Athol didn't have $150 to hire one for the day.

The plan was for Athol to make his first run at nine that morning. That time had to be pushed back when one of the high-speed tires Firestone had finally agreed to make him—they had been flown directly out to the salt and installed at the last minute—was found to be touching the inside of the wheel well. The prime morning racing hours, when the air was calmest, slipped by as Athol and Otto sweated away with acetylene torch and grinder, making space for the tire so that it wouldn't scrape against metal. Cars continued arriving on the scene as they worked, disgorging speed fans eager to witness what had been announced would be a memorable event. A dozen or so vehicles stopped at Athol's little encampment. Many more continued on down the course and parked alongside the measured mile, where the USAC officials had positioned their trailer and set up their timing equipment. As the sun continued on toward its zenith, the crowd of spectators grew to a thousand.

There was something wrong. To those who knew land speed

racing, it hung in the air like a fog, a sense of impending disaster. A typical LSR attempt was a methodical business of test runs and calculated speed buildups spread over days—like walking out on a tree branch, making sure of each step. And yet here was Athol working frantically and saying that he intended to "go all out on the first run." Some observers felt he was being reckless, but no one tried to stop him. You just didn't go up to a member of the select unlimited-speed fraternity and say: Hey buddy, you're going about this all wrong. It would be like interrupting a shaman in the middle of his dance. It would be like raising your hand in church.

Ten a.m. came, and the wind picked up. It was gusting across the course at 20 mph, fine for a leisurely drive, deadly at high speeds. "He won't run today," *Deseret News* sports editor Hack Miller reassured sportswriter Hi McDonald. "That wind is too wicked." Hack was speaking from experience. He had reported on Bonneville LSR attempts going back to the 1930s. He and Hi both considered Athol a friend. They had come out from Salt Lake City for the big story, but a postponement at this point would have been a relief. It just didn't feel right. Hack was picking up on the same feelings Marion Dunn had divined—that Athol would have liked to back away from the thing, to take more time, but couldn't. His fate was caught up in the flow of events.

Mickey Thompson was also on the scene that morning. He had driven out from Los Angeles to watch his rival in action. He didn't think Athol could break the record with his racer, powered as it was only through the rear wheels. You needed four-wheel drive, Mickey was convinced, to maintain the traction necessary to get anywhere near 400 mph. He did think, however, that in his haste Athol might succeed in killing himself, and he stopped by Athol's camp and urged him to proceed with caution. Take it easy for the first few runs, he said. Get the feel of your machine and of the salt before you floor it.

Mickey was the only person present who had more LSR experience than Athol and the only one living who had ever gone faster.

If anyone could presume to give advice, it was him. Athol, however, didn't want to hear it. "Look," he replied, "I've already gone 344. I don't have anything to learn below that speed. I've been there." Mickey tried to point out that the condition of the salt had changed since the previous December—that it was constantly changing and needed testing as much as Athol's revamped racer. But Athol's mind was made up.

At 11 a.m. the *City of Salt Lake* was nearly ready. The extreme gusting had eased, but the wind was still blowing at up to 15 miles an hour, more than was prudent to run in. It's bad, someone anxiously observed at the USAC trailer.

It wasn't so noticeable five miles down the course at the start line. In any event it was up to Athol to decide whether he was going or waiting—and he was definitely going. He spent a final private moment with Zeldine. The next day was their 10th wedding anniversary. They were going to do something special. "See you at the other end," he said as they kissed and parted.

Are you worried, Zeldine, the reporters asked as she came away. She smiled and said, "No." Then: "Not many people know this, but if the car works all right today, I get to drive it. Athol said that if he gets the record, I can go for 300. I drove it 125 miles an hour here last summer . . . I want to do it. I know I can reach 300. After all, I've worked alongside him all these years. I know as much about the car as he does. I'm ready." She was clearly excited. She clearly believed.

Zeldine hitched a ride in one of the trucks heading to the far end of the course. As she disappeared into the whiteness, Athol turned his attention to fueling the racer. It burned 100 gallons an hour. Steaming chunks of dry ice were then packed against the system of pipes that cooled the Allison engine. The pipes were filled with 20 gallons of antifreeze, four whole cases of the stuff that had cost Athol a hundred bucks he couldn't afford. He spent a final few moments bantering with reporters and posing for photos, then with a cheery "Good luck" and "Here goes," he climbed into the cockpit and clipped on his air mask. There was no safety harness or seatbelt

to buckle. The engine was started, an angry rumble in idle. Otto eased the canopy down.

Off to the side, three planes revved to life and started rolling, two light Cessnas and the larger twin-engine craft sent out by Firestone. They would cover the run from the air. When they were up and in position, the *City*'s huge V-12 roared and belched smoke and the racer began to move forward, slowly at first, then with increasing speed until it had shrunk to a floating speck in the shimmer. Then it was gone.

"He cr . . . sss . . ." crackled the radio in the timing trailer. It was the ham radio operator serving as observer three miles from the start. The transmission was hard to make out for the static.

"Did you say he passed?" radioed back one of the officials.

"No, he crashed . . ."

The crowd spread out along the measured mile saw it as a cloud of dust. One of the pilots overhead observed black smoke pouring from the racer's exhausts moments before the crash, indicating that Athol had tromped down hard on the gas. A second pilot said that, "It looked just like the wind had caught it and picked it up."

The general consensus was that Athol had accelerated too fast. By the three-mile marker he had punched the *City of Salt Lake* to over 300 mph in 47 seconds, pushing so hard that the rear wheels started spinning and the racer began to slip and then turn. From his position in the nose, Athol would not have been able to readily see that he was now moving down the course at an angle. By the time the realization hit him, it was too late. The car had turned enough for the wind blast to catch its broad flank and turn it completely sideways. Then it lurched into the air and started tumbling end over end, leaving behind a half-mile-long trail of wreckage and smears of red paint on the salt.

Mickey Thompson, who had been at the mile with his home movie camera, was one of the first on the scene. He found the racer lying on its roof and smoking. Its streamlined shell was gone, smashed to pieces somewhere back down the course. The frame

beneath was scoured and battered, parts were missing or hanging from wrenched brackets and torn wires, tires were ripped from wheels, the smell of leaking fuel strong in the air. Fortunately, the wreckage had not caught fire. Approaching the cockpit, Mickey noted that the roll bar was intact, essential for Athol's survival. Inside, however, the signs were not good. Marion Dunn, who had arrived moments before, was holding Athol's hand through the smashed canopy and desperately urging him to live. Athol was not responding. Dunn would come away with almost no recollection of what he said or did in those terrible few minutes. The *Tribune* photographer with him would fill in the blanks.

Other vehicles kept arriving. Soon a crowd had gathered around the shattered racer, Athol's wife Zeldine among them. She was visibly shaking. Friends tried to comfort and shield her as the wreck was eased onto its side and Athol gently pried out. He didn't appear to have any external injuries, but he was unconscious and clearly in very bad shape. He was loaded onto the Firestone plane that had landed nearby and immediately flown to the Latter Day Saints Hospital in Salt Lake City. Zeldine, in shock, went with him. When they arrived, the doctors pronounced Athol dead.

Back on the salt flats, Otto Anzjon stood beside the racer, physically and emotionally exhausted, his clothes dirty, his hands smeared with grease. He was 18 years old and had just witnessed the destruction of a man he greatly admired and a machine he believed in. When the plane carrying Athol and Zeldine had disappeared over the eastern horizon, he sank to his knees and, clinging to one of the battered wheels, burst into tears.

And so Athol Graham, the first man to go after the land speed record that summer, disappeared from the picture. The course was cleaned up, the wreck of his car was hauled home and his body was buried in Wasatch Lawn Memorial Park under a stone etched with an image of the *City of Salt Lake*. "It is a good thing to have young

Americans who are willing not to stand on the sidelines, but to get in and do things," the preacher said at his funeral. It was how pretty well everyone felt.

Then it was Nathan Ostich's turn. The stocky doctor with the ready joke and easy manner had the salt booked for the week starting August 7 and he intended to use every minute. There would be no rash flooring, but rather plenty of methodical testing and incremental speed buildups. By the end of the week, Ostich announced, he hoped to take his jet-powered *Flying Caduceus* to 500 mph. It didn't happen.

Mickey Thompson had the course for the next week. Witnessing Athol's crash had left him a bit apprehensive. "I know what Athol went through before the run Monday," he had said after. "I could feel the pressure building in him then. I know that right now I have a couple of things wrong with my car that would not have bothered me six months ago. But with my run coming up, they have me worried sick." When he arrived on the salt he found the International Course a welter of washboards, too rough to run for the record. He decided not to try. He went home to Los Angeles, planning to return at the end of the month.

The Bonneville National Speed Trials followed, the annual gathering commonly known as Speed Week, the chance to test machines in classes ranging from go-carts on up. Then they were gone and the salt was taken over again by the big boys, the select few, the LSR chasers. Mickey Thompson would be back, ready to take another crack at the record. So would Dr. Ostich. They would be joined by Donald Campbell and his gigantic *Bluebird*, currently being loaded onto a flatbed rail car on the East Coast for the cross-country journey. With Athol Graham no longer of this world, the 1960 LSR season had come down to these three most likely contenders.

And then, driving out of the desert, there appeared a fourth man, "the darkest of dark horses," the *Deseret News* called him, an Ohio drag racer and do-it-yourselfer unknown in LSR circles. His name was Art Arfons. He arrived at Bonneville on August 26, driving an old bus.

The Pickle Road Mechanic

A rt Arfons pulled his converted bus, a combination trailer, toolshed and bunkhouse, off the highway in Wendover on the border between Utah and Nevada. He and his partner Ed Snyder got out and stretched. They hadn't been expecting much and that's what they got. Wendover was a straggling burg on the baked dirt of the desert—a couple of motels, gas stations and greasy spoons, ugly houses and weathered trailers, old wrecked cars along the highway and fading reminders of more prosperous times during the war. Back then the town had been home to 15,000 men stationed at Wendover Air Base and all the businesses that large concentrations of G.I.s attracted. All that was gone now. The base was closed. So were the bars and the dance clubs, the grocery stores and cafes, the car dealerships, the bus depot, the Western Pacific railway station—all boarded up.

The highlight of Wendover now was the Stateline Casino. You couldn't miss it, what with the 90-foot-high cowboy named Wendover Will standing out front. Art and Ed could see his mechanical arm waving at them down the street as they looked around before hunting up some dinner. The sign on the base under Will's feet read: "Where the West Begins." And nearby, in blinking neon: "This is the place . . . This is the place . . . This is the place . . ."

Art wouldn't be spending much time at the casino. He wasn't interested in that kind of risk. His attention was focused five miles down the highway in the other direction, on the vast white expanse that was Utah's Bonneville Salt Flats. He was hauling a brand-new car in the back of the bus that he was planning to race there. He had never before gone after the LSR, but he knew a lot about powerful dragsters and white-knuckle racing—enough to give him what he figured was a pretty good chance.

Hey man. What you got in there?

One of the young hot-rodders in town for Speed Week had approached the bus and was peering through a gap in the covered-up windows.

An anteater, said Art, smiling. What's it look like?

Otherwise known as the Green Monster, said Ed. Number 15.

Holy cow, said the hot-rodder, you're Art Arfons. I saw your brother Walt run his jet car in Salt Lake last week. Is he here with you?

The smile faded from Art's face. He said, No, we ain't together no more.

The diner was busy, crowded with speed freaks who had come from all over to race their rods and talk shop. Art ordered a cheese-burger, his favorite meal, and a cup of coffee. He was tired. So was Ed. They had been hard at it for the past five weeks since leaving home in Akron, Ohio, driving the bus first out to L.A. to have an aluminum shell fabricated by a streamliner expert, then working nonstop to get it attached to the car. They hadn't had enough time to paint it, much to Art's disappointment. It was still bare metal.

Word had gotten around that he was there. Guys were stopping by now to shake his hand and reminisce about the meets where they'd seen him. It was: I saw you last year when you beat Garlits in Kansas. And: I saw you when you broke 150. Some guys were trying to tell me that Scott in that *Bustle Bomb* car done it first. But I said, hell no. It was Art Arfons. I saw it.

Ed looked up from his coffee and said, Darn right he was first.

Art smiled and exchanged pleasantries in his high-pitched drawl and easy manner. He sounded and acted like a farmer, down to earth and humble. There was something about him, though, that suggested that steel lay inside. Maybe it was his strong nose, the hint of Indian and Greek, the slightly forward-thrust jaw. There was something there that said: Don't mess with this guy. He means business.

After finishing lunch, he and Ed left Wendover and continued on down the highway to the turnoff leading out to the salt flats. It was marked with a huge billboard, a picture of John Cobb's *Railton Special* filling one side. "This is the world's fastest racing course," read the message beside it, "BONNEVILLE SALT FLATS, Tooele County, Utah. DO NOT ENTER UNLESS POLICED." The policing bit was for hapless tourists who might get lost out there in the white desert. If your car broke down and you started walking, there was a good chance you'd get lost and die of thirst. It happened on a regular basis. Art cranked the steering wheel and got the bus, creaking and swaying, onto the side road. They continued on through desert that was brown and scrubby, just as it had been on the drive through Nevada. Then it started to lighten. And then they were there.

It was Art's first time on the salt and he was impressed. Would you look at that, he breathed as they stepped off the bus. Jesus, that's eerie.

Strangest place I ever saw, said Ed.

They stood for a while under the blue dome of sky, gazing out across the whiteness. There was not a rock or shrub or blade of grass to spoil the stark two-color contrast, only snowy tarmac extending all the way to the horizon. Everywhere you looked was space and flatness—so much of it that you could actually see the curve of the Earth.

Art knew all about the records that Malcolm Campbell and George Eyston and John Cobb had set here. Now he was proposing to try his hand at the game. Building the racer had been an

all-consuming task—designing, fabricating, testing, adjusting. But now that he was here, he knew that he was involved in something greater, a journey into the unknown in a place like no other.

This was holy ground. The thoughts it stirred up were solemn. This was the place Art had dreamed of since he was a kid.

Arthur Eugene Arfons was born in Akron, Ohio, in 1926, the youngest child of a half-Cherokee mother named Bessie and a Greek immigrant father named Tom. The name Arthur was given to him by Bessie in memory of her brother, killed in a farm accident at the age of 17. "Arfons" was the Americanized version of Arfanos that Tom had adopted when he'd arrived in the United States from Thessalonika in the 1910s.

Art grew up on Pickle Road a few miles outside town, in a farmhouse beside the family business that his father ran—a feed mill, an apple press and a hardware-store operation. Bessie, a gregarious, outgoing woman, was the leader of the household. Tom, stocky, with a clipped mustache, was a quieter sort. "It took a lot to get him mad," recalled Art, "but once he was, look out." There were three other children in the family: an older sister, Lou, with whom Art was close, and two much older half-brothers, Walt and Dale, from Bessie's previous marriage to a man named Stroud—"a mean son of a bitch," Walt Arfons would later say with feeling. Art was still in elementary school when his two half-brothers were grown and Walt left to join the navy, so he never really got to know them when he was a child.

Tom and Bessie raised Art to be hardworking, self-reliant and frugal, Depression-era traits that would stay with him for the rest of his life. Early on, he also learned to work with machinery, helping his dad in the feed mill. By the time he was 11, Art had figured out how to take apart and reassemble one of the mill's diesel engines. Within a year he was working on an old car.

In 1943, when he was 17, Art told his parents that he wanted to join the war effort and fight for his country. Like many other

young men, he was hot to get into the action before it was over—
and equally hot to get out of high school, where he felt he was wast-
ing his time. He had always loved airplanes and his first choice was
to become a pilot. Without a high school diploma, however, that
was out of the question. After Tom reluctantly signed his enlist-
ment papers, Art followed his half-brother Walt into the navy as a
mechanic. He saw his first action in early 1945, aboard the attack
transport *Caswell*, operating a landing craft shuttling troops and
supplies onto the beaches at Okinawa. The realities of war weren't
what he had expected. "There sure as hell ain't nothing glamorous
about it," he would recall to LSR writer Harvey Shapiro. "You're
scared all the time."

In 1946, after three years of navy service that took him across
the Pacific and up the Yangtze River in China, Art returned home
to Akron in one piece, an anchor tattooed on his forearm. The fol-
lowing year he married June LaFontaine, his high school sweet-
heart, and started working in the mill with his father and Walt for
$35 a week. At first, he and June lived with his parents in their house
on Killian Road, just up Pickle Road from the mill. Then, in 1948,
June had their first child, Ron, and Art figured it was time for a place
of their own. He built a house himself right next door. Walt did the
same, on the other side. Two years later, Tom died at the age of 52,
leaving the mill to Bessie, Walt and Art. Dale, the black sheep of the
family, was left out.

Art and Walt had by this time developed a close relationship
working together at the mill. It extended into what they did for fun,
most of it involving machines. They began by piecing together a dis-
assembled surplus Second World War trainer airplane that they'd
bought for $175. Art came close to killing himself on his inaugural
takeoff, running out of tarmac and almost ending up in a swamp.
The mishap left him shaken, but not discouraged. Soon he was in
the air, buzzing the mill and annoying his sister and flying under
the bridges that were being constructed for the new Ohio turnpike.
Art, more than Walt, liked doing daredevil stunts like that. He was

the same on his motorcycle, playing games like follow-the-leader, speeding over an eight-inch plank laid across a creek.

And then, one day in 1952, a revelation. Art and Walt had driven out to the airport to take the plane for a spin and found the access road blocked off and a large crowd assembled. It was a drag race, one of the first to take place east of the Mississippi. They wandered over to watch. "I wasn't aware of drag racing until that day," Art would recall. "It was fascinating, the smoking tires, the screaming engines, a lot of horsepower running wide open." The two brothers decided to try it.

It took them all of a week to throw their first dragster together, a rough-and-ready thing welded from an old car body and spare parts laying around in the yard. At the last minute they slapped on a coat of green John Deere tractor paint to pretty it up. Then they hitched it behind the mill truck and towed it to their first drag race.

Art hadn't driven more than halfway down the strip when the engine in the old clunker started coughing and died. He got it all the way to the end on his second run but only managed 85 mph, not even close to the winner's speed. All in all, it wasn't a propitious start to their new career as racers. But at least they came away with something: a name, thanks to the race announcer who was entertaining the crowd over the loudspeaker. I'll tell you what to feed it if you tell me what it is, he joked as the junkyard creation was rolled forward.

It's a green monster! somebody called out.

Hey now, there's a mighty fine name. Okay, folks, let's have a big hand for the Arfons brothers' Green Monster!

Art and Walt liked the jibe. They would call all their racers "Green Monsters" after that and lay in a supply of green paint.

Over the next several years Art and Walt rapidly progressed from a joke to the top of the drag game, building a succession *Green Monsters* fitted with war-surplus aircraft engines, cheap power that could be picked up for as little as $35. Bessie, who got a kick out of her sons' racing, came up with the idea of painting tiger teeth across the front of their cars, adding to the *Monster* mystique, and she often

came along to watch. By 1956 Art had won the World Series of Drag Racing and become the first driver to break 150 mph in the quarter mile, behind the wheel of *Green Monster* No. 6. The brothers were now earning more with their cars than they were from the mill—a necessity, really, because the feed business was declining along with the area's small farms. Racing dragsters would eventually become their full-time profession. It was hard on both wives, Art's June and Walt's Gertrude, who worried about their husbands every weekend, but they accepted it because drag racing was what was supporting the family. To cope with the stress, June refused to accompany Art to the drag strips. It's because she doesn't want to see me get hurt, said Art. But that was only part of the reason. "I don't like to be around the track," June confessed, "because I feel like something happens when I'm there. When I'm far away it doesn't seem to happen as much."

One of those somethings occurred in 1957, when June went along with Art to a meet in South Carolina. She went shopping. Art went to the Chester Drag Strip. He was hauling *Green Monster* No. 10, the first dragster he had not painted green. Art had nicknamed it "Baloney Slicer" on account of the spinning propeller attached to the rear-mounted engine. It was painted black—and it almost killed him, in a spinning, tumbling wipeout that cracked the cement strip and sent up a shower of sparks. Art was unconscious when they got to him, pupils dilated, pulse barely a flicker. But when he was released from hospital it was with only one permanent reminder, a mangled finger that would heal crooked and become a source of fun for his kids. "Dad would offer me $10 if I could straighten it out," recalls Art's son Tim. "I'd sit in his lap and do all I could to straighten it, but it wasn't going to move."

Art and Walt built one more Allison-powered *Monster* together, Number 11. Then they split up and wouldn't have anything more to do with each other. They wouldn't even speak. No one, including Art and Walt, would ever be able to explain exactly what happened. When pressed, they might mention some slight or rejection, bad

blood between their wives, a growing list of aggravations. But neither would be able to put a finger on just what had started the feud.

If there were an answer, perhaps it could be found in Art's highly competitive nature, which by the mid-1950s Walt felt was being directed against him. The brothers by that time were racing two cars at meets, Art in one and Walt in the other, doubling their chances of winning money that would be split down the middle. But then Walt started noticing that, "If I would get top time and have the money earned, and if Arthur took eliminator and had that earned, and it was all over with, he would have to beat my time. There wasn't a cent in it. We had the money already. He was endangering the car and his own life just to beat my time. And he done that so many times. And then I didn't go back for more because I knew better. Why should I endanger my life and the car and everything if we've got the money? So I just let it slide."

The tension boiled to the surface at a drag meet in Columbus, Ohio. Walt finished in first place with a run of 152 mph, Art in second with 150. The placings didn't matter; they had the prize money earned for first and second and would share it equally. But Art wouldn't let it rest. Bessie was on hand and told her son to let Walt win for a change. "You always have to win," she scolded. "Just stay out of the car for once and let your brother win."

Art didn't listen. "When I got down just about to the clocks, I remembered her saying take it easy, don't break Walter's 152, and I just sort of put my foot clear through to the radiator, had a temper tantrum. I went through the clocks at 167 and tore off a wheel and skidded around in a great big arc. The wheel bounced and went about 60 feet in the air. And then I remembered my mother had said if I beat Walter she'd never speak to me again. When I come back to the other end, she was gone."

"Yes, I got real angry with him that day," Bessie admitted. "He was winning all the time, and Walter had a nice little car and I guess Arthur couldn't stand for somebody to beat him. Every kid has their own pride. They want to be top dog."

Walt's wife Gertrude put it more bluntly. "Arthur's big problem was he's a bad loser. Lots of people are bad losers, but he's an exceptionally bad loser."

Whether or not Art's competitive streak was the main cause of the rift, there was no mistaking the outcome. They completely severed their relationship and went their own ways. They would live as neighbors and have workshops side by side at the Pickle Road mill. They would hear each other banging and grinding and welding away, building their own racers that each would call *Green Monsters*. They would see each other almost daily, out cutting the grass, driving by on the road, picking up the mail. Their kids would play together and come and go freely in each other's houses. But the two brothers wouldn't speak.

As early as 1956, when Art and Walt were still a team, they talked of building a car to take to Bonneville to run for the land speed record. The mechanical challenge was attractive. So was the glamour of playing the game of giants like Campbell, Cobb and Eyston, a game that seemed to hold out the promise of fame and fortune. And then there was the appeal of breaking free from the confines of a quarter-mile drag strip. In land speed racing, you could tromp your foot down on the gas and leave it there for mile after mile. You could really get down to the business of answering the question: *How fast can I go?*

By early 1960 Art had decided to find out. He would build a new *Green Monster*, No. 15, specifically designed for the job. He would do so with his lantern-jawed friend Ed Snyder, who lived nearby on Killian Road. They had known each other since the fourth grade, playing around with motors and building things in the little time off they had from their chores. Ed had helped out the Arfons brothers with their dragsters from the very beginning and he had stuck with Art after the split, volunteering whatever time he wasn't on the job stamping out battery cases at the American Hard Rubber Company

in Akron. To acknowledge Ed's essential assistance, Art always made a point of calling him his partner.

To build the land speed car, Art and Ed started with a war-surplus Allison engine off a P-38 fighter. Equipped with two super-chargers, it generated 2,300 horsepower, the equivalent of about 20 family cars rolled into one. To keep it cool they would use dry ice, thereby avoiding having to hang a radiator out in front where it would ruin the airflow. There were just two gears: low, which Art would use until he hit 300 mph, and high, which would take him the rest of the way. The whole thing needed to be streamlined, encased in a sleek aluminum skin that Art had neither the equipment nor expertise to create. For that, he turned to L.A. tin bender Lujie Lesovsky, one of the best in the country. The price was $4,000, an expense Firestone agreed to cover in addition to supplying the tires. Art's personal expenditure came to around $5,000, far more than he had ever spent on a car.

He and Ed spent five weeks on the West Coast at Lujie's, helping out in the shop and learning how to work aluminum sheets. *Green Monster* No. 15 emerged with a beautiful sleek shell, shiny like an airplane's. There was no time for a paint job. It was all they could do, working around the clock, to get the panels put on. When they got it all together the look was very distinctive, especially the cockpit, which drooped down in front like a nose. Art said it looked like an anteater and the nickname stuck. They rolled it, bare metal, back inside the bus and set out for the salt flats, taking turns driving, running nonstop. They had to hurry to make it in time for the end of Speed Week and the chance to run on the cheap.

They arrived in Wendover on August 26, quietly confident that they had the machine which would take the speed record. Donald Campbell's advance crew was already in town, setting up in a hangar at the abandoned Wendover Air Base while Bonneville Speedway Association officials fell all over themselves trying to make them welcome. Art and Ed, like all the hot-rodders still in town for Speed Week, were amazed at the size of the British contingent, the immense

Bluebird racer on its semi-truck trailer followed by a long line of Land Rovers and trucks loaded with a seemingly endless supply of equipment. It made Art a little resentful, this English guy with his three-million-dollar car—or was it four million?—and his big entourage and his lavish budget. It also got him thinking. Wouldn't it be great to beat an aristocrat driving a car like that with something that he and Ed, a couple of farm boys, had put together for a few thousand dollars? Wouldn't it be great to be such a big underdog—and win?

The next day Art took *Anteater* out for a series of test runs. He had never raced before on the salt flats. The place was not like a drag strip. It was just a big sea of white with a black line to keep him going straight and mile markers to show where he was. It was all very strange. And when he snuggled down in the low-slung cockpit projecting off the front of the racer, down into a semi-reclining position with his backside a few inches up off the salt, it just got stranger. "It's scary," he said. "You can't see nothing except salt rushing at you. It really gives you the sensation of going fast."

There was just one problem: he wasn't going that fast. Not LSR fast. On his best pass that day Art was clocked at 223 mph. There was something wrong with the clutch. He couldn't get his thundering Allison shifted out of low gear.

With Speed Week over, he and Ed returned to Akron to get some rest and do more work on the car. They were back in the first week of September, the cancelled Renault week when the salt was open and Mickey Thompson and Nathan Ostich were running. Firestone engineer Steve Petrasek went with them. "Don't sell this Arfons guy short," Petrasek had told the newspapers in August, back when the *Deseret News* had called Art Arfons, "the darkest of dark horses." Firestone knew that Art was a long shot, but figured he was worth it. If somehow he managed to grab the record, the publicity would be worth millions—and it would only have cost them some tires and a few thousand dollars.

It promised to be quite a week, three LSR contenders all running at the same time. Nothing like that had happened in the solitary

world of land speed racing since the 1920s. There was even a largely overlooked fourth, Bill Martin of Burbank, California, going after the motorcycle speed record in a thigh-high machine he called *Scat Cat*. With almost no one watching, Martin pushed it to 140 mph, then had a wipeout. Are you hurt, Bill, frantic rescuers asked as they rushed up in their cars. "No, but look at my *Scat Cat*," replied Martin, almost in tears as he picked through the wreckage.

Then Donald Campbell showed up too, reuniting with his advance party to begin shakedown runs in his *Bluebird*, making it four LSR contenders on the salt in a single week. At one point a photographer got him and Art and Ostich together for a group photo, Art borrowing a Firestone jacket from Steve Petrasek to cover up his own greasy sweatshirt. "Nice meeting you, Steve," Donald said to Art as they were parting, misled by the name embroidered on the front. That really got to Art. "It just hurt me no end. I thought, 'Why, you son of a bitch. If there's only three or four men in the world running for the record and you don't know my name. If I ever meet him again I'll say, 'Campbell, I heard of you someplace. Was your dad in the soup business?'"

After that Art *really* wanted the record.

He didn't do it. It was the clutch again. He would push *Anteater* up into the mid-200s and the Allison would really be revving, then he would throw it into high gear and the clutch would burn out. He and Ed sweated it out for three days, repairing and adjusting and trying again, but nothing worked. Finally, on September 7, they joined Nathan Ostich in throwing in the towel.

Art Arfons, the darkest of dark horses, ended the season running at the back of the pack.

While Art and Ed were in L.A. working overtime to get *Anteater* ready, Mickey Thompson was hauling his *Challenger* racer back out to the salt flats for another try at the record.

Mickey had found the International Course to be in very poor

condition during his first trip out in the third week of August. There had not been enough rain that year to smooth it out and the surface was like a washboard in places, promising a hellish ride and greatly reduced traction. It would soon be determined that a contributing factor was the nearby potash mining facility, which was diverting brine away from the flats and lowering the water table beneath it. In his 1964 autobiography Mickey would claim that he actually took a run over the washboards that first morning before abandoning the effort. "The pounding I went through was terrible and I don't know what it did to my insides. When Judy and Fritz pulled me out of the car I was vomiting and in a great deal of pain." Neither his chief mechanic Fritz Voigt nor his wife Judy have any recollection of this, however, and there is no mention of it in the newspapers. It seems that Mickey may have fabricated the story to make a point with the Bonneville Speedway Association, which he felt was not receptive to his concerns. When he urged the BSA head to improve the course, Mickey writes, "I was treated with utter coldness, with downright unfriendliness. This was in contrast to the BSA's almost fawning cooperation with the British."

Mickey returned to the salt for Speed Week at the end of August, this time running on the shorter, smoother hot-rod course and hitting 354 mph. Then the week was over and the crowds filtered away and he was once again back on the International Course with Fritz and the crew. They spent a day patching rough spots with salt and buckets of brine, getting the course ready for the grader. But the grader didn't come. "I was raging," writes Mickey. By the time it arrived and the work was completed, two more days of the one-week booking were gone. And then the wind picked up and the rain moved in and Mickey's week was up. He hadn't made even one run. Fortunately, Renault and Cooper-Climax cancelled their reservations for the following week, leaving the course open, so Mickey was able to stay on.

The days that followed were spent in a sleepless battle with the mechanical complexities of the four-engine racer. It was like working with a house of cards, and Mickey could only hope that all the

elements would function long enough for him to grab the record. It was an exciting time, what with other LSR teams working alongside them out on the salt. George Eyston, three-time record holder in his *Thunderbolt* racer in 1937–38 and now with Cooper, was there as well, enjoying the show. "Very colonial," he observed one day as Mickey and Fritz worked on one of *Challenger*'s transmissions, using a truck tailgate as a work bench.

"What'd he mean by that?" Fritz asked one of the university-educated Goodyear boys as the great man wandered off.

"I guess he means we're kind of Okified," said the young man, gazing over at Donald Campbell's sprawling camp of tents and trailers and brand-new Land Rovers.

Finally things came together. *Challenger*'s engines were synchronized, the multiple clutches were working, the tendency of the front wheels to lose traction was overcome by adding to the car's nose a heavy bronze bar that Mickey had found on the salt. At 10 a.m. on September 9, on his first run of the morning—and despite running into a slight head wind— Mickey tore through the clocks at 406.6 mph, comfortably beyond John Cobb's 13-year-old mark. "Look at that," he joked with reporters, holding up a steady hand after wriggling out of the cockpit. "I never felt better."

To officially claim the record, he needed one more good run. A 390 on the return leg would give him a two-way average beating Cobb—a 390 with a favoring breeze behind him. The LSR was right there in front of him now. All he had to do was seize it. If *Challenger* would just hold together for one more run . . .

"Mickey, I've got to tell you something."

It was Roland Portwood, the Utah State Highway Department worker who graded the course. He had been on hand the month before at the crash of Athol Graham.

"I was driving back from Salt Lake last night," said Roland, "and I was driving along the highway and the *Lord* stopped me, Mickey. He said to me, 'Roland, don't let Mickey make that return run tomorrow because if he does he'll be *killed*.'"

Mickey had been friends with Roland for two years and had never known him to speak like this. The warning shook him almost enough to back out of the second run. But he didn't. With Fritz's help, he squeezed back into *Challenger*, this time with serious misgivings. The push car chunked against his rear bumper and got him going, the engines roared to life and he was away.

With more room to accelerate going south and running with a tail wind, Mickey was expecting to blow right through 400, maybe hit 420. Either that or get killed, as Roland had predicted. Neither happened. Instead, he destroyed one of his four engines when he shifted from first gear to second. He managed to keep the car in a straight line and coasted to a stop, black smoke pouring from under the hood. A drive shaft had broken, he told reporters, a lousy $3 drive shaft. Admitting that he had blown one of the Pontiac engines would only have made his sponsor look bad.

"I'll never quit," Mickey vowed, dead tired after three weeks of all-out work on the car. "Whatever I have tackled, I have always succeeded." With that, his crew wearily loaded up their gear and wheeled the car back onto its trailer, relinquishing the salt flats to Donald Campbell. In the days that followed much would be made in the press of Mickey's one-way record. Some wiseacre even messed with the sign on the road leading to the speedway, the one featuring the big picture of Cobb's *Railton Special* and proclaiming his record. "M. Thompson — 406.60 M.P.H." read the inscription lettered over Cobb's number, crudely slathered on in dripping black paint.

But there was no such thing as a one-way land speed record. Officially, it was two-way or nothing.

By September 10 Donald Campbell was alone on the salt flats. The smart money was on him to break the land speed record. His *Bluebird* racer had a 4,250-horsepower Bristol-Siddeley Proteus aircraft engine, double the power possessed by Art Arfons and Mickey

Thompson, and was a marvel of engineering, a collaborative effort by more than 70 firms, all devoted to keeping the record British by pushing it up beyond the Americans' reach.

The press instantly took to the 39-year-old Campbell when he arrived on the East Coast from England. Photogenic and a bit eccentric, he could be relied on to serve up grand quotes. "We are on the threshold of the great human adventure," he announced at one press conference. "Today's unknown becomes tomorrow's known." And, on a note less likely to make Art roll his eyes: "This particular activity has nothing to do with racing. It is a completely different tree in another part of the forest. The challenge here is in the machine itself. This is a cold-blooded, calculated, lonely business."

And even better, in response to the question, "Why?": "It will be a sorry day when we no longer do something for the hell of it."

The first several days were spent testing the sapphire-blue racer at low speeds and making adjustments until Donald was satisfied with the handling. On every run he was accompanied by his good-luck charm, a teddy bear named Mr. Whoppit. And there was his beautiful wife Tonia, anxiously waiting. The press ate it up. There were always spectators on hand, for even standing still the car was something to see. Its most distinctive features were the four humps over the enormous wheels, 52 inches high, the largest in LSR history. The humps were so prominent that the designers felt it necessary to add roll bars over the cockpit. In the event of a crash, the wheels would protect the driver inside his Plexiglas canopy bubble.

They would be needed. On September 16, the 13th anniversary of Cobb's record-setting run, Donald crashed. The crew back at the start line could not see it. All they knew at first came from the telemetering signals radioed back from the racer, the needle on the speed indicator steadily climbing to 240 mph, then shooting up to 360, then dropping to zero. "My God," said chief engineer Leo Villa, "the Skipper's in trouble."

It happened as Donald was nearing the two-mile marker, accelerating toward 300 in gusty conditions. In trying to steer back

to center after being pushed to one side by a crosswind, he ran *Bluebird*'s left wheels along the line of oil that marked the edge of the course. It was this, he said after, that caused the wheels to lose traction and begin wildly spinning, sending the car into a skid that felt like skating on ice. It turned as it skidded until it was going sideways and the tires dug in and sent the car into the air. It flew for 825 feet, bounced four times, then went into a quarter-mile slide.

Donald was unconscious when his crew arrived and pried off the canopy, expecting the worst. The car, its engine still screaming, was horribly battered. The right wheels had been ripped off and one of the raised wheel humps ground down to nothing, leaving the Plexiglas bubble over Donald's head exposed. One more bounce would have squashed him. "Are you all right?" someone shouted. Donald roused slightly but only managed to mumble. Blood was trickling out of an ear. An eye was rolling strangely.

He had revived by the time he was extracted from the cockpit and managed to walk a few steps, with help, to a stretcher. "I'm all right, honey. Don't worry," he reassured his wife. His head was throbbing, however, and he was still stunned. "Tell the boys to get the car in shape," he instructed project manager Peter Carr as he was carried to the ambulance, not yet comprehending the extent of the damage.

Sorry, boss, Carr replied gently. The car's a washout.

The press was waiting when Donald, leaning on ambulance driver Ted Gillette, arrived at the nearest hospital in the town of Tooele. A cut extended across the bridge of his nose and right cheek and his eyes were still somewhat glassy. An X-ray examination would reveal a hairline skull fracture. He nevertheless seemed completely undaunted. "Good morning!" he said cheerily as he teetered through the hospital lobby. The morning had been "Bloody awful," he admitted, but he wasn't discouraged. *Bluebird* would be fixed and he would return. He would have another go tomorrow morning if the car were ready. Even Tonia Campbell, still shaken, had no doubts on that score.

"Of course he'll do it!" she said. "This is a setback, but he'll do it. That's why he's the man he is. He's a marvelous man. Every time I admire him a little bit more."

Campbell's misfortune meant one more chance for Mickey Thompson. Within days he was back at Bonneville, eager for another crack at the record before the end of the season. He and Fritz Voigt had spent the previous week overhauling the car, returning it to top condition after the pounding it had taken in the hundred miles of speed runs Mickey had racked up for the year. Maybe it was ordained that he should now claim the record. Maybe it was only right, considering that he had been chasing it longer than anyone, since 1958.

But it was no good. There was something wrong with the salt. A thin layer of crumbly crystals had formed on the surface, like coarse sugar. No matter how carefully Mickey stepped on the accelerator, the wheels would lose traction somewhere in the 300s. He kept at it for two days, taking the car up to the threshold and then oh-so-gently easing down a bit more on the gas. But every time it was the same thing: wheel spin. On September 21 he gave up.

That was it for the 1960 LSR season. Five men had gone after the record. All had failed and one had died. John Cobb was the only winner.

Spirit and Cyclops

C raig Breedlove pulled to a stop outside Shell Oil's Los Angeles district office. He was driving a '55 Ford pickup he had fixed up into a beauty, a rolling advertisement with the message painted on the back: "Craig Breedlove, Spirit of America, World's Land Speed Record Attempt." He was going to see Shell's district manager, Bill Lawler, the man in charge of company operations for most of Southern California. He didn't have an appointment. He was going to try just walking in.

Craig got out and stood looking up at the imposing building, wishing he had had something better to wear than Levis and a sports shirt and his black leather shoes from high school graduation. Oh well, no point stewing about it now. This was the best he could do. He picked up the model of his jet car and Bill Moore's artwork and flip charts and headed into the lobby, going over the presentation he had honed over the past several weeks. *Good morning, Mr. Lawler. My name's Craig Breedlove. I'm here to tell you about the car that will break the world's land speed record . . .*

Lawler's secretary looked up quizzically as he bumped through the door with his armload. I'd like to speak with Mr. Lawler, he said. My name's Craig Breedlove. He handed over one of the business cards he'd made up.

Do you have an appointment?

Ah, no I don't.

The secretary buzzed down to Lawler and said: There's a Mr. Breedlove to see you.

Okay, send him in.

This was going really smoothly. Craig had expected to be kept waiting and here he was being ushered right in. He followed the secretary down the hall to Lawler's office, faced flushed, feeling nervous. *Good morning, Mr. Lawler. My name's Craig Breedlove. I'm here to tell you . . .*

Bill Lawler was a top-notch district manager. His door was always open to the company's vendors, the front-line men who ran Shell gas stations and sold Shell products—men like Victor Breedlove, whom he was expecting this morning. Just give me a second, Vic, he said, signing off on a paper. Then he looked up and his welcoming smile turned to a frown.

"You're not Victor Breedlove . . ."

"No sir Mr. Lawler I'm *Craig* Breedlove and I'm here to talk to you about a project that I think will not only benefit myself but Shell Oil Company as well and I'm sure it will interest you because I am going to bring the world's land speed record back to the United States after an absence of 34 years and after many people have tried and failed and I have the car that can do it."

Lawler, a major in the National Guard, sized him up for a moment. Then he said, "You've got 10 minutes."

The setbacks of 1960, when he quit his fire department job and lost his wife and his sponsor as well as the promise of tires from Goodyear, had not kept Craig down for long. Moving in with his father Norman in Culver City, he drew unemployment insurance for a time and then got a part-time job at a garage. To keep his land speed car project moving forward, he sold off the only things of value he owned, a small plot of land he had saved from the divorce settlement with Marge—and his beloved '34 coupe.

There was also a new love in his life, a feisty car-hop named Lee Roberts who worked at a drive-in on the corner of Pico and Sepulveda. Lee was a kindred spirit, divorced like Craig and raising two kids and not put off by his LSR obsession. "The first time I went out with him," says Lee, "he took me over to where he was living with his father and showed me the mock-up of the jet car. It wasn't anything really, just made of wood, and he was trying to explain to me what he wanted to do and that he needed financial help to get things like welding gas and tubing so that he could start building the car." When Craig's father finally got fed up with his house being turned into a garage and told Craig to move out, Craig turned to Lee. They were soon living together.

Not long after that, Craig's nonexistent car got its name. The idea came to him one evening in Lee's apartment, as he sat at an old school desk he'd bought and refinished. "I was always impressed by Lindberg's flight. So when I was trying to come up with a name for the car, I thought, 'What can I call it that would be similar to *Spirit of St. Louis*, but that represented what we were trying to do, which was to bring an international record to the United States?'" What he came up with was *Spirit of America*. It seemed perfect. After the idea hit him, he wrote it down on a piece of paper and mailed it to himself so that it would be postmarked. "I was hoping to amateurishly copyright it to myself. I kept that letter for years and years, but it's gone now. I don't know where the heck it went."

Along with a new name, the car had a new design thanks to a Task Corporation engineer named Rod Schapel, yet another volunteer that Craig had talked onto his team. He had approached Rod for expert help after reading in a hot-rod magazine that he'd done design work and wind-tunnel testing on one of Chet Herbert's streamliners. "Sure, I'll help you design a car," Rod said, turning Craig's model over in his hands. "But not this one."

Rod liked the three-wheel configuration and the outboard wheels of Craig's concept. What he didn't like were the pointed nose and wheel fairings and swept-back lines. That's fine, he explained,

if you're intending to go supersonic, break through the sound barrier and do Mach 3 or whatever. But you're shooting for something in the 400-mph range, right? Look—and Rod started sketching. Instead of a pointed nose, we make it rounded. Same with the wheel fairings. That's a better configuration for a low-drag vehicle traveling at subsonic speed.

Armed with Rod's drawings, Craig and Art Russell made a new wooden model with a variety of interchangeable noses and wheel fairings so that the optimum shape could be determined through wind-tunnel testing. Rod arranged for after-hours tests at the Naval Post-Graduate Institute in Monterey, using the smallest of the institute's seven tunnels to lower the cost. "We would slather on this mixture of lamp black and kerosene," recalls Stan Goldstein, who gave up his weekends to help with the testing. "The kerosene doesn't dry up right away, so when you turned the wind tunnel on, it just blew the kerosene off and the lamp black would stay stuck to the model and would trace the airflow."

The tunnel testing also confirmed another design modification that Rod had come up with: the tail fin Craig had incorporated into his original model was removed altogether. The tests showed that a tail only increased the drag of the car without enhancing its stability. It was needless weight. "A tail wasn't necessary," Rod asserts today. "It still isn't necessary. It depends on where the center of gravity is, where the center of lateral resistance it. There are a lot of things to consider."

By 1961 *Spirit of America* was far removed from those early sketches Craig had made sitting on the sofa back in the firehouse. It had evolved into something sophisticated and cutting edge, a vehicle professionally engineered to blow right through the land speed record. Now, the challenge was getting it built. Craig managed to keep things moving by relying on a growing team of volunteers and spending everything he had and everything he could beg and borrow from family and friends. The jet car was a dream that a lot of people were coming to share.

One of them was Gordon "Nye" Frank, who would become Craig's chief mechanic. Nye was co-builder of the record-breaking *Freight Train* dragster that Craig himself had driven a few times, and Craig regarded him as one of the best. To do the fiberglass work, Nye brought in a protégé named Bob Davids, who had mastered the skill from building surfboards. "Bobby" was just 18 at the time and the youngest member of what was a very young team. In fact, the whole bunch of them were just a few years out of high school, and sometimes it showed.

"When we were building the air ducts," recalls Bob, at the time a 6-foot-4 beanpole, "there were only two people small enough to fit inside, myself and Craig's wife Lee. I would go in and do the fiberglass work and she would do the polishing. To squeeze into that little space, I had to turn my head as far as I could and push myself back into the duct. Then I had to collapse my chest and open up in a part of the duct where I could actually turn my head up and see. I would go about five feet back into the duct like that. Well, one day Nye and the guys came in, and they put a garden hose in one end and they sprayed water on me and I just panicked. I had to collapse my chest and turn and squeeze to get out, and I came flying out of there. I was ready to kill them. I told Craig I quit, and I got in my car and left. But Craig's a smooth talker. A couple days later he got me to come back."

Fabrication was already underway when Rod Schapel came to Craig with another idea that would dramatically change the racer. After wrestling for a month with the complex mechanical problem of how to steer at high speeds with a single front wheel, Rod had designed a revolutionary new system. Craig would steer at lower speeds using brakes on the rear wheels and at higher speeds using a fin or an air-rudder suspended beneath the car's nose. That way, the wheels themselves would not have to turn at all. They could be fixed in position.

"It seemed like a far-out design," says Craig, recalling his apprehension. "But I really looked up to Rod and his expertise. He's a real

sharp guy. So I just sort of acquiesced. I said, 'Well I don't know, Rod. I've obviously never driven anything like this before. I'll just accept your word that it's going to work.'"

In the meantime, there still loomed the huge problem of finding a sponsor. Without backing, it would be impossible to finish the racer and pay the fees required to run for the record on the Bonneville Salt Flats. Bill Moore created artwork of the new, improved racer, as well as a presentation flip chart. Art Russell painted the wind-tunnel model and made it a beautiful thing, and Craig started brushing up on his sales pitch. He had to sell Firestone, Goodyear, Shell Oil, *somebody*, on the idea of forking over enough money to bring his dream to fruition.

Craig Breedlove wasn't a natural salesman. Just standing up in high school to give a report had been an ordeal for him. When it came to his jet car, however, his passion overcame his shyness and made him eloquently persuasive. After 10 minutes at the Shell district office, he had Bill Lawler hooked. After an hour he had laid out the whole package: Rod Schapel's cutting-edge design, the wind-tunnel test results that proved the aerodynamics, the perfection of Walt Sheehan's air ducts, the speed potential of the car with a J-47 jet engine, the patriotic angle—and the publicity bonanza that Shell would reap if it backed him.

All the while, Craig left the mahogany case containing the model unopened on the desk until Lawler could stand it no longer.

"All right," he said at last, "what's in the box?"

Craig reverently opened the top and pulled back the velvet to reveal Art's gleaming model. "Mr. Lawler," he said, "this is the *Spirit of America*."

Lawler, the crusty ex-Marine, lunged excitedly out of his chair, seized the model and hurried off down the hall, shouting, "Look at this! Look at this!" When he returned he said, "I'm taking you out to lunch."

During the course of the meal, Lawler asked if Craig really thought he could break the land speed record. "I don't think I'm going to break the record, Mr. Lawler," Craig replied. "I *know* I'm going to break it." Lawler believed him. "Well," he said, "you're going to need a suit."

In the weeks that followed, Bill Lawler overcame Shell Oil's initial resistance to sponsoring the jet car and coaxed Stan Golden, vice president in charge of marketing, to listen to Craig's pitch on a West Coast stopover. As with Lawler, Craig won the cagey executive over. "Mr. Golden," he concluded as he removed *Spirit* from its velvet-lined case with a flourish, "can you imagine one of these models in every home in the United States with a Shell emblem on it?"

Golden stroked his chin thoughtfully and said, "Yes I can."

Craig was in. After Shell engineers approved his design plans— "We're not getting into anything that someone's going to get killed in," Golden told him—the head office people asked for an estimate of cost. Craig gulped and suggested $30,000. Okay, you got it, they said, privately smiling. They knew the 23-year-old hot-rodder would in fact need much more and budgeted for $75,000. It was serious backing, and Craig knew it meant leverage. He immediately contacted Goodyear again.

"You really have Shell?" was the incredulous response. "You mean Shell Oil in New York?"

"That's the one."

A rushed trip to Goodyear headquarters in Akron and Craig had the tire giant enthusiastically back on board, this time with custom-made tires and additional funding as well. After two years of struggling in obscurity, he suddenly rivaled Mickey Thompson as a land speed mover and shaker.

The fabrication team Craig assembled was made up of many of the same people who'd been involved in the project as volunteers. Now, however, they could be paid. A key new member was Quinn Epperly, a renowned West Coast race-car builder with a resume that stretched back to the 1930s. "It's the biggest thing I've ever seen," he

said, awestruck, when Craig showed him *Spirit*'s unfinished 40-foot frame. The plan was to move the car to Epperly's garage in Gardena, where the builder would oversee work on the tubular chassis and the outer aluminum shell and do much of the welding. "Everybody gave the welding to Quincy," recalls Bob Davids. "He was the best that ever lived." Others working on the car would include Wayne Ewing, Alan Buzkirk, George Boskoff, Bill Fordham and Don Henry. Stan Goldstein would keep the books and do payroll and procure parts and supplies.

The project that had been limping along for two years now shifted into high gear. The *Spirit of America* had to be finished in a hurry. Money was flowing like water now and the clock was ticking: the grand unveiling was scheduled for the summer of 1962. As Craig wrote in his autobiography, "We worked 18 or 20 hours a day on the car. We didn't stop, and some of the guys would work until they dropped. Then they would sleep on the floor. It was a complete, out-and-out crash program." Bob Davids recalls literally living with the car for two-week stretches before taking short breaks to return home to see his worried mother, who would periodically call the garage to ask if her boy was okay.

Back east in Ohio on Pickle Road, Art Arfons had started building a jet car of his own. It was his 16th *Green Monster*. He would nickname it *Cyclops*.

By this time, Art had made a second trip to Bonneville with his Allison-powered streamliner *Anteater*. He was clocked at a top speed of 313 mph in August 1961 during Speed Week, a big improvement from the previous year, but still far short of Cobb's mark. Mechanical problems continued to dog him and his partner Ed Snyder, particularly trouble with the clutch. Art just couldn't get shifted into high gear.

The condition of the salt flats hadn't helped. It was so bad that Art was the only land speed contender from 1960 to return. Nathan

Ostich cancelled his booked week after surveying the International
Course and finding it too rough. It would be better, he decided, to
pull out and hope for better conditions in 1962. Mickey Thompson
reached the same conclusion. There was no way he was running
Challenger on a surface like that. It was dry and choppy and easily
rutted, broken into a mass of shingle-like slabs that would shake his
racer apart.

Some blamed the sparse rainfall of the winter and spring, which
had deprived the salt of the standing water that served every year to
break down the ridges and smooth the surface. Others were start-
ing to point to another factor: the 10-foot-deep trench that a local
company had dug over the winter to collect brine water in large
ponds for the production of phosphates. The trench snaked for
miles across the flats and ran parallel to the International Course
for a stretch. The Bonneville Speedway Association had given
its approval to the project in the belief that it would improve the
course: the embankments of salt and mud heaped up from the dig-
ging would help to hold rainwater on the course for enhanced reju-
venation. As it turned out, however, the trench had the opposite
effect. Carrying away vast quantities of brine water, it had lowered
the water table from just a few inches beneath the surface to several
feet. When it rained, the water no longer sat for a time, slowly and
gently smoothing the surface. Instead, it was instantly soaked in.

Donald Campbell, meanwhile, had no intention of ever return-
ing. After his request to lease a portion of the salt to construct his
own private speedway was turned down, he turned his attention
to a dry lakebed in Australia named Lake Eyre. It was extremely
remote and totally undeveloped, but there was room to build a
20-mile-long track. He even invited Mickey Thompson to join him.
Mickey, still put out with the BSA for the lack of cooperation he felt
was reserved personally for him, was seriously thinking of taking
Donald up on the offer.

Art remained convinced that with a stronger clutch and a few
other improvements his *Anteater* could still break the record. After

the 1961 season, however, he abandoned the effort. He eventually sold the car, a move he would come to regret. He did it because he had come to accept that the future of the LSR was with jet engines. Jets generated a tremendous amount of relatively cheap power, they didn't need transmissions and clutches that were prone to break down, and they provided direct propulsion, which avoided the problem of wheel spin that had plagued LSR racers for decades. Even if he or Donald or Mickey managed to squeak past Cobb's mark in one of their wheel-driven racers, Art now knew that jet cars would blow past them with higher speeds than they could ever attain. If Nathan Ostich didn't do it, there was that kid Craig Breedlove who Art had read about in the paper and the Romeo Palamides project in San Francisco that he'd heard rumors about.

And then there was his own brother Walter.

Walt Arfons was one of the pioneers of the jet dragster. The idea came to him in 1958 or '59, back when he and Art were still partners, but drifting apart. "We just couldn't seem to get along," said Walt a few years later. "If I had a good idea, it was, 'No, we won't do it that way. We have to do it this way.' And when you start arguing like that, you just can't work together. I knew we were splitting up."

After finishing the Allison-powered *Green Monster* No. 11, their last car together, Walt suggested that they go in on a jet car. Art wasn't interested. According to Walt, Art and just about everybody else he spoke to said that a jet car wouldn't be able to accelerate fast enough to be any good on a quarter-mile drag strip. A friend of Walt, however, had proved this wrong by running his jet plane down a runway over a quarter-mile distance and hitting 90 mph. If a big heavy plane could get to 90 mph in the quarter, Walt reasoned, a jet car weighing a fraction as much could do at least double that.

"I tried to explain that to Arthur," said Walt, "but he wanted to build the *Anteater* then, so he started that and I built my jet. I built the first *Green Monster* jet, and that was the world's first jet dragster."

Walt started with a J-46 engine. He would come to prefer J-46s to J-47s, believing them to be safer. It was trial and error all the way,

exploring the engine without a manual or expert guidance, puzzling out how to fit it into a dragster, then climbing in and lighting it up and seeing what would happen. "Oh my goodness, it scared the hell out of me," he recalled to Harvey Shapiro. "I couldn't believe the horsepower . . . It's like you bend over and take a twenty-foot two-by-four and someone smacks you in the butt. It's quite a sensation, believe me." A few crack-ups followed, one of which broke his ankle, and there were some hairy rides with chutes burning up in the scorching exhaust until he figured out the deployment sequence. But finally Walt got his *Green Monster* jet working. And when he did, he started making good money—so good that he built a second jet dragster and then a third and hired drivers for them so he could put on bigger shows and work multiple meets.

When Art decided to build his own jet car in 1962, Walt was therefore already known across the country for his jet dragsters. Art's plan was to build something along the same lines, an exhibition car that would earn him fat appearance fees on the drag circuit. There was no way he was going to ask Walt for advice, so after buying a surplus J-47 he just let it sit in the shop for a while, until he and Ed screwed up enough courage to take the 15-foot-long beast apart and explore the innards. It would be the same trial-and-error learning process Art had gone through at the age of 12 to figure out a car engine—and the exact process Walt had undertaken in his shop a stone's throw away. The result was an open-cockpit dragster that Art called *Cyclops*, named for the aircraft landing light he'd placed in the nose to provide illumination in the shut-down areas at drag strips, which at most meets were dark after sundown.

Walt saw the whole thing as an attempt by Art to copy his success. "He wouldn't call it the *Green Monster* because I called mine the *Green Monster*. He had just as much right to the name as I did, because it was both of our names. It still is. But he come up with *Cyclops*. My *Green Monster* jet had made such a name then that the demand for it was terrific. By golly, I couldn't fill the dates. But Arthur couldn't get enough dates with his *Cyclops*. It just wouldn't

run like it should, I mean, as fast as these cars go. So he turned around and called it the *Green Monster Cyclops* and painted it green. Then he started getting some dates."

But Art had bigger plans for *Cyclops*. He wanted to take it out to Bonneville and run it for the world's land speed record. With its open cockpit and lack of streamlining, it was not an LSR racer. It was meant for the drag strip—and in some ways, that was a good thing. By running the car on the drag circuit most weekends from early 1962 on into the summer, Art became skilled at operating a jet engine, accelerating at maximum thrust and stopping safely. By the time he arrived at Bonneville in August, *Cyclops* was a proven vehicle and Art himself an experienced jet driver.

It took an all-out effort, but Craig Breedlove and his team got *Spirit of America* finished in time for its grand unveiling at the Wilshire Country Club in early August. Shell Oil had planned the event to stir up media attention, with the gleaming blue racer looking futuristically magnificent on the club's manicured green lawn. Craig, despite feeling exhausted, stood gamely by in his new suit with a name tag pinned to the pocket, smiling and shaking hands and answering questions as he led little tours round the car. Retired general Jimmy Doolittle, holder of the airspeed record in the *Shell Speed Dash* back in the early 1930s, was brought forward to pose for pictures—hero past with hero present. "All America is with you, Craig!" summed up the Spotlight newsreel of the event that would run in theaters. The Shell executives looking on were well pleased.

There was one thing that was privately bothering them, however. Bill Lawler, now general manager of the *Spirit* project, was tasked with clearing it up.

"About that babe you're shacked up with," Lawler told Craig after calling him into his office. "Here's the deal. Either marry her or get rid of her. I want it resolved by tomorrow."

Craig went home and popped the question to Lee. Within days

they were on their way to Yuma, Arizona for a quick marriage and honeymoon. When they returned, Shell was happy and they were all set to leave for Bonneville. The departure date was August 22, 1962.

The same week that Craig was glad-handing on the Wilshire Country Club grass, a second jet car was presented to the press at Bovard Field on the campus of the University of Southern California just a few miles away. The engine was fired up for reporters, sending a cloud of dust out across the football gridiron and filling the air with the smell of kerosene. The racer was called *Flying Caduceus*. It belonged to LSR hobbyist Nathan Ostich, a Los Angeles doctor more than double Craig's age.

Caduceus wasn't new. It was an improved version of a vehicle Ostich had been driving at Bonneville since 1960. When it came to land speed racing in jet cars, he had been at it longer than anyone else.

Doc's Red Racer

A l Bradshaw was 23 years old when he moved from the woods of northern Minnesota to California in September 1957. He had a young wife and a four-month-old baby and almost no money, but there was a job waiting for him with a power tool company so everything was going to be fine. By the time they arrived in Los Angeles hauling their meager possessions in a homemade trailer, Al knew he had made it. Everything looked so new and vibrant and rich. California was a land of opportunity, just like his sister had told him.

But there was one problem: the job at the power tool company was gone. Completely out of money, Al moved his family in with his sister and started looking for work. The search led him to a garage on Slauson Avenue in East L.A.

"You got tools?" the owner asked the slight Minnesotan.

"Sure I've got tools. I'm a mechanic."

"Well, go get 'em and let's see what you can do."

That's how Al got the job at Ak Miller's garage, the premier speed shop on the West Coast.

Working for Ak Miller wasn't like the job Al had had with the Chrysler dealer back in Minnesota. It was more fun. Some of the cars he worked on were bona fide racers, the coolest of hot rods, the kind of machines he loved. And then there were the people around

him, the other mechanics and the hot-rodders who drifted in and out of the shop. The place was always buzzing with car talk, with design plans, with fantastic ideas. There was usually something to be excited about. Losing that power tool company job was turning into the luckiest break in Al's life.

Most of the comers and goers at Ak's were in their teens or 20s, young guys like Al. There was also a craggy-faced older man who showed up, usually after work or on the weekend, often in a suit and tie, an expensive Patek Philippe watch on his wrist that he had worn since the war—upside down, for some reason, the winding stem turned to his elbow. He was highly educated, but he had no trouble fitting in with the Ak Miller crowd, most of whom had squeaked through high school at best. He would casually strip off his jacket and roll up his sleeves to pore over an engine or just hang around and talk. He wasn't a mechanical genius by any means, but he earned respect just the same with his enthusiasm and his friendly manner and his nerve as a fast driver. His full name was Dr. Nathan Ostich. But down at Ak's, he was just plain old "Doc."

Doc had been born in 1909 to Slovak immigrant parents in Rouleau, Saskatchewan, a one-horse town like the one Al Bradshaw had come from. He immigrated to the U.S. as a young man, training in medicine at Michigan State and Loma Linda, then serving his new country as a doctor in General Patton's Third Army, patching up troops in the march across Europe. After the war he settled in Los Angeles, eventually opening his own clinic in a working-class neighborhood in the east part of the city. In 1958 he was a year shy of 50, comfortable but not rich, and still unmarried. It was as if his life were too full for a family. When he wasn't tending to his patients, he was either trouncing challengers at the Los Angeles Tennis Club, where he was a member, or—more likely—fooling around with fast cars.

Doc's latest obsession was a Chrysler 300 that he'd had souped up at Ak's to race on the Bonneville Salt Flats. With his Chrysler background, Al was the mechanic assigned to work on the car. As Al got to know the older man, he learned that Doc had been

a hot-rodder since just after the war— and that he had a taste for far-out things. Recently, for instance, he had teamed up with Ak to put a Chrysler Hemi and a Harley Davidson motorcycle-engine-powered blower into a Kaiser Henry J, a 68-horsepower economy car available through the Sears catalog. It had caused some head scratching when Doc took it to the salt flats to run it, like a supermarket buggy transformed into a Formula One racer.

One day, Doc had an even better idea: Why not build a jet-powered car to go after the land speed record? The crowd at Ak's was used to big thinking, but this was too much. "Now here's a physician in East Los Angeles," recalls Al, "who is not overly mechanical, and he's talking about setting the world land speed record with, of all things, a jet car. He started jabbering about that, and the naysayers came out of the woodwork. Everybody thought he was really out in left field. They said a jet car would be uncontrollable, it would go in circles, that Doc was nuts and he'd never get it built, that it was an impossible task."

That did it for Doc. He had a stubborn streak running from one side of his stocky frame to the other. He decided to go ahead and build the racer. He would call it *Flying Caduceus* after the snake-entwined symbol of the medical profession, because he was a doctor and he was going to fly in the thing.

One person who didn't think Doc was crazy was Ray Brock, technical editor for *Hot Rod* magazine and a regular at Ak's. Ray was a beefy Oklahoma boy, the son of destitute farmers who had fled the dust bowl for California during the Depression. He had gone on to train as an engineer at USC and knew a lot about cars and racing. He liked Doc's never-before-tried idea of an LSR jet car and came on board as the project's lead engineer and mechanic. As the project gained momentum, Doc hired Al to join them as the number-three man and the only full-time paid employee.

Just how do you go about building a jet racer? That was the first thing the trio had to work out. A jet engine all by itself was larger than an entire car, so *Flying Caduceus* was going to have to be all

engine; built as a traditional streamliner, it would be as big as a yacht. So where to put Doc? In a cockpit behind the engine? No good. He wouldn't be able to see sitting behind a 15-foot engine, he'd be in the way of the scorching exhaust, and in the event of a crash he might be squashed by the weight of the jet. Perching him on top made no sense either. That would make the racer so high it would be like driving a barn. So the cockpit had to go in front. But then Doc would be blocking the flow of air being sucked into the engine. Okay, so what if we move the air intake to the sides. Let's have dual air ducts . . .

And so it went.

Eventually, a finished model of *Caduceus* was subjected to wind-tunnel testing, which yielded some interesting results. The three men learned that having an airplane-like tail fin on the back and streamlined fairings over the wheels didn't improve the model's aerodynamics as much as expected—not enough to justify the additional weight. Both elements were dropped from the final design, leaving *Caduceus* looking like a thick, needle-nosed pencil with four-foot-high wheels sticking out from the sides, completely exposed like on a Cub Scout's wooden derby racer.

In 1958 they were ready to start building. By this time Doc had moved into a storefront on East Olympic Boulevard within earshot of the train tracks. There was plenty of space in the empty shop on the ground floor to build the racer and store all the tools and supplies. Upstairs, there was a nice apartment for Doc to live in. Then he bought two surplus jet engines, worn-out J-47s off a B-36 bomber, one to put into the racer and the second for parts. By this time the crowd at Ak's had warmed to the project and were eager to help, melding into an inner circle of a dozen or so volunteers. They put in countless hours of unpaid work in the evenings after finishing their day jobs. Additional help, from menial labor to expert guidance, came from reporters on Brock's staff at *Hot Rod*, Doc's patients at the clinic, local companies and research labs and even the Air Force.

It would take about two years to complete the racer, with Ray and Al working side by side with the volunteers in what Al describes as a "hot-rodder co-op project." Doc would pitch in whenever he could spare time away from the clinic. He took special charge of fabricating the air ducts, sweating over a 200-pound form that a patternmaker had made, laying down layers of fiberglass and wire and resin. "He could be grouchy sometimes," says Al, "but I think that's because he was busy. He really had a heart of gold. He took care of my family, delivered two kids, did tonsillectomies, a hernia surgery, all at no charge. He would even submit the bill to my insurance and give me the check when it came. That tells you the kind of guy he was.

"Doc liked his fun too. He kept a Ping-Pong table right there in the shop and wasn't above challenging anybody who came by to a game. He'd give you a paddle and he'd use a Coke bottle, and he'd probably beat you just the same."

And then there was the practical joking. Doc loved a good prank. There was the time, for example, when he delivered Joann and Ray Brock's baby. The child arrived safely and the father was ushered into the maternity ward to see it. Oh Ray, Doc gushed, you have got one beautiful little daughter here, and he went over to a bassinette and picked up a bundle swathed in a blanket. Oh, she's a beauty, Ray, Doc enthused, carrying the bundle across the room to show the beaming father. And then he tripped and the baby went flying. It was just a doll, of course. But to see the look on Ray's face . . .

"That was with our first daughter," remembers Joann, laughing. "With our second child, he showed Ray a stuffed monkey. And when we had our third daughter, Doc fixed it up with a dildo. So yeah, he really liked his practical jokes."

As *Flying Caduceus* neared completion, it started attracting a lot of attention, so much that a rope had to be strung across the shop entrance to keep out the gawkers. "Hey mister," one young fellow called out to Doc one day from the far side of the rope. "Why are you building this thing anyway? Why would you want to drive more than 400 mph?"

The kid was probably just showing off to his friends, but Doc didn't mind. He looked up and then ambled over. "Well I'll tell you, son," he said, sounding thoughtful. "Some guys drink. Some guys smoke. Some guys chase women. I race cars."

The finished *Flying Caduceus* was unveiled to the press in Los Angeles on August 3, 1960. The three-ton racer was just over 28 feet long, four feet wide, about chest-high. Painted dark red, it looked like a parsnip, one reporter observed, or maybe like a cucumber with the front end whittled to a point. Steve Petrasek of Firestone briefly described the wheels his company had donated, milled from solid aluminum blocks, the tubeless tires only a fifth of an inch thick and treadless. You can touch them, he cautioned, but don't gouge them with your fingernails. Doc then outlined the racer's unprecedented power—5,200 pounds of thrust, equivalent to 6,930 horsepower when it reached its maximum speed of 500 mph.

How much did it cost you? the newsmen wanted to know.

Doc cringed as he divulged the figure: $50,000, most of it from his own pocket. "It makes me sick every time I think about it," he said. "But I guess it's cheaper than a wife. Try to get by with only 10,000 man hours of time with a spouse."

Four days later, the *Caduceus* team was on the Bonneville Salt Flats. The International Course had only just been cleaned up after the crash of the *City of Salt Lake* and the death of Athol Graham. No one wanted that to happen to Doc. They would take it nice and easy, using as much of the booked week as they needed to test the car before going after the record.

Things didn't go as planned. On the first day, a fuel leak brought everything to a halt until a part could be flown in from Los Angeles. Then the starter motor burned out, necessitating another delay to replace it. The cockpit radio wasn't working either—so much for the idea of communicating with Doc through headphones. Then they discovered that the jet was not revving to maximum power.

They chained *Caduceus* down to test it, Ray advancing the throttle to 90 percent power, and *kaboom*, the air ducts imploded, sending Al, who was monitoring the engine, scrambling backward. The powerful J-47 was blasting air out the back faster than it could be drawn in through the front, creating a vacuum that had sucked the fiberglass inward. After a frantic all-night effort, new ducts were installed in time for their last day on the salt flats. Doc set out on a run on August 13, the engine was purring, he was building up speed, and then, *kaboom*, the air ducts caved in again.

It was a huge disappointment, but Doc took it in stride. It took more than a few bumps in the road to discourage the doctor. By the time reporters had arrived on the scene, he was in fine spirits, rechristening the *Caduceus* "El Collapso." So what do you plan to do now? they asked him. Doc said, "I'm going to ride sidesaddle on an Atlas."

One month later, Doc, Ray and Al took *Caduceus* back to the salt with more durable air ducts. This time they held up, Doc hitting 237 mph on the first day and 259 on the second. The bugs that had plagued the engine on their previous trip seemed to be worked out. But another problem had arisen: Doc was having difficulty steering at higher speeds. If *Caduceus* drifted away from the black line and he tried to steer back, it would overcorrect, forcing him to ease the steering wheel back, only to have the car lurch in the opposite direction. This back-and-forth would continue, the oscillations increasing, until Doc had no choice but to deploy his chute to bring the racer under control.

The team couldn't figure out what was causing the problem. Was it a wheel-alignment issue? Was there something wrong with the GMC truck suspension they had used? Was it the steering system itself? After three days of frustration, they ran into a brick wall. There was nothing to do but go back to L.A., tear *Caduceus* apart and try to improve it.

* * *

Poor weather conditions over the winter had left the salt in such poor condition that the 1961 LSR season was a washout. It wasn't until 1962 that the *Caduceus* returned to Bonneville to take another crack at the record. Doc's week began on Monday, August 6, the day the papers broke the news of Marilyn Monroe's death. This time, things got off to a more encouraging start. The J-47 worked, the air ducts held, and there was no cockpit radio to break down. It had been scrapped. The car was still exhibiting sporadic handling difficulties, but Doc was hopeful. By Wednesday he was hitting the low 300s. At the end of the afternoon, to make sure everything was perfect, they installed new wheels and tires and bearings. The next day they would go for the record.

Thursday morning and *Caduceus* was ready to go, but it was too windy. John Ostich, Doc's brother, a Los Angeles dentist who had come along to lend a hand, raised his pocket meter every few minutes, checking the wind speed, while Doc stretched out for a nap on the shady side of the racer. He had been up since before sunrise.

Finally, the wind started dropping back down to the five miles-per-hour threshold.

"Okay, everybody," announced Ray. "It's getting calm. Get to your stations."

Doc got up and stretched and reached for his helmet and goggles as the generator was plugged into the racer and the turbine rotated. Off to the side, Joann Brock got into the family car with her two young daughters and drove down the course to watch at the entrance to the measured mile.

Doc got away hard, the J-47 spewing black smoke. He took it up over 300. Then he started to crash. It began with a shimmy, oscillations that he couldn't control. Then he was veering off course and the racer was no longer level. The left front wheel had torn off and the bare hub was dragging, carving a scar into the salt that extended for more than a mile. Doc cut the engine. He yanked the chute-release cord. Then he reached for the fire extinguisher handle, praying to himself, *Please God, don't let me burn.*

Thankfully, *Caduceus* did not catch fire or flip over. It smashed through a plywood mile marker, the still-rotating turbine inhaling a mass of chips, executed three complete turns and then ground to a halt. Doc instantly threw open the canopy and scrambled out. Hack Miller from the *Deseret News* was among the first to roar up. The scene was a replay of the wreck of Athol Graham's *City of Salt Lake*, the racer lying at the end of a long smear of red paint on white salt. But this time the driver was alive and smiling—visibly shaken but smiling. "Guess I broke a wheel," were Doc's first relieved words.

Other vehicles were now arriving, their occupants emerging white-faced and hurrying toward the racer. In one of the cars sat a woman and child, both crying hard from the shock of witnessing the wipeout. It was Joann Brock and her young daughter Maureen. "I hadn't been worried about Doc," says Joann. "I was always very confident about what he and Ray and the guys were doing. But that spinout . . . it scared the bejesus out of all of us."

The immediate cause of the crash was a burned-out wheel bearing, one of the fresh parts that had been installed the previous day. It had seized up and superheated and the wheel had snapped off. Behind this episode, however, lay the ongoing and more worrisome handling problem, those uncontrollable oscillations that could beset *Caduceus* at higher speeds. "We were in a dilemma," says Al, "trying to figure out why the car would go as straight as a string one time and the next time we would get into oscillations, right to left, right to left. Doc would make a run at 300 and the car would go straight. Perfect. He'd turn around to go back and the car would start wig-wagging. Did that cause the wheel-bearing failure? What the heck was going on?"

The answer was provided by two test pilots from Edwards Air Force Base, one of them the legendary Herman "Fish" Salmon, renowned for his ability to feel out the problems in prototype aircraft. Test pilots and astronauts tended to be deeply interested in fast cars, and so it wasn't too hard for Ray Brock to coax Fish down to Los Angeles for a brain-picking session.

The appointed time came for the meeting and Fish didn't show up. An hour passed, then another. Finally a Harley rumbled to a stop outside Doc's storefront, Fish and another test pilot riding tandem and looking rough. They had skidded out on the Santa Ana Freeway and were pretty skinned up. Doc took them upstairs and patched them up, then they all went out for lunch.

While they ate, Fish explained the likely reason for the handling problems the doctor was having with *Caduceus*. It had to do with the pressure of the air the car encountered as it attained higher speeds. If it got only a little off course and Doc steered to correct it, intense air pressure would build up on one side of the car and a partial vacuum would occur on the other, causing the car to pull in that direction. Doc was right not to fight it. Deploying the chute was the only sensible course.

So what do we do? the *Caduceus* team wanted to know.

You need a vertical stabilizer on the car, said Fish. A tail fin.

But we're not supposed to need one. The wind-tunnel tests showed that a tail would just give us more drag.

Forget the wind tunnel, Fish replied. There are all sorts of things going on with a car moving along a ground plane that a wind tunnel can't measure. Sure, a tail will give you more drag, but that's what you need. It'll give stability to that tube shape you have now.

After seeing Fish and his partner back onto the Harley, Doc, Ray and Al returned to the garage and stood around the jet car they had now been working on for four years. It was Doc who finally broke the silence.

Okay, boys, he said, let's get to work on a tail.

Zeldine and Otto and Harry

It was August 20, 1962, at the start of Speed Week, when a land speed car that everyone had thought dead and buried made its ghostly return to the Bonneville Salt Flats. It was the *City of Salt Lake*, the racer that had crashed at over 300 mph on August 1, 1960, killing its builder and driver Athol Graham. Since then, the car had been rebuilt by Athol's widow Zeldine and his teenaged assistant Otto Anzjon. The plan was for Otto to test it up to 300 mph during Speed Week, then return to the salt in 1963 to go after the record. By then Otto would be 21 years old, the USAC's minimum age requirement for drivers in record attempts it officiated and timed.

The project to rebuild the *City of Salt Lake* had been initiated less than two months after Athol's death. The idea, Zeldine told the *Deseret News*, had been all Otto's. "I would never have asked him to race it," she said, "but he expressed a strong desire to fulfill Athol's lifetime dream." It was evident, though, that Zeldine had LSR dreams of her own, asserting to reporters that the car "is still capable of going over 400 miles per hour" and even expressing an interest in driving it herself for the women's land speed record, then 150 mph. There was also that lingering notion of Athol's —that after the investment of so much money and so much time, and now a human life, the record just *had* to be broken to justify the whole thing and claim the financial windfall that would supposedly go to the victor.

Finding money would be a problem. The $3,000 in donations collected for the Graham family after the accident went to paying off the debts Athol had amassed going after the record. That left Zeldine with her salary as a part-time nurse, her Social Security widow's pension, and the payout on her late husband's modest life insurance, grudgingly forked over after the Chamber of Commerce got behind her and threatened the insurance company with legal action. Leasing out Athol's garage, Canyon Motors, brought in some more. "It's a dandy garage in a fine location," the *East Mill Creek Neighbor* pointed out to its readers. "Let's help Zeldine find the right party. Then that can be taken off her mind, too." Altogether, it was enough to allow Zeldine to support herself and her four young children, with little left over.

There were those who encouraged Zeldine when the news came out on September 20 that she was thinking of rebuilding the *City of Salt Lake*. "I think, Mrs. Graham," wrote a local business owner, "that with sufficient organization and campaigning, the money can be raised . . . I also believe that enough of the work would be donated by companies and mechanics to do the job for much less than $10,000."

"I'm sorry I don't have what is required most—money," read another letter from a car painter, "but it would be a privilege and a pleasure to help in whatever other way I might if the project gets underway. By that I mean physical, manual assistance, or whatever. (I'm proficient with a spray gun!) Well, you never know when you might need someone to run over to the junkyard to hustle a lug nut. I'll do it."

Not everyone responded so favorably. In fact, the majority opinion in Salt Lake City seemed to be that Zeldine was crazy. "I was criticized when I let Otto rebuild the car," she remembers, "because I was spending money that people thought I shouldn't spend. Too many people had too many opinions about what they didn't know about. It was something I just had to let pass." Letting it pass wasn't easy. Castigating letters to the editor appeared in the newspapers. In his sports column, Hi McDonald publicly urged, "Please Zeldine,

don't do it. It will cost you far more than you can possibly antici-
pate." People phoned Zeldine up at home and stopped her in the
street to give her a piece of their minds. "I sent you only a dollar,"
scolded one old lady, "but I meant it to be used to take care of your
children, not to rebuild a racing car."

What people didn't know, what Zeldine couldn't tell them, was
that there was more to the project than simple ambition. Part of
her motivation was concern for Otto. His parents had confided in
Zeldine information that they had withheld from their son. He had
been diagnosed with leukemia in 1956, and he had already long out-
lived the doctor's prognosis.

Otto knew that something was seriously wrong, if not exactly
what. By 1960 he may have suspected that his life would be short.
He was experiencing bouts of extreme weakness, his face was
covered with acne and he was losing weight. It's only anemia, the
doctors assured him. But whatever they were doing for him wasn't
making him better. There were months when he coasted along,
but then his condition would deteriorate. His already slight frame
would get thinner and his spirits would plummet. Then came the
shock of Athol's death and things suddenly got worse.

It was Otto's father, Truls Anzjon, who first broached the idea
of his son rebuilding the racer. Concerned by his son's physical and
mental decline after the crash, he went to Zeldine and asked that
Otto be allowed to work at restoring the car. It would give him some
hope, the will to live, Zeldine remembers Truls saying. She agreed
and spoke to Otto the next day about it. "I'm sure the Allison engine
is all right," he said, immediately brightening. "I've already washed
all the salt out of it. I could make drawings of each part as I tear it
down; then I could restore it exactly the way Athol had it—except
for the bodywork. I don't know much about streamlining." As for
going after the land speed record with virtually no experience
racing, that didn't seem to faze young Otto one bit. "I guess I should
be scared," he said, "but I'm not . . . My parents say it's okay and I'm
most eager to drive the car."

The work of rebuilding was done in the garage behind the Graham house, with Zeldine somehow scraping together the money they needed and Otto contributing his labor. Otto already knew the engine was in good enough shape to reuse, and he soon discovered that the sturdy aluminum rails and part of the frame were likewise fundamentally undamaged. Once everything had been taken apart he began the slow job of piecing the car back together, scrounging parts from junkyards whenever he could to save money. The P-51 fighter cockpit was crushed and had to be cut away and replaced. So did the battery and the carburetor and one of the magnesium wheels. Athol's customized cooling system, which ran on antifreeze and dry ice, had to be entirely rebuilt. The list was long, but Otto was confident that he could work his way through it—all except fabricating an aluminum shell to replace the car's original B-29 drop-tank body, which had been torn to pieces. Zeldine eventually found a firm in Pontiac, Michigan that could do the job. That brought the cost of restoring the *City of Salt Lake* to over $10,000, all of it borne by Zeldine, who had been unable to find a sponsor.

The car was ready by Speed Week in August 1962. Otto's first hurdle was passing the safety inspection. The Southern California Timing Association, which presided over the event, would not allow any vehicle to run before being thoroughly looked over. The *City of Salt Lake* was given particular attention on account of its tragic history and Otto's inexperience, but it still passed. It was placed on the list of approved vehicles and on August 20 Otto climbed into the cockpit to drive it for the very first time.

The sight of such a young and frail driver in such a big car made everyone nervous. The apprehension grew when Otto admitted to having never driven faster than 75 mph. Okay, course starter Bob Higbee told him, this is just your first run, so keep it under 150 mph. Otto idled down the course as instructed and posted 148. For his next run Higbee set a limit of 175 mph and Otto was clocked at 172. For his third run the bar was raised to 200 mph and Otto did a 197, impressing Higbee and the other officials with his coolness.

For a green kid he was handling the car like a pro. No one seemed to take much notice of how slowly he got out of the cockpit after each run and how much time he spent resting. Only Zeldine and his dad knew that it was because Otto was exhausting himself.

On Friday, August 24 Otto continued his incremental speed build-ups, Higbee setting a new limit of 250 mph and Otto posting a 244. After making one more run at 254 mph, the SCTA officials were at last satisfied with his competence and cleared him to go all out.

It was then that Otto's lack of experience finally showed. On his next run, with Truls proudly filming home movies, he floored it. Perhaps he knew there wasn't going to be a next year, that it was now or never. Whatever was going through his mind, it prompted him to tromp on the gas so hard that his wheels quickly lost traction and started to spin. The abrasive salt ate through the thin rubber of the Firestone tires and there was a blowout. There was no crash, but the car was finished for Speed Week.

Otto would not live long enough to run the car for the land speed record in 1963. During the fall of 1962 he entered a final decline and was soon confined to his bed. He died on November 25, 1962 at the age of 20. At the funeral service his parents asked Zeldine to sit with them and the rest of the Anzjon family. "You gave my son two years of life, his best years," Truls told her. Otto today lies buried at Salt Lake's Wasatch Lawn Memorial Gardens, not far from Athol Graham.

Although the *City of Salt Lake* now had a reputation as a twice-jinxed racer, it didn't remain idle for long. It was restored and driven again by Harry Muhlbach, a 26-year-old amateur road racer who made his living leasing out the dump truck he owned. By early 1963 Harry was seeing a lot of Zeldine. They would eventually marry and launch an auto-parts business together. But first they teamed up for another run at the record, rechristening Athol's old car the *Graham Special* by way of a new start.

The car was in fairly good condition, Otto's low-speed blowout having done minimal damage. After a thorough engine overhaul and some minor touching up, it was ready to go. Harry drove it at Bonneville for the first time during Speed Week in August 1963 and pushed it to 293 mph. "It ran absolutely beautiful," he recalls. "It was just as smooth as silk." The ride was nevertheless scary. When Harry hit his top speed the canopy over his head, which was held down with springs, was sucked upward several inches by the air-flow. Strangely, no wind blast came smashing in against his face. "At that point I knew the car was creating lift. It wanted to fly."

The Speed Week runs encouraged Harry and Zeldine to mount an official LSR bid, the one that Otto had not lived long enough to make. Zeldine would handle the paperwork, booking the salt and the USAC timers. Harry and his small crew would take care of the car. There were some safety alterations he wanted to make before plunging into what was obviously a risky endeavor. A number of small L-shaped spoilers were attached to the shell of the racer to counter lift tendencies and keep it down on the ground. To aid with steering, a tripod-like guidance device was installed on the nose. It projected out eight or more feet and had a little horizontal bar on the end that Harry could use like a gun sight to keep himself traveling in a straight line. That was necessary because it was difficult to tell from the extreme forward cockpit just when the car was starting to veer.

Finally, something had to be done to protect Harry in the event of a tire blowout like the one he believed had killed Athol. He and his crew decided on an automatic chute-release system—a set of switches attached to the inside of the wheel wells, one directly behind each tire. "They were just flat pieces of steel three or four inches across," says Harry, "kind of like pedals, that tripped a sole-noid when they were pushed down. The idea was that if a tire blew and started to shed rubber, the remnants would fly back, hit this pedal-switch and trip the chute."

Ironically, it was this safety mechanism that caused Harry's high-speed crash on October 12, 1963. At least that was the

conclusion he reached with his team. "A tire didn't blow. Evidently the salt thrown up from the tires hit these switches with enough force that it tripped the parachute. It came out and I didn't know it. There was no warning light in the cockpit and I couldn't see behind me at all, so I had no idea the chute was out and I was still trying to accelerate. I felt the car start to lift and get thrown around and then it tipped over and I went skidding down the course on my roof. I dragged along upside down at least a quarter mile before I came to a stop. I didn't feel any anxiety during the wreck, but once I stopped moving I had a lot of fear about fire because I was trapped inside the car. It was maybe five minutes before they came to pry me out, but it seemed like an hour."

Harry was right to worry about fire. As he lay upside down, trapped, gallons of antifreeze poured out of the cooling system and onto the scorching-hot engine, filling the cockpit with smoke. "He's lucky—very lucky," observed Joe Petrali, marveling at how calm Harry was when they found him. The worst injury was suffered by ambulance driver Ted Gillette, who cut his forehead while helping Harry get out. Harry himself escaped with nothing more than light salt abrasions. Had the *Special* tumbled, he likely would have ended up dead. News accounts stated that the crash occurred at around 300 mph, but Harry asserts he was doing close to 400. "I guess it doesn't count for much, but I think I probably went faster with a single piston-driven engine than anybody else ever did."

Following the crash, Harry told reporters that he intended to repair the *Graham Special* and try again the next year for the record. Zeldine wanted to try again as well, "to try and retrieve some of the money I've spent on it. I don't know what it will mean by way of money if we beat the mark. But it should bring some of it back... We came so close." The news sparked an immediate outcry.

"Oh God, I hope she doesn't race that thing again," moaned Andy Granatelli, who had been on the salt at the time of the crash, doing some test driving. "It's frightening for us to know that thing is running out there." Harry remembers *Deseret News* sports editor

Hack Miller being particularly upset—so much so that he phoned Harry and told him he wasn't going to allow him to "publicly commit suicide" and would do everything in his power to stop him. Nothing ever came of it, however. The restoration of the *Graham Special* was never completed. "There was no particular reason," says Harry. "There were financial problems, and then I started a business, and it just never happened."

He and Zeldine married in 1964. Five years later, they went through a very acrimonious divorce. Zeldine's memories of their time together are bitter; Harry doesn't like to say much about it. Today, the *Graham Special* sits in the garage of Athol and Zeldine's only son, Butch Graham. Butch is restoring it to how it looked in 1960—and to its original name, the *City of Salt Lake*.

Out of Control

Afer losing a wheel and spinning out at 331 mph, Nathan Ostich had joked with the press about the difficulties of handling a three-wheeled car on the salt flats. "I would like to warn Craig Breedlove," he said, "that this is not an easy thing to do—run this course on just three wheels."

Two weeks later, on August 22, 1962, Craig and his new wife Lee and the *Spirit of America* team set out from Los Angeles to find out for themselves. They made quite a convoy. There was the huge trailer with the jet car bolted to it and a "Wide Load" sign on the back, a customized semi filled with tools and parts, a camping trailer towed behind a pickup to provide a little comfort on the salt flats, a Shell tanker filled with jet fuel and a line of cars loaded with engineers, public relations men, experts and crew. When they arrived at Wendover and checked into the Western Motel, Craig was stunned to learn they filled 21 rooms, including a spacious double just for Lee and himself. It was real luxury. On previous trips to Bonneville he had slept in a tent.

Spirit of America was arguably the most visually impressive land speed racer ever to appear on the salt flats. First of all, it was big—36½ feet long, 11 feet wide at the rear wheels, 6 feet 3 inches high at the canopy. Craig needed a stepladder to climb up and into the cockpit. The air ducts hugged the side of the chassis like on the

F-104 Starfighter that duct designer and jet specialist Walt Sheehan had helped develop at Lockheed. The wheels were forged aluminum and gleaming. The hand-crafted 48-inch-diameter Goodyear tires were inflated to rock hardness at 250 psi, so extreme that they spooked some of the crew. The paint job Bob Davids had given it was a thing of beauty, a swath of dark blue sweeping back from the nose into a lighter shade of silvery blue that was the car's primary color—"Yorktown Blue Metallic," recalls Bob, nearly 50 years later, the shade of GM paint still clear in his mind.

After spending a few days getting the car ready, they hauled *Spirit* onto the salt for its inaugural run. Its tank was filled with the special jet fuel that Shell had shipped out from its refinery at Wood River. In place of air, a bottle of nitrogen gas was wheeled forward to top up the tires—nitrogen didn't contain moisture, which in the heat generated at high speed would turn to steam and increase the pressure. Craig climbed up the ladder and snuggled down into the seat, Nye Frank helped him strap in and put on the oxygen mask and the Plexiglas bubble that would shield his face. The canopy was locked in place and the start cart moved forward; an electrical cable was run to the J-47 engine. As he surveyed the instrument panel before him and looked out at all the people working around the racer, the thought passed through Craig's mind, "So this is what the big league looks like."

An hour passed and *Spirit* had not moved an inch. The crew couldn't get the jet started. It was the engine Craig had purchased with Ed Perkins' money, one of the first things he'd acquired to build the racer. After a morning of frustration, they gave up and hauled *Spirit* back to Wendover, wheeling it into a hangar at the abandoned air base so they could strip it apart without worrying about salt blowing into every exposed cranny. It was turning into a horrible start.

They never did get the engine going. When it became evident that it was a dud, Shell shipped in a replacement J-47 and the crew installed it and got it working in a marathon 12-hour session. On August 30, the car was ready and Craig was back in the game. When

he and the crew returned to the salt shortly after sunrise, they were greeted by an earthquake. It gave the whole of northwestern Utah a very good shake.

Craig's arrival at Bonneville coincided with the end of Speed Week, 1962. The week had seen the return of Art Arfons to land speed competition with his newly built *Cyclops*. It was a dragster pure and simple, four exposed wheels and an open cockpit and not even the pretense of streamlining. What it did have was a tremendous amount of power, a J-47 with an afterburner added that boosted the thrust by about 50 percent.

Art was now officially a full-time, professional drag racer. Earlier in the year, he and Walt had closed down the family feed mill and hardware store operation because it was no longer turning a profit. When Art started touring the drag circuit with *Cyclops* in early 1962, cars were his sole source of income.

Cyclops lived up to his expectations. After working out the bugs and developing a feel for the jet engine, Art began hitting over 200 mph at regional drag meets, a phenomenal speed at the time for a quarter-mile strip. And just as Walt had predicted, he started earning very good money. Crowds loved to watch his fire-spewing *Cyclops* in action and that made promoters anxious to book him, offering him $250, $500, even $750 to make just a couple passes at one of their meets. It was the start of the good life for Art, racing every weekend and pulling in real money, enough to ensure his family's financial security and provide some comforts. There was just one thing he didn't like about it: the traveling. Working meets all across the country meant that he was away from home for long stretches, weeks when his contact with June and the boys was limited to phone calls. That bothered him.

Art's *Cyclops* runs at Bonneville during Speed Week were hairy. When you're pushing an open-cockpit racer past 300 mph, that's the only kind of run there is. "It was really a bitch," he would later

tell Harvey Shapiro, "but I couldn't put a canopy on it. If I'd have closed it in, I'd have taken air away from the engine." Rather than do that, he opted to sit in the open, the J-47's massive intake sucking in air directly behind him, a low wind deflector out in front providing minimal protection from the onrushing blast. Apart from the jet engine, it was old-school land speed racing. You had to go all the way back to Malcolm Campbell and his *Bluebird Special* in 1935 to find a record-setting car in which the cockpit wasn't completely enclosed. Campbell had set his final record that way, his ninth, with a run at Bonneville of 301 mph that had nearly pulled off his face. Art attained a two-way average in *Cyclops* of 330 mph and a top speed of 342, a personal best. It was faster than anyone had ever gone in an open-cockpit car. The record still stands.

Art might have gone even faster if *Cyclops* had had a bigger fuel tank. As it was, it held only 20 gallons, plenty for the drag strip but not enough for a complete run on the salt flats. All his runs therefore had been truncated—quick accelerations until the tank was dry. "If I had five more gallons of fuel," he would say later, "I would have gone 400."

The wind blast Art experienced on his runs was ferocious, almost beyond endurance. He had to tape his goggles onto his face to keep them from being torn off. And at maximum speed he did not dare turn his head. If he had, the wall of oncoming air would have pinned it to the side and he would have been unable to turn it back and look forward. It was blood-and-guts racing—and he loved it. He left the salt at the end of Speed Week completely satisfied with *Cyclops'* performance and wanting to go even faster—and convinced that the future of the LSR lay with jets.

Craig Breedlove was impatient on that first run in *Spirit of America* with the newly installed, properly functioning J-47. He was going to go with the throttle set at 100 percent, full military power. There was no afterburner on the engine, so that was all the car had. The plan was to accelerate quickly up past 150 mph as he tried steering

with the rear brakes, then throttle back at 200 mph and hold it there while he checked out the air rudder. If everything tested okay, he would turn around at the far end and try a high-speed run, maybe even go for the record.

The sensation of acceleration was unlike anything Craig had ever felt racing a hot rod. It rammed him back into the seat with such force that it gave him a strange lifting sensation in the pit of his stomach—"The sort of feeling that you get in a car when you go over a big dip in the road at high speed," he would write.

That passed in a few seconds. Then there was trouble. For some reason the car was veering off course to the right. He stepped on the left brake to correct, but instead of easing back to the center, *Spirit* overshot and then veered left. Craig hit the right brake and this time the car overshot back to the right. Craig kept working the opposing brakes, trying to be gentle, but he couldn't get *Spirit* to follow a straight line. It would zig to one side and then zag back to the other, back and forth, back and forth.

The car was now doing over 150. He had to get it under control. He turned the steering yoke, which was connected to the air rudder under the nose. It was designed for high-speed steering using wind resistance. The car was now going fast enough for it to be effective.

Nothing.

He turned the yoke as far as it would go.

Still nothing. No response at all. What was going *on*?

He was now going 240 mph. He had no control over the racer and was feeling profoundly alarmed. There was only one thing to do. He shut down the engine and braked to a stop.

Rod Schapel was one of the first to drive up. "What's wrong?" he called out as he ran forward. "Why did you shut it off?"

"The brakes didn't work," Craig answered, close to tears with frustration, "the fin didn't work, nothing."

Rod couldn't believe it. "They had to work!"

"Well, I'm telling you right now they didn't. I was out there still trying to steer it with the brakes at 240. The fin didn't work."

That was it for the day. First the balky engine and now this: no steering. The team went back to Wendover and Craig spent some time alone in his room trying to puzzle through the problem. He came to the conclusion that he had rushed things unduly; that he had accelerated too hard and tried to go too fast on the very first run. After cooling down and talking it over with Rod, they decided the best thing would be to take it easy when they resumed tests the following morning, go slow until Craig got a feel for the car.

On his first run the next day, Craig idled *Spirit* down the course at no more than 100 mph. Once again it started to drift. And once again he had to fight with the rear-wheel brakes to try to get back to the black line. He stopped and the crew tried various adjustments, but nothing seemed to make any difference. "I'm in there trying to steer right and the car goes left," Craig remembers. "It seemed to have a mind of its own where it wanted to go. It was pretty unnerving."

What followed was a long day of frustration and then another and then a third, until everything was in turmoil and Craig and Rod were mad at each other. Rod was convinced there was nothing wrong with the car. The problem had to be with Craig. It is a position Rod still holds today.

"Craig claimed the car would wander one direction or another," he says. "But we went out and rented a jig transit, and we surveyed the entire course to make sure it was level. And it *was* level. So that threw that out as a reason he couldn't steer the car. Craig also couldn't really say the steering canard on the front wasn't working because he wasn't going fast enough to make that statement."

For his part, Craig felt that Rod was too caught up in defending his reputation. "He just sort of lost touch with finding the problem," he would write in his autobiography, "and spent more time trying to justify the design than trying to find out what was wrong."

It was Nye Frank who finally identified the cause of the drifting. It was a straightforward mechanical issue with the front wheel, an inadequately restrained bearing that was sliding around inside the housing. It had been overlooked because the looseness was not

apparent when the car was stationery. Securing the bearing in place solved the erratic drifting problem. Craig continued to have trouble with the air rudder, however. He would take *Spirit* up past 150 mph, the speed at which there was supposedly enough wind resistance for the rudder to work, but he found it to be totally ineffective. He pushed past 200 and still got nothing.

By this time, Rod had lost faith in Craig as the driver. That led to some harsh words, including the accusation that Craig was lying about the car's performance, that he was steering off course on purpose—and that he had lost his nerve.

"The car doesn't take an ignition key," Craig shot back. "Get in and drive it yourself."

"I would," said Rod, a big, chunky man, "but I can't fit in."

They never got to the end of their booked week on the salt flats. Shell, after consulting with Craig, decided to pull the plug early. There was no point continuing with a car that wasn't working. The team needed to go back to Los Angeles, tear *Spirit* to pieces and do whatever it took to make it into a workable racer.

As they were wrapping things up, the solution to the air rudder problem at last emerged. Once again, the answer proved ridiculously straightforward. The linkage running from the steering yoke to the rudder had been left at its tightest possible setting after *Spirit* had been unloaded from its trailer on the salt flats. While Craig had been cranking away at the steering, the rudder itself had been barely turning, moving just half an inch from lock to lock. It was easily corrected and Craig took the car out for one last run. "It was our last day on the salt," he says, "literally at sunset. I came out and climbed into the car and made a run and got the fin to work. I actually got the thing to steer with that fin. Rod was there, and it worked fine. But we were out of time and we had to leave. And of course by then everybody was in an emotional shambles."

That final run proved that there was nothing fundamentally wrong with Rod's design for *Spirit*; that the problems Craig had encountered had been due to mechanical glitches, the sort that have

to be worked out of any revolutionary new machine through testing. Shell, however, wasn't interested in proving cutting-edge engineering ideas. They wanted a sure thing—and that meant making adjustments. In the weeks that followed a number of expert consultants were brought into the project and, to Rod's consternation, *Spirit* started to change.

The first thing to go was the steering-with-brakes system. Rod had come up with the idea as an answer to the complex problem of making the single front wheel steerable. Now an engineer from Hughes Aircraft, Bob Heacock, showed a different way forward. "It's real easy to make the front wheel steer," he explained to Craig and the assembled team. "You just put it on a focusing link."

"We all looked at each other," recalls Craig with a chuckle, "and then we turned to Bob and said, 'What the heck's a focusing link?' And Bob sketched this thing on a piece of paper, and it was a brilliant solution that was just slam-dunk simple. And so we ended up making the front wheel steer along with making the fin turn."

Attention next turned to *Spirit*'s tail—or more precisely its lack of a tail, for Rod had determined that one wasn't necessary for the configuration he had designed and wind-tunnel-tested. Bernie Pershing, an aerodynamicist with Aerospace Corporation, now disagreed. For stability and safety, Pershing advised, the car needed a tail fin. And so it would get one.

Rod tried to defend his design concepts in these meetings. There was nothing wrong with the car, he asserted. What was needed was a different driver. At one session he put forward the name of Mike Freebairn, who had a lot of experience flying jet fighters. The suggestion was not seriously considered. "It caught me completely off guard," Mike says of that meeting. "I mean, I'd have loved to drive that car. But it was never my project. It's was Craig's."

And so Craig grew a year older and 10 years wiser, and his *Spirit of America* jet car began to take a new shape. The alterations still rankle Rod Schapel to this day. "A tail wasn't necessary," he says. "It still isn't necessary. It was put on there because Craig was afraid to

drive the car." Rod doesn't recall the mechanical glitches, the loose front-wheel bearing and the poorly set linkage, all of which had rendered the car unsteerable and given Craig good reason for caution. Nor does he remember the successful test run on the very last day.

As for Craig, that first trip to Bonneville with *Spirit* remains a painful memory, a dark and lonely nadir when all his land speed dreams seemed to crumble into a welter of argument and bruised egos. "Rod had a lot of his personal reputation at stake—at least he viewed it that way—in this system working. And when it didn't, he for some reason took it as a personal affront. And his system was fine. It was really kind of brilliant. The big problem was that there were development bugs. You get up there and you have to get things done in a short period of time, and you've got these huge companies, Shell Oil and Goodyear, behind you and you're burning money like it's bad toast and that adds up to a lot of pressure to deliver. And so things get overlooked. Everybody got so emotionally involved that no one was checking the basics, like how far was the steering fin actually moving, stuff like that. And it just became this horrible conflict.

"And then, sadly, Rod sued me."

But that would come later.

Art Arfons was back working the drag circuit and thinking about his next step. He would not be going any further with *Cyclops*. The racer had become his main drag earner, and that's where he would keep it, on the strip. Instead, he was forming a plan for a brand-new, purpose-built land speed car, a jet-powered successor to *Anteater*. It would have an enclosed cockpit and an ample fuel tank and some attempt at aerodynamics, unlike *Cyclops*. Art hoped to give it more power than could be squeezed out of a J-47—more power, in fact, than had ever been put in an LSR racer.

There was a new jet engine out there that he wanted. Called a J-79, it had come into service in the late 1950s to power the Air Force's

supersonic F-104 Starfighter. A J-79 with an afterburner would put out three times the thrust of a J-47, around 17,000 pounds. It would take 40 of the powerful Pontiac engines Mickey Thompson had put into his *Challenger* to generate that much energy. *Forty.* Art wanted that behind him the next time he went to the salt flats.

Getting his hands on a J-79 wasn't going to be easy. When he tried calling around to military surplus suppliers, the response he got was: A J-79? Are you crazy? Those things are classified, man! That didn't stop him from hoping to get one, however. And after a bit more thought he figured out how to do it.

In the meantime there was nothing he could do but sit back and watch what happened to the record. Craig Breedlove had failed in his first attempt, but he was reportedly redesigning his car for a second try in 1963. There was also Nathan Ostich and his *Flying Caduceus*, another bust for the year, but Ostich was still in the game. And then there was Art's half-brother Walt, now building a land speed jet car of his own. If Art needed anything extra to spur him on, that was it.

As for the *Infinity* jet car from San Francisco, driven by a guy named Glenn Leasher who Art had met a few times at drag meets . . . well, he didn't like to think about that.

CHAPTER 8

Infinity

They drove east all day from Oakland, towing the jet car on a trailer behind Romeo's truck. The sun had long since set when they arrived on the salt flats, but it was unbelievably bright with the moon reflecting off the whiteness, almost like daytime on some blue-tinged other world. Why wait till morning? someone suggested. Let's get it off the trailer and run it right now. They had spent over a year building the racer and were dying to test it. And so, sometime near midnight, an ear-splitting roar shattered the desert silence and the *Infinity* took off, the orange flame from the engine fading into the distance until it was a speck and was gone.

The whole thing had started with Harry Burdg, manager of the Fremont and Vacaville drag strips near San Francisco. Harry was always on the lookout for good business ideas. One day it occurred to him that a jet car might be a winner. The first person he recruited for the project was Romeo Palamides, who built and raced dragsters out of his shop on MacArthur Boulevard in Oakland. Romeo had the skills to build a body for the racer, but he didn't know anything about jets and the complex monitoring systems required to run them. To handle that end of the project and the car's more technical design elements, they recruited a 20-year-old engineering student named Vic Elischer, then working his way through UC Berkeley with a job building race cars for Benny Hubbard. Vic in

turn recruited a volunteer named Tom Fukuya, a longtime friend who had briefly studied at Caltech.

The project hit a snag right from the start when they discovered that the jet Harry had purchased, a surplus J-47, had been stripped of key parts; that it was in fact U.S. military policy to strip *all* surplus J-47s in this manner before selling them off to the public. For Vic, the next few months were an odyssey of hunting down and acquiring the necessary components. He finally found them and they built the car. It was the most powerful dragster in the nation and was accordingly christened *Untouchable*. Korean War fighter-pilot-turned-racer Archie Liederbrand was hired to drive it.

For over a year *Untouchable* tore up drag strips up and down the West Coast, outpacing traditional dragsters by wide margins and attracting huge crowds. Strip promoters balked at first because Harry drove such a hard bargain. But soon they were gladly shelling out fat appearance fees plus a gate percentage for the privilege of headlining the car that could shoot out 40-foot flames. The project was so successful that Harry and Romeo and Vic decided to build a second jet racer, one that could break John Cobb's world land speed record.

Their first challenge was getting another J-47—one with all its parts intact. They cleared that hurdle with a little sharp dealing in Medford, Oregon. An F-86 Saber, almost brand-new, had just been donated to the town as a monument to the Air National Guard. Sensing opportunity, Vic and Romeo drove up to Medford with a flatbed truck and their most winning smiles. You know, they pointed out to the city council, it would be a whole lot easier if you took that engine out before you mounted the plane. That would make it much lighter, you wouldn't need such a robust pedestal, and everything would look just the same. Heck, we'd take the engine out for you if you like, because we can use it. We might even throw in a few bucks.

The pitch worked. The pair returned to Oakland with the J-47 strapped to the flatbed. It was in pristine condition, afterburner intact—and they had got it for $750. Recalling the incident today still stirs up some of the old glee for Vic.

The jet car they set out to build would be called *Infinity* at Vic's suggestion; Palamides' idea of calling it the *Romeo* was nixed. It would be jointly owned by the four principals in the project. Harry Burdg, who put up the initial investment of $12,000, was accorded a half share. The rest would be divided three ways between Romeo, the builder, Vic, the technical expert, and the guy with the Midwestern drawl who would do the driving, a 26-year-old from Kansas named Glenn Leasher.

Glenn Leasher had developed a taste for speed and raising hell growing up in Wichita, Kansas. When he wasn't racing jalopies at county fairs on the weekend, he was bombing around town on his motorcycle, acting like Marlon Brando in *The Wild One* and annoying the cops. There was the time, for example, when he rode his bike through a local movie theater as his cronies Archie Liederbrand and Tom Hanna held open the doors. He did it right in the middle of the afternoon matinee, headlight on and engine roaring, down one aisle and in front of the screen and up the other aisle and back out the door, leaving the stunned audience sputtering: What was *that*?

In 1959 Glenn started to make a name for himself as a driver when he pushed "Kansas Al" Williams' dragster *Hypersonic* to 185 mph, the fastest speed yet attained on a quarter-mile drag strip. With this accomplishment under his belt, in 1961 he followed his friend Archie Liederbrand out to the West Coast, where he figured bigger opportunities awaited. He started out at Ted Gotelli's Speed Shop in San Francisco, driving a truck, then graduated to one of Gotelli's dragsters. The handsome Kansas boy quickly proved that he was more than just photogenic and gutsy. He was a winner, taking top speed at the very first meet where he drove for Gotelli.

In early 1962 Glenn left Gotelli and joined Archie as a driver for Romeo Palamides. Gotelli wasn't happy about it. "Anything that Romeo built was a bunch of crap," he groused to Cole Coonce more than three decades later, the hard feelings of the past still

not forgotten. Part of the acrimony may have been due to Romeo's involvement with jets, a source of aggravation among traditional drag racers. As they saw it, here they were struggling to make a living running their dragsters, earning a few hard-earned bucks on the weekend, when into the picture comes this jet-powered freak show, wowing the crowds and grabbing all the attention and most of the money because it could fart flames. Sure, *Untouchable* on the bill could double audience turnout. But it also hogged the spotlight, and that didn't seem right.

In the meantime, *Infinity* was taking shape in a small rented hangar at the airport in Oakland. Archie initially was to be the driver. When he had a falling out with Romeo and quit, Glenn took his place. Glenn was a mechanical whiz in his own right and put in countless hours of fabrication time alongside Romeo, Vic, Tom Fukuya and the few others who had been brought into the project. He was also instrumental in making money with *Untouchable* to cover their ongoing expenses—not just driving the car at weekend drag shows, but towing it around to burger joints and drive-ins as an advertisement on wheels. One look at that monster engine was usually all it took to get the young people all excited and lined up to buy tickets.

They finished building *Infinity* that summer, 1,000 pounds of body encasing 3,500 pounds of engine. The shape was starkly simple—a sleek, tailless tube open at the front end, angling forward at the bottom like a scoop. The purpose of the angling was two-fold: it would help direct air into the engine and create a partial vacuum under the car to hold it on the salt. Additional downward pressure would come from the slant of the engine, about two degrees. A needle-nosed black capsule for the driver was situated inside the tube, emerging from the front end like a bullet. It would place Glenn directly in front of the jet's whirling turbine, in the center of the flow of air being sucked into the engine. The aluminum skin was left bare because they didn't have the money to paint it. It added to the machine's austere beauty and menace. "I'll stake my reputation on the world's record if the tires come through," enthused Romeo,

referring to the $150 tires promised by Firestone. That was the only sponsorship *Infinity* had.

The entire team shared Romeo's confidence, and it wasn't just hubris. They had gained two years of valuable experience building and running the *Untouchable* jet car, experience that had been poured into *Infinity* to make it more aerodynamic, more powerful, more sophisticated, more certain. It had never occurred to them to contact the newspapers or hold a press conference or make a big deal about what they had created. The plan was simply to make a quiet trip to Bonneville without fanfare, an unofficial preliminary foray to see what the racer could do. That way, it wouldn't cost them much. If the car performed as expected, then and only then would Harry shell out the money to mount an official LSR bid. There was no point paying all those fees until they were absolutely sure they were ready.

The initial trip to Bonneville in late August went well. In the two days of tests after that first moonlit run down the salt, Glenn took *Infinity* to a peak speed of 360 mph. The J-47 checked out, there were no major hitches and they had plenty of power to spare. The team was ecstatic as they packed up that last day and headed back to Wendover for a celebratory dinner. "We felt absolutely wonderful," recalls Vic. "We were just so happy. We had gotten to 360, no problem. No problem. We didn't have to use the afterburner. We didn't even try to open up. I mean, the record was at 394, and there was just no way we weren't going to break it."

Beneath the high spirits, however, there was friction. When everyone else went to bed that evening, Harry and Vic stayed behind to talk.

The problem was Glenn. Vic had misgivings about him driving the car. He was great at piloting dragsters, the sort of wild man who loved to slam the gas pedal down to the floor. He'd climb onto anything from a souped-up Harley to a motorized hay wagon and drive it so fast it would turn your hair gray. That was all great for the drag strip or the race track. But it wasn't what they needed to go after the record.

This land speed business, explained Vic, it's not really about driving. It's a controlled flight—a controlled flight on the ground. It's a more cerebral thing than drag racing. You've got to have a plan, and you've got to have a driver who's going to follow it. No emotions. No egos. No cowboy stuff. Just stick to the plan.

It sounds like what you're saying, said Harry, is that we need a test pilot.

Yeah, that's about it.

So there was the problem: Glenn the hot-rodder didn't have the temperament for land speed racing. He couldn't be relied on to follow the plan. When Vic told him to take it easy during one of the test runs, Glenn had floored it. When Vic explained that the car couldn't be run at higher speeds at the lower tire pressure upon which Glenn insisted, using drag-strip chutes, Glenn had ignored him and pushed it all the way to 360 mph. Beneath the euphoria, this independent streak was causing a rift in the team. Tom sided with Vic in viewing this behavior as needlessly risky. Romeo sided with Glenn in thinking the university boys should keep their noses out of the cockpit. "Don't listen to those eggheads," he was overhead telling Glenn. "They don't know how to drive the car."

Okay, Vic, said Harry, I see what you're saying. So what do we do? Do you think we should replace Glenn? Maybe try to get Archie to come back?

Vic knew that was the smart thing to do. Archie Liederbrand was a calm, steady, mature sort of driver, better suited for land speed racing. But it wasn't so easy to simply say "Yes." The preliminary tests of *Infinity*, after all, had gone very well despite Glenn's refusal to follow the plan. It was hard to argue with success. And there was the personal side of things to consider, the fact that *Infinity* was Glenn's dream just as much as it was everyone else's. He had worked alongside Vic and Romeo and the rest of them right from the start, investing countless hours building the racer. He had driven *Untouchable* at the weekend meets, earning the appearance fees that had helped fund construction. He had paid his dues.

They talked on into the night about it and Vic finally backed down. He couldn't bring himself to push for Glenn's removal. *Infinity* was Glenn's dream, his ticket to fame and fortune. Vic couldn't recommend that it be taken away.

And so Glenn would stay on as the driver. If they could just rein him in a little, things would probably be fine.

There was still work to do to prepare *Infinity* for an attempt at the record. The Firestone wheels needed attention. After the first runs at Bonneville, Glenn claimed they were out of balance and were shaking the racer. Vic and Tom Fukuya were inclined to believe him, noting that the wheels had been sent out from Akron with no weights attached to the studs. When they took the wheels to the specialty balancing shops in the Bay area, however, they were turned away after admitting that they were off an LSR jet car. In desperation, they tried an ordinary tire dealer. The young man behind the counter didn't balk when he heard what was required. "Well," he said, "I can spin them up to about 150 mph, and if I do a really careful job they should be good for much higher than that." That had to do. When he was finished— Glenn had been right, they were out of balance—Tom removed the clip-on lead weights and replaced them with brass weights bolted into the rim. It was a nerve-racking job drilling holes into expensive LSR wheels. It had to be done, however, so that the weights wouldn't fly off from the centrifugal force when *Infinity* really got going.

A second concern was the high-speed parachute braking system that Tom had worked on. It was a twin-chute setup, with separate anchor points for each canopy on either side of the tail pipe, so they needed to open simultaneously or the car would be jerked sideways. The release mechanism was a D-handle cable situated behind the driver's head in the cockpit. It generated a lot of friction and required a very hard yank. Tom has a distinct memory of Glenn getting so frustrated during a stationary test as he fumbled for the

handle and strained to pull it that he jumped up in the cockpit, braced a foot against the seat, grabbed the handle with both hands and ripped it right out.

"My workmanship on details like connecting the cables to the D-handle was almost certainly some of the worst ever put on any LSR car," Tom says with laudable self-deprecation. He and fellow volunteer Randy Griepp and Dan Abbott of Security Parachutes came up with something better, an actuating lever near Glenn's left hand and new and improved canvas covers for the chute compartments in back. Romeo let them do the work without interference, but he kept an eye on things just the same.

"You guys are building it hell for strong," he observed as Tom and Randy painstakingly drilled yet another hole. They weren't sure what he meant by that. Maybe: "Why so many holes?" When they got it all together, Glenn climbed back in the cockpit, did a countdown and hit the lever. Both chutes deployed perfectly and at the same millisecond. Glenn said, "That's slick, guys," and someone yelled, "Let's go to Bonneville!"

They returned to the salt flats late on Friday, September 6, 1962. This time, Harry had the International Course booked and the fees all paid to make the record bid official. Saturday was spent setting up camp. On Sunday Glenn made three test runs, hitting a top speed of 330 mph. "It's smooth as silk," he said, describing the ride with the wheels now balanced. "It's running like a Cadillac."

It was slow, monotonous work, typical of LSR racing. Glenn would do a run and it would be over in scarcely a minute, the car would be towed back into position and again made ready, then things would grind to a halt while Vic and Tom checked everything, made their observations and jotted down notes. They would check the sensors hooked up to the J-47 to ensure that it was performing at an optimal level. They would take off the wheels and examine the bearings for wear. They would measure the pressure on every tire, looking for clues in psi increases that might point to uneven loading on either side of the car. Romeo, who was not known for being

overly meticulous with his maintenance and inspections, found this exactitude annoying. And when Vic started coaching Glenn on how to handle the car, it was too much. "Quit bothering Glenn!" he exploded. "He knows what to do. Just get in the car, light it up, and stick your boot in it." Glenn was in total agreement. He seemed intent on just flooring it and ignoring Vic's careful instructions. His approach to the whole thing seemed casual, almost flippant.

That evening, Tom realized that both Glenn and Romeo were operating under a misapprehension. Earlier, he had seen Glenn emerge from the cockpit all smiles after one of his runs, as if he had just broken the record. The look turned to disappointment when he learned that his speed had been clocked well short of the mark. Over dinner, Glenn expressed bewilderment at the low speed recorded—and some of the others suddenly realized he didn't understand the LSR rules.

"I looked at Dan Abbott," recalls Tom, "and we must have both looked extremely alarmed. Before I could speak, Dan said something like, 'Ah, Glenn, there's something you have to know,' and he started explaining how the speed was actually an average over the entire mile. It became clear to us that Glenn thought the timing was being done as though we were at a big drag strip, with a short speed trap at the start of the mile, and that whatever speed was registered in that trap was the LSR." Looking back, Tom sees this as a key reason for what happened next. Glenn, realizing that he wasn't as close to the record as he had thought, went out the next morning, Monday, September 10, determined to go all the way.

They started with another test shortly after dawn, this time to check out the chutes, which so far had seen little use. Glenn took the car up to 283 mph, again exceeding Vic's instructions, and everything worked. The next two hours were spent going over the racer, checking, monitoring, examining, peering, probing, until Glenn and Romeo were both starting to fidget.

Finally, at 9 a.m., they were ready for the next run. Okay, Vic told Glenn, let's do it again. Make sure you don't push it too hard—not

until we get the pressure up on the tires. And we haven't run in this direction before, so let's take it easy. No afterburner. Let's keep it under 350.

The low tire pressure had been a concession to Glenn. He had a bit of a phobia about tires at high pressure, ever since a friend had been killed by a blowout when he was changing a truck tire. It had been one of those heavy haulers that took a ring to hold the tire onto the rim. The guy had changed the tire and put the ring in place, but when he inflated it, the ring blew off and hit him in the head. The special tires on *Infinity* took much higher pressure, 180 psi, and they made Glenn nervous. They made *everyone* nervous. "When you flicked them with your finger," says Tom, "they sounded like metal. They made a *ting, ting, ting* sound just like a bell." Glenn, fearing they would explode, insisted on keeping them at 120 psi, and Romeo backed him. Vic was going along with it until Glenn was comfortable and they were ready to go for the record.

There were a few newsmen present and one or two movie cameras. *Infinity* had finally been noticed. Hey Glenn, the reporters wanted to know, why the drag-strip start? Why don't you use the full five miles to build up your speed? They were referring to the fact that Glenn had been starting his runs just five-eighths of a mile back from the time traps. He was locking the wheels, revving up the engine, then accelerating hard, taking *Infinity* to speed faster than previous LSR contenders had thought possible—or prudent. Glenn just smiled and shrugged like James Dean. Don't need to, he said, patting the racer's J-47. With this baby, five-eighths of a mile is plenty.

Glenn seemed relaxed as he climbed back into the cockpit, so laid-back that he was whistling. The turbine was rotated using a compact starter Vic had invented, a belt-and-pulley setup attached to a generator that ran off the chase truck's engine. When the J-47 was going, Vic unplugged the umbilical cord from the side of the racer and heaved it into the back of the truck and jumped in beside Tom for the drive down the track. Tom took the truck to 50 mph

and no faster so as not to overstress the engine and its generator attachment. If it broke, they would have no way of restarting the jet.

They were nearing the initial timing sensor for the measured mile, jolting along on the rough salt, when *Infinity* tore by them at a terrific speed. Glenn was really pushing it. Jesus, how fast was he going?

And then flames were shooting out the back of the engine. The afterburner was firing.

"What the hell is he doing?" Vic blurted out. "He's not supposed to do that!"

He and Tom watched, stunned, as the jet shot ahead at what must have been well over 400 mph. Glenn was ignoring the program again. He was done with testing. He was going after the record.

And then *Infinity* started to veer away from the black line. It was slowly arcing to the right, drifting off the course and onto the ungraded salt.

The correct response now was to deploy the drag chute. It was the only sensible option. Release the chute, and the car would straighten and slow down. Just release the chute.

No chute. Surely Glenn wasn't going to try to steer the car back onto the course. Not at that speed. "Throw the chute," Vic said through clenched teeth as he watched the car disappear into the distance. "Throw the chute, Glenn. *Throw the chute.*"

No chute. Only a big foundation of salt.

The crash which followed was the most horrific that had ever occurred on the Bonneville Salt Flats. Initial reports were that the car had exploded. It had not. What looked like an explosion was actually the huge cloud of salt raised by the tumbling racer and the eruption of the fuel tank after it broke free from the chassis. The crash was probably precipitated by a tire blowing or a wheel tearing off. The car gouged in, flew into the air and smashed down nose first, the force of the impact tearing Glenn's capsule away from the engine and cartwheeling it on down the salt.

Vic and Tom were the first to arrive at what was left of the cockpit. It lay some distance from the battered hulk of the engine.

And inside, still strapped in the seat . . . what Vic saw that day has never left him. "It was like an airplane crash," he quietly remembers. "Pieces of his body were there. The basic trunk and most of his body, but parts of his arms and other things were missing. It was awful. It was a horrible sight."

For Tom, the memory is equally searing. "When I got the truck parked and jumped out and started running over, Vic came back to stop me. He said, 'You can't help him. You can't help him.' Until that second, I was hoping Glenn was alive.

"There was a long streak of red on the salt, pieces of bone, and you could smell the iron scent of blood in the air. It was excruciating to think that these were the remains of our friend. My mind couldn't accept that at all. Much more acceptable was the notion that Glenn and *Infinity* had passed through a huge door out on the salt, the door had slammed shut and vanished so that we couldn't follow, and this was just the inanimate debris of their passage. Bits and pieces of the car that you knew intimately were scattered everywhere, and you longed for them to somehow be reconnected again.

"In a while, slowly it seemed, people began to arrive, Harry, Romeo, the others I'm sure and the timers and track officials. Harry assumed leadership of our team, and I remember being grateful for that. He had never issued orders or been pushy in any way before, but he stepped forward now. The first thing I remember him saying to the track officials was something like, 'We want to apologize to you guys for doing this to your track. We'll get started immediately cleaning it up.' Everyone on our team nodded in agreement."

And so ended *Infinity*'s run for the record. The beautiful shimmering creation of Vic Elischer, Romeo Palamides, Glenn Leasher and Tom Fukuya and the others lay scattered in pieces over two miles of desert. As had occurred after the crash that had killed Athol Graham, a painstaking cleanup of the course was required, a line of volunteers walking side by side down the salt, picking up shards of aluminum, lengths of tubing, broken chunks of chassis, screws and bolts and broken flanges. It would all be loaded onto a truck

with the crumpled mess of the engine and hauled to the Highway Department storage yard alongside Highway 40. While poking through the remains there a few days later, Lucille Christensen of Wendover and her teenaged son Ron would find what appeared to be a piece of human skull and the end of a knee or an elbow with flesh still attached. They had evidently fallen out of the wreckage when it was set down. Ron, an avid photographer, lined them up and took a picture.

On the way home, the *Infinity* crew stopped in Wendover so that someone could call Glenn's 19-year-old wife Lynn. The young couple had married in secret just eight months before and were planning to announce it the day Glenn returned home with the record. The call was made and San Francisco's newest widow braced herself to collect what was left of her husband. She would later file a lawsuit against the three remaining partners, Harry, Romeo and Vic. "None of us could feel any ill will toward her," says Tom. What became of Glenn's recovered remains after that, no one seems to remember. He's buried somewhere out there, in a grave now forgotten, somewhere in the thousand miles between California and Kansas.

After arriving back in San Francisco, the *Infinity* team broke up and went their separate ways. Of those most deeply involved in the project, Vic Elischer and Tom Fukuya are the only ones living today. It still bothers Tom that the pieces of the car were left there on the road leading out to the salt flats. He didn't find out about it until years later, while reading an old magazine article in which Art Arfons expressed annoyance about the abandoned wreckage. "We had been repeatedly assured," says Tom, "that the remains would be properly disposed of, that the course fees Harry paid had bought some sort of insurance to cover this kind of thing. For sure, Harry, who owned a track, never would have tolerated the car just being left there. *Infinity* never deserved that."

As for Vic, he remains convinced they would have broken the record that week in September 1962 if Glenn had stuck to the game

plan. "He wouldn't listen," he says, the anguish over the fate of his friend still apparent after nearly half a century. "He was going to die, and he wouldn't *listen*."

It's the talk he had with Harry, however, that sticks most in Vic's mind, the talk they had after the celebratory dinner at the end of that first trip to the salt flats. Looking back on himself as a young university student, Vic still wonders if he did the right thing. Should he have pushed harder for Glenn to be replaced as the driver? If he had followed his head and not his heart, could he have made a difference? Would Glenn Leasher still be alive?

"It's that talk with Harry. That's what haunts me more than anything else . . ."

"If Some People Want to Play Around . . ."

By the summer of 1962 the quest for the land speed record was being taken over by jet cars. There was Nathan Ostich and his *Caduceus*, Art Arfons and his *Cyclops* at Speed Week, then Craig Breedlove beginning runs in his *Spirit* while Glenn Leasher and *Infinity* waited in the wings. For Mickey Thompson, who had been going after the record longer than any of them, this shift away from conventionally powered, wheel-driven racers was a source of consternation. With jets, you didn't have to contend with the challenges of transferring power from engine to wheels and you didn't have to worry about wheel spin. Jets were rewriting the rules of land speed racing. They were changing the game. And it bugged him.

On August 30, 1962, Mickey shot back. In an article that appeared in papers across the country, he announced that he was building a land speed car powered by rockets. "If some people want to play around," he was quoted as saying, "well then, we'll really play around . . . The rocket car is designed for a lot faster than 500 mph. It could go 700." Mickey was apparently planning a major new offensive on the land speed record—after stating only a month before that he was retiring from the contest.

Mickey had been the first contender to go after the LSR at Bonneville that year. He and his wife Judy and chief mechanic Fritz Voigt had arrived in late July to find the course much improved

from the previous summer, off-season precipitation having given the salt a good soaking and smoothing. It would be his final attempt at the land speed record, Mickey informed the press.

Just getting into *Challenger* for his first run on July 23 was a problem. Fritz had to use all his strength to get Mickey shoved down and his helmet popped under the roll bar and into the headrest. Mickey's body just didn't fit the custom-made seat anymore—not with three vertebrae fused together, the result of a high-speed boat crash in November 1960 that had crushed his spine and temporarily left his legs numb. The doctor's prognosis was grim, but in his typical bull-headed way, Mickey ignored it. After not much more than a week in the hospital, he had checked himself out and gone home. After two weeks, he had the cast cut off his torso and was fitted with a brace. Then he forced himself to walk and he went back to work.

Mickey came up short in his final run at the record, hitting a maximum speed in *Challenger* of something under 360 mph. He later ascribed his failure to the roughness of the course, and there is no doubt that the jolting his back took wracked him with pain. He hung around Bonneville for a while after that, knocking off other records on the 10-mile oval, then packed up and returned to Los Angeles, his LSR dreams presumably behind him.

And then, out of the blue, came the rocket-car announcement. The designs were all finished and the front end was built, said Mickey. The vehicle would be 14 feet long, three feet wide and just under two feet high, tiny compared with Craig's *Spirit* but packing at least as much thrust. That meant it would have a vastly superior power-to-weight ratio and more potential to hit much higher speeds, maybe even punch through Mach 1.

It all sounded very exciting, the sort of far-out project that might just attract a sponsor—which was Mickey's intention. But the fact was, there was no purpose-built rocket car being assembled in his garage. According to Fritz, the only concrete step Mickey took in the direction of rockets was to devise a plan for adding one or two JATO bottles to *Challenger* to give it an extra boost. "We had

provision on our four-engine streamliner for a rocket," he says. "Mickey spent a lot of time on it. The thing with rockets, though, is that once you set one off, you can't meter it down again. You can't shut it off. It's gone. That was the only thing that alarmed Mickey. But he was already set up for it just the same.

"But then he couldn't get a sponsor. Who the hell cares if you got a rocket? Pontiac, if you got Pontiac engines, would be happy. But not with a rocket. So that's why that was never pursued. But I can attest to the fact that he went to a lot of trouble with a gadget, a big rack next to the parachute in the back that was going to be for some rocket assistance."

Mickey never raced *Challenger* again after July 1962, with or without rocket assistance. Increasingly his attention was focused on the new love in his life: the Indianapolis 500. In the two years since setting his 406-mph one-way record at Bonneville in September 1960, he had developed a lightweight car with a rear-mounted engine that anticipated the future look of Indy. Mickey qualified one of these radical machines for the race in 1962, two of them in 1963 and two again in '64. Then his Indy dreams went up, quite literally, in flames.

It happened when his driver, Dave MacDonald, crashed during the second lap and the oversized fuel bladders Mickey had installed in the car caught fire. MacDonald burned to death in the resulting inferno. A second driver, Eddie Sachs, plowed into him and was also killed. The pileup precipitated four other crashes as thick black smoke billowed across the Brickyard. For the first time in its history, the red flag was waved and Indy came to a halt.

Mickey mounted one final LSR bid after that, building a twin-engine streamliner called the *Autolite Special* to capture the wheel-driven record. The weather at Bonneville spoiled things in his first year, 1968. Then Ford Motors, the car's primary sponsor, withdrew its support and the project folded. That was it for Mickey as far as land speed was concerned. He went on to have an illustrious career in off-road racing and meet promotion, founding the Mickey Thompson Entertainment Group and becoming rich.

He did so without his first wife, Judy, who had been with him since the beginning. He divorced her in 1968, and she eventually got together with Fritz Voigt. "Mickey hated my guts like hell for that," says Fritz. "You know the saying about when a dog doesn't want to eat a bone, he'll bury it, and if some other fucking dog wants to dig it up he'll fight him? That's what it was. Oh, he was pissed at me. And then the minute, the absolute minute he got hooked up with Trudy, he come by the shop and we made up."

Mickey Thompson's story, however, does not have a happy ending. Shortly after sunrise on March 16, 1988, as he and his second wife Trudy were leaving for work, two masked assassins rode up on bicycles and gunned them down in their driveway. Neighbors reported hearing gunshots, with Trudy screaming and Mickey shouting, "Please don't hurt my baby!" Mickey's former partner Mike Goodwin was an immediate suspect. Mickey had severed relations after learning that Goodwin was cheating him. He had taken him to court over the matter and won, but he did not see any of the settlement money. Instead he got death threats. Mickey brushed them off as bluster from a bad loser, but Trudy didn't. She feared for their lives.

After a torturous legal battle spanning nine years, Mike Goodwin was found guilty of arranging the murders of Mickey and Trudy Thompson and sentenced to two consecutive life sentences without possibility of parole. The two hit men he hired remain at large. A one-million-dollar reward is still being offered for information leading to their arrest and conviction.

"My biggest regret," says Judy, now Judy Creach, "is that if Mickey had to die, that he died the way he did and not racing. He would have loved to die racing. It was that important to him."

Goodbye John Cobb

The thing about John Cobb was that he made it look easy. The impression came from his calm, methodical approach to land speed racing and his apparent lack of ego. From the standpoint of car designers and builders, he was the perfect driver. During test runs, he stuck to the plan and maintained an even demeanor. He did not get in the way when the car was worked over. If the weather turned nasty, he stood by with limitless patience. And when everything was set to go for the record, he proceeded without drama or fuss. "It is not particularly frightening," he would tell reporters with typical aplomb after. "It's a relief when you pass out of the mile and you can let up on the throttle. It's a comfortable feeling."

Like his prolific land speed predecessor Malcolm Campbell, Cobb was born to wealth: a family fur brokerage provided him with the means to pursue his interest in racing. That, however, was where the similarity between the two men ended. Unlike the dashing, rugged and self-publicizing Campbell, Cobb was stodgy, shy and physically a bit doughy, a bachelor who had lived with his mother for most of his life. He made a name for himself as a driver on the Brooklands race track outside London before turning his attention to the land speed record in the mid-1930s. Campbell was just then retiring from the game after more than a decade of record-setting, having pushed the LSR from 146 mph in 1924 to 301 mph in 1935.

He would go on to claim the water speed record. Cobb and fellow Briton George Eyston then took up the challenge. They would do their racing on the Bonneville Salt Flats, where Campbell had set his final mark after giving up on Daytona Beach, which he said offered inadequate grip for his tires and was too confining. Eyston would drive a monster car called *Thunderbolt*, a six-ton, eight-wheeled chunk of mechanics powered by the same Rolls Royce aircraft engine as the one in Campbell's *Bluebird*. Instead of just one of these engines, however, Eyston used two, giving him a total of nearly 5,000 horsepower. Cobb had to settle for two older Napier Lion engines with only half as much kick. Reid Railton, the man he chose as designer, compensated for this by building a much lighter car with better aerodynamics and equipped with four-wheel drive, a new concept in land speed racing. In recognition of Railton's ingenuity, Cobb named the sleek, low-slung creation the *Railton Special*.

Eyston was the first to reach Bonneville to take up the torch relinquished by Campbell. He arrived in the fall of 1937, and on November 19 set a new record of 311 mph. When he returned in 1938 to improve his mark, John Cobb followed. They would share the salt through late August and the first half of September, setting the scene for an exciting three weeks of back-and-forth dueling. Eyston started off with an impressive run that was clearly a record and emerged smiling, his face and coveralls blackened with exhaust and smoke from the brake pads. The timing devices, however, had failed to register his passage, the photoelectric cells apparently overwhelmed by *Thunderbolt*'s dazzlingly reflective aluminum skin. Eyston had black stripes painted on the sides of the car and tried again a few days later, this time posting a scorching—and properly recorded—345 mph. The record lasted for just over two weeks, when Cobb answered with a 350. "It was easy, Mac," Cobb remarked to Dunlop tire expert David McDonald— "Dunlop Mac"—as he climbed out of the cockpit. And to the press: "Everything was top-hole and I'm tremendously pleased."

Eyston, despite being distracted by shimmering mirages, came back the very next day with a 357, rivaling Cobb in the area of coolness

by briefly dozing off in the cockpit during a delay prior to his run. "I've figured it out scientifically," Eyston said, "and I don't think a land speed of much more than 360 miles an hour is possible. . . . After you pass 300, the graph of danger rises almost vertically and the graph of car and engine performance drops rapidly. Man won't go much faster than 360 on land and live to tell about it."

Cobb didn't agree. "If you can get tires that will hold up, if mechanical engineering continues its remarkable development, and if you can get long enough straightaway courses, I don't think there's any limit to the speed man could travel."

There was talk of a coming war in Europe when Cobb returned to Bonneville in the summer of 1939, this time alone, to reclaim the LSR with a run of just under 369 mph. Once again he did it in undramatic Cobb fashion, even producing his British driving permit for the bemused head timer and saying in all seriousness, "I suppose you want to see my license." It was a seemingly flawless performance, the *Railton Special* handling even better than it had the previous summer, Cobb likening it afterward to a train on rails. He had experienced no difficulties whatsoever during his two-way pass, he added, and could have gone even faster had he "let her all out—safety first, you know."

As he was on his way home across the Atlantic, the Second World War started with the invasion of Poland. Although in his 40s, Cobb learned to fly and joined the Air Transport Auxiliary, ferrying planes around for the RAF for the duration. It wasn't until 1947 that he would take his *Railton Special* out of storage for another trip to the salt flats, this time to challenge his own record. By then, he was 47 years old and driving a 10-year-old car powered by engines built in the 1920s. He had hopes, however, that with some additional tweaking his racer might get him to 400 mph.

It was a curious thing to see the *Railton Special* being worked over out on the salt flats. It didn't have the usual panels that could be raised or removed to expose motor and wheels. Instead, the entire outer shell of the car lifted off in one piece that the crew called "the

bun." After each run, a dozen men gathered around the racer and hoisted the bun off the chassis, leaving the car naked. When the necessary work was finished and the bun replaced, Cobb, clad in cloth cap and white overalls cinched at the ankles, face greased for protection, would squeeze back into the cockpit via a plank laid from a truck parked alongside the *Railton*. Then the bubble canopy was snapped in place over his head. It looked as if he were being locked into the racer. Effectively, he was. "Had anything gone wrong," wrote Dunlop Mac, who had come along again to tend the tires, "he could not have got out in a hurry. That did not dismay him because he took the realistic view that he was unlikely to survive any major accident at a very high speed anyway."

Of course, with Cobb, nothing *did* go wrong, or at least nothing that was too exciting. On September 16, 1947, as the moisture in the salt subsided and the course hardened in the cool of the evening, he traversed the mile with a two-way average of 394 mph and topped 400 one-way, the first human ever to do so. It was a triumph of British engineering and cool-headed driving—and the only show of pleasure it stirred in Cobb was a subdued smile. "He took the news calmly," recalled Dunlop Mac, "driving up to the reception bay in the racer looking like a private motorist at the end of a Sunday spin." It was only when Cobb thought no one could see him that he allowed his emotions to come to the surface, and he wept.

That was the end of Cobb's quest for the land speed record. In 1952, like Henry Segrave and Malcolm Campbell before him, he turned his attention to the water speed record, hoping to add it to his LSR. He did so on Loch Ness in Scotland in a boat called *Crusader*, designed again by his trusted associate Reid Railton. His goal was to break the record of 178 mph set earlier that year by the American Stanley Sayres and, in so doing, return the WSR to Britain.

On September 29, after waiting all morning for the wind to drop and the lake to settle, Cobb set out on the first leg of his attempt, watched from the shore by his wife—he had recently married—and a gathering of locals. He passed through the measured mile

at well in excess of 200 mph, then hit a series of low swells and *Crusader*'s nose dug into the water. The impact smashed the boat so thoroughly that it appeared to explode. Cobb was thrown 150 feet and was dead when they found him. *Crusader* sank to the bottom of the loch. It was never recovered.

By the summer of 1963, John Cobb had held the LSR for 24 years, longer than anyone else. American contenders had been trying now for six years to dethrone him and two of them, Athol Graham and Glenn Leasher, had died. As Tom Fukuya remembers Glenn exclaiming over dinner the night before crashing, "Jesus Christ! That John Cobb is the baddest son of a bitch that ever lived!"

Walt Arfons was the next man to step forward. He was 46 at the time, 10 years older than his half-brother Arthur, a bit shorter and paunchier, and he needed glasses. He had three fading tattoos on his arms and chest from his time in the navy—an anchor, a hula girl and a big eagle—he had a wife of 26 years, a son in the air force and another son and a daughter in high school, and he kept the fat wallet in his back pocket attached by a chain to his belt. Like Art, he was completely down to earth and soft-spoken, but he was perhaps a little shyer and a bit less forceful than his younger brother. Jack Olsen recalled witnessing an incident at Wendover's Stateline Casino when a slot machine Walt was playing shortchanged him four quarters, spitting out 10 rather than the promised 14.

"You got 14," the engineer barked when he was summoned from the back in response to Walt's gentle complaint.

"It only paid off 10," Walt persisted, still smiling. "But I don't want to start an argument about it."

"You got 14."

And that's where it ended. Walt knew he was right, but let it go. Being friendly was more important. For that, he was willing to bend a bit more than Art. Art might just have continued the conversation with, "Friend, are you calling me a liar . . . ?"

It was in early 1962 that Walt started to think seriously about going ahead with the land speed jet car idea he had suggested to Art two years before. He had a lot of experience by this point running jet dragsters—certainly more than Art, who was then finishing *Cyclops*—and he figured he could knock off Cobb's record with a streamlined version of one of his tried and true *Monsters*.

Coming up with a design for the car was the first hurdle. Walt wanted engineering help for that. He found it late that same year at a trade show when he met Tom Green, a sales manager with the torque wrench manufacturer P.A. Sturtevant. Tom had an engineering background and a personal interest in land speed car aerodynamics, and after a short conversation, the pair were planning a racer together. Tom would design the outer configuration. Walt would build it.

The power plant would be a J-46, the same jet engine Walt used in his *Green Monster* dragsters. With an afterburner it would produce 7,000 pounds of thrust, 50 percent more power than Craig Breedlove's *Spirit*. It would also be lighter, giving it a superior thrust-to-weight ratio. For the body, Tom came up with a waist-high tube design with a forward cowling that enclosed the front wheels. The cowling came to a point to reduce frontal drag and had a small air rudder perched on top that was attached to the front wheels to assist with the steering. The rear of the vehicle featured exposed wheels and a small tail fin.

With the design down on paper, Walt went to Goodyear in the hopes of attracting some money. Goodyear bought his pitch and came on board as chief sponsor. They were already backing Breedlove and his jet car as secondary sponsor with Shell. Backing Walt would be a way of hedging their bet that the LSR would boost tire sales. In recognition of the company's support, Walt agreed to change the name of the racer. Instead of being another *Green Monster*, he would call it *Wingfoot Express* after the Goodyear corporate logo. Fabrication of the car started that same year, in the fall.

Walt, assisted by Jim Taylor and Rich Elebrock, built *Wingfoot* over the winter. It was completed the next spring. At that point, Walt was still toying with the idea of driving it himself for the record at

Bonneville later that summer. That plan changed when he collapsed on May 30, 1963, with what seemed to be a heart attack. It was the second episode he had suffered in the space of one year.

This time it happened at the Detroit Dragway. Walt had brought two jet cars to the track that day, one of his regular *Green Monster* dragsters with Doug Rose as driver, and the recently completed *Wingfoot Express* with Chuck Hatcher at the controls. Doug had been driving for Walt for a year; Chuck was new and being tried out. The purpose of the appearance was twofold: to test *Wingfoot* and to earn some money by putting on a show for the fans, with two jet cars going head-to-head down the track, lighting up the night with afterburner. Walt knew that the race itself would be no contest. *Wingfoot*, purpose-built for Bonneville, was the heavier car and therefore would lose over the quarter-mile distance—which it did in the first race of the evening, and again in the second.

"I was doing the flagging," Walt remembered. "It was midnight, on the last run. On the first two runs Doug beat Chuck each time and I could see Chuck sweating and getting madder and madder. And so I talked to him. I said, 'It doesn't matter who wins. We'll get the same money. We're just here to put on a show.' That's what I tell these boys, and they understand. But Chuck, he got a little hotheaded."

Walt knew there was trouble when he saw Chuck's afterburner continue flaming after Doug's cut out. When Chuck tried to stop, he was going too fast for the chute *Wingfoot* was equipped with. It was intended for the lighter *Green Monsters*, not the heavier Bonneville car going 250 mph. It tore off and Chuck kept going. He shot through the hay bales at the end of the track, tore up a length of cyclone fencing, cut down some small trees and crossed a highway and a couple ditches and some plowed ground and came to a halt in a wood.

Walt and his 16-year-old son Craig leaped into a truck driven by Bill Neely and raced down the track after the runaway jet car, Walt so upset that he was crying out, "Oh, my boy! My boy!" and beating his fists on the dashboard. "I got all shook up and beat the panel

clear in. I just couldn't stand it for my car to hurt somebody, that's all. I didn't want anybody to get hurt." When they got to the end of the track, Walt leaped out and started running on ahead into the darkness, following the swath *Wingfoot* had cut in its passage. He kept running until he felt the giant hand clamp round his heart and squeeze like it had done the previous year. It sent him gasping to the ground, clutching at his chest. Then he blacked out.

Chuck Hatcher survived the crash with nothing more than bruises—and didn't do any more driving for Walt. *Wingfoot*, however, took a pretty bad beating. A lot of repair work would be required to get it ready for the trip to Bonneville, now less than two months away. As for Walt, he recovered fully. Any lingering thoughts he'd had about driving, however, he now set aside on the advice of his doctor. He wouldn't even sit in his jet cars after that, he said, let alone drive them. "I know I would get tense, and when I get tense and all drawn up, that's when I go to pieces, and I wouldn't hurt nobody for nothing." He would always describe his condition after that as a bad heart. His son Terry isn't so sure.

"My dad insists that he had heart trouble, but he's never had any trouble with his heart. He didn't have a heart attack." The fact that Walt is still alive today in his 90s would seem to bear this out and suggest that his heart-attack-like symptoms were caused by something else.

After he was back on his feet, Walt hurriedly repaired *Wingfoot* for the trip to Bonneville in the last week of July. Goodyear had booked him three days to kick off the 1963 LSR season. He went with a small team: designer Tom Green, fabrication assistants Jim Taylor and Rich Elebrock, and his son Craig. Jim Deist came out from the West Coast to help with the chutes. Walt's wife Gertrude went along too. "I was scared to death something might happen to him," she said, still shaken by Walt's recent collapse. "I felt that if something happened to the car out there, then for sure something would happen to him. I didn't want him to be alone."

The plan had been for Doug Rose to be the driver. That changed at the last minute when Doug broke his back. He was now laid up in

a Utah hospital, out of action. As much as Walt might have wanted to step in, it was out of the question. Heart concerns aside, physically, he wasn't up to it. He had severed a tendon in his finger on a frayed cable and his hand was swathed in a bandage. That left only one person: Tom Green. Tom knew the car well, but his only real driving experience was some stock car racing he'd done a decade earlier.

They began on the first day with Tom taking short idling runs at one end of the course to familiarize himself with the feel of the car. Then they wheeled *Wingfoot* onto the course proper and he began to push up his speed, Walt anxiously coaching him before every run. Tom found the ride extremely rough and unnerving. "I hadn't fully anticipated that I'd have the feeling of rattling and banging down the black line like a rock in a can," he said. "At 250 mph the upholstery of the seat hugged me like a pressure suit, at 275 I had the weird feeling it was snowing in the cockpit." It was salt crystals being forced in around the canopy edges.

On the second day Tom pushed *Wingfoot* up past 300 mph, an impressive performance considering his lack of experience. The course was wet, however, and that soon led to trouble. Tom knew there was something wrong when he heard the whining J-46 change pitch mid-run. After getting the car stopped, he and Walt discovered that the wet salt sticking to the front tires had been sucked into the air intake where it had baked onto the jet's hot rotating blades, throwing them out of balance. A rushed effort was made to clean them, but it was too big a job for the one day they had left. There was nothing for it but to call off the attempt. He would go home to Akron and fix *Wingfoot*, Walt announced before leaving the salt flats, and return in September to try once again.

As Walt was hauling his damaged jet car back east to be stripped down and cleaned, Craig Breedlove and the *Spirit of America* team were setting up camp on the salt. The car had been significantly altered since the year before. The most noticeable change was

the new tail fin. It was big, six feet high and emblazoned with an American flag, and it made the car look even more like an F-104. Bobby Davids had made it from fiberglass and foam like the wheel fairings, employing the techniques he had perfected on surfboards. Fiberglass was right for the job because it was light and strong and allowed complex shapes to be formed quickly—much more quickly than could be done hammering on aluminum sheets. Less noticeable but even more significant was the change that had been made to the front wheel: Craig could now steer it. He couldn't turn it much, just two degrees, enough for *Spirit* to make a half-mile circle. At the extreme speeds Craig would be traveling, enabling the single front wheel to turn more than that could flip the racer over.

Getting back to this point for Craig had been a horrible strain. The worst part had been the first few months after returning home from the salt in 1962, sitting in on the meetings set up by Shell to determine what had gone wrong and how best to fix it. Craig definitely wanted *Spirit* fitted with a steerable front wheel and eventually came to accept the idea of a tail fin. He knew he would have only one more crack at the record before Shell lost patience and pulled out, and so he wanted *Spirit* in 1963 to be a sure thing. Meanwhile, Rod Schapel stood by his assertion that all the car needed was a new driver. The frustration and emotional turmoil this caused Craig was so intense that he had difficulty eating and experienced pains in his chest. Finally, after five excruciating months, the outside experts endorsed the steering and tail-fin modifications he wanted. "It was as if someone had taken 4,000 pounds off my back," Craig would write.

For Bill Moore, the addition of the tail fin was personal vindication. He had included a fin in the initial concept drawings he had done for Craig back before Rod joined the project and had been chagrined when the idea was dropped. "The reasons for adding the fin were very simple," recalls Bill. "One was for the sake of stability, obviously, or planes wouldn't have them. The other thing was that a tail would make a nice signboard for a flag or whatever we wanted

to do." After the failure of 1962, Bill tracked down plane and car designer Walter Korff, the author of several books on the subject, and arranged for him to meet Craig and give his advice.

"Well," the aging engineer said as he looked over the *Spirit* model, "I can't say exactly without doing some calculations, but I can tell you right now that this car needs a fin on the back." Craig was initially skeptical and whispered to Bill as they were leaving, "I don't know, he's a really old guy." Korff's on-the-spot assessment was confirmed by the experts brought in by Shell.

Despite the emotional scars of the previous summer, Craig returned to the salt in 1963 confident that this time he would break the record. He already knew that the car in its original configuration had worked. He had proved it on that final run in '62, after the bugs in the steering had been fixed. With a steerable front wheel and a tail fin, it would be even better. Craig also felt that he was now more capable of leading the crew and maintaining the necessary control and focus. In hindsight he had allowed himself to be intimidated the previous summer—by the size of the operation, by the pressure of having corporate sponsors looking over his shoulder, by the media watching and a film crew shooting, by Rod's pushiness and the subsequent confrontation that seemed to cloud everyone's judgment. That wasn't going to happen again. This time it would be all business.

Once again, Bob Davids was assigned to the chutes. His memory of his duties provides insight into just how much was demanded of each crew member every time Craig made a timed run: "After I had installed the chutes and everything had been checked, I had to stand with a fire extinguisher by the rear exhaust pipe during engine fire-up, watching for fuel leaks and smoke. When the engine was going and Craig was ready and the canopy closed, I was then to put the fire extinguisher in the Ford pickup and race on ahead to the end of the measured mile, staying a quarter mile off to the side. We had radios and as I went I could hear Nye saying, 'Get ready,' 'Take off one minute,' that kind of stuff.

"When I saw Craig enter the measured mile, I would start toward the course as fast as I could go. Just as soon as he went through the exit markers, the lid on the parachutes would eject 50 or 60 feet into the air and it would pull out the drogue chute bag, and then the main bag would deploy and the chute would come out. I had to pick up the lid and the drogue projectile and drogue bag and the main bag and then race as fast as I could down to the far end of the course to where Craig had stopped. After they got the car turned around, I would pull the used chutes out of the car and wad them up and stick them in the back of the pickup and then install the new chutes I had packed the previous night and carried in the front seat. Once they were in, I would take out the used drogue charges with a wrench—they were like 12-gauge shotgun shells—and put in new charges. Then I had to go get Nye. He had to come back with Alan Buzkirk and they would do a circuit check and check the charges. No one could do anything by themselves. Everything had to be double-checked."

It was the same for every member of the crew. They all had specific tasks to perform that had to be checked and double-checked and then signed off on. It was Stan Goldstein's job as inspector to collect the signatures on a two-page checklist. "It was a real military operation," says Stan.

Craig began test runs on July 29, a Monday, in his modified *Spirit.* In three days he was within striking distance of the record. The car was then taken to Wendover for a thorough overhaul prior to returning to the salt the following Monday. Barring calamity or a change in the weather, that would be the day John Cobb would at last be knocked off his LSR perch.

Monday, August 5, 1963. The *Spirit of America* crew had been up since well before dawn. Craig arrived on the salt at 5:30. His racer was positioned at the two-mile marker to avoid the rough stretch at the start of the 11-mile-long course. That meant he would have less distance to accelerate on the first leg of the record attempt and his

speed would be lower. If *Spirit* was to take a pounding, better save it for the return when he would really pour on the coals.

USAC officials were on the scene and had everything ready, the course measured and timing devices installed. The head timer was Joe Petrali, a motorcycle racer back in the 1920s and '30s with a distinctive scar on his upper lip from one of his smashups. He would oversee things from the timing trailer at mid-course, jokingly referred to as "Joe's U-Sac Shack." An official from the Fédération Internationale Motocycliste based in Switzerland was also on hand to give the attempt FIM sanction. The Fédération Internationale de l'Automobile had declined to do so, declaring that *Spirit* was not a car because it had only three wheels and none of them were driven directly by the engine. In the pigeon-holing world of officialdom, it was deemed a motorcycle—or more precisely a "cyclecar" to account for the third wheel. The ruling seemed obtuse, but Craig knew, as did Shell and Goodyear, that in the eyes of the public it wouldn't matter. If he broke the record, he would be seen as the world's fastest driver and there was nothing the FIA could do but sulk in the corner for missing the show.

The sun had been up for little more than an hour when Nye handed Craig the clipboard showing wind readings that had been radioed in from observers stationed at six points along the course. There was only a slight breeze at the mid-point. The other stations were reporting dead calm. "Let's go," said Craig. He put on his new helmet, silver with blue stars, and the goggles that now replaced the awkward face bubble of the previous year and Nye helped him strap in. He wanted to get it over with and put the apprehension behind him. Waking with a case of nerves was becoming something of a Bonneville routine—that and skipping breakfast. A big feed of eggs and French toast before a record attempt might sit well with Doc Ostich, but it put Craig off. He also felt that it was better to have an empty stomach in case he was injured.

The canopy was hoisted up to be slotted in place. Just before it was locked down, a crew member ran forward and handed Craig

an envelope. Postcards, one of the watching newsmen conjectured. They'll be worth something as souvenirs, the fastest surface mail ever carried. Craig took the package and stowed it.

His wife Lee was waiting down the course in front of the USAC trailer where most of the spectators were gathered. She was excited, but not particularly worried. She had confidence in Craig's abilities and wasn't given to fretting. Craig's teenaged half-sister Cynthia Bowman was there too. She had driven out from L.A. with her boyfriend. Craig's parents hadn't come. His stepfather Ken wasn't that interested in racing and his mother Portia couldn't bear to watch.

The override hand throttle on the J-47 was set at 90 percent for the first run. The presetting meant that Craig simply had to stomp the foot pedal all the way down to get the exact power he wanted. As he left the start line and gathered speed, the butterflies in his stomach finally subsided. The car was performing well and he could control it. He was nearing the mile now, the black line drifting closer. He had started several feet to the right of it to compensate for the gentle breeze blowing at mid-course. It was now nudging him back to the center. Still no hint of front-end lifting. Rod's nose configuration was doing its job of keeping *Spirit* on the ground. That was one thing which had worked perfectly right from the start.

The sign board marking the entrance to the measured mile flashed past, the timing device beside it an imperceptible blur. The apparatus consisted of a car-battery-powered light source on one side of the course shining a beam into a receiver on the other. When *Spirit* broke the beam, an electrical signal passed through the wiring that had been laid to a bulky Hewlett-Packard 5532A digital counter in the USAC trailer, which would record Craig's time down to a thousandth of a second. The same thing happened when Craig broke the light beam at the measured kilometer entrance a couple ticks later and again at the simultaneous exit from both the kilometer and mile. After the HP counter spit out its figures, Joe Petrali and his team would subtract one number from the other to get Craig's

elapsed time and from that calculate his speed. They would work it out manually on yellow pads of paper.

When Craig was through the mile, he cut the engine and released the chute—it popped prematurely but fortunately didn't hamper the run—and coasted to a two-mile stop where the crew was waiting. The stepladder was rushed forward and he opened the canopy and climbed out, turning momentarily to brush his footprint off the air duct. The crew then moved in to surround the racer, working through the long list of turnaround procedures, checking and rechecking everything before signing off with Stan. Craig spent the time walking around, looking things over while he waited for word of what he had done.

The verdict when it came was 9.267 seconds to traverse the mile, which worked out to a speed of 388 mph. This was short of Cobb's mark and therefore disappointing. But Craig hadn't been expecting much better since he'd only allowed himself a speed buildup of three miles. "We'll pick it up coming back," he said. For the return leg, he would take a full five miles for acceleration and increase throttle to 95 percent, further than he had ever pushed it but still utilizing scarcely three-quarters of the engine's power. To better Cobb, he would need his second pass to be at least a 412.

It was tense now down at the USAC trailer. For Joe and the other officials, there was no room for error. If one of their timing devices didn't work, they would be responsible for botching the run. Ditto if their equipment in the trailer failed. Ditto if something went wrong with the miles of wiring laid over corrosive salt that got damp every night. The very thought of something going wrong and spoiling a good run was for Joe and the USAC boys a horror. It would be 1938 all over again, when the clocks had failed as George Eyston shot through the mile on his way to a sure record. Head timer Art Pillsbury had burst into tears when he told the smoke-begrimed Eyston what had happened. And almost as bad was 1935, when officials miscalculated the time on one of Malcolm Campbell's runs, giving him a heartbreaking record of 299.9 mph. When the mistake was discovered

and the number corrected to 301, making him the first through 300, Campbell exploded. "To hell with it!" he roared at the apologetic timekeepers. "You have completely spoiled it for me. You have ruined what should have been my final and finest achievement!"

At 7:50 a.m., with 10 minutes to spare in the allowed turnaround time of one hour, *Spirit* was ready and Craig was back in the cockpit, everyone on the lookout for signs of leaking fuel that could lead to a fire. The wind that had picked up while the crew was working had now subsided to five miles per hour, acceptable if not ideal. One last hurdle: getting the jet engine restarted. It whirred to life without a hitch. The umbilical was disconnected and the start cart wheeled out of the way, Nye flashed a thumbs-up and Craig was rolling. In less than two minutes he was into the mile and still gaining, the breeze pushing him to the left, 40 feet away from the black line and dangerously close to the edge of the scraped course. Craig kept his foot down and began ever-so-gently to ease back to center. Then he was out and slowing down in the rough beyond where he'd started, the racer taking a tremendous pounding before he was able to brake to a stop. When it was all over, he gave a little shrug and sat there quietly for a few moments. Then he flicked open the canopy latches and let in the world.

There was nothing left to do now but wait. Craig joined the crew and they stood around for a while, casting glances at USAC official Ben Torres, who was in radio contact with the trailer. "Hurry up, now," they could hear Ben saying. "We've got a man here anxious to know his time." The reporters on the scene tried to come in with a few questions, but it wasn't easy. Craig still had his helmet on and cotton stuffed in his ears.

"Craig, you said the other day you could tell how fast you were going in test runs by the way the mile markers flipped by. How did they flip on this last trip?"

"It felt like about 425," he said.

Ben's hands went to his headphones. He was getting something. "Repeat that," he said, closing his eyes as he strained to hear

through the static. "And the average?" A pause. Then he was looking over at Craig and the big smile creasing his weathered face told the whole story.

Craig had taken 8.404 seconds to cover the mile, making his return speed 428.37 mph and his two-way average 407.45 mph. He had knocked John Cobb off his very high mountain. He had the new Big Number. After 35 years, he had brought the LSR back to the States.

The celebration was under way when Lee arrived from down course where she had been watching. She ran forward grinning and Craig swept her up in his arms. "We did it, huh?" he kept repeating. "We did it, didn't we?" Newsmen and photographers crowded around them, shouting questions, cameras clicking. How does it feel, Craig? What are you feeling? What was it like going more than 400 mph?

But Craig was still too happy to give them much detail. "It feels great!" was all he could say for the moment, laughing and beaming. "It's great! Just great!" Then he did something he had had to put off the previous year. He went over to his truck and crossed out the last word on the side: "Attempt." The inscription now read, "Craig Breedlove, Spirit of America, World's Land Speed Record."

Portia Bowman was at her new home in Malibu when she heard that her son had just broken the record. She was working out back in the nursery business she and Ken had recently started, Bowman African Violets, listening to the radio as she tended the plants. Then the news came on, and it was all about her Craig and how he had broken Cobb's record and suddenly everything went crazy. "I started jumping around and hollering," Portia remembers, still stirred by the memory at age 96. "And then I started calling up people. I worried about him a lot when he was going after the record. My gosh, I lost an awful lot of sleep." Craig phoned her up from Wendover an hour later. Portia could hear loud shouting and celebrating going on in the background, but by that time Craig had

settled down and sounded matter-of-fact, like he hadn't done anything special.

Before the end of the day newsmen were at the Bowmans' front door looking for comments. Portia told them about her boy going back to the very beginning, to the nickname the nurses had given Craig the day he was born. "They called him—I swear— 'Streamline.' He was a small baby and his head was shaped like a bullet." She told them about the old jalopy Craig had bought to fix up when he was 12 and how she and Ken had kicked in some money to help. Portia admitted that she never tried to encourage her Craig about the land speed obsession. "It seemed to be too big a thing to be shooting for," she said. "He taught me a lesson."

The party back in Wendover continued on into the evening. For everyone on the *Spirit* team the feeling of being part of the record— of having worked hard and achieved something *big*—was exquisite. For some, it was time to get a case of beer or something harder and drink it all down and carouse and howl at the moon. Others just wanted to sit around and quietly bask in the glow. And for still others, the reaction was quite unexpected. Stan Goldstein remembers arriving back at the motel in a state of emotion, locking himself in his room and starting to cry. He had known Craig since junior high school and had been involved in the jet car project from the very beginning, back when it was a sheaf of drawings, back before it had a name. *Spirit of America* had become his dream too.

But where was Craig? He's gone, somebody was saying. The Shell and Goodyear guys took him. He's on his way to New York.

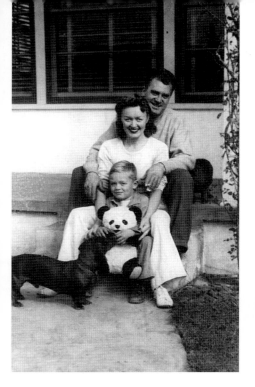

ABOVE: Craig Breedlove at age three with parents Norman and Portia, and at age 14. (both courtesy Cynthia Lee Bowman) **BELOW**: Craig with his Ford coupe and sponsor Ed Perkins circa 1959. (William A. Moore)

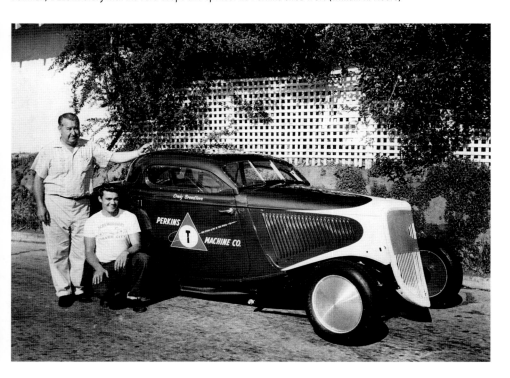

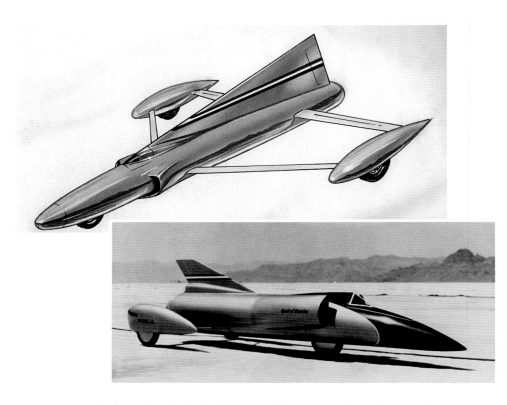

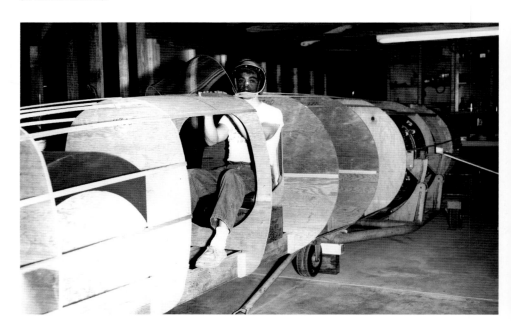

TOP: Bill Moore's original concept drawing for *Spirit of America*, February 1960. **ABOVE**: Art Russell's first model, posed on the Bonneville Salt Flats. **BELOW**: Craig seated in the wooden mock-up of the jet car in his father's garage. (all William A. Moore).

ABOVE: Tom Arfons pressing apples for cider at the Arfons Mill, 1937. **LEFT**: Ten-year-old Art Arfons watching his mother Bessie sharpen the mill's century-old grind stone, 1937. **BELOW**: Art Arfons on his Indian motorcycle with sister Lou in the 1940s. (all Tom Joswick)

RIGHT: Art Arfons in his navy uniform during WWII, with sister Lou and half-brothers Walt (standing) and Dale. **BELOW**: Art in *Green Monster* No. 2, with Walt (right) and Dale. Note the police car in the background. (both Tom Joswick)

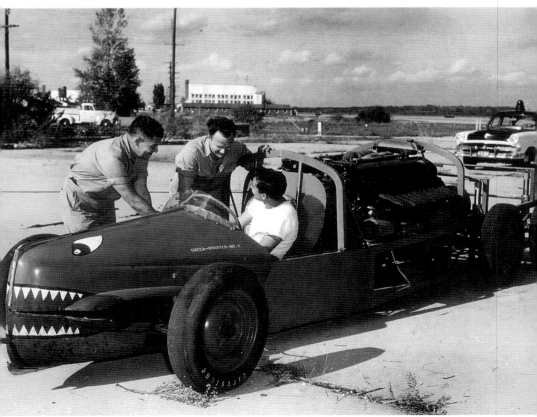

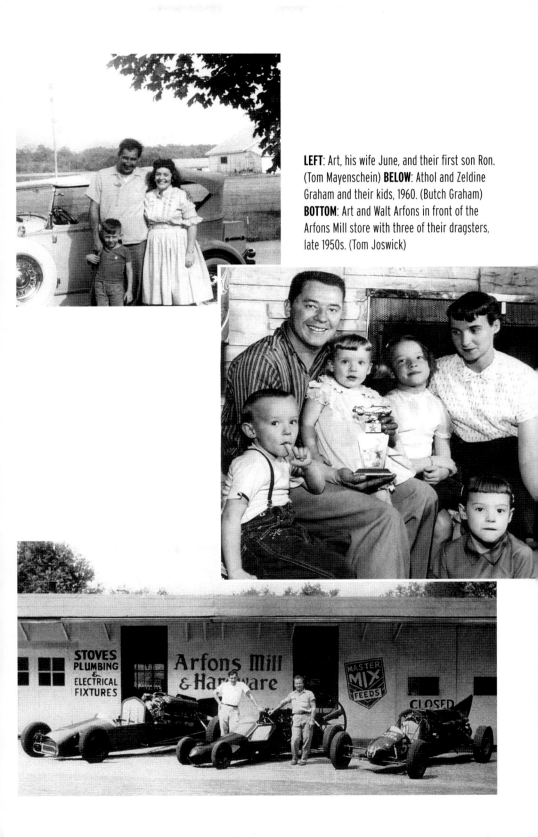

LEFT: Art, his wife June, and their first son Ron. (Tom Mayenschein) **BELOW**: Athol and Zeldine Graham and their kids, 1960. (Butch Graham) **BOTTOM**: Art and Walt Arfons in front of the Arfons Mill store with three of their dragsters, late 1950s. (Tom Joswick)

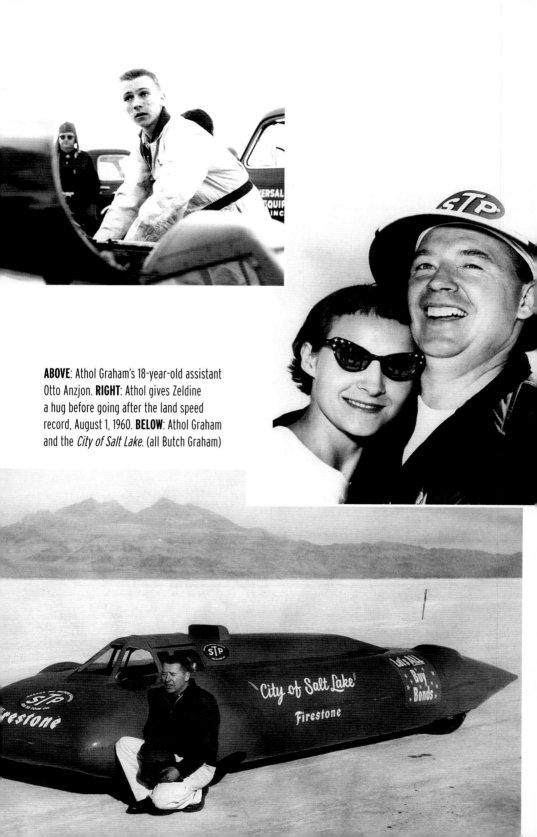

ABOVE: Athol Graham's 18-year-old assistant Otto Anzjon. **RIGHT**: Athol gives Zeldine a hug before going after the land speed record, August 1, 1960. **BELOW**: Athol Graham and the *City of Salt Lake*. (all Butch Graham)

ABOVE: J. M. Heslop's award-winning photo of Otto Anzjon weeping over the wreckage of the *City of Salt Lake*. (Butch Graham, with permission from J. M. Heslop) BELOW: What was left of the car. (Butch Graham)

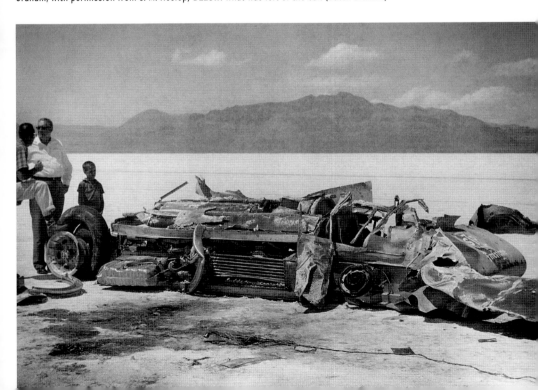

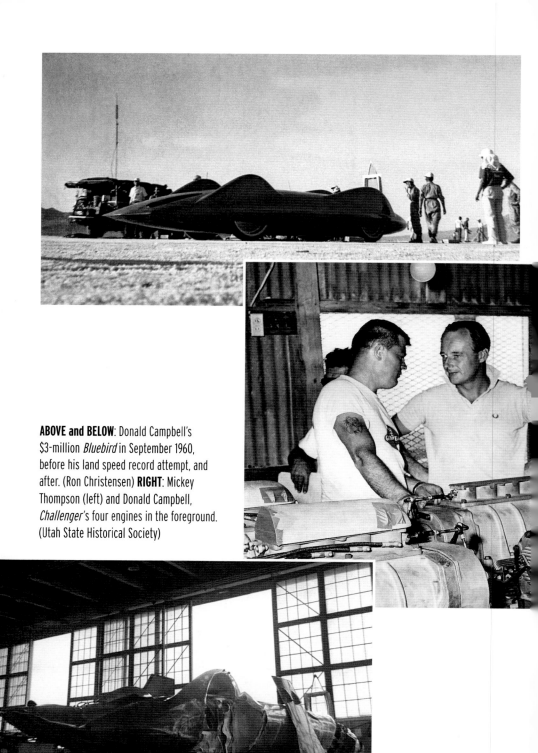

ABOVE and BELOW: Donald Campbell's $3-million *Bluebird* in September 1960, before his land speed record attempt, and after. (Ron Christensen) **RIGHT**: Mickey Thompson (left) and Donald Campbell, *Challenger*'s four engines in the foreground. (Utah State Historical Society)

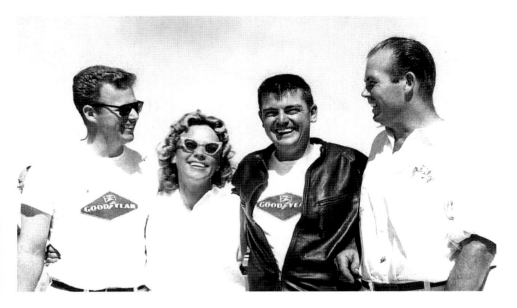

ABOVE: Mickey and Judy Thompson (center) with Fritz Voigt (right) and crew member Darrell Droke after Mickey's one-way run of 406 mph, September 1960. (Judy Creach) LEFT: Art Arfons in the *Anteater*, 1960. (Tom Joswick) BELOW: Art with his first jet car, *Cyclops*, August 1961. (Tom Mayenschein)

ABOVE: Craig Breedlove, Shell manager Bill Lawler and Art Russell's finalized model of *Spirit of America*. (William A. Moore) **RIGHT**: Craig showing two Shell reps around while *Spirit* is under construction. (Bob Davids) **BELOW**: Charlie Mayenschein changing a tire on Art Arfons' *Cyclops*, 1961. Note the ridges in the ungraded salt. (Tom Mayenschein)

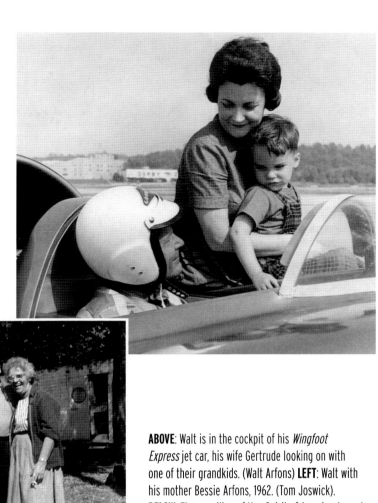

ABOVE: Walt is in the cockpit of his *Wingfoot Express* jet car, his wife Gertrude looking on with one of their grandkids. (Walt Arfons) **LEFT**: Walt with his mother Bessie Arfons, 1962. (Tom Joswick). **BELOW**: The unveiling of the *Spirit of America*, August 1962. (Bob Davids)

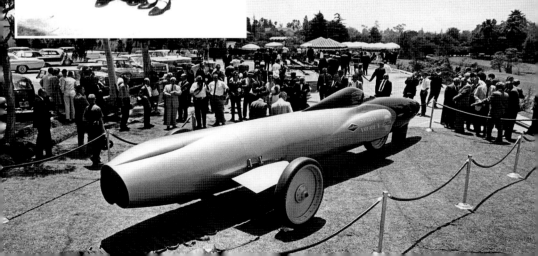

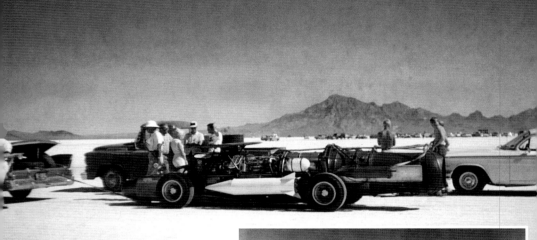

ABOVE: Art Arfons' *Cyclops* back on the salt flats, August 1962. (Ron Christensen) **RIGHT**: Unloading *Spirit of America*, August 1962. **BELOW**: Testing *Spirit*'s engine at Wendover Air Base. (both Bob Davids)

TOP: Craig Breedlove, August 1962. **BELOW**: Craig and the *Spirit of America* crew. (Bob Davids; photos by Tom Carroll)

ABOVE: Walking the course for debris. **RIGHT**: Rod Schapel at the blackboard as the team tries to solve the steering problem. Bob Davids is seated right; Craig is standing right. **BELOW**: Craig and *Spirit*, August 1962. (all Bob Davids; top and bottom photos by Tom Carroll)

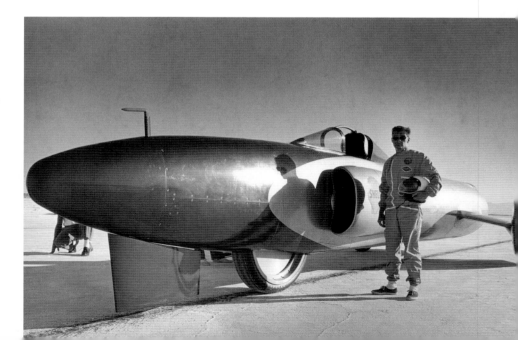

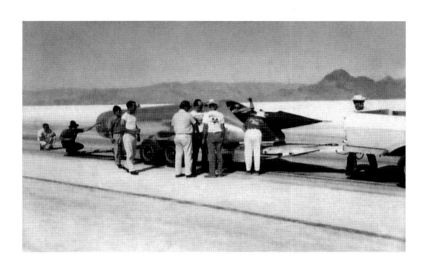

ABOVE: *Infinity* being eased off its trailer, September 1962, Glenn Leasher in the cockpit, Tom Fukuya third from left, Romeo Palamides fifth, Vic Elischer sixth, Harry Burdg at far right. (William A. Moore) **LEFT**: Loading *Infinity*'s chutes prior to Glenn's record attempt. **BELOW**: *Infinity*, September 10, 1962. (both Ron Christensen)

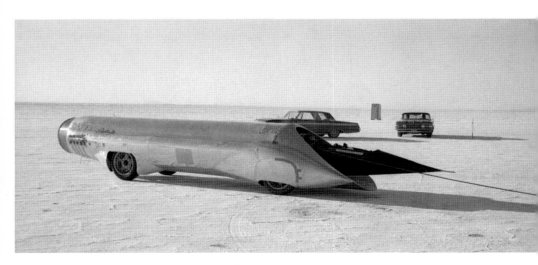

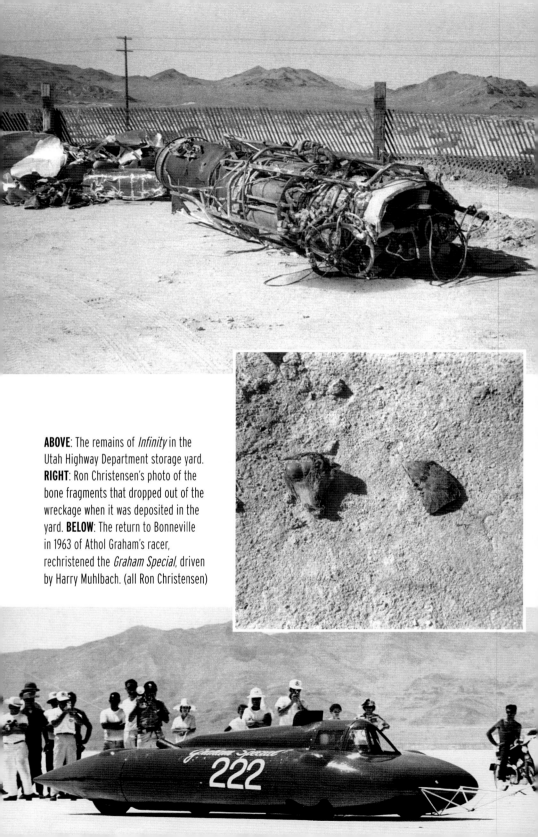

ABOVE: The remains of *Infinity* in the Utah Highway Department storage yard. **RIGHT**: Ron Christensen's photo of the bone fragments that dropped out of the wreckage when it was deposited in the yard. **BELOW**: The return to Bonneville in 1963 of Athol Graham's racer, rechristened the *Graham Special*, driven by Harry Muhlbach. (all Ron Christensen)

Building a Monster

The letter Art Arfons had been waiting for arrived at his Pickle Road shop while he was on the road, working his way along the drag circuit in the Midwest. It was from a place called OK Surplus in Miami, his wife June told him when he phoned home to check in.

Is it about an engine? he asked, his hopes instantly rising.

Yes, it is. He says he's got what you're looking for. He says it's in real good shape.

The engine was a J-79. The idea of building a new land speed racer around one of these advanced, hugely powerful jets had come to Art shortly after his return from Bonneville with *Cyclops* in 1962. His reasoning was simple: with a J-79 he could leapfrog ahead of every other jet car in the LSR game. While Breedlove and Ostich and his brother Walt were fiddling around with J-46s and -47s generating thrust of no more than 7,000 pounds, he would build a car harnessing 17,000 pounds. He would blow them away with sheer power.

The first hurdle was simply getting his hands on one of the engines. Seventy-nines were still relatively new and therefore classified and unavailable on the military-surplus market. To get around this, Art targeted not just surplus dealers but scrap yards as well, the places that bought junk metal by the bin at auctions. When the Air Force pulled a damaged or worn-out J-79 out of one of their aircraft,

it had to be discarded somewhere—and Art figured one might end up in these bins. Throughout the fall of 1962, as he toured drag meets across the country, he contacted every surplus outfit and junk dealer he passed or could find in the phone book, telling them what he was looking for and leaving his name.

The letter from OK Surplus, which arrived in November 1962, was the result of all that searching. A J-79 had turned up on the surplus market after all. As soon as Art got home, he headed south to claim it. Charlie Mayenschein, a mechanic friend and fellow Navy veteran, went with him. Charlie had been building cars since he was a kid and knew a lot about jets from his work on fighters and bombers at Wright-Patterson Air Base in Dayton. He and Art had met at a car show in 1960, where Art was exhibiting one of his dragsters and Charlie his customized Ford Phaeton; Charlie made his first trip to Bonneville with Art the following year. They got down to Miami and looked over the 17-foot-long engine and Art paid the asked-for $600—"I didn't try to chisel down the price," he remembered. On the way back to Akron they talked out a design for a car and Charlie sketched it on a piece of cardboard.

The Miami dealer was right about the J-79 appearing to be in good shape. It was only after Art got it home and started taking it apart—it took a special wrench which Charlie had snuck off the base—that he discovered the problems. Three of the required 10 fuel nozzles were missing. So was a scavenge pump and a control alternator, all parts that you couldn't just go down to the hardware store and buy. Most of the hoses snaking all over the machine were also shot and needed replacing. And then he got to the turbine blades and saw that a number were bent. In aviation parlance the engine had been "fodded," a term derived from the acronym FOD, "Foreign Object Damage." Something, perhaps a bolt or a tool or a rock off a runway, had been sucked through the engine and had banged up the blades.

The J-79 was too far beyond repair ever to be used again in an F-104 fighter or a B-58 bomber, which was why the Air Force had

scrapped it. For land speed racing, however, it just might do. The first task was to fix the blades. Of the hundreds lining the turbine, Art counted 67 that were damaged. He and Ed Snyder worked on them by hand with files, painstakingly grinding each one down to remove nicks and gouges. Any that were too badly bent, they removed altogether. They removed the blade on the opposite side of the turbine too, to keep the engine in balance. When that was done, they went at the tangle of worn-out hoses, figuring out where everything went and what it did and replacing what they could. The missing fuel nozzles and other components, however, left Art stymied. Replacement parts were not available for purchase and couldn't be hand-crafted. There was really no way forward but to locate a second J-79 and cannibalize it for parts.

It was about this time that an Air Force colonel showed up at Art's shop, looking very serious. Art's purchase of the scrapped J-79 had passed entirely under the military's radar. It was his subsequent phone call to General Electric requesting a manual for the engine that had raised a red flag. These engines are classified, the colonel told him. I don't know how you got this one, but you're not supposed to have it.

Well, I got it, Art replied. I bought it fair and square and I have the bill of sale to prove it. You people junked it, I bought it, and that makes it mine.

The colonel then revealed the real problem: the Air Force was embarrassed that a cutting-edge J-79 that had originally cost $175,000 had slipped into the hands of a drag racer and backyard mechanic. They were willing to provide Art with the manual he wanted and would even give him some help, but in return they wanted him to keep quiet about how he had acquired the engine, especially when he was talking to reporters. It seemed like a fair deal to Art and so he agreed.

It took a lot of searching, but Art finally found the second J-79 he needed, two of them in fact, beat-up ones being auctioned off as scrap in Indiana. He showed up at the sale, bid high and got them.

He now had three non-functioning engines, enough to supply the parts to assemble one engine that worked. They had cost him a total of $5,000, far more than he had ever spent on power for one of his racers. He had never set out to build a car like this next *Green Monster*, however. It would be Number 17, and it really would be a brute.

Art already had a bare-bones design for the car, Charlie's sketch and follow-up wooden model. The parameters for the dimensions he chose were unorthodox: he wanted the finished machine to fit into his bus. That meant it had to be no more than 22 feet long, six feet wide and four feet or so high with the tail fin removed. These size restrictions ruled out a forward cockpit like the one Breedlove, Ostich and Walt had in their racers and that Art himself had used in his *Anteater*. In *Green Monster* No. 17 he would by default have to sit next to the engine. Since a side-mounted cockpit would make the racer lopsided, a second dummy cockpit would be built on the opposite side to balance it out. Both would have to be very narrow— again, so the car would fit in the bus. To increase his chances of survival in the event of a crash, Art would encase both cockpits with tubing, turning them into pods.

The tail fin would have to be detachable, of course, a feature that could be unbolted and stowed for ease of transportation. To assist with steering, Art would attach an air rudder to its trailing edge. Also detachable would be the pivoting wing that Art devised to fit onto the front of the racer, a refinement of the wing he had used at Bonneville on *Cyclops*. It would work along with the downhill angle of the engine to prevent the car from flying. It was his rough-and-ready answer to the sophisticated nose design of Craig Breedlove's *Spirit*, which precisely directed the airflow to counter any tendency toward lift. Art would achieve the same result by linking the pitch of his wing to the movement of the front axle suspension by means of two hydraulic cylinders. If the *Monster*'s nose started to pitch up, the action of the axle dropping away from the frame would lengthen the first cylinder running between them, which would in turn shorten the second cylinder between the frame and the wing and pitch the

wing down. It was simple and intuitive, the way Art liked it, something he and Ed could fabricate from a drawing—they never used anything as elaborate as blueprints. And it would work like a charm.

How to configure the front end of the car itself, what would sit beneath the wing, at first seemed a big problem. In any discussion of land speed car design, a fundamental question was how to reduce frontal drag. The typical answer was to make the frontal area small with a rounded or pointed nose that would help the car slide more easily through the air. The problem for Art—apart from the fact that it would make the car too long for the bus—was that such a nose would block the J-79's intake and thus necessitate adding air ducts to feed air to the engine. He didn't want that. Air ducts would be difficult to design and fabricate and would only make the car more complex and problematic. Hadn't it been imploding air ducts, after all, that had sunk Ostich in 1960?

The solution came to Art while he was thumbing through some pamphlets on jet-powered aircraft. He learned that the air intake didn't count toward a plane's frontal drag because the air in front of the intake wasn't being pushed aside, it was being sucked in. Frontal drag, in other words, was the frontal area of a vehicle, minus the intake. This simple formulation led him to a revelation: Why not just leave a nose off the car altogether and make the front end a huge air intake? That way, he would get reduced frontal drag without even trying; he would ensure maximum airflow into the engine without using ducts; and he would keep the overall design simple, something he and Ed could build on their own. The end result might not look aerodynamic, but the thing of it was—*it didn't matter.* The car would be like a tube, the air passing through it as it shot down the black line.

The ingenuity of this still stirs E. J. Potter, a motorcycle-racing friend of Art and a fellow backyard builder who would serve on his *Monster* crew during the upcoming trips to the salt flats. "Breedlove and the other guys were making a big thing out of how a jet engine would be so big and so hard to push through the air," says E. J. "But

none of them took into account that the front end of a jet was suck-ing that air in as hard as it could suck, so it was like having no frontal area at all. That's why Art didn't do as much streamlining as every-body else. Streamline this and streamline that, change this and change that. It was nonsense. Art was one of the first guys who real-ized that. Nobody was taking into account that there really wasn't any need for aerodynamic shaping. Just put it out there, suck air in the front end, blow it out the back, and go."

By the spring of 1963, Art and Ed had the J-79 restored to the point where they were ready to test it. The testing of jets on the Arfons place out behind the mill, either by Walt or by Art, was not an infrequent occurrence by this time. The testing of the J-79, how-ever, was a whole new experience.

"That's one of my real distinct memories," says Art's nephew Tom Joswick, 12 years old at the time and living with his widowed mother Lou in the old family farmhouse right by the mill. "When Uncle Arthur chained that sucker down behind the mill and fired it up, it was pretty incredible. It set a bunch of bushes on fire and it dried up the little creek that was out back there for about 10 min-utes. It basically just steamed it all gone."

"I remember my Aunt Lou passing out," recalls Art's son Tim, then eight. "She thought it was a monster coming after her. I don't know if you've ever heard a J-79 before it goes into burner, but it gets to a certain point, at about 95 percent, where it makes a distinctive howling, like Godzilla or something. It's the neatest sound in the world."

"Yes, I did faint," Art's sister Lou Wolfe admits with a laugh. "I've got really sharp hearing, and that engine was so loud, it was like explosions were going off in my ears."

Art himself seemed to revel in the noise. He never wore ear plugs when he was working on any of his engines. He would bend right over them, his face inches from the hot, vibrating metal, as if he were tinkering on a lawnmower, casting an occasional grin at the kids and the visitors who would gather to watch, everyone standing

well back with fingers stuffed in their ears. It was almost inconceivable to him that anyone wouldn't want to be bathed in the noise, the sweet sound of all that power.

Art's neighbors, meanwhile, didn't appreciate the racket. It shook windows along Pickle Road and up and down Killian Road a quarter mile away, and to the uninitiated it sounded like an airplane crashing. When Art's application to erect a new building on his property was brought forward at a township meeting, he would claim to be surprised by the bottled-up resentment. "I found out then what my neighbors thought of me," he groused. "Raising all kinds of hell about the noise." Tim recalls another time when an irate neighbor threatened to return with a gun if Art started his jet engine again. Art started it up anyway—with a pistol close by.

Art and Ed began the actual fabrication of the *Green Monster* in the winter of 1963–64. By the following spring they had kicked into high gear. "They kind of worked around the clock," Ed's wife Nadine remembers. "Ed would work his shift at the American Hard Rubber Company in Akron and then he would go down and help Art out."

They would be assisted by a 55-year-old housepainter named Nyles "Bud" Groff. Bud was a character, 5 foot 4 and feisty, with a waxed handlebar mustache. "A stick of dynamite," his son Ted remembers. "He'd fight a damned gorilla and get whipped and fight him again tomorrow." Bud had come on board as a casual volunteer a few years before, just for the fun and excitement of being a part of the racing. Out on the salt he would join Charlie Mayenschein and Ed as an important member of Art's team.

And then there were the kids, Art's sons Ron and Tim and his nephew Tom and Walt's younger son Craig; the brother's feud didn't extend to the children. "If you hung around in the shop too long, you'd be handed the broom," Tom Joswick fondly remembers. "Another thing they'd have us kids do is sort out the bolts and nuts and screws and things that they'd buy by the pound at junkyards. But we loved doing that. We loved being around there, being around those guys. I can still remember the distinct smell of the place. It has

to do with degreasers and aviation fuel and steel and welding and all that sort of thing. I don't go back there to visit very often, but every time I do and I step into that shop, I'm taken back to when I was a kid by the smell. It's kind of like smelling Grandma's apple pie."

The fabrication of the *Green Monster* is for hot-rodders today a legend, the ultimate expression of the do-it-yourselfer ideal. Art by his own estimation spent just $10,000 to complete the car, half of that on the engine. For many of the parts, he simply took a wrench or cutting torch to the hulks that littered his yard or dug something out of a box of scraps in his shop. The axle came from a '51 Dodge truck, the steering assembly from a '55 Packard, the five-gauge instrument panel and brake pedal from one of Art's old airplanes, the chute-release mechanism from a shotgun he purchased for three bucks at a pawn shop. When something special was needed that he couldn't scrounge or didn't know how to make, he would study up and ask around until he figured it out.

"I'm a tool-and-die maker by trade," says Lee Pendleton, a drag-racing buddy of Art going back to the 1950s, "and Art would talk to me about how to machine things, how the geometries and every-thing worked. And before you know it, he'd have a lathe and a little mill and he'd be doing a lot of that work himself. He would explore anybody's mind and get answers that way."

When everything was finished and the car was ready for skin-ning, Art talked some free aluminum sheeting out of Alcoa and then built his own metal-forming machine, a copy of the device he had seen in Lujie Lesovsky's L.A. shop back in 1960 when he had spent $4,000 to get his *Anteater* covered. He also built his own start cart for the J-79 engine, reportedly at a cost of $32. To purchase something similar would have cost several thousand. Bud Groff then gave the whole car a paint job with epoxy-based green, expen-sive stuff that he said would never flake off. "Well, what the hell," Art shrugged. "We want the best."

There were two big expenses that Art couldn't avoid with hard work and ingenuity: the custom-made tires he would need on the

salt flats and the $1,000-plus per day in fees to book the course and pay for the timers. For these he went to Firestone, the company that had been supplying him with tires from the beginning. His pitch, like his approach to building the *Monster*, was simple. He possessed by far the most powerful car in history, so powerful that if he set it up on its tail it would shoot him into the sky. It was nearly built now and he needed a sponsor to run it. He wasn't asking for any money up front for fabrication expenses. He had that covered. What he needed were tires that could withstand some very high speeds and the fees attendant with running for the record. If he succeeded, Firestone would pay him a sum in return for the publicity harvest. If he failed, it wouldn't have cost them much.

Firestone sent representatives out to Pickle Road to take a look at the *Monster*. The car impressed them. Its green paint job did not. Humpy Wheeler, sales manager for Firestone's racing division and soon to be Art's closest company contact, would laugh about it later, describing it as a sickly pea green paint that cost 50¢ a can. "It was 26 bucks a gallon," Art shot back, peeved. Nevertheless, it had to go. A new paint job was ordered for the *Monster*, a combination of green—a *nice* green—and Firestone red.

A deal was struck. It was supposedly sealed with a handshake. Firestone would back Art Arfons for the land speed record and pay him $25,000 each time he broke it.

Accolades and Acrimony

Things changed fast for Craig Breedlove when he broke the record on August 5, 1963. He had been planning to return to the salt the next morning, after giving *Spirit* a quick overhaul and looking into whatever had caused the chute to release prematurely on the first run. The course, after all, was booked until August 15, so why not boost his record still higher? But the executives at Shell and Goodyear had other ideas. With the record now in hand, it was time to capitalize on the achievement, and for that they needed Craig on the road. Within hours of setting the record he had been hustled to Salt Lake City for a press conference and gala dinner. Then, the next morning, it was onto a plane east for a slew of public appearances that would drag on for weeks.

"I found it difficult," says Craig. "I'm kind of a shy person. Within 24 hours of setting the record, I was in New York at the Americana Hotel having a press conference for about 300 people from all over the press, and they had me scheduled on the *Tonight Show* with Carson and a whole bunch of other stuff that was all foreign to me. It made me really nervous. I mean, in high school I was the kind of guy who didn't even want to get up to give a book report."

It also bothered him that he had been pulled so suddenly away from his crew. "I never did have much time to sit down and talk with

them," he would write later, "not even to thank them properly for making it all possible . . . I hoped they understood."

But there were compensations. It was Bill Lawler who broke the good news. Shell and Goodyear, he said, were going to each pay Craig $1,000 a month for three years to serve as a racing consultant, plus $200 a day and expenses for the duration of the publicity tour they were planning. To Craig, accustomed to scrimping, it seemed like riches. He felt like grabbing Lawler and giving him a kiss. "Fortunately I restrained myself and said, 'That sounds fine to me, gentlemen. I'll be honored to work for Shell and Goodyear.' What I wanted to say was, 'I'll take it. Wow!'"

The tour took Craig to every major city in the United States, 38 all told. It started as a heady whirlwind of adulation, but quickly settled into a grind—particularly after Lee flew home at the end of the first month to take care of their kids. An advance team would precede Craig to every stop to arrange a press conference and line up appearances and interviews and get everything ready. When Craig arrived, he would then be handed a schedule that kept him on the go from first thing in the morning until almost midnight, drop-ins at TV and radio stations, interviews with local newspapers, luncheons with some group at noon, a function with some other group in the evening, with Craig being called on each time to tell the same story and answer the same questions, on and on, city after city, day after day, week after week. For Shell and Goodyear it was gold, free publicity to augment the ads they were already running, ads with tag lines like "Fastest Man on Wheels . . . Using Shell Fuel" and "New Land Speed Record! 407 mph on Goodyear Tires." Craig did everything expected of him and did it well, taking to his new role of all-American hero and corporate spokesman like a natural. But it was a lot of hard work. When it was over, the nationwide tour and then a junket to England and two weeks in Australia, the strain and fatigue had pared his already slender frame from 150 to 134 pounds.

Craig made the trip to England not knowing what sort of reception he would receive. He had, after all, claimed a record that had

been a British institution since the mid-1920s, returning it to the United States for the first time since Ray Keech's brief time as title holder in 1928–29. There had been some grumbling in the British newspapers that *Spirit of America* wasn't officially a car as defined by the Paris-based Fédération Internationale de l'Automobile, which held ultimate authority over the land speed record. *Spirit* did not have the minimum of four wheels as set down in FIA regulations, but only three, which the Fédération Internationale Motocycliste defined as a "cyclecar," a vehicle "with three wheels, forming three tracks and composed of an inseparable ensemble." Nor was it driven by power being applied to at least two of its wheels. Instead, it was powered by the direct thrust from a jet, a category that the USAC recognized but which the FIA did not. "Breedlove's [run] was made in a jet car and couldn't be considered a record," harrumphed one of the British industrialists backing Donald Campbell. "It is just like putting an airplane engine into a car." Apparently he didn't realize that Cobb, Eyston and both Campbells, father and son, had all used airplane engines. The beef was specifically with jets.

The official wrangling started on the very day Craig made his 407-mph two-way average. "You really haven't broken Cobb's record, you know," a journalist with a London paper told him during a telephone interview that afternoon. When the issue came up again the next day at his New York press conference, Craig conceded the point.

"I call it a car," he said, "because I built it as a car. As far as automobiles go, John Cobb's record of 394 miles an hour still stands." It was a diplomatic statement and didn't entirely reflect his true feelings. "Who the hell are the FIA?" he would say in a less guarded moment. "If they don't like our car they can do the other thing—we got the record." The fact was that the general public didn't care that some French outfit didn't view *Spirit* as a car or consider jets kosher.

"I don't think this is really important," admitted Donald Campbell, then in Australia mounting another bid for the record. "Technically, yes. But in the eyes of the world, no. If we are to

succeed in beating Cobb's record with *Bluebird* and fail to break Breedlove's as well, then, in my mind, we will have failed."

Donald was exactly right. In the eyes of the world Craig had the LSR and was accordingly feted. There was even a hit pop song written about him, "Spirit of America" by the Beach Boys: "Half airplane half auto now famous worldwide/The Spirit of America the name on the side/The man who would drive her Craig Breedlove by name/A daring young man played a dangerous game . . ." The hot-rod-inspired album it was on, *Little Deuce Coupe*, would go on to win a platinum record.

The publicity tour kept Craig on the road into 1964. When he finally returned home early that year, he began construction on a $50,000 ranch house with a pool in the exclusive Los Angeles suburb of Palos Verdes and started living the good life with Lee. He was a celebrity now. He got fan mail; companies were courting him to endorse their products; the networks wanted him to appear on their shows. Then a trio of film producers came calling with a plan to make Craig's life into a movie. By May, Craig was officially a co-producer on the project, a production company had been set up with offices at Goldwyn Studios in Hollywood, a script was being written—and most importantly, funding was lined up courtesy of Shell and Goodyear, contingent on Craig upping his record later that year and keeping his name hot.

The title for the film was a no-brainer: *Spirit of America*. Steve McQueen was the first choice to play Craig. Craig knew Steve through his father Norman, who worked on special effects for *Wanted: Dead or Alive*, the TV series that launched Steve's career as a star. (It was Norm who fabricated the sawed-off Winchester carbine that the actor carried in the show.) Steve was interested in taking the lead in *Spirit* when Craig approached him about it, but his work schedule was so packed that it would have meant a wait of four years. "Why don't you just do it yourself?" he told Craig. "It's real easy. You'll just be playing yourself." As the script was finished and the anticipated start of production drew nearer, this option was

given serious consideration. Actual filming would begin after Craig returned from the salt flats later in the fall, after he'd boosted his record to what was hoped would be 500 mph.

And then a letter arrived from a lawyer. It concerned a lawsuit. Craig was being sued by Rod Schapel.

The tension that had arisen between Craig and Rod during that first trip to the salt in 1962 had continued to simmer in the background. The subsequent changes to his original design for the car, the addition of a tail fin and a steerable front wheel, had deepened Rod's feelings. As Craig sees it, these changes "basically, I guess, diminished Rod's ultimate authority over the design of the car. He just really got his dander up and that's what caused the suit. And the other thing was that because of the record, there was a lot of publicity and a lot of notoriety from it. I think frankly there was a certain amount of jealousy from Rod's point of view that he had contributed to this thing, and that as the driver I was getting a lot of accolades for this record, and I think he felt he was not receiving the credit he deserved for the design work on the car. But I mean, in everything we publicized, everything always referred to Rod."

The actual lawsuit, however, didn't focus on design issues or the allocation of credit. It was about money—the money that seemed to be showering down on Craig. "My suit was based on the fact that Craig told me he would give me 10 percent of all the money he got from Shell," says Rod, "and he didn't do it . . . It was the fact that he was being paid lots of money by Shell and Goodyear and I was getting nothing. And we had a verbal agreement, Craig and I."

There is little doubt that Craig made vague assurances when he was trying to get his car built. Things like that happen when a little guy is struggling to achieve a big dream. Craig's wife Lee remembers him promising her the chance to drive the car when she lent him some cash shortly after they met. "At one time or other, Craig promised *all* of us the opportunity to drive the damn car,"

Stan Goldstein recalls with a laugh. As for all the volunteer hours that friends like Stan and Bill Moore and Art Russell put in on the project, sure, there was talk of great things happening once the record was broken. And indeed, once Craig secured sponsorship, the people involved in the project, Rod included, were paid for their subsequent efforts. Rod, however, didn't see this as fair compensation. He asserted that Craig had made a verbal agreement with him back in the beginning, and he now insisted it be honored.

Art Russell, who had made the models of *Spirit of America* for wind-tunnel testing and to attract sponsors, appeared at the trial and testified on Craig's behalf. "It was a pretty nasty situation," he says. "Rod claimed that there was a verbal agreement between him and Craig that when he broke the record and started coming into money that Rod would get X amount of dollars or something. And Craig said there was no such deal. So when I testified at the trial, it was to say that I didn't get any money out of it and wasn't promised any money, and as far as I knew, nobody else was either. I wasn't paid anything until Shell and Goodyear came into it. Before that, I was a volunteer. We were all volunteers. Everybody was just helping on a volunteer basis."

Rod Schapel lost his lawsuit. The jury sided with Craig. The victory was of course a huge relief, but at the same time it didn't leave Craig feeling entirely good, for Rod had been a friend and a mentor. The trial, moreover, would be just the start of a series of troubles that would dog him in years to come. "When Rod sued Craig," says Stan Goldstein, "it was like somebody rang a bell. Because from that moment on, every time that kid turned around, somebody was fucking suing him."

That was the thing about success and fame: it attracted trouble like a magnet.

13

Down to Three

In September 1963, Nathan Ostich returned to Bonneville with his *Flying Caduceus* jet car for a third crack at the record. You had to hand it to the doctor: he was persistent. This time his racer had a tail, the result of another year of labor by Doc and chief builders Ray Brock and Al Bradshaw and the team of volunteers at Doc's East L.A. storefront. They set up on the salt under a huge umbrella-like awning done up in Firestone red and white and got down to work.

There was no doubt that the tail was a major improvement. The Edwards test pilot "Fish" Salmon had been right on the money. Doc came away from the first runs enthusing about how well the racer was handling. Very quickly he felt confident enough to push his speed up past 350 mph, emerging from the cockpit after one run with a jubilant, "Hey, that's the fastest I've done!" The only mishap was a spinout at low speed when he braked too hard. The damage was minor and he was back making runs the next day.

But then something went wrong. Doc now had the J-47 at maximum power, enough to push *Caduceus* easily into the 400s to snatch Breedlove's new record, and he couldn't get it beyond the 350s. What was going on *now*? Were they back to having a problem with the jet engine?

It all came to an end on the morning of September 26. Al and Ray and the team had stayed up all night installing a new fuel

control valve in the hopes that it would correct the problem. They'd also removed the stop screw from the throttle so that Doc could advance the lever to the absolute limit. But when Doc made his runs that morning, driving through the measured mile with one hand on the throttle lever in case it had been drifting backward, he couldn't push *Caduceus* past the mid-300s. "What the Sam Hill," he said afterward, frustrated. "The guys worked all night for nothing." In a last-ditch effort they got a jet engine specialist to come out from Hill Air Force Base in Salt Lake City. He looked the J-47 over and concluded that it was working just fine.

The *Caduceus* team had once again been beaten. Five years of labor, a huge dent in Doc's wallet, and the best they had done was 359 mph. "Well, back to the drawing board," said Ray, leaning against the car, head in hand. Al was too tired to say much of anything at all.

Back in L.A., it didn't take long to figure out what was wrong with the racer. It had been hovering in the background, but they hadn't wanted to face it. The problem was in large part the car's aerodynamics. The design, which the wind-tunnel tests had led them to think was "almost perfect," as Doc had put it back in 1960, was producing far more drag than had been predicted, a lot of it coming from the exposed wheels, four feet high and the better part of a foot across to begin with, and growing even wider as they were squashed by the pressure of onrushing air at high speeds. As Al recalls today, "That became a major—probably *the* major cause of our inability to get to speed."

Adding streamlining to the existing design was not a viable option. At three and a half tons, *Caduceus* was already pushing the limit that Firestone had set for the tires. There were only two options if they wanted to stay in the LSR race: build a new car from scratch with better aerodynamics, or increase the thrust of the present racer and overcome the drag with brute force.

They agreed that there was no point starting over. It would take at least two years to design and build a new racer, time in which

Breedlove was sure to push the record still higher. No, the only way to stay in the game was to increase the car's power. Doc was all for that and started talking enthusiastically about rockets. Ray and Al wanted no part in the scheme; they felt it would put their friend in too much danger. They had worked out the engine bugs that had plagued them in the first season. They had solved the handling issue that had dogged them the next year. But with the aerodynamics problem, they knew they were licked. They had pushed *Caduceus* to the limits of its potential and could push it no further.

It was at this point that relations between Doc, Ray and Al became strained for the first time. Doc was stubborn. He was pushing 55, but he still wanted to continue. Eventually, however, he acquiesced to the advice of his friends. Al stayed on for a while in his employment, partially disassembling *Caduceus* and preparing it for storage, straightening up the storefront, cleaning the place out. Finally, the day came where there was no work left for him to do. There'll be other things, Doc reassured him, not yet ready to see the lights in his workshop extinguished entirely. But Al knew it was over. He packed up his family and his trailer and moved on with his life.

Some years later Al received a phone call at his new home in Kansas City, where he was working for Chrysler. It was his old friend from the *Caduceus* days, Ray Brock, and he had bad news: Doc had cancer. I'm planning a surprise birthday party at Doc's, Ray told him, and I need you there, Al, so that we can do something special.

Doc had donated *Flying Caduceus* to a museum and had been worrying about how he was going to get it put back together. That would be the surprise for his birthday: Ray and Al and some of the old team would meet at Doc's to celebrate his life and reassemble the racer.

It's a bittersweet memory for Al, one that still brings back the emotion. He flew out to L.A. for that day in September, he saw Doc one last time, and they all pitched in and put *Caduceus* together. A few years later Doc was dead.

You can see *Flying Caduceus* today at the National Automobile Museum in Reno, Nevada. It's a testament to a man who lived life large, who had the courage to push to the edge—and who knew when to quit.

Eight thousand miles away, in the remote outback of Australia, an ancient Ford Model T was rusting into the salt crust of a dry lakebed known as Lake Eyre. Some wag had posed a cow skeleton upright on the front seat, hoofs extended to the steering wheel to give the impression that it was about to motor away across the desert. It was an apt symbol for Donald Campbell, camped nearby with his idle *Bluebird* racer. Since abandoning Bonneville in 1960, Donald had not moved a single step closer to the land speed record. In fact, since he'd arrived in Australia the quest had become a soul-destroying exercise in frustration.

After the 1960 crash of *Bluebird*, the consortium of British companies backing Donald built him a completely new racer, a virtual copy of the original with the addition of a stabilizing tail fin, raising the total cost of the project to what was then the staggering sum of $5.5 million. When the car was ready to drive, Donald chose not to return to Utah. Instead, he regarded Lake Eyre in central Australia as a more promising speed mecca. It was remote and almost completely inaccessible, but Donald was convinced the struggle to get there would be worth it. He envisioned a course 20 miles long, a salt-and-sand surface that offered better traction and less wheel spin, and freedom from worry about the weather: at Lake Eyre, it hardly ever rained. Or so the story went.

The Australian government had stepped in to help, grading 65 miles of road from the nearest railhead and taking on the task of preparing the course. When Donald arrived in April 1963, things were almost ready and the prospects for record-breaking looked rosy. He and his wife Tonia settled into a sheep ranch homestead 35 miles from the salt pan with their butler and cook, *Bluebird* was

towed out to the course and made ready . . . and then the nightmare began.

It started with the first course having to be abandoned just as it was being completed: the salt crust was too thin in places. A second, much shorter course was started—it would be called the Hobson's Choice track—while the *Bluebird* crew waited. Then it started raining. When Donald was finally able to take the car out for a speed run two weeks later, the surface of the course was mushy and slippery and he never got beyond 240 mph.

Then it started *really* raining, an inundation that flooded the lakebed, the worst in recent memory. There was nothing to do but retreat and hope for better conditions in 1964. When Donald got back to civilization, it was to learn that Craig Breedlove was preparing for an August assault on the record. "*Bluebird* was built for the record," he mused forlornly. "It would be a very sick joke indeed, costing five and a half million dollars, if somebody else beat us to it."

Less than two months later, of course, Craig did just that. *Spirit of America* was jet-powered and with only three wheels was not even considered a car—and Donald knew that none of that really mattered. In the eyes of the public the LSR was about ultimate speed, not FIA rules. He therefore had to raise his target to something over Craig's 407 mph. It was still doable, but it would be just that much harder.

Before he could return to Lake Eyre for another try at the record, Donald first had to weather a storm of controversy and sniping. The discontent had been simmering ever since he'd totaled his first *Bluebird* racer in 1960. There had been doubts expressed at the time over the speed of 365 mph that he claimed he reached before crashing: it seemed a physical impossibility to accelerate that fast in a wheel-driven car in just 1.6 miles. Then, as a replacement *Bluebird* was built and the cost of the project continued to mount, the focus shifted to Donald's expenses. He was accused of living like a millionaire on sponsorship money. As for the debacle in Australia, there were those who asserted that the problem hadn't just been the

weather, but that Donald himself was partly to blame for not push-ing harder to get the job done.

"Did he make the most of his available time on Lake Eyre?" asked one critic rhetorically. "The hell he did! *Bluebird* was built around an engine capable of pushing her to 475 mph for 1,000 hours with-out overhaul [a reference to its use in the Bristol Britannia airliner]. What did we see at Lake Eyre but Donald's personal engineer, Leo Villa, and his boys pulling this, that and something else down and putting it back together again and again. It was utterly unnecessary."

"Campbell was always talking about the Utah crash," added an anonymous *Bluebird* crew member. "He kept harping on rescue drill; on the procedure for getting him out of the car if something went wrong; whether the aircraft supplied by the government as an ambulance would be able to get down quickly enough to help him; where the doctor ought to be . . . I don't think he looked like a trier at all."

As bad as this was, worse was coming. Sir Alfred Owen, chair-man of Owen Organization and one of the project's biggest backers, publicly scolded Donald for dragging his feet at Lake Eyre, while other corporate backers started making noises about cutting off the flow of money and containing their losses. Then British racing legend Stirling Moss came right out and said it: Donald should step aside and let a real race car driver take over. "I have been in speed realms that Moss doesn't know about," Donald replied coolly. Nothing came of the suggestion, but the thrust must have hurt.

When Donald returned to Australia in April 1964 he was there-fore under a great deal of pressure. If he didn't deliver *something*, there would be no further chances. In what was apparently an attempt to cover his bets, he announced that after claiming the land speed record he would go after his own five-year-old water speed record and attempt to break it as well within the same year.

When the crew arrived back at Lake Eyre, it was to wait again on the weather. For a desert, the place got a ridiculous amount of rain. It was as if the gods were conspiring to thwart Donald, perhaps to

punish him for rejecting the Bonneville Salt Flats. Finally, in the latter part of May and early in June, he was able to make a series of speed runs, hitting the mid-300s for the very first time. It was the absolute best he could do, given the conditions. The course was far shorter than what he had hoped for and the surface was so soft that his tires left ruts three inches deep. "Heartbreaking all the way," he said after. "[It was] like driving through a pudding. It was the same as driving along with the brakes on."

After a month-long break away from all the frustration, Donald returned to Lake Eyre in July, this time to break the record or give up altogether. On the 17th he finally did so, posting a two-way average of 403 mph despite horrid course conditions and chunks of rubber flying off the tires. He had at last broken the land speed record . . . for wheel-driven cars. It was a great achievement, but at the same time a disappointment, for he had failed to better Breedlove's mark. "I felt a wave of resentment that it all had to be so difficult," Donald told Cyril Posthumus later, "and relief that I'd got the bastard at last." From this point onward the LSR would split in two: the ultimate speed record held by the jet cars, which attracted the most public attention; and the wheel-driven record that only aficionados would appreciate fully.

Two days later *Bluebird*'s chief designer Ken Norris announced that plans were in the works to build Donald a jet car. He hinted that the machine would be very special, more than just a jet engine on wheels—presumably a knock at Breedlove and others. "We have a surprise for the Americans and anyone else," he said, but declined to give any details. Nothing came of these plans. Britain would not return to LSR competition with a jet car until the 1980s.

In the meantime Donald returned his attention to the water speed record, where he had started his racing career in the mid-1950s. He had already set the world record six times between 1955 and 1959 with his *Bluebird K7*, surpassing his father Malcolm's post-LSR performance in boats. When he left Lake Eyre, Donald returned to the game to better his own unbroken mark. He succeeded on the

last day of 1964, on Lake Dumbleyung in Western Australia, with a two-way average of 276 mph. Two years later he was at it again, this time looking to break 300 mph.

The attempt, made on Coniston Water in England's Lake District, did not go well. The more powerful engine fitted into *Bluebird K7* was plagued with problems and the weather was horrid. It was not until January 1967 that Campbell was finally able to begin a serious assault on his own record, clocking 296 mph on his first pass. Inexplicably, he then turned around and began his return run in the space of scarcely four minutes, not waiting for the chop he had stirred up to settle.

He didn't make it. *Bluebird K7* was doing better than 320 mph when it began to pitch from side to side on the rough water. Then it flew into the air and came down on its nose, cartwheeled and broke into pieces. Campbell's final words, recorded from the cockpit microphone, were: "Tramping like mad . . . Full power . . . Tramping like hell here . . . I can't see much and the water's very bad indeed . . . I can't get over the top . . . I'm getting a lot of bloody row in here . . . I can't see anything . . . I've got the bows up . . . I've gone . . . oh!"

Donald was probably dead by the time *Bluebird* stopped tumbling and sank to the bottom. His good luck charm, the teddy bear he called Mr. Whoppit, was found floating in the debris.

With the passing of Nathan Ostich and Donald Campbell from the LSR picture, the race for the record came down in 1964 to three main contenders, all running jet cars: current record-holder Craig Breedlove with his *Spirit of America*, Walt Arfons with his *Wingfoot Express*, and Art Arfons with his yet-to-be-debuted *Green Monster*. In October, these three men would go head-to-head at Bonneville to break the record wide open. It would be the most intense and the most exciting four weeks of competition in LSR history, a time of spectacular speed increases and even more spectacular crashes.

It would be a month of speed.

Brother Against Brother

I t was after midnight when Art Arfons began the long drive to Utah. He had said goodbye to his wife June earlier that evening with the usual promise, "I won't go fast." Down at the workshop, Ed Snyder and Bud Groff helped him load the jet car into the white-and-red bus and got it securely strapped down. They would take turns driving the bus, Lee Pendleton following in the truck with spare parts and equipment and Art's homemade start cart. They creaked and swayed their way out of the yard to Pickle Road, past the mailbox labeled with stick-on letters, the final "r" missing. The sign read: "Art Arfons, 2396, Home of the Green Monste-."

The drive west had to be taken slowly, the bus straining and overheating as it headed into the mountains. It was late in the evening on Wednesday, September 30, 1964, when they arrived and put up at the Wend-Over Motel, tired out from the 50-hour haul. Before heading off to bed, Art parked the bus in clear view by the swimming pool, taped a length of pipe to the antenna and ran up a four-by-eight-foot Firestone banner.

When he awoke the next morning, the pipe was bent in half and the banner was lying on the ground. It was still the middle of his half-brother Walt's week on the salt, and Walt's Goodyear-sponsored crew hadn't appreciated the partisan display. "He parked his bus right here," Walt would privately grouse to writer Jack Olsen, "and he flew

a flag with Firestone on it, a great big one. And it was all Goodyear here. It was my week here. He come in on Wednesday, on *Wednesday*, of my week. That's just one thing that shows how chicken shit he is."

"Yeah," Art shot back when Jack asked him about it, "and someone went and bent the flag down."

After stowing the pipe and banner and having his breakfast, Art headed out to the Bonneville course to watch Walt and driver Tom Green run for the land speed record in the *Wingfoot Express*, the same jet car they had failed with the previous year. They were running out of time—Art's booking began on Saturday—and they were still a long way from the record. Once again they were having all kinds of bad luck.

This time it wasn't salt getting sucked into the engine. Walt had made some alternations to the car during the off-season and that problem seemed to be beat. Whatever was going on now, it had been dogging them since Tuesday and they couldn't figure it out. If they didn't come up with a solution soon, they would be heading home frustrated and empty-handed—again.

Things had started well with Tom's initial shakedown runs on Monday. He took the *Wingfoot* up to 300 mph, everything checked out, and he and Walt announced that they would go for the record the next day. On Tuesday, however, with the USAC timing equipment in place and everyone expectant, the jet car seemed to lose all its kick. It was clocked through the mile on its first pass at just 282 mph, more than a hundred miles an hour below what it should have done for its throttle setting. Walt worked on the engine and Tom tried again, but he couldn't do any better. More adjustments and more tests were made on Wednesday and the results were the same. Most of Thursday was spent pulling the engine out of the car and replacing it with a backup J-46. It didn't help. When Tom tried a run at the end of the day, he couldn't even get his speed up to 300.

For Tom's wife Pat, the week was turning into a strain. While she shared her husband's frustration, what was worse was the worry, the dread that assailed her every time Tom climbed into the cockpit.

"I prayed every run he made," she said. "Our friends in Wheaton [Illinois] were praying too. A high school friend of Tom's who had become a priest and whom he hadn't seen in years called before we left to say he would say a Mass for Tom." The two young Green daughters, left behind with Pat's parents, were also anxious. Pat would remember how Denise, aged seven, had been upset earlier by overhearing Walt say something about how the installation of *Wingfoot*'s brakes would have to be delayed. She had thought her daddy was going to drive a car with no way of stopping, and it had worried her so much that she got sick to her stomach.

That evening, Tom ran into Art at the Stateline Casino and they had a quiet drink together. "What in the *hell* is wrong with my car?" Tom said, nearly at the end of his tether.

Art had been out on the salt that day, watching the *Wingfoot* crew desperately working, and he knew the answer. "Tom," he said, "you got the damn tail pipe closed down too far and your automatic controls keep shutting off your engine."

It was the governor, Art went on to explain, the safety device that automatically cut off the engine to prevent a backfire when the pressure at the tail pipe neared the pressure inside the compressor. When that happened, the governor would shut off the fuel flow until the pressure subsided, then turn it back on again. That was why the engine was performing so poorly: it was cutting in and out all the way down the course. The solution was simple: open the tail pipe a bit wider to ease up on the pressure.

Friday, October 2 was *Wingfoot*'s last day on the salt and the crew was desperate. Tom took Art's suggestion to Walt and a slight adjustment was made, increasing the tail pipe aperture from 17 to 19 inches. It would mean a loss in maximum power, but if it got the engine working they might still have a chance. For good measure they also cut away some of the aluminum skin around the jet engine's intake in the hope that this would let in more air and in turn increase its power. It meant snipping off half the Goodyear logo behind the cockpit. On Tom's next run, *Wingfoot* got to only

around 300 mph, far below its potential. The J-46, however, seemed to be running more smoothly.

It was now 4 p.m. They were almost out of time. The car was quickly turned around and refueled and again made ready, then Walt huddled with Tom and said, "Use the afterburner." The J-46 was fired up and the car started rolling and Pat Green started praying. So did Walt. "God, keep him safe," Pat heard him whisper as Tom roared off down the salt.

Tom gave the afterburner three short taps through the measured mile and was clocked at 406.55 mph. Suddenly they were back in the game. For the return trip, made as the daylight was fading, he left the burner on all the way through the mile, but for some reason his airspeed indicator remained stuck at 400. He thought he hadn't made it and emerged from the cockpit looking disheartened. Things just got worse when they discovered that a small piece of debris had been sucked through the engine and had bent some of the blades. Then word came down from the USAC trailer: Tom had in fact done a shade over 420, giving him the land speed record with a two-way average 413.20 mph. "I set the idle adjustment up one-twentieth of a turn and that did it," Walt exulted after. "It was like falling in a rocket," said Tom, ecstatic. And: "Walt has half his life tied up in this car. I wouldn't have let him down for the world."

Art watched from the edge of the crowd as the jubilant *Wingfoot* crew hoisted Tom onto their shoulders. He watched as Pat Green arrived and tearfully threw her arms around her husband. He watched as Tom gleefully poured water from a thermos over Walt's head. He watched it all and he felt genuinely happy for Walter, for he knew what the record meant to his brother after the countless hours and the personal savings and the piece of his soul that he himself had put into his own car. Even with the flagpole incident still rankling, he had been hoping that Walt would succeed.

Go on, Art. Go over there and shake your brother's hand.

It was Lester Medvene, a drag-strip manager friend of Art's who had come out to Bonneville to watch the show and help out.

Get over there, Art. Be a man. Shake his hand, for Christ's sake.

It was funny how much it unnerved him. The butterflies were worse than anything he'd ever felt climbing into a racer. The two men stood before each other awkwardly for a few moments, eyes downcast, each afraid to make the first move in case the other rejected the gesture. Well, congratulations, Art said. You done real good. A hand at last went out and it was taken and for the first in a long while there seemed to be a connection between them. "I damn near had tears in my eyes and everything," Art remembered. "I called my mom that night and I said, 'I made up with Walter. We're all buddies again.'"

Well, perhaps not quite. At the impromptu press conference that took place on the salt after *Wingfoot* set the record, Tom called out for Art to come to the front. "In fact, we owe part of the record to Art," he announced to the gathered reporters. "I'm not at liberty to say how he helped us, but he made a significant contribution. That's all I can say."

"That's what got Tom in bad trouble with Walter," Art would say later. "When he said that, Walter just about shit his drawers."

Art drove the bus onto the salt flats on Saturday, October 3 to begin his own week. The first step was to ease the *Green Monster* down a ramp out the back of the bus and get the tail fin and nose wing bolted back on. At this point the car was still sitting on utility wheels. Firestone had only just finished work on the special high-speed tires Art needed and had shipped four or five sets direct to Bonneville along with engineer Steve Petrasek. They were absolutely treadless and as hard as rocks, inflated with nitrogen to 250 psi. Before they were gingerly bolted onto the racer, Bud Groff and Ed Snyder applied white paint to the raised "Firestone" name stamped into the rubber so that it would show up clearly in photos.

While all this was being done, jet engine specialist Henry Butkiewicz checked out the J-79. General Electric had sent the tall,

reedy engineer out to the flats to assist Art with the powerful jet engine—and to prevent him from doing anything foolhardy with it that might get him killed. Art had already removed the protective filter screen from the front of the engine to ensure maximum airflow, something that was definitely not recommended. He had also refused to place a steel shield between himself and the turbine spinning at a fantastic speed an inch from his shoulder. It would be unnecessary weight, he figured, adding, "I don't mind being next to the blades. I just remind myself of how many jet engines have ever exploded in the few hours we have on this one and figure the odds are in my favor."

By noon everything was set for a test run. It would be the first time Art had actually driven the car. First, the braking chutes, main and backup, were packed into the compartments on either side of the tail pipe with "Beware of Blast" stenciled over the doors. Doris Tennant, the wife of Art's friend and drag-racing buddy Bob Tennant, helped with the task. She had pieced together the chutes for Art on her sewing machine back home in Akron and had come out to Bonneville with Bob to watch and help out. Next, the *Monster* was fueled with kerosene, carefully strained through a cloth to remove any traces of dust as guys stood around smoking. To get the engine started, the car was eased forward to the start cart hitched to Lee Pendleton's truck, and the long white drive shaft extending from the back of the cart was inserted into the nose cone of the engine. After overseeing this, Art pulled on his crash helmet, then a brown leather jacket over his white-and-red Firestone fire suit. The jacket, a gift from Bud a few years before, was worn out and too small, but Art considered it lucky. He wore it in all his runs in the *Monster*.

It was an extremely tight squeeze getting into the cockpit. The sides pressed hard against Art's arms and restricted his movements. With help from Ed and Bud, he got the harness over his shoulders, then lowered his goggles. There was no oxygen mask to fiddle with; Art considered oxygen a pointless complication. While Bud stayed

by the cockpit to relay hand signals, Ed went forward to crank up the start cart. When the Buick car engine that powered the unit was up and running, he threw a switch directing power to the drive shaft connected to the *Monster*'s engine and the turbine started to turn. Back in the cockpit, Art waited for the rpm's to build, then he opened the fuel line, set the throttle and hit the ignition. When the jet fired, Bud lowered the canopy and banged down on it until Art got the inside latch turned. Then he peered intently through the glass, watching for Art's signal that the J-79 had reached 67 percent power. That was idle. When Art flashed a thumbs-up, Bud instantly relayed it to Ed at the start cart, then ran forward to guide the drive shaft out of the nose cone as Ed cut the power and Lee eased the truck forward to haul the cart out of the way. Art was on his own now, the *Monster* roaring, ready to go.

Art didn't usually express his concerns openly, so not many observers knew how his first runs in the *Monster* shook him. In fact, everything about the car made him uneasy: the unfamiliar side-saddle position of the cockpit; the way the side of the car blocked off the view to the right; the constricted feeling he had once in the seat, the sides pressing against his arms; the almost unbearable heat when the J-79 got going, the big turbine spinning barely an inch from his body; the suspensionless rear wheels and the unyielding, 250 psi tires, transmitting every jolt and bump up through Art's back.

And then there was the actual experience of driving. Every time the *Monster* hit a ridge or pothole, it would lurch up and the nose wing would bring it back down in what became a series of bounds. Every time it came down, moreover, it tended to be at a tangent that required correction until, as Art put it, "you're driving like an old woman." The experience as a whole was so unnerving that by the end of his second day Art was seriously thinking about calling it quits. The final run on Sunday, when he plowed into six inches of brine water after missing the sign warning him to shut off the engine, felt like the last straw. The rest of the day had to be spent taking the *Monster* to pieces to clean out the salt.

"The car is so darn uncomfortable that I just don't know what to do," he confided over the phone to June when he got back to Wendover.

"I've felt uneasy about that car for a long time," she replied. "You know how some people have said you could get brain and ear injuries from being so close to the noise of that engine."

"I've never worried about that much because there are so many other things to worry about. But right now nothing seems to be going right. Would you care if I came home right now?"

Art was quiet with the crew during dinner that evening. It was evident that he was tense and preoccupied, so they gave him some space. Finally, after letting the desultory conversation flow around him for the whole of the meal, he seemed to arrive at some sort of grim resolution. All right, he announced quietly, tomorrow we'll try it at 375.

They were out on the course and ready to go at 8:45 the next morning, Monday, October 5. The assumption was that two or three days of speed runs lay ahead, with the try for the record not coming until Wednesday or Thursday. When Firestone's Humpy Wheeler questioned Art to make sure he wasn't intending to rush any faster, Art soothed him with, "Of course not, Hump. I'm just going to see how it feels."

As it turned out, the first run that morning felt very good. After gritting his teeth and pushing through the unpleasantness that lay in the 200s, Art found that everything about the *Green Monster* began to smooth out. By 350 mph the jolting was subsiding and the car had ceased its bounding and veering, "and jeez, the damn thing held like a dream." It all felt so good that Art nudged the throttle further forward, just a bit to see what lay up near 400. When he got stopped and wriggled his way out of the cockpit, his confidence was back and he was smiling and he knew he could do it. "She performed near perfect," he said as the sweat dried on his face. "That squirrel-feeling it had below 300 was gone and it seemed to take the bumps better." Joe Petrali then arrived in his blue pickup and made things better still, announcing the speed as 396 mph.

Walt and Tom Green's record was suddenly within striking distance. After a quick huddle with Ed, Art decided to reach out and grab it. For the return trip, he would set the throttle at 100 percent, the full power of the J-79 before the afterburner kicked in. It would give the 6,500-pound *Green Monster* roughly 10,000 pounds of thrust, enough, Art figured, to take him to the 438 mph he needed to clock.

It was another smooth run, another confidence builder. Accelerating more surely this time through the lower speeds where the car handled poorly, Art took the *Monster* up to a breath-taking 479 mph through the measured mile, giving him a round-trip average of 434.02 mph, a new land speed record. He had bettered Walt's mark after only three days. The performance had in fact been almost miraculous considering that Art had never even test-driven his car prior to Saturday. No one in the history of land speed racing has come near this degree of economy and efficiency in setting the record—no one in the six decades before or the four and a half decades since. For getting the job done cheaply and quickly on sheer ingenuity and courage, Art Arfons had just established himself a head above everyone else.

After a celebration that had the crew cheering and hugging and Ed dabbing at tears, Art headed back to Wendover for lunch. Calls from jubilant Firestone executives followed, and phone interviews with newspapers and wire services that had not been expecting much action before Wednesday. In the meantime the *Monster* was left in its tent on the salt, for Art wasn't finished. He had four days left in his course booking and he was going to use them. He wanted to push his record higher, up beyond the reach of Craig Breedlove, who was waiting in the wings to take over the following week.

Walt wasn't on hand to witness his brother's triumph. "Have to be getting along," he had said as he packed up to leave Wendover the previous day. Goodyear was laying on a big celebration in Chicago and he was expected.

He and Gertrude were driving through a small town in southern Wyoming when they heard over the car radio that Art had just broken the record. Walt stopped the car at a traffic light and walked back to break the news to Tom and Pat Green in the car behind them. There would be no marketing bonanza for Goodyear, and what Walt and Tom personally stood to gain in appearance fees and endorsements had just been slashed to a fraction. "Third-Shortest LSR Record in History!" didn't make much of a pitch for an ad or a come-on for exhibitions.

Walt's mind was already working, thinking of ways to improve the speed of his *Wingfoot*. He was glad for Arthur, but he also had every intention of reclaiming the record. As for Tom, he took the news with a resigned shrug, for his LSR quest was over. He had promised Pat that he would give it up once he broke the record, and he wasn't sorry to do so. He didn't want to risk his neck all over again. He had held the record at least for a little while and his name would always remain in the books. It was something other men had died trying to achieve. He was content.

With the light turned green and other drivers getting impatient behind them, Walt returned to his car and led the way to a pay phone to place a call to Art in Wendover. After offering his congratulations, he passed the receiver around to Gertrude and his crew members so they could all say a few words. Then they got back into their vehicles and continued on east.

Art spent the day after his record, Tuesday, October 6, going over the *Monster*, making adjustments in preparation for the speed runs he would resume on Wednesday. He was planning to shoot for 500 mph, a target that was making the engineers from Firestone nervous. Five hundred would be too fast for the tires, they told him; it would mean taking them to their design limit under actual racing conditions, and that was not prudent. The boys back in Akron had new, improved tires in the works that would be good for 550 mph.

They could be ready in as little as two weeks. Until then, Art would be well advised to set his sights lower. Why not try for 450 mph? That would be safer.

The Firestone technicians had good reason to be anxious. Land speed racing put a horrific strain on tires. Back in John Cobb's day, when the record was still in the 300s, tires took such a beating that Dunlop sent an entire truckload of them out to Bonneville so that the *Railton Special* could get a complete changeover before every run. Technology had improved a lot since then with the development of multi-plies and tougher synthetics, but it was still a very demanding business, and in the case of Art's *Green Monster*, it was even tougher. The *Monster*, after all, took small tires by LSR standards, family-car-sized tires mounted on 18-inch rims. That meant they covered about seven feet in a single rotation, not much more than half the distance traversed by the 48-inch Goodyears on Craig Breedlove's *Spirit*. That meant they had to spin nearly twice as fast to achieve a comparable speed. At 500 mph that was something like a hundred rotations per second, generating more strain than the Firestone engineers were willing to vouch for. The risk of a catastrophic blowout would just be too great.

Art listened to their concerns and nodded, but he had made up his mind. It had been the same with the Air Force jet experts he had talked to, the guys who waggled their heads and issued dire warnings about leaving the debris screen off the J-79 and doing this and that with the engine. "I pay no attention to what they say about the consequences," Art said. "They'd scare you to death." As he saw it, he had already done nearly 500 mph in the latter part of the second run of his record. To squeak past that mark now and make it official wouldn't put much more strain on the tires than they had already endured.

There was a hint of levity among the crew when they returned to the salt flats on Wednesday morning. The car was made ready and Art climbed in—and on the opposite side, screened from view, Charlie Mayenschein slipped into the second cockpit, clutching a tape recorder to record his reactions. Charlie had already taken a

ride in the *Monster* in the early test running, but he wanted to experience real speed and he knew that Art would never agree to him riding shotgun. Firestone was also dead set against it. The only way was to sneak into the right-side cockpit without Art and Firestone knowing, Bud giving him a hand and Ed turning a blind eye.

Art made the run and got the car halted and emerged to wait for the crew to catch up. It was one of the stranger aspects of land speed racing, these lonely few minutes on the barren moonscape when you are the only living organism for miles. So it gave him a jolt when he walked around the back of the *Monster* and saw Charlie standing there, grinning, tape recorder in hand. The open canopy and the helmet on Charlie's head told the whole story. "Why, Charlie," Art growled, "you crazy son of a gun." After that, the second cockpit was sealed.

The run itself was disappointing, the USAC timers clocking the *Monster* at 413 mph, satisfying for Charlie but well below Art's expectations. Fortunately, the problem was quickly discovered: a faulty nozzle setting on the J-79 that had resulted in a drop in the tail pipe temperature and in turn a loss of power. Art made the necessary adjustment and the racer was turned around and prepped for its second run of the morning. It was ready to go with just three minutes to spare in the hour.

Charlie wouldn't be sorry to miss what came next. As Art was entering the mile at around 500 mph, his car took a tremendous jolt, so powerful that he thought an axle had broken. The right rear tire had just exploded. Inflated to 250 psi, it had gone off like a bomb, blasting the tire to pieces and crumpling and tearing the surrounding body panels. Art instantly backed off the engine and released his primary chute, things happening so fast there was no time for fear. The one clear thought he would remember afterward was, *I hope I don't run over Joe's timing gizmos.*

He didn't. Nor did the *Monster* flip or tumble. The car stayed upright and dragged itself to a stop, its large frontal area assisting the chute now that air was no longer being sucked into the engine.

It was another advantage of the *Monster*'s blunt front-end design—significant aerodynamic drag when it was really needed.

Ed took the narrowly averted disaster the hardest. He was nervously puffing on a cigarette and looking haggard as a crowd gathered to marvel at how much damage had been done by the fastest blowout in history. The thought that his best friend could get killed out here in a car he helped put together filled Ed with dread. Art seemed to take the whole thing calmly. There was no sign of jitters, no nervous laughter. Nathan Ostich, who had driven out from Los Angeles to watch, came over to commiserate, and he and Art spent a few minutes together. They came from completely different walks of life, but their shared experiences at Bonneville made them close. As they talked, Art draped his arm casually around Doc's shoulder.

In the examination of the course that followed, the gouge in the salt left by Art's bare rim was followed back to the scene of the blowout and the immediate area was searched. A bolt was discovered nearby that would be deemed the cause of the mishap. They speculated that the *Monster*'s front tire had dug the hidden piece of iron out of the salt and flung it back against the rear tire like a bullet. Art wasn't so sure that was the answer, but he went along and kept his doubts to himself. Privately, he was starting to wonder about the tremendous torque of the engine, its rightward twist. In early tests, when he and Ed ran the J-79 chained in place and mounted on a bare chassis, the torque generated at full power had been strong enough to lift the left wheels up off the ground.

To repair the damage that had been done to the *Green Monster*, Art would need his metal-forming machine, which was back in Akron. That meant he was finished on the salt for the week. He would have to pack up and make way for Craig Breedlove—and hope that his 434-mph record would hold.

To Five Hundred

Craig arrived in Wendover five days later. It was the same edge-of-nowhere town he had left with his 407-mph record the year before . . . the same place where there wasn't much to do but gamble, where the women wore their hair piled up and lacquered, where the funny-tasting water just might give you diarrhea, where the best place to eat was at a picnic table in front of the house of the guy who sold barbecue out of his kitchen.

A closer look revealed one significant addition. It was behind the Wend-Over Motel, where Craig had just checked in, up on the cliff above where the State Police shot their pistols at targets to keep themselves sharp. The weathered rock was covered with graffiti going back decades—Hank-loves-Mabel type stuff, what looked like a bear's paw, a knight, insignias of groups once stationed at the air base. Dominating it all now was a brand-new logo, a foot sprouting wings framed by the name "Goodyear." Walt Arfons' crew, his sons Terry and Craig among them, had found some blue paint and daubed it up there before leaving. It made the neighboring red of the "Firestone" logo, several years old, look faded. Craig now hoped to do the same to Art's record.

Bill Lawler was no longer in charge of the project. For his role in cultivating Craig and getting the LSR for Shell, the much-admired, no-nonsense commander had been given a big promotion to the

New York head office. Roy Van Sickle was appointed to replace him. Another difference: this year, Craig's wife Lee wasn't with him. Craig had asked her to stay home. He thought it would help him maintain focus and develop a deeper camaraderie with the crew, none of whom had the option of bringing their wives. Craig's father Norman, who had recently worked on the film *It's a Mad, Mad, Mad, Mad World*, would be on hand instead. He was enormously proud of his son—and almost as worried about him.

When *Spirit of America* was hauled onto the salt on Sunday, October 11, 1964, Craig's target was no secret. Like Art, he was aiming for the nice round figure of 500 mph. It would mean pushing his car nearly 100 mph faster than he'd gone the year before. The prospect of attempting such a huge leap made Craig apprehensive—not so much about the car as about himself. The past 12 months of touring and publicity had been one long distraction, keeping him away from the workshop and racing and the exercise he needed to stay in top shape. To get back into LSR mode and deliver was going to be tough.

The pits were set up that first day and Craig took a couple of low-speed runs by way of a shakedown. *Spirit* had been strengthened at several key points, the nose had been made slightly sleeker and the front canard modified, and a rebuilt J-47 engine provided an extra 500 pounds of thrust. Everything checked out. The biggest concern was the condition of the course in the aftermath of *Wingfoot* and *Monster*. Craig was especially sensitive to the bumping—*Spirit*'s single front wheel tended to follow any rut it got into, like a bicycle tire caught in a streetcar track.

Things got more serious the next morning. It was time to build up speed. Craig's best pass for the day was clocked at 452 mph, record territory. He didn't attempt a return to make it official. That would be rushing things, and with the LSR Craig never rushed. Before proceeding, he wanted a rough patch on the course dealt with that had nearly thrown him into a spin. Roland Portwood and his road crew took over. They would drag the salt all through the night. That would smooth out most of the ruts and ridges, but it

would only partially reduce the hump around the four-mile marker. It amounted to a rise of scarcely six inches over 800 feet, but at high speed that was a veritable ramp.

Craig tried for the record the following day, Tuesday, October 13. The engine was balky and the entire car had to be raised by the nose to drain excess fuel. That delayed things for three hours. The first run finally got underway at 10 a.m. Craig was heading south and encountered the hump as he built up speed and was able to steer around it. The run was timed at 442 mph. For the return, the throttle was advanced five ticks to 95 percent. Craig paced up and down, looking grim, as the crew rushed through the turnaround prep. Staying in motion kept his nerves under control. If he stopped he was apt to get shaky.

The uneven patch was just beyond the measured mile on his return pass. When he hit it, the results were dramatic. The slight rise, encountered at such velocity, launched *Spirit* several feet into the air. The racer came back down with such force that Craig's head smashed the quarter-inch canopy glass. His head was aching when he got the car stopped and removed his helmet to examine the gouges. A knot of spectators and crew and journalists soon gathered. Joe Petrali arrived from the timing shack and the call went up, "Make an aisle for Joe!" That he had good news was clear from the way he was grinning and waving the results like it was a winning lottery ticket. "It's a hot paper, it's a hot paper," was the excited buzz as he passed through the crowd.

The figure written on it was 498.13 mph. That gave Craig a two-way average of 468.719 mph, a new land speed record. It was the third time the Big Number had been pushed up in less than two weeks.

"Are you going to stay?" someone called out in all the cheering and hugging.

"Yes," replied Craig, "We're going to get that 500."

* * *

Craig and his crew wasted no time in starting to tear down the racer. *Spirit of America* had taken a beating and needed to be thoroughly checked and cleaned and tuned before Craig made another attempt. Land speed racing was brutal on a machine. They worked through the rest of the day and on into the night and all through Wednesday with scarcely a letup. Craig stayed with the team until late into the second evening, then headed back to the motel for some sleep. He needed to be sharp when he climbed back into the cockpit.

Three a.m., and he was still awake. It wasn't just nerves; he knew what they felt like. This was a deeper, darker sense of foreboding. It kept him tossing and turning for most of the night and finally drove him to get up and write letters to his kids. That gave him some momentary peace and he was at last able to briefly drift off. But as soon as he opened his eyes again, there it was, the dread, the yawning abyss.

It was still dark when he got out of bed in the morning, alone and exhausted and with the same premonition of doom. The feeling stayed with him as he washed and shaved and put on his racing outfit and laced up the boxing shoes he had found in a sporting goods store to replace his old sneakers. He couldn't face food right now and didn't feel much like talking. To kill some time, he thumbed through a local paper. "Top Cash Paid for Deer and Elk Skins . . . Deer Bags, Reg. $1.00, Now 39¢ . . . Hunters, the Choice is Clear: Vote for Wilkinson for U.S. Senator. . . Rent a Rifle. Downtown Only! Zinick's, 50 S Main."

No doubt about it, he wasn't home in L.A.

The crew was already gathered when he arrived on the salt with Nye Frank. Quite a number of spectators and newsmen were on hand as well, old Bonneville hands bundled in coats, the novices shivering in light jackets and sweaters. It was cold in the morning out here in the desert, before the sun was high enough to burn off the night chill. Craig got out of the car and all those faces looked up.

"How's everything, Craig?"

"How are you doing, Craig?"

"How do you feel?"

"Fine," he replied briskly. "I'm fine." He wished everybody would leave him alone for a while, keep quiet so he could set his mind right and get on with this thing.

"Do you feel okay, Craig? Did you have some breakfast?"

"I had a sip of water. I feel fine."

Spirit was positioned at the zero-mile marker at the southwest end of the course. It was pointing toward the peak known as Floating Mountain, so named because it seemed to hover in the distance above the shimmering salt. As the crew worked through the checklist of pre-run procedures, Craig did his own checking. When it came to his *Spirit*, he was extremely exacting—"meticulous to the point of crankiness," as one observer had put it. His dad Norman hung around for a while, then drove down the course to watch from in front of the USAC trailer.

Fueling was complete now. The J-47 jet engine was being warmed. It required careful handling to start. The Goodyear tires, paper-thin rubber over a dense conglomeration of cord, had been checked and okayed and the wheel fairings put back in place. The chutes were loaded and the deployment charges installed. As with everything else, Craig gave this a personal check as he mentally reviewed what he had to do on his run. Heading down the course wouldn't be just a matter of following the black line. There were slight adjustments he wanted to make, easing to the left or right to avoid rough spots.

Eight a.m., and the car was ready. Time for the takeoff procedures. Craig stuffed cotton into his ears, then donned his helmet, blue stars on silver with "Breedlove" on the front. Bobby Davids had done a nice job painting it for him. He lowered his goggles. These would keep the pulverized salt thrown up by the front wheel out of his eyes. At high speed, it would seep into the cockpit like white smoke. He climbed up the ladder and eased himself into the seat, a

crew member first brushing clean the soles of his boots. The leather was still cold from the night. He snuggled down in, shoulders touching the sides, helmet just grazing the roll bar.

He snapped himself into his harness and took a moment to look at his hands. They were steady. So were his knees. At least he had his body under control. Inside, however, the fear was still gnawing. What was he doing here? Was it really worth it? He used to enjoy racing. It used to be *fun*. His mind went back to his first run at El Mirage in '53 when he was a 16-year-old kid. He had been scared then too, behind the wheel of his Ford coupe out in the desert, but it had felt different, the sweaty palms and butterflies of nervous anticipation. What he was experiencing now went much deeper, a feeling that extended down into the pit of his stomach, where something kept telling him: *You're going to get killed.*

He pressed his helmet back into the pocket-like headrest. He snapped on his oxygen mask—he needed it to ward off the salt and the smoke of a fire if there was one—and adjusted the valve that regulated the airflow. The cool breeze smelled strongly of rubber but felt good on his lips. Nye stepped forward with the canopy cover. Craig jiggled it until the pins chunked down into the holes and turned the latch to lock it in place.

It was quiet. He could see people hurrying around out there, his team clearing away the ladder and all the equipment, the guys from Shell and Goodyear, the newsmen, the spectators, but he couldn't hear them. He looked ahead at the stark view out the windshield, blue sky above, white salt below it, the black center line, used engine oil, extending all the way to the horizon. The Donner Party had come this way, on its way to starvation in the Sierra Nevadas.

Five miles down the course, Joe Petrali was sitting in the USAC trailer at the equipment-laden counter facing the windows. It was sparsely furnished, just a few chairs, a water cooler, a kettle and coffee makings on a shelf in the corner, a scattering of newspapers

to while away the long waits. Ted Gillette, his ambulance parked outside, was seated next to Joe with bulky headphones and an old-fashioned mike. He was the voice of the timing shack, communicating with the Auto Club official at the start line and observers along the course. Jim Economides of Capitol Records was standing behind him with a portable tape recorder to pick up the sounds of the run.

Joe had just given the wind a final check. It was okay, barely wafting. The start-line official called in to say Craig was ready to go. Ted radioed down to the course observers, "Is the track clear all the way along?" A pause and he had confirmation. He radioed down to the start line, "Okay, let him come."

Out in front of the trailer, Norman Breedlove was standing beside *Salt Lake Tribune* sportswriter Marion Dunn. They both had binoculars hanging from their necks. They were well back from the course and would need them to see *Spirit*. "I don't care if he doesn't get the record," said Norman. "I just don't want anything to happen. I love that boy." A few moments later Dunn saw him bow his head and whisper a prayer.

Craig hit the start button. The engine lit and started to whine. He advanced the throttle to idle. The cable from the start cart was detached and the cart towed away.

Two fingers. It was Nye's signal reminding him to perform the last two procedures on the checklist: turn on the camera to film the instrument panel gauges and the electronic recorder to tape the readouts from the car's sensors, including airspeed and wheel loads. The machines whirred to life, the noise lost in the enveloping roar of the jet. Outside, the last remaining crew members were getting into their cars for the drive down the course. The truck pulling the start cart was already on its way, off to the side. Others had left some minutes before to receive Craig at the far end. He would need help with the canopy and the ladder to climb out.

Craig took a firm grip of the steering yoke, thumbs near the buttons that deployed the chutes, the main and the backup. As on his previous runs, a stop device had been installed on the accelerator that would give him the exact amount of power required for the speed he wanted, in this case 97.5 percent. No need to gently press down on the pedal. He took a deep breath and stomped his foot to the floor.

Spirit leaped forward, slamming Craig back into his seat. Within seconds the needle on his speed indicator was sweeping past 200, then was approaching the three, the pitch of the air being sucked into the engine rising higher and higher. The hump that Roland and the Utah State Highway boys had managed to only partly scrape down was coming up. Craig eased the yoke slightly to the left, guiding *Spirit* away from the center line and then back when the danger was past. The front wheel shock struts were clanging now and the tires were booming—it sounded like someone was banging on them like a drum. He was into the most uncomfortable part of the ride, when the jolting was severe.

Another glance at the needle. It was at the four.

The measured mile was coming up fast. He could see the marker, a man-sized black number on yellow, the USAC trailer a speck farther up ahead and off to the side. The roar of the wind outside the cockpit was now the main thing he could hear, so loud it overwhelmed the whine of the engine.

The sign whipped by. He was into it, doing 500 and the needle still creeping. He was covering 900 feet now every second, three football fields every second, traveling faster than a bullet from a .38 special, so fast that the ride had become strangely smooth. At this speed he could pass over a knee-deep pothole and he wouldn't feel it. In the time it would take *Spirit*'s suspension to react, he would be hundreds of feet past it.

Another black-and-yellow blur and he was through the mile. It had taken a hair under seven seconds. He hit the cutoff button, flaming out the J-47, and let the car coast for a while to drift down from its top speed. Then he hit the chute release. *Bang.* The deploying

explosion was loud. He was thrown forward against his harness by the force of deceleration, a force so upsetting to his inner ear that for a moment the world tipped over and he felt like he was driving straight down a cliff. Then it abated and everything was once again flat. He was down to 200 mph, the roar of the wind fading. Then the needle touched 150 and he was back in the safe zone, back down where he could use his brakes to bring his car to a stop. He rolled it up to where the first of his crew had just arrived and were exiting their cars. He had covered 11 miles in scarcely two minutes. The ride had been perfect.

He popped open the canopy. It was taken and set carefully on a pad laid on the salt. As Craig wriggled out of the cockpit, he was greeted with congratulatory shouts and hoots of elation.

"Beautiful!"

"All right!"

"You got it, Craig!"

They were crowding around now, big smiles, slapping him on the back as if he already had the thing done. Craig found it annoying. He wanted to tell everyone to shut up, that it was a two-run game and they were going to jinx him. "We're only halfway there, guys," he cautioned.

In fact, they weren't even halfway there. The first pass, with plenty of time to prepare and wait for ideal conditions, was always the easiest. Now came the hard part, scrambling to repeat the performance in what was left of the hour, under conditions you could no longer control. In factoring out the influence of a possible tail wind, the two-passes-within-60-minutes rule also factored out luck.

Craig tried to stay out of the way as the crew got busy, resuming his pacing off to the side. The Shell truck drove up and started pumping. *Spirit*'s J-47 gulped aviation fuel by the gallon. The film from the cockpit camera and sensor-readings recorder was removed and fresh film loaded. The 80-foot-long towline for the deployed chute was detached from the back of the racer. A fresh chute, already packed in its bag, was loaded into the empty compartment. The

wheel fairings were removed so that the tires could be examined for signs of damage. They were new ones Goodyear had just developed, tested under 4,000 pounds of load to 620 mph. They were still good. No need to change them. The fuselage was wiped down, removing the salt buildup. The starter unit was wheeled into position and a cable run to the engine. Getting the J-47 relit would take crossed fingers all around. If it flooded, the hour would be lost and with it the first run. They would have to begin all over again.

Joe Petrali arrived from the USAC trailer. Craig, he reported, had just become the first driver to surpass 500 through the mile one way. His exact speed had been 513.33 mph. All those threes struck Craig as lucky. Maybe he had been overreacting. Maybe he wasn't going to get killed after all.

"Say Craig, could you spare a minute?"

It was Bill Fleming from ABC's *Wide World of Sports*, microphone in hand, cameraman filming over his shoulder. At any other time Craig would have gladly consented to an interview. He was the LSR's golden boy, the best with the press. But not now. Not when there was work left to do and he had to stay focused. "I'm sorry, Bill," he said, "but I can't talk right now. I have another run to make before it's official." Fleming backed off.

The turnaround was quickly completed. Craig was back in the cockpit with time to spare in the hour. Before snapping himself into his harness, he reached down and removed the stop from the accelerator pedal. He would go all out on the return trip, 100 percent, the throttle setting beside which a crew member had painted "Banzai." Craig tossed the stop out to Nye. Nye kissed it for good luck and put it in his pocket.

Foot down hard, acceleration again smashing him back into his seat. "He's on his way," Ted Gillette announced in the Auto Club trailer, relaying the call from the start. In the background someone shouted, "Hey, he's on his way! Get off the track!"

The 10-mile marker swept past. The nine-mile. The eight-mile. Then the seven-mile, a blur. Craig was doing 450 now and getting

faster. He was going to enter Joe's clocks at better than 500. It would easily get him the new record he wanted. If he kept his foot down he would smash his two-day-old mark.

Then, from somewhere forward, a very loud . . . *snap.*

Craig hears it through the cotton in his ears, through his helmet, over the scream of the wind and the roar of the engine. Immediately the racer pulls to the right, veering toward the edge of the course. He turns the yoke to correct but gets nothing. He keeps turning, using all his strength, turning and leaning until *Spirit* finally responds. By then the yoke is upside down, an alarming sight in a system designed to move the front wheel just two degrees in either direction.

He has lost his steering. He still seems to have some tendrils of control, perhaps from Rod Schapel's canard under the nose, but not much. A hundred thoughts surge through his brain as the measured mile marker comes into view: Must have been a suspension bolt . . . Sheered it off . . . Abort or keeping going . . . Don't run over the timing lights . . . Abort or keep going . . .

Keep going. Craig's foot stays down hard on the pedal. The marker whips by.

One . . .

Spirit is heading off course. He turns the yoke again.

Two . . .

Nothing. He's not going to make it. There goes the kilo marker.

Three . . .

He backs off the engine. He has to abort.

Four . . .

The car straightens itself out as if relieved from some kind of torque.

Five . . .

He can still make it. He slams his foot back down.

Six . . .

The exit marker.

He's through. A glance at the airspeed. Five-five-oh. Eyes back on the black line. All right, got to slow down, got to slow down. Hit the engine cutoff. Flame out. Hit the primary chute button. *Bang.*

He hears the chute-release charge fire. He feels a tug. Then nothing.

In the timing trailer the USAC officials are staring down the track through their binoculars, waiting for *Spirit* to roar into view. Norman Breedlove and 300 other observers are out front, doing the same.

"He's on his way," crackles Ted's voice, relaying reports from track observers. "He's standing on it. He's really standing on it now . . . Pick him up, Frank."

There. They can see the rooster trail of salt Craig is throwing up. It's 20 feet high.

"He's really rolling . . . He's into the mile . . . He's really coming along . . . He's really pouring it on . . . He's out of the mile . . . Watch him, Darby."

Then: "Wait a minute, something fell off the back of the car."

It's Craig's chute. The towline, designed to withstand a force of 14 tons, has snapped. The strain of deployment at 550 mph was too much. Another mile marker ahead, Number Four. Craig hears himself say: "Let it slow down, let it slow down." A blur and the marker flashes past. Only three miles left.

He hits the button on the opposite side of the yoke to release the emergency chute. He hears the bang. But this time there is no tug. He hits the button several more times before realizing that the emergency must have ripped away when the primary fired.

Both chutes are gone. All he has left are his brakes. The pedal is there, inches from his foot, but he knows he can't use it, not at nearly 500. The brake pads would burn up.

The two-mile marker streaks past. Two miles left.

You're going too fast. You've got to slow down.

The brakes are his only option. They are all he has left. He places his foot on the pedal and very gingerly starts to press down.

The brake pads turn to ashes. His foot goes right to the floor. And *whoosh*, there goes the one-mile marker. Up ahead are the pits where he started the morning, *Spirit's* tent and trailer, Goodyear and Shell trucks, a scattering of cars, people waiting to greet him as he rolls to a stop. He's coming up and then he's past them, too fast to see the startled looks on their faces.

If he can just get the car to respond, he might be able to do a huge U-turn and head back the other way to burn off his momentum. He turns the yoke again, as hard as he can, throwing his body to one side with the effort. *Spirit* changes course slightly, but not enough to make any difference.

The zero-mile marker and suddenly the black line is gone. He glances down at his speed. Four-hundred-twenty. He has no steering, no chutes, no brakes, in a racer designed to slip through the air with minimal drag—and he's out of course. It's the worst racing situation he has ever faced in his life.

Then he sees the telephone poles straight ahead.

And beyond that, a six-foot embankment.

And beyond that, a lake.

Drowning in the Desert

"**W**ait a minute, something fell off the back of the car."

Sportswriter Hi McDonald heard the words over the radiophone from his position at the south end of the course. He was with Roland Portwood of the Utah Highway Department. Twenty seconds later they could make out a speck of gray shimmering way up the track.

"I see him. Here he comes."

The spray of salt *Spirit of America* was throwing up seemed awfully high. Craig must really be moving. Why wasn't he slowing down? And then, with shocking speed, he was upon them and roaring right past.

"He lost his chute," the radio crackled. "He lost his chute."

And then: "Better roll the ambulance." It was Ted Gillette repeating the message from a down-course observer. His last words before bolting out of the trailer and scrambling into his wagon were, "I'll roll down there . . . Okay, I'll roll." Jim Economides followed him out the door of the Auto Club trailer with his tape recorder and ran to his car.

"Come on, let's go," said Roland, five miles ahead. "Craig's in trouble."

He and Hi jumped into Roland's pickup and went charging off after the runaway racer. Up ahead they could see *Spirit* careening across the ungraded salt, disappearing into the distance.

* * *

Back down the course, the crew members who had worked on *Spirit* were oblivious to what had happened as they followed. Jim Deist and Bob Davids, the chute men, were in Jim's pickup, Craig's old friends Art Russell and Bill Moore hitching a ride in the back. On the way down to meet Craig, Jim and Bob were to pick up the chute compartment lid and the drogue chute that hauled out *Spirit*'s main canopy. You couldn't just leave that stuff laying out on the track.

"All of a sudden," recalls Art Russell, "there on the salt we find the whole chute, and then just a little bit later the second chute, and we said, 'Oh-oh, he's really in trouble.' We heaped it all into the back of the pickup and we're going down the salt flats as fast as we could go, probably 100 mph, and it seemed like we could have gotten out and walked faster. We thought we were never going to get to the end of the course."

The black line was gone. Craig was out of course. He was hurtling along on the rough, shingled salt with little control over his car and no way of stopping. Up ahead loomed a row of telephone poles. If he could just get over a bit he could pass between them. He turned the yoke and leaned hard.

Spirit seemed to respond a little. He made it safely through. But it was just the first row of poles. Beyond lay a second. He was approaching them at an angle now so there was no clearance. If he could just keep turning and get parallel to them . . .

No good. He was going to hit.

Suddenly, everything seemed to slow down. He looked at the roll bar above his head and remembered making the welds. He remembered drilling the holes in the instrument panel and installing the gauges, forming the frame of the canopy, bending the Plexiglas around it. What was he doing here anyway? What was the point? He could be back in the fire hall right now, studying the fireman's manual and drinking coffee, safe on the sofa. What was he *doing* here?

A pole. It was coming right at him. He hunched down into the seat and closed his eyes tight, bracing for what he expected would be a terrific impact and the start of his death roll.

He hardly felt it. A short *whack* and he was past, the left wheel outrigger sheering off the pole like a toothpick. He went tearing on into a sheet of water beyond, several inches that had collected in a depression, sending up huge arcs of spray. Up ahead was an embankment with what looked like a lake beyond it. He would be going right in.

His stomach dropped into his boots. He was flying. The embankment had launched *Spirit* into the air at around 160 mph like the wingless jet that it was. The horizon started to tip onto its side. He was going to land upside down. Then the rear wheel clipped the lip of the dirt and the racer righted itself for its final flight into the water and for a moment everything was quiet. No clanging and banging and rattling. Just the sound of the air whistling past.

The racer hit the lake, throwing Craig hard against his harness. It hit and skipped like a pebble and then plowed in, a wall of water washing over the cockpit. It was sinking nose first.

The canopy. If he went down with it on the water pressure would lock it in place. He fumbled at the latch and undid it and pushed the Plexiglas up and away. Water came pouring into the cockpit. In seconds, it was up to his chest.

The harness. He plunged his hands into the water, found the release and undid it. The straps over his shoulders loosened. He heaved himself up.

He couldn't get out. Something was holding him down. He tried to heave himself up again, and a third time, pushing with his legs, straining with his arms. He couldn't get out. Something was holding him down. The water was up to his neck now. It was touching his chin. Frantically he felt at his harness. It was undone. The water was splashing around his face. What was holding him down?

Figure it out, Craig.

He was teetering on the edge of panic. He was going to drown in this thing.

Figure it out, Craig.

He was going to drown in this thing . . .

Figure it out.

Roland and Hi saw *Spirit* annihilate the pole. A puff and it toppled over. They saw the spray when the racer plowed through the brine-filled depression. Then it hit the embankment and was airborne. Then it was gone.

A freight train was passing on the railway tracks beyond where Craig had disappeared. It gave Roland an even more horrible thought. "Oh Lord," he said, "he's crashed into that train across the highway."

They kept following Craig's wheel marks in the salt crust, the pickup roaring between the telephone poles, heading toward the pond at top speed.

"Hang on. We're going right through."

Roland blasted his truck through the water, sending brine flying and obscuring the view out the windshield until he could switch on the wipers. Ahead, *Spirit*'s tracks led them on toward the embankment. And there at the top, a figure. Roland brought the pickup to a long skidding halt.

"He's okay! He's out of the car!" he yelled into his radio mike before leaping out, Hi right behind him.

It was his oxygen mask that had trapped Craig in his sinking racer. So simple, and yet it had nearly killed him. He realized what it was and unclipped the mask and struggled out of the cockpit just as *Spirit*'s nose went to the bottom, 15 feet down. A dike running along the right edge of the brine lake was not far away, but it was a gasping struggle to reach it, his racing outfit and helmet and boots weighing him down, the surface alive with bubbles and shrouded in steam from the engine. He staggered out of the water and then just stood there, unsteady and

stunned and dripping, oblivious to the yellow truck racing toward him. And then they were there beside him, Roland and Hi, good guys, he knew them both, and his legs just seemed to turn to rubber.

"Hold me," he said weakly. Roland seized him in a bear hug and held him up until his strength returned and with it his senses.

"Look at my racer," Craig said after a moment, gazing in wonder at *Spirit*'s tail, the only thing showing now above the lake's surface. "I almost drowned in that thing . . ."

"Are you okay, Craig?"

"I almost drowned in that thing . . ."

He was coming out of it now, shaking off the shock like the fog from a blow to the head. The strain, the fear, the crescendo of terror, suddenly all of it was draining away, replaced by a flood of relief so overwhelming that it was making him giddy. "I almost *drowned* in that thing," he repeated. And this time it struck him as funny. In fact, *everything* was funny, a sheer pleasure, delightful. Standing there in his wet clothes, the salt stinging his eyes, all bedraggled and cruddy—it felt like just about the greatest thing in the world.

Bill Neely, one of the Goodyear public relations people, roared up in his Mustang and came running over, splashing through the salt slush and mud, his face a sick shade of gray.

"I'm all right, baby!" Craig called out. "What's the speed?"

Bill didn't know. It hadn't been the first thing on his mind. He had come expecting to find Craig dead or gravely injured, not laughing and acting half-drunk. More people arrived until cars lined the embankment, Craig greeting them all with hugs and guffaws and happy chatter until everyone was talking and laughing and having a good time. "Look at my racer," Craig kept saying, as if it were a great joke. "Just look at my car. I almost *drowned* in that thing!"

Here was Jim Economides from the timing shack with his portable recorder. He started taping. He was joined by cinematographer Rexford Metz, who had had his camera set up at the finish to record Craig as he came to a stop. Ted Gillette was stuck a couple hundred yards back, his big red ambulance mired in the salt slush.

"Suppose you'll get a water speed record on that too?" someone
was gleefully saying.

"I think so!" It was Craig, his voice unnaturally high.

"Who do you think you are, Cobb or somebody?"

"What a ride! For my next trick,"—Craig started laughing
again—"I'll set myself afire."

"Holy Jesus . . ."

Traffic was backing up on Highway 40 on the far side of the rail-
way tracks. Passersby could see *Spirit*'s tail sticking out of the water
and were stopping to gawk. Back at the dike more people were arriv-
ing, most from the vicinity of the timing shack up the course.

"Did I break it?" Craig asked. "Did I break the record?"

No one knew. Everyone had bolted to their cars and forgotten all
about the record.

"If Petrali missed the time on that, boy, he's out of business. I'm
not doing it again!"

"See you had to swim there. That was an underwater job."

"That was the last we expected to see of Craig Breedlove."

Here was Stan Goldstein, splashing through the brine and
throwing his arms around Craig, overcome. He had been sure he'd
lost his friend. Jim Deist and Bobby Davids were close behind in the
pickup carrying the lost chutes, Art Russell and Bill Moore leap-
ing out the back. They gathered round Craig, hugging him and each
other and wiping away tears. "I'll tell you one thing," one of them
managed to choke out, "you're spectacular, man."

"If you can't win, at least be spectacular," Craig exulted. "Hey,
what's my time! How fast did I go? How *fast* did I go?"

Someone in the background said, "Nobody heard, Craig."
Someone else arrived and seized Craig and started sobbing.

Here was Nye Frank, eyes wide with amazement.

"Did you see what I did to that telephone pole, Nye? I gritted my
teeth and that pole just sheered off like nothing. You know, *boom*,
and no pole . . ."

"Jeez-us."

"...and I hit the bank and it just went right over the top there. I was flying through there about 30 feet in the air and I thought, 'Now I'm going to drown.'"

Recovering now from the flood of emotion, the latest arrivals joined in the laughter. Craig's brush with death suddenly seemed like a hoot.

"...and I couldn't get my mask off and the water was filling up like that..."

"Holy mackerel."

"Next run, scuba gear."

"...and I thought, 'What a way to go. After all this and now I'm going to drown.'"

"Next run, scuba gear, baby!"

Another car pulled up and an older man hurried forward. He wasn't laughing.

"Craig, here's your dad."

Norman pushed through the crowd and wrapped his arms round his boy. "Oh my God," he kept saying. "Oh my God..."

"I'm okay, Pop," Craig said softly.

"I couldn't afford to lose you," Norman said through his tears.

As the celebration of survival on the dike continued, Craig kept shouting out to arriving vehicles, "Did we break the record? What was the time!" No one knew. He would launch into another giddy account of the crash, then break off as another car pulled up and roar out, "What was the time! I want to find out how fast I went, man!"

Finally, after what seemed an eternity but was closer to 10 minutes, Joe Petrali arrived with his slip of paper. On the return leg Craig had been clocked at nearly 540 mph, making his average for the two runs 526.277. It was now official. He had become the first human to break through 500 mph, besting Art Arfons' mark by more than 90 mph, by far the greatest jump in LSR history. *The*

Guinness Book of Records would later find something else about the run worth noting: the world's longest skid marks, nearly six miles. The record stands to this day.

A few weeks later an official-looking letter arrived at Craig's home at Palos Verdes from the Mountain States Telephone Company in Salt Lake City. It concerned the telephone pole Craig had turned into toothpicks—pole number 4158, to be precise, on the Salt Lake-Wendover toll line. The cost of repairing it was estimated at $200, and Craig was asked to "please furnish us with billing information."

Blowout

A rt Arfons was exhibiting his *Green Monster* in Cleveland when he heard that Craig had broken his record after only a week. Then, two days later, came the news that Craig had pushed the LSR up an additional 58 mph, the biggest jump ever. "He certainly surprised me," Art told Hi McDonald of the *Deseret News* over the phone. "I figured he would just top 500."

Hi asked Art if he had any thoughts about quitting.

"I can't quit. He's given me a tough mark to shoot at. We're going to come out and try, anyway."

What speed are you going to try for?

"I'm not real brave. I'm just going to get my one percent over."

One percent was the minimum increase that was required for a new land speed record. That made Art's target at least 532 mph—a hundred miles an hour faster than he had gone two weeks before.

Those two weeks had been hectic. There was the damage that had to be repaired on the *Monster,* the interviews and press conferences and photo shoots arranged by Firestone and the public appearances he himself had lined up. With so many calls on his time, Art was unable to accompany Ed Snyder and Bud Groff on the long drive back to Utah. They went ahead in the bus and he followed two days later by air, arriving in Wendover late on Sunday evening,

October 25, just a few hours before the start of his course booking. Everything was being rushed.

Art's plan was to get the car ready on Monday morning and take it up over 400 mph by way of a shakedown, then "go for broke," as he put it, on Tuesday. He would be doing so on the new and improved tires that Firestone had promised, good for speeds of up to 550 mph. Art had reassured the Firestone engineers that he wouldn't try to go any faster, but privately he knew he would have to. To get an official two-way average of at least 532 mph would mean pushing into at least the high 500s and possibly to 600 on one of his runs.

Also improved were the braking parachutes the *Monster* would carry. The chutes Doris Tennant had sewn were no longer adequate for the higher speeds at which he was aiming. He had recruited Jim Deist, who had done the chutes for Breedlove's *Spirit*, to make him something stronger. Jim and assistant George Callaway had driven out from the West Coast to personally load and handle the chutes. A third change had to do with the rudder on the back edge of the tail, which Art had initially intended to help with the steering. The first trip to Bonneville had convinced him it wasn't needed, and he now had it fixed in a neutral position. From here on, the *Monster* would be steered solely through the front wheels.

The salt was too rough for running on Monday. Art's first day was given over to preparing the car while Roland Portwood dragged a grader up and down the course, trying to smooth out the ruts left by Craig's *Spirit*. Evening came on and Art headed back into Wendover, not feeling at all settled. He had a cheeseburger with Ed and Bud at the Western Café, then decided to head over to the Stateline Casino in the hope that a little gambling would take his mind off things and tire him out before bed.

As they left the café they passed a scruffy old man with a big dog for a companion. Art had seen him before on the salt flats, hanging around on the edge of the crowd, watching. The old-timer recognized Art and tagged along for some of the walk to the casino.

I seen Cobb set the record back in '47, he was saying. And I seen Breedlove do it with that three-wheel contraption last year. And I seen you do it too.

And you know that fella that got splattered out here a couple years back? I seen that too. Why, my dog here, he helped clean him up.

When Art got up early the next morning, there waiting outside his door was the film crew that had been following him since the flight into Salt Lake City. They were filming a segment on him for an hour-long documentary on daredevils entitled *The Bold Men*. When the young director William Friedkin explained that the actor Van Heflin would be the narrator, the name hadn't rung a bell with Art and he had responded: Who's that?

Art was used to having movie cameras around when he was racing at drag strips and out on the salt flats, but they were usually 8mm jobs, amateurs standing on the sidelines filming home movies. Now things were different. Firestone was making two documentaries about him, and then there was his young fellow Bill Friedkin from a Los Angeles outfit called David Wolper Productions. It made for quite a bit of additional pressure. Friedkin in particular could be pushy. He wanted to get the camera in close, and he would even ask Art to do things—to *act*.

After getting two takes of Art closing his motel room door and walking into the parking lot, Friedkin offered him a ride out to the salt flats in the car he had rented for himself and his crew. Art warily accepted. They made it as far as the turnoff from the highway when he realized his mistake.

Jesus, look at that light, said Bill as they pulled onto the road leading out to the International Course. The sun had just climbed over the distant mountains, bathing the desert in a soft orange glow.

Then: Pull over here. Pull over here.

Oh no, thought Art, for he knew right away what Bill wanted. There, just inside the fence around the building where the highway

department stored its equipment, was the wreckage of the *Infinity* jet car in which Glenn Leasher had been killed. First the old-timer with his dog, and now this.

Hey Bill, Art said, let's not stop now. Let's do it after I finish my runs.

Look at the light, Bill said. Just look at the light. It's perfect. We've got to grab some shots now.

I'd sure as hell feel better if we waited till later.

Come on, Art. When you see light like this, you've got to grab it. Let's go.

And so the crew scrambled out of the car and Art sourly followed. It was bad enough having to drive past the *Infinity* wreckage every time he went out to the salt flats. Now he was going to have to pose with it—and right before his run.

The camera was set up on one side of the fence with the *Infinity* remains filling the lens in the foreground. Okay, Bill coached after sending Art to the far side, walk up to the fence and look at the wreckage. You're anxious, you're thinking about . . . well, you know, you're thinking about your friend and all that. Sort of casually hang onto the fence and be thoughtful.

When the camera was rolling, Art strolled into the viewfinder and draped a hand on the wire and gazed through at *Infinity* and made it look pretty good.

That's beautiful, Art. Now just hang on right there while we come in for a close-up.

The camera was hustled forward and repositioned a foot from Art's face, pointing up through the wire. Let's get that bit of cobweb into the shot, Bill instructed. Hey Art, move a little to your left . . . A bit more . . . There, that's perfect . . . Okay now, we're rolling . . . You're being thoughtful . . . and cut. Beautiful. Now let's get something along the railway tracks. Come on, come on, let's not lose this light. Art, go down there 50 yards or so, and when I give the signal, start on back. Remember, you're in a thoughtful mood, you're walking slowly, you're thinking about, you know, you're thinking about what could happen.

They got the footage Bill wanted before the golden hour faded. Then they continued on to the flats where the *Monster* was waiting, Art feeling like he was now thoroughly jinxed.

There were two other film crews waiting for Art on the course, both making documentaries on his quest for the record. The films would be called *The Long Black Line* and *Challenge*. Both projects were being backed by Firestone, so Art was obliging, even to the extent of allowing them to fiddle with his car. To capture some authentic footage of the on-board view from the *Monster* as it streaked down the salt, a camera was installed in the right-side cockpit, the lens pointing forward out the canopy window. When it was securely in place, a length of wire was attached to the start mechanism and the car's canopy gently eased down on top. When the car took off, a pull on the wire would start the camera rolling.

As was now his usual LSR pattern, Art would make his runs nothing but acceleration and stopping to minimize his exposure to top speed. He had needed a run-up of one and three-quarter miles to set his 434-mph record earlier in October. Today, to get into the 500s, he would use two and a half miles. That, he figured, would give him enough acceleration with the J-79 set at 100 percent power without afterburner. If he entered the mile at close to 500 and exited at close to 600, his average speed would be enough for the record. To guard against Art overshooting the exit as he had previously done when he drove the *Monster* into several inches of water, Bud had painted two giant markers to augment the USAC course signage. The first, green and black checks, was erected at the entrance to the mile alongside Joe Petrali's timer. The second, black and red, was placed at the exit.

Art was distant and quiet prior to climbing into his racer. As he would admit to Harvey Shapiro years later, driving the *Green Monster* "scared the hell out of me." He never revealed even a flicker of nerves to the crew and onlookers. That wasn't his way. It wasn't

hard, though, to imagine what he was feeling, particularly as you watched him suit up for the run. There was his lucky leather jacket, his lucky green shoes, the lucky 1926 silver dollar he carried, minted in the year he was born, the St. Christopher's medal given to him by his father-in-law. It wasn't that he was superstitious, he insisted. It was just that he felt more comfortable having these items along.

Ed, meanwhile, was openly anxious, puffing nervously on a cigarette as he manned the start cart, waiting for the signal from Bud to cut power. Art's close call earlier in the month had shaken him and he now feared something worse. As for Bud, in his familiar white cap, his mustache twirled to waxed points, he seemed to love every minute. As he waited for Art's thumbs-up he braced himself with all the intensity of a Super Bowl lineman. And when it came he sprang forward to uncouple the drive shaft as if he were still in his teens.

The course was rough despite the hours of grading. Art would say it bounced him "up and down like a yo-yo." Then, when he was in the measured mile, he heard a loud roar and felt the car pull to the right. He eased up on the throttle and hit the chute-release button and brought the car to a halt to discover that the right-side canopy was smashed. It was the wire that had been used to start the movie camera inside that had done it. It had left a small gap between the canopy and chassis, enough for the wind to get in and rip the Plexiglas back.

It was a potentially serious setback, but Art and Ed soon figured out a quick fix. They removed the curved metal hood from the top of the start cart and, with some cutting and bending and hammering, fashioned it into a replacement canopy cover. It wasn't pretty, just bare metal, but it would do. By early afternoon they had it bolted and taped in place. Art passed up the lunch of bologna sandwiches laid out on the back of one of the trucks. He didn't feel like eating. Neither did Ed.

Art set out on his second run just after 1 p.m. As he built up speed approaching the mile, he went into afterburner for the very first time. It was unintentional—he had set the throttle for a little more power

than he wanted—and he immediately eased back a little. The one-second burst felt like a kick in the pants. The *Monster* leaped forward and the front end lifted and then slammed back down as the nose wing automatically changed pitch to correct. When he was in the mile Art bore down again on the gas and the same sequence repeated. Then he did it a third time. It really did feel like trying to handle a monster.

The run was clocked at a hair under 516 mph. Although slower than what Art had hoped for, it still put him within striking distance of Craig's record. Jim Deist and George Callaway repacked the chute—it was a tight fit into the bag that called for a mallet and a good deal of whacking—then stowed it in the compartment beside the engine, which had now cooled and ceased smoking; 60 gallons of kerosene were filtered into the fuel tank, enough to run the engine for about one minute; the rear tires were changed after cuts were found in the rubber; the start cart, its top now exposed, was wheeled into position. Just before Art climbed back into the cockpit, Bob Martin of Firestone reminded him not to exceed 550 mph. Art nodded and promptly put the limitation out of his mind. He intended to clinch the record on this very next run and had purposefully left the throttle setting untouched.

The *Monster*'s airspeed indicator was reading 550 mph as Art neared the green and black marker at the start of the mile. The indicator tended to read high; his actual speed was closer to 500. In any event it wasn't high enough to ensure him the record. As the sign flashed by he went into burner, and this time he left it on, six full seconds. The car leaped up and the nose wing brought it back down and the speed climbed toward 600 and Art prayed everything would hold together.

The explosion came just after the *Monster* was clearing the mile. Art knew what it was this time, another tire blowout, the concussion so loud he would liken it to "dropping a grenade right in the cockpit." He had suspected that the torque of the engine had had something to do with the first incident. Now there was no doubt about it. He cut the engine, released the main chute, felt a tug, then

nothing. No brick wall. No harness straps digging into his shoulders so deep they left bruises. The chute's towline must have parted.

At least he still had his car under control. It was running on a bare rim, digging a furrow into the salt at more than 500 mph, but it was staying on course. Art hung on until the drag and friction had slowed him to 400 mph, then hit the backup chute-release button. He felt a much stronger tug this time and the *Monster*'s velocity began to tail off more quickly. When it got down to 200 he tried the brake pedal but got nothing. The brake pressure gauge needle was at zero. Pieces of the exploding tire must have torn through a fluid line and put the Airhearts out of commission. He sat tight and let his momentum gradually expend itself covering what was left of the course.

He was out of the racer and examining the damage when the crew caught up and came tumbling out of their cars. It was the right rear tire all right, blown to smithereens. "I tell you," Art would tell Charlie Mayenschein's son Tom years later, "I had two 12-volt batteries end-to-end, and a chunk of tire about an inch square went endwise through those batteries. It just cleaned everything off that side of the car. You couldn't believe the force involved." Jim Deist's backup chute was also ruined, most of the fabric panels split by the violence of the deployment.

And yet, somehow, there was Art, on his feet and unhurt. Everyone clustered around him, slapping him on the back and grabbing him to reassure themselves that he was okay. Ed once again was particularly upset and couldn't hold back the tears. In the fewer than 10 runs Art had made so far in the *Monster*, there had been one smashed canopy and two tire blowouts. It was nearly enough to turn Ed off racing for good. He and Art draped their arms around each other and Art said, "My foot just got too darned heavy. I figured something would go but I wanted the record."

He got it. Joe's verdict was 559 mph for the return, making Art's two-way average 536.71 mph. George Callaway was so excited when the numbers were read out that he started jumping up and down like a Masai warrior. Bud Groff and Henry Butkiewicz were

hugging and dancing beside him. Ed was just spent. "I'm a nervous wreck," he told Art. "You know when you work with someone as long as I have with you, you're scared to death on these things. I'm still worried."

"Ed," said Art, "no matter how you feel, I can tell you one thing. You don't feel as bad as Craig does right now."

"So congratulations," concluded the editorial in the *Deseret News* on what was the fifth land speed record in less than a month. "And now may we hope that the racing season is over—mercifully before someone is killed?"

Say Art, we still need a little more footage.

It was Bill Friedkin. He wanted some shots of Art in the cockpit. Art donned his gear again and climbed back in his wounded *Monster* and the camera was brought in for a close-up of his gloved hands on the wheel. Now shake it, said Bill, and the cameraman started agitating the camera as the film rolled. Then the camera was positioned between Art's knees and pointed up into his face and there was more shaking.

Don't be grinning like that, Art. Try to look serious.

This is really going to make it look like I'm going fast?

That's all it takes, said Bill. It'll look great.

And it did.

Art was pulling back into his yard at the end of the long drive back to Ohio when Ed leaned forward in the seat beside him and said, "Look at that. See where your brother dumped his dirt?"

Walt had been excavating a basement for his new house and had hauled the dirt to the other side of the road. Art had been paying for dirt to fill a low spot on his own acre, and here Walt had dumped 50 loads of it across the road where it would do him no good. "I would have paid him for that dirt," Art fumed. "I'd have paid for the hauling.

Yet he hates me that much, I guess, that he would take it and haul it to a neighbor and dump it. And I tell you, I got home and, it's just something small, but it's the *principle* of the thing. It just burned me no end."

Art hadn't been home five minutes and the hard feelings toward his brother were already returning. Then, with a phone call from Humpy Wheeler, they got even stronger.

We've got a problem, said Humpy when he rang up the next day.

What's up now, Hump?

It's Walter. Goodyear has just come out saying he's putting rockets on his car, a bunch of JATO bottles. Bobby Tatroe's going to drive the damn thing. They've got the salt booked for next month.

Why, that little . . . He's trying to screw up the ad.

The ad was in fact a media campaign, spreads for magazines, layouts completed, a commercial for TV filmed and cut and narrated. Firestone's publicity department had put it all together in anticipation of Art recapturing the record from Breedlove and holding it for the year, and he had delivered so they were all set. But this announcement about Walt and his rockets had thrown a wrench in the works. Should the ad campaign be postponed until Firestone was sure Walt couldn't snatch back the record for Goodyear? Or should they wait and see what he did?

After a few days of dithering, Firestone decided to bet on Art's 536-mph record and went ahead with its ads. The gamble paid off; the record wouldn't be challenged, at least not that year. It nevertheless left Art harboring yet another grudge against his brother on top of all the other past baggage. That pile of dirt had really bugged him, and that announcement about putting JATOs on *Wingfoot*—well, Art suspected it wasn't a sincere effort, but rather intended to undermine him. The feud was back on.

Walt for his part would insist he didn't know that Art wanted the dirt. As for his plan to use rockets on *Wingfoot*, he really meant it. He outfitted his jet car with three JATO bottles, one on each side and a third behind the cockpit, an additional 3,000 pounds of thrust all together. When he and Tom Green's replacement Bobby Tatroe

showed up with the car at Bonneville on November 8, however, USAC refused to sanction and time the altered racer. The problem was that the tacked-on JATO bottles were not a part of the engine and could not be controlled in any way from the cockpit. They were, in other words, not an integral part of the car, but rather an external source of power and therefore invalid.

Goodyear didn't waste the time it had booked for Walt on the salt flats. With the JATO-boosted *Wingfoot* relegated to the sidelines, the company came up with a plan to back Paula Murphy for the women's land speed record. Paula, a 36-year-old education major turned professional driver, already held a long list of speed marks, including the women's LSR of 161 mph, set in 1963 in a Studebaker Avanti. She readily accepted when Goodyear approached her with the idea of breaking her own record in Walt's *Avenger* jet dragster. Walt would be paid $5,000 for providing the car.

The Bonneville course was sodden from recent rain when Paula showed up on November 12, 1964. Bobby Tatroe, the *Avenger*'s usual driver, took the open-cockpit, tail-finned racer out first to test it. Then Paula, shivering with the cold, took over, sitting on a pillow to give her some height. She had never driven a jet car before and had only three miles of semi-dry track. She nevertheless got the job done in only two passes, ending the first with a swerve that nearly gave Walt another heart seizure. "How'd you like those apples?" she called out brightly when they caught up to her and the car sitting in four inches of water. Her average for the two runs was 226.37 mph, a new women's mark by a very wide margin.

Paula's record wasn't a particularly big number, but it still ruffled feathers at Firestone. The executives hadn't given much thought to the women's land speed record, but now that Goodyear had it, they started wanting it too. It actually made a lot of sense, for didn't women buy tires? Heck, it made perfect sense. It would make a complete marketing package with the ultimate LSR that Art Arfons had already bagged them.

A call was made to Art to see what could be arranged.

Sonic I

Craig spent the day after his crash watching *Spirit of America* being hauled out of the lake and confirming that it could not be repaired. The frame was bent and the engine was ruined and all the instrumentation was shot by the saltwater bath. He would subsequently restore the car for exhibition, but it would never again run. It sits today in the Museum of Science and Industry in Chicago.

The next day he was on his way to New York for the now standard publicity tour kickoff, a press conference, talk shows and an appearance on *To Tell the Truth* as Mystery Guest Number One. Tony Randall, sharp as always, guessed him. Then it was on to the next city.

It was at the Detroit press conference that Craig learned that Art had broken his record. He maintained a good front and responded, "Boy, isn't that something." But the blow was heavy. His 526-mph record, which he had hoped would be too high for Art to touch, had cost him his *Spirit*. Now Art was back on top and Craig was out of competition until he could build a new racer, a huge task that would take at least a year, maybe two.

Craig returned home to Los Angeles after that, the publicity tour a bust, and opportunities started disappearing. The first thing to go was Shell's plan to sell models of *Spirit* as a collector's item through its vast chain of gas stations. The crash had spooked the company

and stirred up doubts about its land speed involvement. Then the feature film about Craig's life was cancelled. Shell no longer wanted to fund production and so the whole thing was shelved. As Craig would discover, there were executives within the company who had opposed sponsoring him in the first place on the grounds that his possible death would be a public relations disaster. These executives had been obliged to eat crow when he broke Cobb's record and had been looking for ways to shoot the project down ever since. The image of *Spirit* nose-down in a lake with a Shell logo on its side was just what they needed.

A part of Craig wasn't sorry to be knocked out of the game. He had been under so much pressure that the crash had been almost a relief because it meant it was over. But of course it wasn't over. Public expectations, his own ambition, the sudden dwindling of opportunities now that he had lost the record—it all combined to drive Craig to decide that he had to build another car and go through it again.

The prospect scared him. It scared him enough that he wasn't sleeping and he eventually went to a psychiatrist for help. "I thought he could give me a mental exercise, some little trick to perform to help me handle my fear," he would tell *Sports Illustrated* in 1970. "Instead, he started explaining what the ego was and told me I was competing with my father and that I had a hostility to women. We went on that way for three visits and this guy was having a field day with me. Finally I said, 'Hey, wonderful, but what about my fear?' He told me my fear was the only thing he found normal about me, and that he wouldn't disturb it." Craig soon gave up on the high-priced sessions and immersed himself in his work.

The first step was coming up with a plan for a new racer, this time one with four wheels that would meet the definition of a "car" in the FIA's newly sanctioned jet-powered class. Craig wasn't sorry to give up on the tricycle design. While the single nose wheel did allow for a small frontal area, it also had the tendency to tram along in any rut it encountered—a potentially fatal tendency at the speed of

sound with which Craig was now expecting to flirt. Eighteen years
had passed since Chuck Yeager became the first human to reach
Mach 1 in 1947. He did so at an altitude of 45,000 feet where it is
well below freezing and thus the boom had come at about 660 mph,
the speed of sound depending mainly on temperature. Down on the
Bonneville Salt Flats, Mach 1 was higher, somewhere in the vicinity
of 720 mph on a mild day.

For expert help in designing the car he would call *Spirit of
America-Sonic I*, Craig turned to Walt Sheehan at Lockheed, the
man who had done the air ducts on the first *Spirit*. Walt knew a great
deal about designing airplanes that would pass through Mach I high
up in the air. For a land vehicle doing so at an altitude of six inches,
he could do little more than make educated guesses. A big ques-
tion concerned the "ground effect," the cushion of air that would
pile up under the car at high speed, making it want to fly. Another
unknown was what would happen when the shock wave generated
by breaking the sound barrier bounced off the ground and back at
the car. A third was what the impact would be when the air pass-
ing over certain parts of the car, the cockpit for example, sped up
to exceed Mach 1 before the car itself, much like water speeds up
to get around obstacles in a fast-moving stream. This "local sonic
flow" could alter the car's center of pressure, making it unstable and
resulting in a crash that would almost certainly be fatal.

What Craig and Walt came up with was a 34-foot-long body
pinched in at the middle like a Coke bottle. The idea behind this
shape was to create two shock-wave centers as the car neared
Mach 1, one up front at the bulge of the cockpit and air duct and
a second at the back where the body bulged again around the rear
wheels. That, they hoped, would stabilize the car by balancing
out sonic-flow regions, lessen the ground effect and dissipate the
impact of shock waves bouncing back off the ground. Other stabi-
lizing features would be a large, swept-back tail fin rising to a height
of 10 feet and small side-mounted canard fins to create downward
pressure to keep the car from flying. The single air duct leading

to the engine was placed above and behind the cockpit to prevent debris from being sucked in. To guard against a repeat of his wild ride the previous October, Craig would use far more durable brakes than he'd had on the original racer and hire Jim Deist to fabricate sturdier chutes.

As for the engine, Craig decided from the start that it had to be a J-79 equipped with afterburner. Combining the same brute power as in Art Arfons' *Green Monster* with more sophisticated aerodynamics would give him a big edge. Acquiring one of these leading-edge jets, he knew, was not going to be easy. He had already put the word out to surplus dealers across the country but had yet to turn up a lead.

By early 1965 Craig had detailed plans for *Sonic I* and a model built by his old friend Art Russell. All he needed now was money for fabrication—and of course an engine. His approach to Shell Oil, his primary sponsor on the first car, was met with an unequivocal rebuff. With the project looking like it might be a nonstarter, he next went to public relations director Bob Lane at Goodyear, the man who had turned the blimp into a company icon. If Craig could keep Goodyear on board, he might be able to use that as leverage to attract backing from another oil giant.

"Look, Bob," he admitted after delivering his pitch, "I'm requesting tire sponsorship for this new car, but I have to tell you that Shell has turned me down. So it's going to take me a while to get another petroleum company sponsor before I can get going with it, so I probably won't make it out to Bonneville this year."

"Well," replied Lane, "what's wrong with Goodyear sponsoring the whole thing?"

Craig eyed him for a moment and then said: "Are you kidding?"

Lane wasn't kidding. Craig left with a $30,000 advance on a $100,000 budget and the go-ahead to line up his own sub-sponsors. He immediately took the news back to Shell and made a deal for fuel and a $35,000 bonus if he broke the record, for the company a no-risk proposition. Similar but smaller deals followed with the

bolt manufacturer Lamson and Sessions and with Champion Spark Plugs.

Craig now had only six months to build the car if he was to make it to Bonneville before bad weather closed out the 1965 season. It was a tall order and Goodyear wasn't sure he could do it. To avoid embarrassment, the salt flats booking that was made for two weeks in October was done secretly through a public relations firm in Seattle, M-Z Promotions. With that deadline looming, Craig quickly pulled together a crew and leased premises to use as a workshop, a warehouse in the predominantly black district of Los Angeles known as Watts.

There would be several familiar faces involved in the project, the guys with the matching Bulova Accutron watches that Shell had presented to the *Spirit* crew after the 1963 record. Nye Frank would again play a leading role, quitting his job as a fireman to sign on full time; master fabricator Quinn Epperley would also be around; Bobby Davids would return to do the fiberglass work, primarily on the air duct and tail fin and canards; Stan Goldstein would manage the project and run the office; Craig's dad Norman Breedlove would help to build the wooden forms that were used to shape the car's aluminum panels. New additions to the team would include Jim Jefferies, Paul Nicolini and Connie Swingle for the frame and welding; Gordon Barber for electrical wiring; George Klass for liaison and logistics; and Don Borth, George Boskoff, Wayne Ewing, Tom Hanna and Bob Sorrell for the labor-intensive task of forming the aluminum body. Finally, there were Stars and Stripes, two stray dogs that came nosing around the warehouse, their butts painted blue courtesy the jokers in the paint shop on the other side of the alley. The team cleaned them up and adopted them as mascots.

During the months that followed, the crew worked seven days a week under tremendous pressure, often continuing on into the night and snatching a few hours of sleep on cots in the back. It led to strain and flaring tempers. "I don't know what it is about fabricators," muses Stan Goldstein. "Most of the guys we had were quite

brilliant in some way, but they were also emotional. We never spent much time trying to analyze it. It was just, 'Do the work. I don't care, just do the work. Oh, your cat died? I'm sorry to hear that. What can I do? Do you want me to send flowers?'" At one point, Bob Sorrell lost it so completely that he kicked in a panel on the side of the car and had to be wrestled to the ground before he could do any more damage. "He just went crazy and we had to let him go," says Stan. "Of all the guys, he was probably the most talented. But he had a nervous breakdown. I had to take him home and put him to bed."

The warehouse wasn't the only place where there was friction. It had also entered into Craig's relationship with Goodyear. When the sponsorship contract finally arrived from Akron for him to sign, he was stunned to read in the last paragraph on the last page: *Upon completion of the vehicle, it shall become the sole and separate property of Goodyear.* He immediately got on the phone to Bob Lane. "You're asking me to build Goodyear a car for free and then drive it for you," he complained. "That's not what sponsorship is." The conversation went back and forth until Lane said: "Why do you want to own it anyway?"

"Because that's how I make money. After I set a record I take the car around the country to auto shows and things like that and I get paid to make appearances. That's to Goodyear's benefit too."

"Well, what if we allow you to keep possession of the car until, say, 24 months after the record, and you can take it around and go to the shows and make your money. Then we'll take it over."

There wasn't much Craig could do with the car already under construction. He accepted. Goodyear would own the car. They would have full control.

In the meantime, *Sonic I* still needed a J-79 engine. The car was being built around a big empty void.

"This is a jet-driven car called the *Green Monster.* It holds the world's land speed record. It was driven on that record-breaking run by one of these three men."

The camera cut from a photo of the car to three silhouettes and Bud Collyer, host of the *To Tell the Truth* game show, asked them: "What is your name, please?"

"My name is Art Arfons."

"My name is Art Arfons."

"My name is Art Arfons."

Panelist Tom Poston got the ball rolling by asking Number One a question about the *Monster*'s horsepower. Peggy Cass next tried a query about tires on Number Three, the dapper young man on the opposite end who looked a bit like Craig Breedlove. Then Kitty Carlisle took over.

"Number Two," she said, "what did you use from a Lincoln Continental?"

"The front end," said the bald fellow in the middle, looking shifty and nervous.

"The front end. And what was the back end, Number One?"

Art, a bemused look on his face, continued gazing silently down at his desk top.

"Number One?"

"Number One . . ." cut in the host, more urgent.

Art looked up, startled. "Oh, pardon me. It was a Dodge truck."

The game show appearance was part of the national tour Firestone had arranged for Art to publicize his record. At first glance he seemed like a publicist's nightmare. He was shy and uncomfortable in the spotlight, and he didn't like promoting himself too much because it felt like bragging. For Firestone, however, none of this was necessarily a drawback.

"We didn't want to change Art," says Humpy Wheeler, "to corporatize him like you would a race driver today, because we recognized that his character was part of what made the story of his battle with Breedlove so fascinating. Breedlove looked like he could have been the leading man in a Hollywood movie and his car was resplendent. Everything about it was high tech and first class. And here Art was, right out of the backyard. He was just the

sort of guy that regular working people could identify with. And they did. The first time we took Art to Indianapolis, more people wanted his autograph than they wanted A. J. Foyt's or Mario Andretti's or Parnelli Jones's. It was like he had become almost a cult figure."

There are a number of episodes that Humpy can remember today of Art's down-to-earth character coming to the surface during the tour. There was, for example, the evening Humpy took Art and June to see a play on Broadway, some big hit that had the critics raving. It put Art right to sleep. During an appearance at the International Auto Show in New York, Art had a long talk with the actor Rex Harrison about Malcolm Campbell and John Cobb and the land speed heroes of his youth. Afterward, he turned to a friend and said, Who was that guy? He sure knew a lot about cars.

"That's the way Dad was with celebrities," says Art's son Tim. "He met a lot of them, and he usually didn't know who they were. He just didn't follow that stuff. He did know Lana Turner, though. When he met her, he got an autographed picture."

Tim recalls Art telling another story about striking up a conversation with a young man in Las Vegas, a gregarious fellow who drove the same sort of bus. It turned out he was a boxer, the heavyweight champion in fact, in town to fight Floyd somebody-or-other. They had a nice chat and as they parted the boxer invited Art to drop by to watch one of his sparring sessions. Sure, said Art, I'd like to see that. Well, nice meeting you, Mr.

Clay. Cassius Clay.

The name didn't ring any bells with Art.

Humpy saw another side of Art during that 1964–65 publicity tour, the tougher, don't-tread-on-me side. "I can remember going into Cobo Hall in Detroit and Art had that old bus that he used for hauling the *Monster* around. While he was getting the car out these teamster guys came over and said, 'You can't do that. We have to do it.' And Art says, 'You're not going to touch this thing.' Well, they proceeded to take matters into their own hands. And hell, Art went

and got a pistol out of the bus and he says, 'Nobody's touching this car.' They got the message real fast."

Art's sister Lou Wolfe would recall a more personal incident after Art returned home. He had just moved his family into a new house on Sherbrook Road a couple miles east of their old place on Killian. He had bought it with his bonus from Firestone for breaking the record. He was making popcorn for the kids over the living room fire and had just succeeded in burning a hole in June's brand-new carpet. You know, he said, I kind of thought when I broke the record I'd feel different. But I don't. I feel just the same.

Back on the West Coast, fires were burning around the warehouse where *Spirit of America-Sonic I* continued to take shape. Two days earlier, on a nearby street, a white police officer had pulled over and arrested an inebriated black driver. The incident sparked protests that escalated into anarchy and looting and arson. It was the Watts Riots of 1965—and Craig Breedlove and his team were caught in the middle.

The National Guard and police had given them two choices: either vacate the premises or stay indoors. With the deadline fast approaching, the crew opted to continue working, posting a guard on the roof armed with a shotgun to make sure no one tried to burn the place out. They kept on that way for a couple days, taking turns on the handful of cots when they got tired and needed some sleep. Then things got critical, for they were running out of supplies. Someone would have to take the truck out through the riots to pick up what they needed, and no one was keen to volunteer.

It was Stan Goldstein who came up with the idea of an impromptu miniature golf game around the cluttered shop floor, with the loser driving the truck. That person turned out to be George Klass. "The pickup was white with an American flag and 'Spirit of America' on the side," says George, "just exactly right for someone to throw a Molotov cocktail at. I got out there and it was scary. There was no

traffic, buildings on both sides of the street were burning, and there were people throwing rocks and bottles. And I had to drive through all these checkpoints, the National Guard and the Army and police lines. I just kept going. I figured they were so busy that I just kept going, just drove through all that stuff and got back with enough supplies to keep us going for the next couple of days."

By the beginning of September, Watts was being cleaned up, *Sonic I* was nearing completion—and Craig still hadn't found an engine. He was seriously worried now that he would end up with a great-looking car that was only a shell. Then he got the break he needed, a lead on a cast-off J-79 being sold by an outfit on the East Coast. He immediately confirmed its existence and wired the money, then excitedly phoned Walt Sheehan with the good news.

"Hey Walt," he said, "I just bought a J-79."

"You're kidding. Where'd you find it?"

"At Charlotte Aircraft in North Carolina. It's on its way. And I got an afterburner too. A place in Tulsa had one."

"Well, which engine did you get?"

Craig checked his scribbled notes. "The guy said it's a YJ-3."

There was a pause on the other end of the line and then Walt said, "Oh shit."

The YJ-3 was an early version of the J-79, a problem-plagued experimental model that Walt remembered from his development work on the F-104. The engine Craig had just bought therefore was going to have bugs. It was also significantly less powerful than later versions, with a maximum thrust of around 15,000 pounds. And as for the afterburner, in all likelihood it wouldn't even fit, for J-79 burners weren't interchangeable between the dozen or more modifications of the engine developed over the years. The purchases had already been made, however, so there was nothing to do but wait and hope for the best.

The engine was delivered to the Watts warehouse in a huge metal can. "It was so big," recalls George Klass, "that they had to get a huge forklift to lift it over the gate. I'd never seen anything that big

in my entire life. I mean, it had to be four feet or more in diameter and was damn close to 20 feet long. It was just frickin' huge. I think when Craig first saw that thing up close he about fainted too."

They got the can open and pulled out the YJ-3 and found it to be in pristine condition, gleaming and dust-free and looking brand-new. When the burner arrived from Oklahoma it also turned out by sheer luck to be for the YJ-3, just what was needed. Walt Sheehan, however, remained skeptical. He stopped by the shop to look things over and asked to see the paperwork included inside the can with the engine. "This engine made the first flight in an F-104," he said, leafing through the pages. "Right here, I signed the log on it to send it back to GE because the seals on the turbine shaft were starting to squeak and seize up. I guess they just shelved it and it's been sitting around in this can all these years." The YJ-3, in other words, wasn't anywhere close to working condition. It wasn't in as bad a shape as the fodded J-79 Art Arfons had fished out of a scrap bin, but it still needed work.

If Sonic I was to make it to Bonneville before the end of the season, Craig had to get his engine working in a big hurry. He phoned the GE jet rebuild facility in Ontario, California and asked if they could help. They turned him down cold. General Electric, he was told, wasn't interested in being involved in land speed or any other kind of racing. Undeterred, Craig got on the phone to Goodyear and was soon talking to the company's new president, Vic Holt. Goodyear, he knew, had a lot of clout with GE on account of the range of GE appliances it carried in its nationwide store chain—clout that he hoped Goodyear might be willing to use on his behalf.

"I explained the problem to Vic Holt," Craig remembers, "and I said, 'Is there any chance that you could exert a little influence with GE to get them to help us get this engine running?' And he said, 'Yeah, I'd be happy to.' So literally 20 minutes after my conversation with Vic, I got a call from the head of the GE engine shop, the same guy who had just told me 'No' an hour and a half before. He said, 'Boy, I don't know who you know, but you sure have some juice.

Gerhard Neumann [the vice president of GE] just called me up and told me that we're to go out there and pick up your engine and get it running.'"

Things at last were coming together. Time, however, was horribly short. The salt flats booking made through M-Z Promotions was now only two weeks away and the planned unveiling of the car even closer. To meet the deadline the *Sonic I* team would have to work nearly around the clock. It meant exhausting schedules for everyone and a lot of pressure on Craig. And then it got worse with a phone call from Goodyear.

Bob Lane wasn't happy with the pictures sent to him of the car's just-finished paint job. The Goodyear name was splashed across the front of *Sonic I* in big letters alongside the cockpit, but it was nowhere on the back. That worried Lane because it meant that the name wouldn't appear in photographs taken from the rear to emphasize the engine's impressive exhaust. To remedy this, he wanted *Sonic I* partially repainted so that "Goodyear" was also prominently featured on the tail, above the American flag.

Craig bridled at the suggestion when it was gently delivered by one of Lane's staffers. Someone higher up in the public relations department tried next, this time clarifying that Lane's suggestion was more in the line of an order. That got Craig's back up even more. Putting the Goodyear name above the Stars and Stripes seemed like bad flag etiquette, he countered. He also had to consider the contracts he had signed with sub-sponsors, each of which spelled out the size of corporate logos in proportion to what Goodyear was getting. If he started making last-minute changes increasing Goodyear's exposure, he would leave himself open to lawsuits.

"I think I was exhausted for one thing," says Craig, "from building that car in six months. And it was in my judgment not a wise thing to do. And I was young and probably a little headstrong. So I refused to put the Goodyear emblem on the tail like Bob wanted."

Craig's intransigence made Bob Lane so angry that in a fit of pique he said the *Sonic I* program was cancelled. For the next two

days, as Craig sat bewildered in his Watts workshop and Lane fumed in his office in Akron, Goodyear's public relations staff worked to find a compromise and pull the situation out of the fire. Lane eventually admitted that it didn't really matter if Goodyear went on the tail with the flag. He just wanted it somewhere on the back. After a little cajoling, Craig agreed. The name would be placed at the end of the big white strip that ran the length of the car, alongside the logos of the project's sub-sponsors.

The repainting was completed on the eve of the unveiling, just in time for new photos to be taken for the press kits. As far as Craig was concerned, the storm had passed. But it hadn't. He had crossed Bob Lane. There would be payback.

"All-Out, Blood-Stinkin' War"

A s usual when he was on assignment, Jack Olsen, a senior editor with *Sports Illustrated*, arrived in Akron with a tape recorder slung over his shoulder. The recorder didn't need a hand-held microphone and so was great for unobtrusively recording conversations. It picked up relaxed, unscripted comments that were much better material for his articles than formal interviews and scribbled-down notes.

"You got that thing going?" Walt Arfons would ask him during one of their chats.

"Yeah," said Jack, "but it's just my notebook, Walter. Honest to God, nobody has ever heard a word that's been on that tape except me. That's how I take notes. The next time I interview somebody, I'll use the same tape and erase everything you said. Don't give that a thought."

Jack was working on a two-part feature called "Enemies in Speedland." It would explore the bad blood between Art and Walt Arfons and the rivalry between their respective sponsors, Firestone and Goodyear. His first stop was Goodyear headquarters for a meeting with company president Vic Holt. He wasn't expecting to get much in 10 minutes and so was pleasantly surprised by Holt's laid-back, punchy comments.

"They're as tough as a boot," Holt said of top competitor Firestone, otherwise known in Goodyear circles as Flintstone Tire

and Rubber. "Of course, they've been in racing longer than we have. That's their one big thing. When we got into it five or six years ago, hell, that was an insult. It was like them coming out with blimps. But we've actually whipped them real good in everything in racing, really from a standing start a few years back. We've got a record on stock cars that's tops. Sports cars. Drag racing. The land speed record. The only place we haven't whipped them is at Indianapolis, and we're still working on that."

"About the land speed record," Jack gently prodded, "it seems there's a slight negative risk involved for a company like yours."

"You mean if you kill somebody?"

"Yeah."

"We've thought of that a hundred times, Jack. It *is* a risk. Of course, to achieve things you have to take risks. Now, the amazing thing to me is, we take a risk because we're involved in the product, but the poor guys that are doing it . . . Did you ever see the movie about Breedlove's crash? We got a print right here, *The Wildest Ride*. I'm telling you, it'll turn your blood cold, because this was filmed. He's so lucky to be alive it's funny."

Afterward, Jack drove across town to Firestone headquarters to get the other side of the story from Humpy Wheeler, sales manager of the racing division. Humpy went over a bit of the history, explaining how all the other American tire companies had dropped out of the racing game back in the 1920s, leaving Firestone in sole possession of the field until Goodyear's return in 1958. "Brand X" had started out modestly with stock cars, then had gotten into land speed and was now threatening at Indy and Firestone didn't like it one bit.

"You really bang heads with Goodyear, don't you?" said Jack.

"Oh Jack, I'm serious, this is all-out, blood-stinkin' war. There's no question about it. This is as rough a competition as anybody in the automobile business gets into . . . Here's an interesting thing, Jack. Firestone and Goodyear are both here in Akron, and all the executives go to the Portage Country Club and play golf together,

and this racing thing is like a football game between them. I mean, when one side wins a race, they rub it in, 'We whipped you' and that stuff . . . I wouldn't want to be quoted on this, but Firestone and Goodyear are spending more money on racing than any other company, I would imagine even more than Ford Motors. I mean, think about this: every race that's run in the United States, and there might be 3,000 of them in one weekend on local tracks, we've got tires there and Goodyear's got tires there."

"So this total racing tire thing is a losing proposition?"

"Oh yes," said Humpy emphatically. "Oh yes. For both companies."

"Are there any figures about how much each company is spending?"

"You'd never get that, Jack. I couldn't even tell you myself."

The conversation then turned to Art and Walt and the rift between them. Jack knew them both now to be extremely kind men, generous almost to a fault. So why couldn't they get along? "The reason is because of a basic personality difference," Humpy suggested. "Art is not interested in promotion or anything like that. He's interested in things mechanical and getting the job done with as little fanfare as possible. Now, Walt is different. He's an extremely ingenious person, but he's also a promoter. So it's the basic difference between the promoter and the artist. When Walt and Art were together, it was a good combination, and they made a lot of money together. But it just came down to they couldn't get along."

"I wonder if they had one big blowout."

"As far as I know, Jack, it's just been a combination of a lot of little things."

"What's the other guy like, Snyder?"

"Ed? Well, he looks like Art Carney and acts like Ed Norton. He's a good mechanic. He worries all the time, though, constantly worries about what's going to happen. Then there's Bud Groff, totally the opposite. It doesn't bother him a bit. When they're out at

Bonneville, Bud makes daily runs down to Wells. Wells is a . . . Oh, you'll hear a lot about Wells."

"Is that where they have the whorehouse?"

"Yeah," replied Humpy, and they both started to laugh.

Later that afternoon Humpy drove Jack out to Pickle Road in his big black Lincoln. They strolled around the neighboring Arfons properties before heading in to see Art, Jack making oral notes and whistling the Dave Clark Five hit "Catch Me If You Can" that was on the radio so much. Walt's house and shop were on one side, the twin buildings comprising Art's shop on the other, the Ace Boiler and Welding Company between like a buffer on land that Walt rented out.

"Walt's house looks kind of ramshackle. White house. Two stories. Wow, it looks like a disaster area. Is that his garage too? Unprepossessing-looking places, all right."

He and Humpy headed around behind the old mill to where Art test-fired his J-79. The two oak trees to which he and Ed had initially chained the jet were now gone, replaced by an aircraft engine buried deep underground, restraining cables emerging up from the soil. "He's got a 60-foot swath cut through there," Jack recorded. "Old tree stumps. Junk. Let's face it, junk is what he's got the most of. Old tires lying around. Oil cans. Everything's charred."

"That's his homemade tractor," said Humpy as the tour continued. "There's a Buick or Oldsmobile engine in it, a V-8."

"He doesn't buy anything, does he?"

They headed into the first of Art's two workshops. "He's got about $35 tied up in that," Humpy observed proudly as they stopped to look at the homemade metal-forming machine. "Thirty dollars," he continued, motioning toward the *Green Monster*'s start cart.

A magazine photographer was working with Art and Betty Skelton in the windowless building next door, taking shots of them posing with the *Monster* and *Cyclops*. Art was going to take both

cars out to Bonneville this season, *Cyclops* for Betty to drive for the women's land speed record, the *Green Monster* for himself.

Art was uncomfortable about Betty driving *Cyclops*. It wasn't that she didn't have the experience to do it. Betty was a stunt pilot going back to the 1940s and had set all kinds of speed records. What bothered Art was the thought of her—of anyone—getting hurt in one of his cars. It was a key reason why he didn't employ drivers and run multiple dragsters on the meet circuit, but would only do the driving himself. Firestone, however, wanted to take the women's record away from Paula Murphy and Goodyear, set in Walt's *Avenger* the previous year, and they were offering Art good money to make it happen. It would be a nice addition to Art's ultimate 536-mph record that Firestone already held, something for the executives to rub in at the country club when they ran into their counterparts from Brand X.

There was the *Monster*, its fresh green-and-red paint job gleaming under professional lighting. The photographer was working with Betty, petite and vivacious in a Firestone outfit, posing her draped on the car while Art waited his turn. Humpy made the introductions, then they started marveling at the yard-long sonic probe that Art had added to the front of the car to improve its aerodynamics, something he had copied from a B-58 bomber. It was the most noticeable alteration to the *Monster* since the previous year, projecting out of the J-79's air intake like a giant needle.

"Holy cow, that thing is really sharp," said Jack. "You could put an olive on there."

"It's a conversation piece, all right," said Humpy. "Imagine if that hit you at 600 miles an hour."

"It'd sting, boy."

"Tilt your head this way, Betty," said the photographer in the background.

"Look grim and tense, Betty," chimed in Humpy, starting into some wisecracks that soon had Art laughing. "Get tensed up, Betty. Think about driving down there at 300 miles an hour, with all that salt coming up at you."

"She had a really cute smile before this guy started," the photographer groused.

"You know," observed Jack, standing beside Art and surveying the *Monster*, "this car isn't bad-looking. Our story last year said it was the ugliest thing on four wheels."

"Oh, that burned me no end, when I read that," said Art.

"It's perfect. I mean, it's exactly what it needs to be."

You could tell from Art's voice that the good-natured knocks against his car in some magazine write-ups had hurt him. "Some other article called it a garbage truck," he said. "They see that blunt front and they don't realize that every bit of that air is going through there. It's a streamlined car. Man, the work that went into that body, we think it's beautiful. It's the prettiest, most streamlined car ever run."

There was no sign of activity next door at Walt's shop. Walt was already out on the salt flats for another crack at the record. He hadn't been fooling the year before with his talk about rockets. When the USAC refused to sanction his *Wingfoot* jet car after he had added three JATO bottles, he had gone into his workshop and built an entirely new racer, this one powered solely by the compact rockets, 15 all together. As Walt saw it, rockets were the future of land speed racing, the best way to punch through Mach 1. He also just wanted to be the first to try it, to be a pioneer of the rocket car, just as he had been with the jet dragster.

For help designing the car, particularly the crucial front end, Walt turned to renowned automotive designer Alex Tremulis. The configuration they came up with resembled a dart, a large back end to accommodate the 15 JATO bottles narrowing to a needle nose in the front, overall length 28 feet. It would have four wheels to qualify as a car, but they would be arranged in a tricycle pattern, the front wheels only inches apart, the ones in the rear splayed out 13 feet. The back-swept fairings over these rear wheels combined with the prominent tail fin would function like the feathers on an arrow and

keep the car going in a straight line. The cockpit would be situated out beyond the front wheels near the dart's tip, a vertical canard just in front to assist with the steering. Above the front wheels on either side would be little wings to prevent the car from flying. Like the big wing on Art's *Green Monster*, they would automatically pitch downward if the *Wingfoot*'s nose lifted up.

As for USAC's reservations about the rockets, Walt had that covered. The organization's first reason for refusing to sanction his jet car with JATO assistance had been that the rockets were an external source of power and not an integral part of the engine. That would not be an issue with Walt's new racer because rockets would be its only sources of power: they would *be* its engine. The Auto Club's second concern—that the JATO bottles couldn't be controlled from the cockpit—posed a bigger challenge. The bottles, normally used to give aircraft extra takeoff power on short runways, were not designed to be throttled up and down or turned off. When lit, they simply blasted out a thousand pounds of thrust for about 15 seconds, until all of the solid fuel was burned up. To make a cluster of them a valid "engine," Walt therefore had to figure out a way to at least shut them down in mid-blast. What he came up with was a dynamite charge affixed to the front of each bottle that could be set off by throwing a switch in the cockpit. When activated, the charge would blow the top off the bottle, releasing a blast of forward-directed thrust that would neutralize the thrust coming out the back. A thick steel plate between the bottles and cockpit would keep the driver from being roasted alive in the resulting inferno.

Bobby Tatroe would be that driver. The 28-year-old Michigan native, married with five children, had worked as a trucker, welder and uranium miner before being hired by Walt in 1963. Within a year he had become Walt's number-one driver, reliable and safety-conscious with an attractive veneer of bravado and cool. He was Walt's first and only choice for piloting the rocket car, arguably the scariest creation ever built for the salt flats. The prospect didn't faze Bobby, but it did everyone else.

"How would you like to sit in front of those lit rockets?" marvels George Klass, who got a good look at the car on the salt flats. "Because that's where Bobby was. Poor bastard. I tell you what, I didn't even want to get close to that thing."

It took Walt and his small team six months to build the racer. In a hat tip to Goodyear, Walt's continuing chief sponsor, he named it *Wingfoot Express* like his previous jet car and painted it the company's color, light blue. The Goodyear name would also be prominently featured on the front in nice big letters and at the back—on the tail. ("I knew immediately where the idea had come from," said Craig Breedlove.) The car had its first public showing at the Akron airport in early September 1965, a 1913 dime set in the steering yoke for good luck.

Art drove out that day to see it. Walt's son Terry saw him there, looking on from the edge of the crowd, and urged his dad to invite him over. "I can see it good enough from here," was Art's cold response to his brother's invitation. It was the first exchange between them in nearly a year.

"He had his arms folded like this," Walt confided to Jack Olsen at Wendover a few weeks later. "I held my hand out there for almost half a minute before he took it. But he had to take it, because there were other people around. And then I invited him over to see the car. And he said, 'I can see it good enough from here.' I tried to attract a conversation, but I couldn't. So I'm kind of afraid to go over and talk to him now, seeing as he give me that cold shoulder. I don't want to be turned down. Hell, if I'm turned down, it'd make me feel really shitty. In front of people, you know. So I don't know what to do. What should I do?"

"Here's one thing about my brother," Art responded when Jack asked him for his side of the story. "He is sharper than anyone gives him credit for. And he knows how to make an ass out of me eight ways from Sunday."

"Well, that didn't make an ass out of you," said Jack.

"Yes it did. It made me look like I'm carrying the grudge. When

there's no one around he can pass me and never see me, never speak, never acknowledge I'm his brother. But if there's someone around where he can make an impression, he'll come over and pump my hand and say, 'Well hi, Arthur,' just like we're long-lost brothers and he hasn't seen me for years. I think if you're mad at somebody and you're not going to speak to him, then why be two-faced about it. So he just wanted to make an ass out of me out there at the airport, and he succeeded in front of a lot of people, making it look like I'm carrying the grudge. Last year I tried to solve it, because we're both getting older, and why carry a fight like this to the grave if it don't mean shit? And he just turned right around and did me some real dirty tricks and I thought, 'Well, I've made up with you the last time.'"

"What do you suppose it is that makes you and Walt like this?"

"I don't know what he's mad about."

"See, Walt says the same thing."

Jack would ask Walt's wife Gertrude and his son Terry about it too. Neither could explain exactly what had started the rift, but both agreed that gossip helped keep it open. Art would say something cutting about Walt, something he didn't really mean, but it would get back to Walt and perhaps be exaggerated in the retelling, and Walt would say something in turn, and it would go back and forth and keep both of them fuming.

"Do you think it's going to take a tragedy to bring the brothers together?" Jack asked.

"No, I think it's too far gone," said Gertrude.

Terry didn't agree. "I think a tragedy *would* bring them together," he said. "And if there's going be one, it's going to be Arthur. I think he's playing with his life too much with this thing."

The Bonneville Salt Flats were just beginning to dry up after a very wet summer when Walt towed his rocket-powered *Wingfoot Express* out to go after Art's record. Bobby Tatroe had test-driven the car only one time back in Akron, taking it to 120 mph at the airport

with two JATO bottles. Each of these bottles carried a price tag of $486.50 after a very deep discount; the stop-fire igniters to blow the tops off went for $175. To make just two passes on the salt employing all 15 rockets therefore was going to cost a bundle, roughly the equivalent of an average house price in 1965.

The *Wingfoot* in motion proved very impressive. "I'd never seen anything like it in my life," remembers Terry Arfons, working at the time for Goodyear's racing division. "There was a big green puff, because those things were solid fuel-assist bottles. And then all of a sudden there was a hole in this green stuff. We couldn't hear anything for a moment because we were pretty far away. There was just a hole in this green stuff, which was the car accelerating and blowing it away, the exhaust coming out at something like five times the speed of sound. And then when it quit the wind wrapped around the big back end of the car and you could hear it, *whooo*, you could hear it slowing down."

The car's actual speed, however, proved disappointing. In his first run on the salt, Bobby hit an airspeed of 290 mph with seven JATO bottles, slower than expected, and averaged an unimpressive 168 mph through the clocks because he had to start so close to the mile. "Something's wrong," Walt commented when he heard the numbers. With all 15 rockets, Bobby managed a more impressive unofficial terminal speed of around 500 mph, but once again the average through the mile was very disappointing, just 247 mph.

One of the things holding the car back was its weight. "I built it too heavy," Walt admitted. "I built it safe. Every time I was putting in a brace or running a streamer through the body, I thought, 'Well, Mach 1, what's that going to do to this car? Everyone tells me it's going to tear the car up, and I've got a man sitting up there depending on me.' So I'd put another little brace in there, another little gusset, a little stronger here and there, and that's where I got my weight." What made this such a big issue was the brief duration of the JATO bottles, the mere 15 seconds it took to consume all the fuel. Walt had lengthened this burn time by having Bobby set off

the rockets in two stages, eight at the start and the remaining seven when he really got rolling. Even then, however, it was necessary to start a run very close to the clocks so that the rockets wouldn't die when Bobby was still in the mile. Given the car's weight of 8,200 pounds, that just wasn't enough of a run-up to get to record-breaking speed.

In every other way the *Wingfoot* met or exceeded expectations. It handled well and stayed on the ground, it didn't veer off to the side from uneven thrust as some had predicted, and its acceleration was tremendous. For the LSR flying mile, however, the short-duration rockets just weren't doing the trick. There was only one way forward: add more JATO bottles to extend the burn time. Walt figured another 10 would do it, five angling out from each side. "We'll break the sound barrier yet," he vowed as the car was towed off the flats.

The work would be done in a hangar at the Wendover Air Base. When it was finished Bobby would be hunkering down in front of 25 flaming rockets. "This, we hope, should do what we want," he would write home to his family the following week. "We got them all mounted today [October 1] and just have to cut out the body panel and do finish work. We should be ready to run next week . . . Walt and I saved the first two rockets we fired. I'm going to bring mine home when I get a chance. I'm going to put it on the mantel. Even if I have to build a fireplace. Ha. Ha."

Art and his crew and Betty Skelton arrived in Wendover when Walt and Bobby were still running the *Wingfoot*. This time the *Green Monster* traveled in style, in a new trailer Firestone had pressed upon Art, roomy enough to accommodate the car with the nose wing and tail fin attached. *Cyclops* made the trip in the old bus that Art had managed to keep on the road despite the odometer having long since turned over. The small party checked into the Wend-Over Motel. Art would occupy Room 153. Walt was three doors down the hall in Room 159. They didn't speak. Later that evening Jack

Olsen accompanied the crew to the Stateline Casino for dinner and ran into some of Walt's people. When something came on TV about Art, one of them turned contemptuously away and said to Jack: "Look at all those crazy people watching that idiot on television."

On Sunday, September 26, Art took over the salt. The first order of business was to get Betty set up to run for the women's land speed record, an experience that nearly gave Art a heart seizure. The day started with him teaching her how to drive *Cyclops*. Betty, an accomplished jet pilot, needed to hear the instructions only once before she was ready. At scarcely 100 pounds and a bit over 5 feet, she was too small for the cockpit; like Paula Murphy the year before, she had to sit on a cushion. Now hold off on the chutes, Art coached her, hovering nervously over the cockpit in the final moments before the engine was started. Let the car come down a ways out of the mile before you let the chutes go.

Okay, okay, said Betty. Now let's fire this thing up.

She shot down the course and through the mile with complete assurance and then promptly released the chutes despite Art's warning to wait. "It picked the car right up," Art would recall. "That car must have been 10 feet high hanging on to the chute . . . She scared the hell out of me."

It didn't seem to bother Betty at all. "Let me have more throttle," she said at the turnaround, disappointed with her speed. When Art expressed reservations about opening the J-47 up any further, Betty got insistent, saying she wasn't interested in making the return trip if he didn't give her enough power to get past 300 mph. Art backed down and did some work around the tail pipe, then hitched a ride in a small plane to follow Betty back down the course. At least she wouldn't be able to go into afterburner. Art hadn't allowed the tanks to be filled.

Betty hit 315 mph on the return trip, close to Art's own top speed in the open-cockpit dragster. *Cyclops* lifted up again as soon as she exited the mile, and this time it was accompanied by a big cloud of dust. Art, watching in horror from 200 feet up, was sure that she had crashed, that he had killed her. It shook him so badly that he

later said he tried to open his passenger-side door and get out of the plane before the pilot brought him back to his senses. By the time they landed, Art realized that the car hadn't crashed after all and that Betty was fine—that she was in fact having a great time. "Man, when that thing whoas, it really whoas," she said of the abrupt parachute stop. She was eager to go faster if Art would just give her more throttle, but that was it for him. He couldn't take any more of the strain. "Betty's a real sweetheart," he said. "But she probably made me age 10 years that day."

Betty's two-way average of 277.52 mph was a new women's record. Firestone had what it wanted and Art earned a nice paycheck. Betty herself, however, privately wasn't that happy. "I felt the record could have been and should have been a great deal higher," she said years later, "but I knew Art wouldn't want to go through it again . . . He only fixed the car where it could go so fast. I would start off and full throttle it and that was it. You can only go so fast."

The next day Art took out the *Green Monster*. His plan was to use his remaining time on the salt to run the quarter mile, the distance where he'd made his name on the drag strips and continued to earn much of his living. The quarter-mile record currently stood at 210 mph. Art figured that with his *Monster* he could easily break it.

Just before the start, Walt Arfons pulled up and parked. "Twenty feet away sits Walter," said Jack Olsen into his tape recorder. "He's watching quietly, nervously puffing on a cigarette. They don't even indicate that the other's alive." Jack walked over to be closer to Art.

"There's that lucky jacket," someone was saying. Art had lent it to Betty for her runs and had just gotten it back.

"Yeah," he replied. "Betty said she was hot in her jacket and had to put this one on."

"Betty's jacket's hot?"

"I think it's Betty that makes that jacket hot," muttered one of the crew. Then: "Oh-oh. Hello, Betty. I thought you'd left."

Art blew the quarter-mile record away. Using the full power of the engine for the very first time, he covered the distance from a

standing start in 6.9 seconds, passing through the clocks in the final 132 feet at 258.62 mph. It was an impressive thing to witness, flames roaring out the tail pipe as the *Monster* leaped forward. "More hair-raising than his land speed record runs last year because of the great acceleration," said one of the Firestone engineers.

"Well, I'm not worried now," Art said after, pleased with the record and with the way the car had performed. "I just never knew how the engine would react when the full juice was on. It ran as smooth as silk." With that out of the way, he took Ed Snyder, Bud Groff and Charlie Mayenschein each for a short ride in the second cockpit.

As for his land speed record of 536 mph, it was Art's intention to sit on it until someone broke it. He didn't think his brother Walt could do it, so that left only Craig Breedlove. Art had run into Craig earlier that year at a car show in Indianapolis and Craig had told him about the new *Spirit* racer he was building for a renewed record assault in 1966. Art had no doubt that the car would pose a serious challenge. Since it wouldn't be ready this season, however, he was all set to hold onto his speed crown for another whole year.

The same day that Art set his quarter-mile record, Wednesday, September 29, *Spirit of America-Sonic I* was unveiled at a press conference at the Ambassador Hotel in Los Angeles. It had taken Craig and his team a final burst of almost around-the-clock work to get the car ready and they were close to exhaustion. Craig nevertheless managed to make a good impression at the unveiling—like "someone who could shade for Robert Goulet," wrote *Deseret News* sports editor Hack Miller, "but as friendly as old Rover."

The red, white and blue car was hailed by all as impressive: "The sophisticate of LSR vehicles," according to *Hot Rod* magazine, "carefully designed, construction which beams of flawless attention to detail, and incorporating features essential in a car intended to approach the speed of sound on land." Its final cost was estimated

at $200,000, not including the new tires that Goodyear had developed and tested to 850 mph. The most noticeable speed-of-sound feature, apart from the needle nose, was the Coke-bottle waist. Would it work? No one knew. Well, what would happen when the car hit Mach 1 and the shock waves bounced back off the ground just six inches away? Again, no one knew. The plan, Craig explained, was to try for 600 mph and then see what Art did. Even that would take them out into the unknown, where strange things were said to happen as one got close to Mach 1.

"I've seen 'em all," concluded Hack Miller, "from Ab Jenkin's Mormon Meteor, through the Campbell cars, the Eystons and Cobbs, the Arfons brothers. This car wins the beauty contest— with exception, maybe, of a close race with that little bug John Cobb brought over."

The news that *Sonic I* was finished and Bonneville bound that very weekend came as a shock to Art as he prepared to vacate the salt flats. He hadn't thought Craig would have his car ready that year. "I feel Breedlove is actually a good friend of mine," he told Jack Olsen as Jack's tape recorder kept rolling. "I know him pretty well. But the little shit lied to me. M-Z Promotions. Ha! He told me he wasn't going to have a car this year and was sort of going to take it easy for a year or two, and here he had this damn thing happening."

"Yeah," said Olsen, "but isn't that part of the game?"

"Yeah, you got to admit that, Art," chipped in Humpy Wheeler. "You'd probably have done the same thing."

It still seemed sneaky to Art. After loading up the *Monster*, he hauled it to Las Vegas for storage. He wanted to keep it close by.

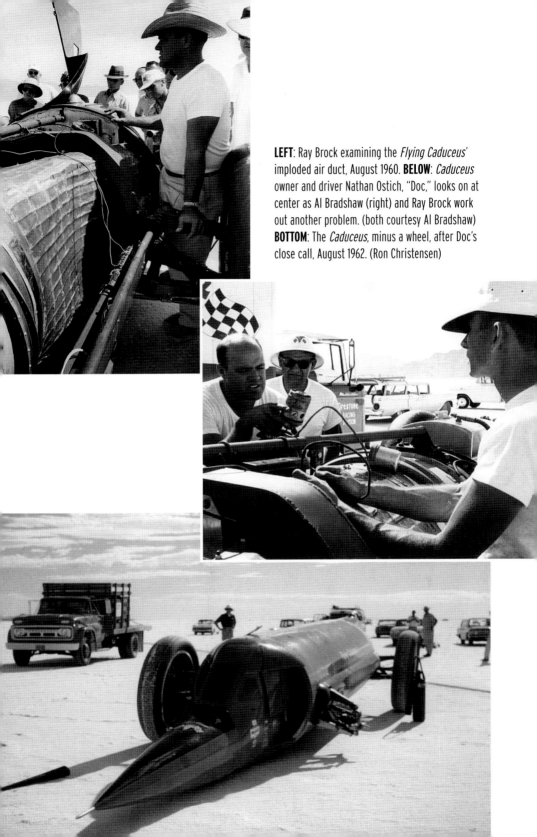

LEFT: Ray Brock examining the *Flying Caduceus'* imploded air duct, August 1960. **BELOW**: *Caduceus* owner and driver Nathan Ostich, "Doc," looks on at center as Al Bradshaw (right) and Ray Brock work out another problem. (both courtesy Al Bradshaw) **BOTTOM**: The *Caduceus*, minus a wheel, after Doc's close call, August 1962. (Ron Christensen)

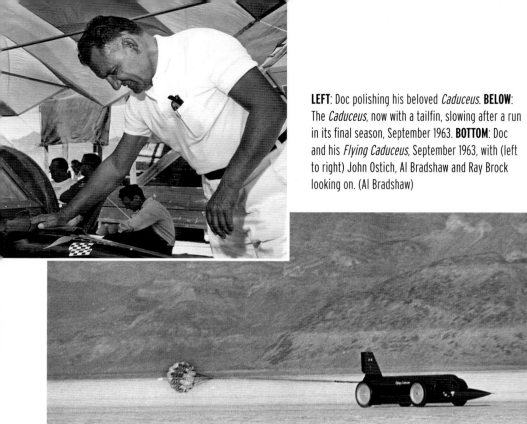

LEFT: Doc polishing his beloved *Caduceus*. **BELOW**: The *Caduceus*, now with a tailfin, slowing after a run in its final season, September 1963. **BOTTOM**: Doc and his *Flying Caduceus*, September 1963, with (left to right) John Ostich, Al Bradshaw and Ray Brock looking on. (Al Bradshaw)

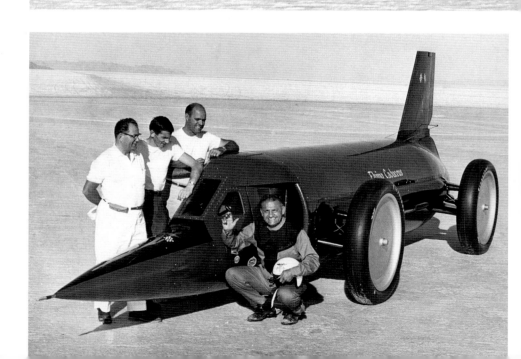

ABOVE: Craig Breedlove, Norman Breedlove and Bill Moore with *Spirit of America*, August 1963. (William A. Moore) **LEFT**: Craig walking the black line. (Goodyear Tire and Rubber) **BELOW**: Getting *Spirit* ready for its run at John Cobb's 16-year-old record. (William A. Moore)

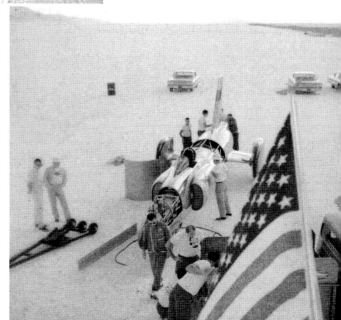

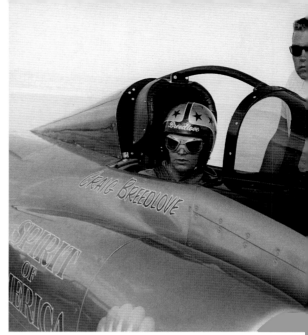

ABOVE: Craig Breedlove in the cockpit, Nye Frank beside him (Bob Davids), and the view from the cockpit. **BELOW**: Craig with *Spirit* after setting a new land speed record of 407 mph, August 5, 1963. (both Goodyear Tire and Rubber)

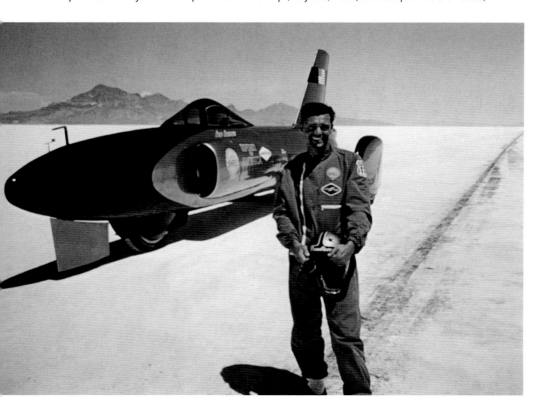

LEFT: Art Arfons with Charlie Mayenschein's model of the *Green Monster* jet car. **BELOW**: Art, back to camera, testing his J-79 jet engine behind his workshop. **BOTTOM**: Ed Snyder (in welder's mask) and Charlie Mayenschein (left) helping Art build the *Green Monster*, early 1964. (all Tom Mayenschein)

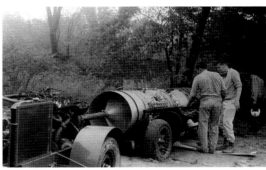

ABOVE: Walt Arfons and his *Wingfoot Express* jet car. (Tom Joswick) RIGHT: *Wingfoot* driver Tom Green, center, and Walt, left, celebrating their 413-mph record, October 2, 1964. (Tom Mayenschein) BELOW: Art Arfons and his *Green Monster*, October 1964. (Tom Mayenschein)

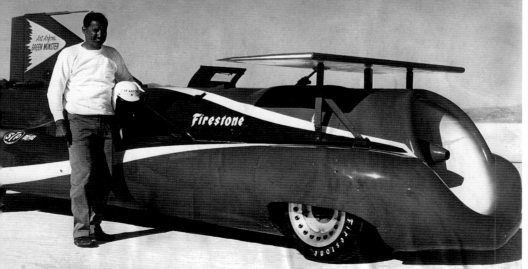

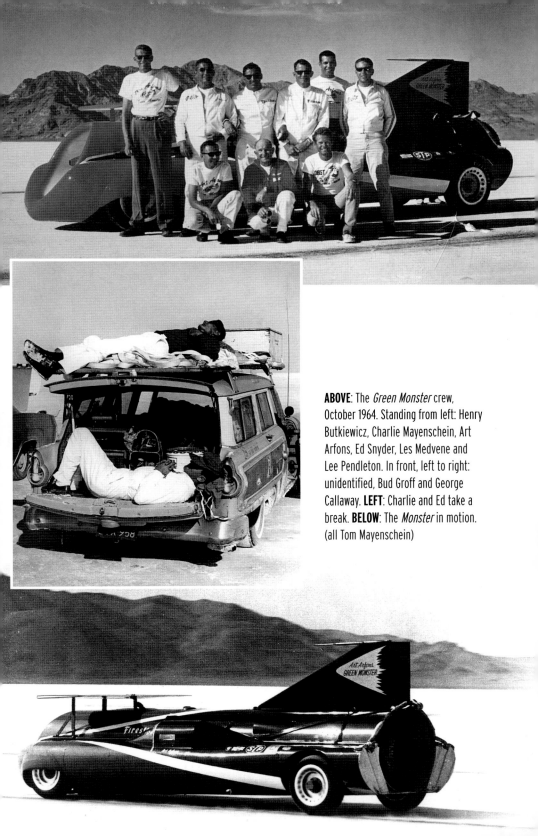

ABOVE: The *Green Monster* crew, October 1964. Standing from left: Henry Butkiewicz, Charlie Mayenschein, Art Arfons, Ed Snyder, Les Medvene and Lee Pendleton. In front, left to right: unidentified, Bud Groff and George Callaway. **LEFT**: Charlie and Ed take a break. **BELOW**: The *Monster* in motion. (all Tom Mayenschein)

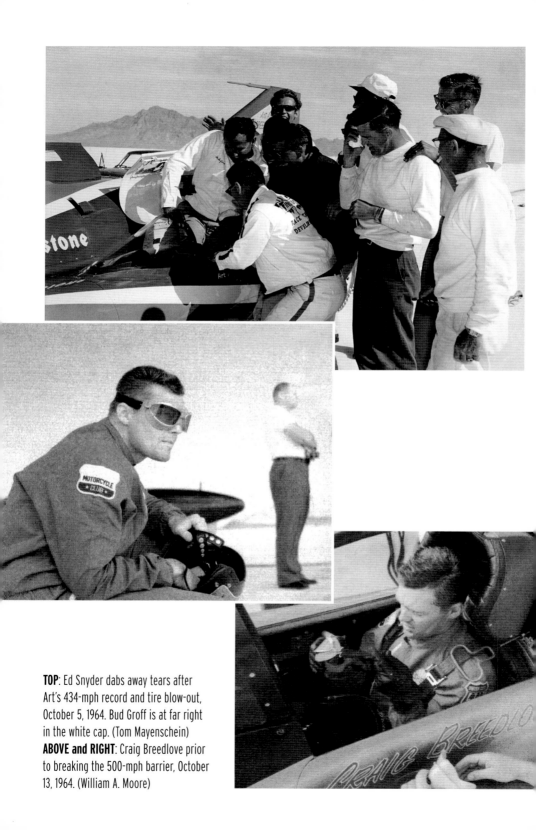

TOP: Ed Snyder dabs away tears after Art's 434-mph record and tire blow-out, October 5, 1964. Bud Groff is at far right in the white cap. (Tom Mayenschein)
ABOVE and RIGHT: Craig Breedlove prior to breaking the 500-mph barrier, October 13, 1964. (William A. Moore)

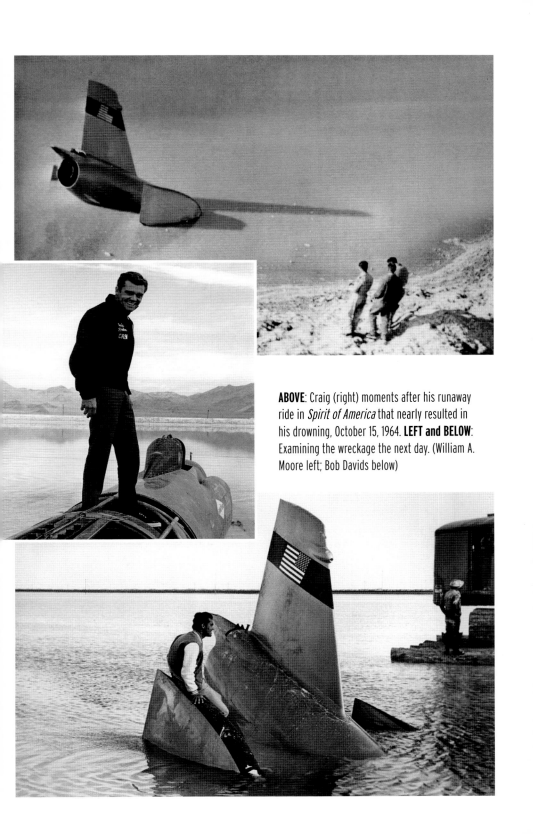

ABOVE: Craig (right) moments after his runaway ride in *Spirit of America* that nearly resulted in his drowning, October 15, 1964. **LEFT and BELOW**: Examining the wreckage the next day. (William A. Moore left; Bob Davids below)

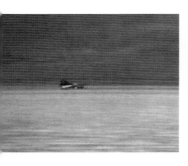
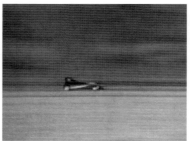
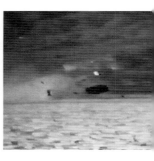

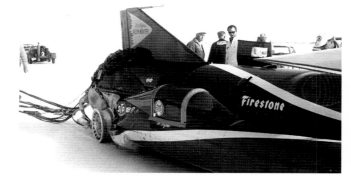

ABOVE and RIGHT: Art Arfons blows another tire while reclaiming the record, October 27, 1964. (Tom Mayenschein) **BELOW**: Walt Arfons (right) and Bobby Tatroe building the *Wingfoot Express* rocket car, early 1965. (Goodyear Tire and Rubber)

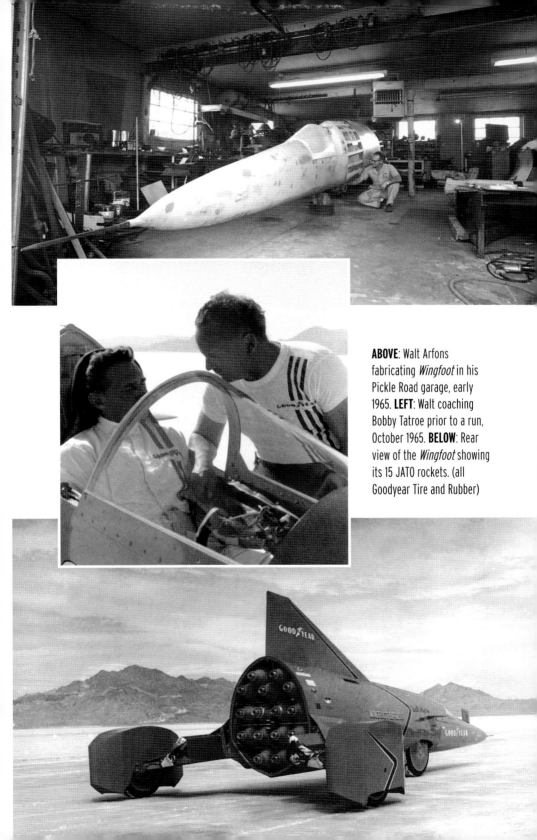

ABOVE: Walt Arfons fabricating *Wingfoot* in his Pickle Road garage, early 1965. **LEFT**: Walt coaching Bobby Tatroe prior to a run, October 1965. **BELOW**: Rear view of the *Wingfoot* showing its 15 JATO rockets. (all Goodyear Tire and Rubber)

ABOVE: Art Arfons clowning with the *Green Monster*'s needle-sharp sonic probe, new for 1965. **RIGHT**: Art, sitting in the car's tail pipe, with Betty Skelton. (both Tom Mayenschein) **BELOW**: Art on the salt to reclaim the record from Breedlove, November 7, 1965. (Nick Gray)

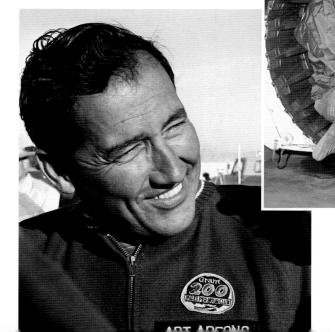

ABOVE: Joe Petrali, center, giving Art the good news: a new record of 576 mph. **BELOW**: Art surveying the damage done by his third tire blow-out. (both Nick Gray)

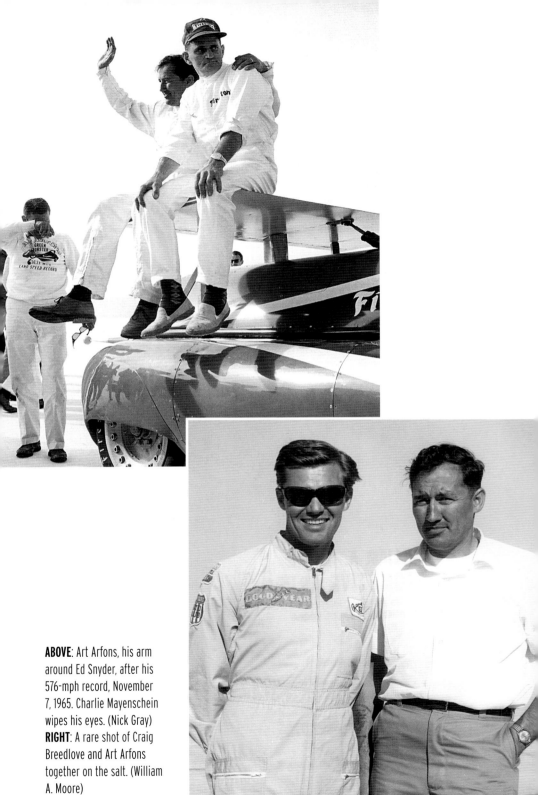

ABOVE: Art Arfons, his arm around Ed Snyder, after his 576-mph record, November 7, 1965. Charlie Mayenschein wipes his eyes. (Nick Gray)
RIGHT: A rare shot of Craig Breedlove and Art Arfons together on the salt. (William A. Moore)

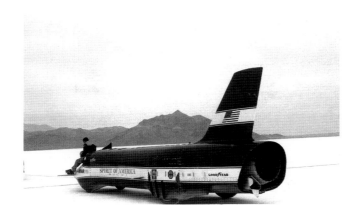

ABOVE: Craig Breedlove sitting on the nose of *Sonic I* as it is towed onto the salt, November 1965. Louvers and protruding flanges have been added to keep the car from flying. (Tom Mayenschein) **LEFT**: Craig with Stan Goldstein (sunglasses) and his dad Norman. (Stan Goldstein) **BELOW**: *Sonic I* on its record-setting run, November 15, 1965, as seen from a chase car. (Tom Mayenschein)

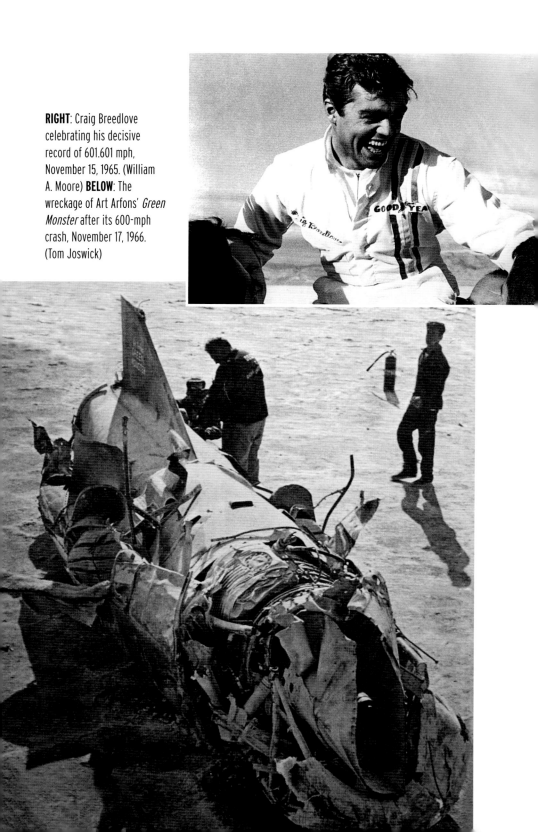

RIGHT: Craig Breedlove celebrating his decisive record of 601.601 mph, November 15, 1965. (William A. Moore) **BELOW**: The wreckage of Art Arfons' *Green Monster* after its 600-mph crash, November 17, 1966. (Tom Joswick)

"Like a Game of Russian Roulette"

There was only so much kerosene you could pump into a J-79. At 100 percent throttle, full military power, it was burning all the fuel it could handle. Any more and the heat generated inside the engine would rise to the point where it would start melting. That's where the afterburner came in. It was essentially a collar that fit over the tail pipe with nozzles inside to spray additional fuel into the white-hot exhaust. On the J-79 these nozzles were arranged in four stages, each stage adding more fuel with the advance of the throttle. All together they increased the engine's power by about 50 percent.

Craig Breedlove had equipped *Sonic I* with such an afterburner, but he was hoping he wouldn't have to use it. According to his calculations, full military power alone would be enough to get him past Art's 536 mph. After that he would push on to 600 mph and wait there for Art to respond. He hoped he could accomplish that too without burner. Sitting in front of a J-79 at full power was as much as he wanted to think about just now.

The awesome thrust of the engine in fact scared him a little. He had seen Art make a run in the *Monster* the year before but it had been from a distance, too far away to get any sense of the thing. The first time he witnessed one in operation up close was when the technicians at GE had test-fired his own refurbished J-79 in September 1965. The screaming power of it, double that of the J-47

in his three-wheeled *Spirit,* had blown him away. When the throttle was advanced to afterburner—something his first car hadn't been equipped with—the engine howled and there were shock waves. A reddish blue flame shot out the tail pipe and the test cell walls shook like the place would collapse. After that, Craig thought he would just as soon not use the burner at all.

It was coming up to one year from his crash and near drowning when he arrived on the salt flats with his new racer. Preliminary tests revealed that the car handled well, much better than the first *Spirit* with its single nose wheel that had taken such concentration to steer. The problems when they came—and they always did—centered around the braking chutes provided by Goodyear's aerospace division, similar to the recovery system the company had built for NASA's Gemini spacecraft. The canopy would pop out of its compartment on cue, but then would only flutter like a streamer and not properly open. The cause was determined to be that the chutes were designed for deployment at 600 mph, not at the lower test speeds that *Sonic I* was still going. They were flown back to Akron for quick modifications.

After they were rushed back, Craig geared up for an attempt at the record. In his first run on Tuesday, October 12 he entered the mile at 580 mph according to his air speed indicator and exited at 590, a huge new record. Joe Petrali's timing equipment told a different story: 518 mph. Craig, disappointed, suggested that there was something wrong with Joe's clocks. Joe was adamant there wasn't. It was soon discovered that Joe was right: the placement of *Sonic I*'s air speed indicator had given false readings. Craig's next run was timed at an equally disappointing 514 mph. Walt Sheehan advanced the throttle from 95 to nearly 100 percent and Craig tried a third run and did no better. And this time toward the end of the mile the car was rocked by a tremendous explosion and twenty-foot flames shooting forward out of the air duct. The blast had been so powerful that Craig was surprised upon scrambling out of the cockpit that his vehicle was still in one piece. It had been the mother of all deceleration stalls, a blast of compressed, fuel-laden air forward

out the air duct when the jet was abruptly throttled back from full power. "Decel stalls" were alarmingly, particularly a big one like this, but the J-79 was built to take them. *Sonic I*'s body was not. The fiberglass air duct had been expanded by the force of the blast and was now cracked all around. The cockpit canopy was also split and the nose was damaged. And in the meantime, what was going on with the speed? According to Walt Sheehan's calculations, Craig should have averaged 540 mph at his throttle setting. Where had those twenty-odd miles per hour gone? Something evidently was not right with the engine.

General Electric fortunately had sent out one of its J-79 specialists, Bob Koken, an amateur hot-rodder, to help. The company didn't want to be seen as involved with a land speed project—Bob had orders to keep a low profile and stay out of photos—but at the same time they didn't want Craig mishandling a GE product and killing himself. While the air duct was replaced and the other damage was being fixed at Wendover Air Base, Bob removed the fuel control from the engine and reprogrammed it to fix the decel-stall problem. With regard to the car's inexplicable shortfall on speed, he advised Craig to start using the burner.

Craig was back on the salt early in the morning on October 14. This time, still running without burner, he was clocked on his first run at 534 mph. "And the clocks were all right, weren't they?" Joe Petrali chided him after. Craig was close now, just two miles shy of Art's mark. But there would be no return trip. The aluminum paneling all along the top of the car had crinkled in the force of the wind blast. If Craig were to attempt a second run, the panels might be ripped off completely and with them the rest of the car's body. It was back to the hangar at the air base, this time to replace the damaged panels with additional stiffeners underneath to prevent further crinkling. Craig's initial booking of the salt had ended by the time the work was finished. Goodyear, however, had the salt booked for the following week, so getting back on the International Course would not be a problem.

But then it was. Goodyear informed Craig that the time it had booked would go to the other car it was sponsoring, the *Wingfoot Express*. *Sonic I* would just have to wait.

To Craig, the decision felt like payback from Bob Lane. He had crossed Lane in that business about the Goodyear name on *Sonic I*'s tail. Now Lane was retaliating by pushing Walt Arfons' rocket car forward to take the land speed record and potentially set it up beyond reach. "We found ourselves in competition with Goodyear," says Craig, "with them trying to knock us out because I didn't immediately fold under Bob. We were not allowed on the salt flats. We were told that it was Goodyear's time and that they wanted to see how well the rocket car did, and that if it did what they thought it would we would not be allowed to run. According to the contract Goodyear owned the car, so I was screwed."

Walt Arfons and Bobby Tatroe had been patiently waiting all week for a chance to test their modified *Wingfoot Express*. They had completed the work with phenomenal efficiency and speed. In little more than seven days the car's entire back end had been rebuilt to accommodate an additional 10 JATO bottles, five angling out from each side. The complex battery of switches in the cockpit had been moved to give Bobby better control. He no longer had to reach forward to the instrument panel to activate the rockets. The switches were now on the steering yoke, close to his thumbs.

The *Wingfoot* took over the salt flats on October 17, as Craig stewed in Wendover. For its first run Bobby fired only the 10 newly installed rockets angling out from the sides. Cost: About seven grand. That was it for testing. The car continued to handle well, but once again the speed was disappointing. The full compliment of 25 rockets would get the job done.

The next day was spent making preparations for an all-out assault on the record. As the course was being graded, Walt worked out the best rocket-firing sequence and put the *Wingfoot* crew through

rocket changeover drills. The best time they could manage was 40 minutes to remove 25 used JATO bottles and install 25 new ones, each weighing 144 pounds. Getting the car ready for a return trip in the hour allowed would be a close call.

As cool as Bobby usually was, even he had a hard time being nonchalant about driving a car powered by 25 rockets. On the afternoon of October 19, he was nervous. Walt, however, was in worse shape. He hovered over Bobby in the cockpit like a worried mother, going through all the procedures again that Bobby by this point probably knew better than he did. Bobby listened carefully, nodding his head.

The car was positioned nine-tenths of a mile from Joe's first clock. The run was to consist of Bobby firing the 10 side-mounted JATOs plus four in the back, waiting six seconds, then firing the remaining 11 JATOs. This, Walt estimated, would put his speed at around 400 mph at the start of the mile and possibly as high as 800 by the finish, giving the *Wingfoot* a record-breaking average and at the same time making it the first car to pass through Mach 1.

"Now remember to watch for the signal!" Walt said just before the canopy was closed, shouting so Bobby could hear through his helmet.

"Do I have to go then? Or can I go when I'm ready?"

"Well, take two minutes after we give the signal."

When the canopy was down and latched, Walt joined his son Terry in the Mustang that served as the chase car. A minute or so passed and Bobby was shooting past them like a Roman candle. Then things started to go wrong. One of the JATO bottles was already missing. It had fallen off the back of the car right at the start, scattering observers. Now another broke free, the force of its thrust arcing it wildly into the air. Then the entire car was lost in a huge cloud of fiery exhaust and smoke and salt dust. It looked like an explosion—and the end of Bobby Tatroe.

Walt was frantic as he and Terry raced down the course toward the rising billows of black. It was a repeat of the nightmare three years before with Chuck Hatcher in the runaway jet car, with the

addition of great gouts of flame. Thankfully, the fireball that was the *Wingfoot* continued on straight and level as the JATOs burned themselves out and the forward-directed thrust set off by the stop-fires slowed it. When Walt arrived on the scene Bobby had already scrambled out of the cockpit, shaken and confused but unhurt. The emotional embrace that followed left them both "crying like babies," remembered Alex Tremulis, the car's co-designer, who pulled up a few moments later. "Their beautiful car was a charred mess. I took one look and started crying too."

Some of the stop-fires on the JATOs had inadvertently gone off, they discovered, blowing the ends off the bottles and sending a neutralizing thrust out the front. That was what had created the fireball: rocket thrust blasting out the back of the JATOs combined with thrust blasting out the front and scorching the car. Newspaper accounts would blame a short-circuit somewhere in the wiring. Walt and Terry Arfons both assert today that Bobby hit the wrong switch on the panel repositioned to the steering yoke close to his thumbs. Instead of setting off the next phase of rockets, he had activated the stop-fires. Whatever the cause of the mishap, it left the *Wingfoot*'s rear end blackened and all its wiring burned out. "There'll be no return ride," said one of the dejected Goodyear people. "The car is destroyed."

In fact it wasn't destroyed. The scorching was largely superficial and Walt had a replacement wire harness on hand. In an amazing comeback the *Wingfoot* was repaired and repainted and back on the course in three days. And this time it performed as ordered, all but one of its 25 rockets firing properly and on cue. When Walt caught up after the first run, Bobby was ecstatic. "Five-eighty!" he called out as Walt ran over from the Mustang. "My airspeed was five-eighty. Change the rockets! Let's go!" The crew started racing to get the spent JATOs pulled out of their slots and fresh ones put in, confident that they were on the verge of claiming the record. Then Joe Petrali arrived from the USAC trailer with his results. After a brief consultation that set his shoulders sagging, Walt walked over to the crew muscling the rockets around and said, "Leave it go."

"What do you mean, 'Leave it go'?" said Bobby.

"We were clocked at 476 through the mile. Leave it go. It's no use."

It was the same old problem. *Wingfoot* had accelerated brilliantly and handled superbly, but it couldn't maintain a record-breaking speed through the mile. If only terminal velocity counted; if Joe's clocks were close together at the end of the mile like on a drag strip, they would have had it. But that wasn't how the game was played.

Walt remained upbeat as the team packed up and vacated the course. "You can be sure we'll be back," he told reporters. "Don't count us out." But it was the end of his LSR quest. He wouldn't build another car and return to the salt flats—and a part of him may not have been sorry. "I want to break the record," he had told Jack Olsen before the trip out to Utah. "This is my life; this is what I chose; it's the only thing I know. But if I don't make the record, down deep I'm glad because I didn't have to push Arthur. I'm afraid for him. He'd throw all precautions to the wind. I wouldn't want nothing to happen to him."

"Walter doesn't give a shit about whether Arthur lives or dies," replied Ed Snyder when Jack asked him about it. "But if Walter sets the record, Arthur will come out here and break it or bring his car home in little pieces. He'd do that with Breedlove too. But it's worse with Walter."

Craig returned to the salt on Wednesday, October 20, the day after the *Wingfoot* was scorched. He had watched the rocket car fail and felt bad for Walt and Bobby. If there was any satisfaction in it, it was when Bob Lane phoned from Akron and started stammering. Goodyear needed him now.

He had made a decision while he had been waiting. He would take Bob Koken's advice and use the afterburner on his next run. He had been hoping to get the job done without it, the thought of Art's two tire blowouts while in burner uncomfortable in the back of his

mind. Would something like that happen when he lit up his own car? He was about to find out.

Sonic I was positioned five miles from the measured mile when Craig climbed into the cockpit at 9:30 that morning. He was apprehensive. He knew that the Arfons brothers were both firm believers in burner, but he had never used it before and it unnerved him. The engine was fired up and he started rolling and then he went straight into first-stage afterburner and took off. "And, man," he would write in *Spirit of America*, "I was gone. I was up to 400 by mile one . . . I could see why Walt and Art had used the burner all along. The burner gets you to the moment of truth in a hurry."

As he entered the measured mile Craig was at that moment of truth, the airspeed indicator reading 600 mph. Then the horizon began to drop out of sight. At first he thought it was some sort of crazy optical illusion due to the speed. But then it hit him: his front wheels were up off the ground. He was starting to fly.

The car started to veer off the course to the right. He turned the steering yoke to correct, but with the front wheels not touching the salt it made no difference. He instantly hit the kill switch for the engine and released the chute to stabilize the car. It tore away. Craig was suddenly reliving the nightmare of the previous year, the runaway ride in the three-wheeler that had nearly killed him. And sure enough, when he hit the button releasing the backup chute, nothing happened. He knew what came next: The brakes would melt. The pedal would go right to the floor and he'd have no way of stopping. He was even traveling in the same direction, down toward the brine pond at the south end of the course. Perfect.

The disc brakes in *Sonic I*, however, were vastly more powerful than in the first *Spirit*. When Craig touched the pedal ever so lightly, once, twice, they didn't melt. Instead the car's nose came down and he again had steering. When the airspeed indicator was at 475 mph he tried again, another light touch on the pedal and then off, wait for the brake pads to cool, then another light touch, then another. By the time he reached the ungraded salt at the end of the course

he had the car down to 200 mph and was able to apply the brakes harder. Two more jolting miles and *Sonic I* came to a halt, smoking and steaming in several inches of brine. The brakes had saved him, but it had been a close thing. An examination would reveal that they had almost completely melted and were fused to the wheels.

Craig kept his cool as he got out of the car and as his relieved crew and his wife and father hurried up to greet him and the newsmen started barking their questions. Walt Arfons showed up too. He had hung around for an extra day to watch Craig's run. "Gee whiz," he observed after giving Craig a bear hug, "you should have let up on the burner after the first couple of miles and then hit it again." Craig smiled and cracked jokes and seemed pretty nonchalant about the whole thing. Inside, however, the experience of almost flying left him shaken. If he didn't fix the car and get back in soon, he might not get back in at all.

"Craig had lots of concerns about dying in that car," recalls George Klass. "It was one of those deals where there was no way you could build a car safe enough for the driver to survive a crash at 600. There was this doctor who came by the shop to look at the car when it was being constructed. We were showing him where the roll bars were, the cage around the cockpit, all the safety features, and he said, 'It doesn't matter. You turn this thing over and roll it around a few times at the speed you guys are shooting for and all your internal organs will come loose inside your body. Too many Gs.' I know that upset Craig. I know that he had concerns about his life. And I also wondered whether he had gotten himself into this whole deal where, because of the sponsorship and the money and the press coverage and all that, if maybe it got to where there was no way he could back out. It's not something you ever ask a guy, but it's something I always wondered, if the whole thing got to the point where you couldn't pull back."

After his near crash, Craig took *Sonic I* to Hill Air Force Base in Salt Lake City for repairs and modifications. The Air National Guard there had the equipment he needed and had volunteered

to help. Over the next week the ruined brakes and heat-damaged wheels were replaced, additional weight was added to the car's nose, and the foot-long wings on the sides of the fuselage up front, designed to create negative lift, were replaced with new ones more than double in size. Dozens of louvers were also punched in the aluminum body beneath the cockpit, along the top and on either side at the back. Their purpose was to relieve the imbalance in pressure that acted upon the car at high speed, which was now believed to have caused the crinkling and contributed to the tendency toward lift. When *Sonic I* really got going, an envelope of negative pressure built up around the outside of the car that combined with the positive pressure inside the body to suck up the panels. The wheel wells had to be similarly vented with louvers to release the vacuum generated by the rapidly spinning tires.

"The wheel wells were so tight around the wheels," says Stan Goldstein, "that at the speed they were turning, it was like an air pump and created this vacuum that sucked the aluminum into the tires. It was like pulling a cheese grater in on top of the tires." This cheese grater effect had very nearly shredded one of Craig's tires, yet another problem that was largely kept out of the newspapers.

Not much was happening back out on the salt flats. Firestone had booked the last week of October for Art Arfons, but with his record still unbroken, Art didn't use it. The week ran out and then the *Sonic I* team was back. Craig made three runs on November 1 to test the car's newly vented body. Minor wind damage was sustained to the panel over one of the rear wheels. In yet another hasty fix, small metal flanges were attached to the panel fore and aft of the wheel to deflect the airflow. That, coupled with the louvers, the enlarged canard wings, the stiffening brackets under the body panels and the vented wheel wells and everything else, they hoped, would hold *Sonic I* together and on the ground long enough for a record attempt the next day.

That evening, while he was taking a turn through Wendover, Craig ran into Art, in town from Las Vegas where he was exhibiting

the *Monster*. He had driven up to take a look at *Sonic I*. They met in front of the Stateline Casino, under the gaze of Wendover Will, the 90-foot cowboy. Will was in need of a coat of paint. His red shirt and blue jeans were fading. The two men stood there together for a while, talking shop, hands in pockets. It was getting close to winter now and the desert evenings were cold.

Art seemed to have something on his mind. Eventually he got to the point. "Now that you've got your car straightened out," he said, "I guess you'll break the record again."

"That's right, Art. I'm going to try for it tomorrow."

"So what's going to happen here? If you break my record, am I going to come back and then you come back and we just keep going back and forth until one of us gets killed?"

The bluntness of it caught Craig off guard. "Well, I really hadn't looked at it that way, but I guess that's a possibility."

"So it'll be like a game of Russian roulette."

"Yeah, I guess so."

Art nodded thoughtfully, gazing down at the dirt. "Well, okay," he said after a while. "I just wanted to know."

Craig made his first run at 8:45 the next morning, November 2. He used a three-and-a-half mile run-up, going into afterburner right from the start. He was getting more used to the additional thrust. From his position in the cockpit the 544-mph pass seemed to go smoothly. If he could just repeat it, he would knock off Art's 536 and set a new record. "That was a great run," he said at the far end, climbing out of the racer with a big smile. Crew chief Nye Frank didn't look so jubilant. He said, "Take a look at your car." A glance back at *Sonic I* and Craig's heart sank. Four feet of body paneling behind the air duct had been squashed down by the wind blast. It looked like he was finished for the day.

Walt Sheehan wasn't so sure. After a quick examination of the damage, he concluded that the car could endure a return trip. For

this time, the paneling hadn't been sucked up by the negative pressure. The louvers had successfully alleviated that problem. This time the damage had been caused by downward compression, a flattening effect that hopefully brought the top surface of the racer into equilibrium with the aerodynamic forces acting upon it.

The edges of the damaged panel were taped down and Craig was on his way again inside the hour. He blazed through Joe's clocks without incident and throttled back the engine and hit the chute release. Nothing. He hit the button a second time. Nothing. The primary chute system, the NASA spacecraft setup, was again letting him down. He waited for a moment, possibilities surging through his mind, finger poised over the second button to release the backup fabricated by drag-chute expert Jack Carter. Craig had brought Jack on board as insurance after the double-chute failure in October that had nearly led to disaster. Jack didn't look very sophisticated working on an old sewing machine in the back of his station wagon, his big belly straining at his shirt buttons, but he knew how to make reliable chutes. Craig trusted his work.

Craig hit the button. Ten full Gs. It slammed him forward in his seat with such force that his goggles were yanked off his face. When he got stopped he found the Goodyear Aerospace chute still in its bag in the compartment beside the J-79's tail pipe. It had been packed in so tightly that it took a Jeep to haul it out by brute force.

Craig was clocked at 566 mph through the mile on his second pass, making his two-way average 555.127 mph. He was the king again. He had knocked Art off his throne. Congratulations and celebrations followed, a delighted kiss from his wife and a hug from his dad. Norman had arrived just in time from Hollywood, where he was now working on the TV sitcom *My Mother, the Car*, maintaining the antique auto that was co-star of the show. "I was sure Craig had the record today," he exulted. "I'm wearing my lucky shirt, the one I wore when he set his last record."

That evening in Walt Sheehan's motel room, however, the mood was subdued. Walt had just finished developing the tapes from the

car's on-board recorders in the bathtub. The results for the wheel loadings were troubling. According to the marks on the photographic paper, there had been barely 200 pounds of downward pressure on the front wheels when Craig hit his top speed—200 pounds in a car weighing four tons.

After all the repairs, after all the modifications, *Sonic I* was still just a hair's breadth from flying.

Boom

This was how things worked on the salt flats: If you had time booked, you had to use it. If you didn't, if you just sat around, killing time and hogging the course, the Speedway Association would kick you off and your time would go to whoever was next.

For Craig, the next in line after he set his 555-mph record was Art Arfons. He was therefore anxious to stick around and use up the four days left in his booking. That would keep Art waiting until his own course reservation began on Sunday, November 7, pushing him even further into the fall storm season, which was already long overdue. It was part of the hardball version of the LSR game; the strategizing to protect a record so that it would last a whole year. "That's the reason we had Craig's wife, Lee Breedlove, break the women's speed record," recalls George Klass, "so we could actually hold the salt. We didn't give a shit about that. And the same with that deal with the Shelby Cobra, running it in a circle for 12 hours or whatever the hell we did. Strictly a con to hold on to the salt."

The idea for the first stall had been around for some time. Lee had wanted to drive Craig's three-wheeled jet car even before it was finished and Craig had sounded out Shell about it after breaking Cobb's record. The company didn't like the suggestion. The possibility of a woman getting hurt or killed driving a car bearing the Shell logo scared them. Goodyear in November 1965 didn't have

such qualms. Paying Walt Arfons to let Paula Murphy drive his car for the women's record the year before had been a marketing coup aimed at the untapped market of women car owners. Why not do it again with Lee? In Craig and Lee Breedlove, Goodyear would have the world's fastest husband and wife. And there would be the added sweetness of taking the women's record back from Firestone, set just a little over five weeks before by Betty Skelton in Art Arfons' *Cyclops*.

Craig spent the day after setting his record teaching Lee how to handle *Sonic I*. The next day she went out on her own, apparently unfazed despite never having driven competitively before. "You have to realize that Lee was no prissy lady," explains Stan Goldstein. "She was no Susie Cream Cheese. She was a tough chick—a very attractive one—but nevertheless a tough chick. She didn't walk around in crinoline dresses, I'll tell you that."

Watching helplessly from the sidelines, Craig was almost wild with worry as Lee built up her speed in a series of passes. She ended the day with a two-way average of 308.56 mph, a women's record that still stands for a vehicle with four wheels. It was a piece of cake. The next day Craig started preparing for a 12-hour endurance run, trading off with Bobby Tatroe to drive a Cobra Daytona on a circular track overlapping the International Course to set a total of 23 records. That took them to Saturday and the end of Goodyear's booked week. As Craig and Lee headed to the airport for a flight to New York for a TV appearance, it was under threatening skies and the prospect of bad weather. When Art took over the next morning, there was a fair chance it would be raining.

Art was already on the scene, waiting. He had set out from Las Vegas with the *Green Monster* on Wednesday, November 3, the day after Craig broke his record, and was now at the Wend-Over Motel. Humpy Wheeler and Jack Olsen from *Sports Illustrated* joined him there a day or two later. Ed Snyder, Bud Groff and Charlie Mayenschein would follow on the weekend. Ed had had trouble

getting time off from his job at American Hard Rubber. They were letting him have only two days. The plan was that he would fly out on Saturday to be on hand for the attempt at the record. It wouldn't feel right running the *Monster* without him.

Sunday. That was when Art intended to get the job done. He might indulge in one practice run if he had to. Otherwise he would get right down to business. One thing driving him to what might seem like haste was that tendency to view land speed racing like Russian roulette. "The more times you pull the trigger," he would say, "the greater your chances of blowing your head off." Another thing was concern about the weather. With rain in the forecast, he had to snatch the record back at the first opportunity or he might lose the season. He was also anxious just to get the whole thing over with so that he could head home to June, nine months pregnant with their third child. He wanted to be with her for the birth. If it was a boy he would call him "Dusty." He had always liked that name. It reminded him of when he was a boy himself, working at the mill alongside his dad with the grain dust swirling around.

Saturday, and Art's small team was assembled. The *Monster* and all the gear was hauled out to the salt in the afternoon so that it would be ready for the next morning. "Watch everything out there, not just the car," Bud told the man detailed to stand guard through the night. "If somebody even takes our starter, we're out of business." In the meantime the International Course was examined and found to be in very bad shape. The multiple passes by *Sonic I* had left the usual furrows and the endurance run in the Cobra, held on the overlapping circular course, had chopped things up badly. There was grumbling in the Firestone camp that the damage done by the Cobra had been intentional to spoil things for Art.

"It was not!" retorted an incensed Goodyear man to Jack Olsen. "I felt awful when I heard that we'd damaged the course."

Ed Snyder didn't buy it. "Last week the salt was ours," he fumed, "and we knew we weren't going to use it, and we offered it to Breedlove on a Monday. Now he ties up the salt all week and ruins

the course. Well, let's go out there tomorrow and ruin it so he can't come back. We'll take the bus out there and plow it up for plantin'!"

That evening Art got together with Jack and Humpy for a drink in his motel room. As usual before a speed run, Art was tense but was doing a good job of not showing it. "This place," as Humpy put it to Jack, "compared to Indianapolis or Daytona or any of the major races where the death factor is there, nothing approaches this place during the week when a guy's got a high-speed run. I mean, when he's going for the record, it's just more tense than even Indianapolis, and you can cut it with a knife there. It just affects everybody."

"Art," Jack said, chewing on his gum, "I've been trying to figure out what makes you so competitive, because nothing ever happens accidentally. I mean, people are the product of what happens to them as children. Do you have any idea what makes you so competitive?"

If there was one thing that could make Art wary, it was an attempt to dig into his psyche. "Explain your question," he said.

"Well, a lot of people just don't give a shit. My point is, there must be a reason."

"Well, my gosh, Ed and I work a whole year putting a car together, and if someone beats you, I think if the car is capable then I'll be man enough to get out of it what we built into it."

"What Jack's trying to get at," said Humpy, "is something early in your life that's given you the drive to excel in these things and do something that other human beings never even think about doing, except in a daydream."

"Well, I don't know what you're asking me so . . ."

"Well," said Jack, "it's very complicated and often you find that the answer is something that isn't obvious at all. But from what I can learn about your childhood, it seems to have been pretty relaxed, a pleasant family, there wasn't any father beating you up. And that doesn't usually produce a champion, that kind of a family. But still, deep down in you, you have a fierce competitive drive. And I just wondered, when you were a kid, did you have your nose rubbed in the dirt? Were you the little kid that the other kids pushed around?"

"Not any more than any kid gets shoved around."

"And this competition with your brother, that didn't exist in childhood as far as I can see, because he was much older than you."

"No, we really didn't hang around at all until after I got out of the navy, and then we both had motorcycles. And then hell, we were as close as any two guys can be for years."

"But you know, Art," said Humpy, "most drivers involved in racing, they get out of it after a while. Even Indianapolis drivers, when they get to be 30, they don't take the chances. They just let experience count."

"Well Jesus, you should have seen me when I had guts. I lie awake nights and scare myself to death thinking about the stupid things I used to do. With the airplane and letting guys hang all over the car and racing 'em down the street. Boy, when I think of that, that one of those guys could have fallen under the wheels or something . . ."

"It's not obvious that you used to have more guts," said Jack.

"You didn't know me then." And then Art offered this up: "I held the national record four consecutive years for National Hot Rod and two other outfits. And the only time I could really get a speed out of my car is if somebody would beat my time. And then I could come back, and I could always get more out of it than was there."

"See, that's the difference between you and other drivers," said Jack. "That's the difference between Sandy Koufax and somebody else. It's some mysterious quality that the champions have, and the fuckin' champions can never explain it. I've never seen one yet who could explain it. I've been trying for five years to find out what makes champions, and I'm still trying to find it out. I'm convinced that it goes back to childhood."

"It does," said Humpy.

"It's got to, because everything does. Your whole goddamn personality's formed when you're a kid."

But Art wasn't going any deeper. "Well," he concluded, "that's a hell of responsibility for your parents, isn't it?"

* * *

The storms of autumn were still holding off the next morning. It looked like Art would get at least one passable day. To make the most of it he gave up on the International Course, which needed extensive grading, and opted instead to run on the parallel hot-rod course 200 feet to the side. It needed dragging only where the circular track crossed it and Breedlove's Cobra had cut it up. Its big drawback was that it was shorter. Art would therefore have to accelerate hard using afterburner—the burner that caused the torque which had twice blown out his right rear tire. Firestone had come up with better tires since those memorable runs the previous year, stronger and with higher speed ratings, but for Art they were only a marginal comfort. When he headed out to the salt that morning, quiet after a night of tossing and turning, he knew there was a good chance he would have to do some white-knuckle driving.

"It's quite obvious that somebody's going to get killed," Jack noted on his tape recorder that morning, "with Breedlove going through the fence and snapping a pole, and Arthur blowing two tires. Sooner or later a car's got to start rolling, and once it starts rolling it's not going to stop till it's shredded. That's the consensus of the experts . . . Are they crazy? Are they ridden by the death wish? Or are they what they called the governor in Bull Brammer's book *The Gay Place*? Quote: 'That men like you and Ed Shavers are the proud, resolute individuals of our time and that the rest of us are just along for the ride.'"

At 11:20 the course was prepped and Art's mile markers were up and the *Green Monster* was in position and almost ready to go. Jack spent the final few minutes wandering around the pits, soaking up the atmosphere. There was Charlie Mayenschein, replacing a body panel after making final adjustments to the engine. He was wearing an "Art Arfons 536.71 mph" T-shirt from the year before. He had altered the speed to read "636.71 mph."

"Easy now . . . easy." Ed Snyder was guiding the truck backing up with the start cart. The sharp end of the *Monster*'s sonic probe was folded up and the cart's drive shaft was guided into the hole to engage the J-79. "Come back . . . easy . . . easy now . . ."

"Where are the charges at?" It was Art, clad in his white-and-red fire suit, calling out from the chute compartment at the tail end. "Hey Ed, where are those charges at?"

"They're in, I think. All we got to do is hook these plugs on."

"The chutes will work," said Jim Deist, laying a friendly arm on Art's shoulder.

"If they don't, you'll have to help clean out the cockpit."

A lot of people were milling about now, spectators and press, forming a ring around the car that gradually began to close in. "Okay, all you folks who aren't crew, please get back," announced a Speedway official. "Come on now."

"This one's for practice," somebody beside Jack was breathlessly saying. "Then he's back here for the run . . ." A plane was circling overhead, its engine momentarily drowning everything out. Jack moved over beside one of Art's crew members. "It ain't gonna be no warm-up run," the man confided. "You know how Arthur goes— quick and dirty."

The start cart rumbled to life, turning over the J-79. Art admitted to having butterflies before climbing into the cockpit. Now, squeezed into his seat, cut off from everyone by the latched canopy, his nerves started to settle. It was the rising whine of the engine that did it. "Power affects me the same way as good music," he had told Jack. "Not this damn jazz, but some real concert music or something. It kind of puts me in a trace. It just sort of takes over. I get into the car and as soon as that engine fires up nothing bothers me no more."

The *Monster* was rolling now. It started slowly, moving away from the crowd so that they wouldn't be blasted. Then, with the tail-pipe temperature gauge reading 1,290°F, the afterburner fired and the tail pipe narrowed and the car shot off down the course in a white cloud. Jack muttered, "Jesus Christ."

If this was a practice run, it had to be the world's fastest. Art was doing 600 when he passed the first of Joe's clocks and was still accelerating hard. He was going too fast. At this rate he would hit 750 by the end of the mile—assuming his right rear tire didn't disintegrate first.

He was here to break Craig's record, not get himself killed. He throttled back on the engine when he was halfway through the mile and coasted the rest of the way. The tire held. Jim's chute came out. The front end had come up once or twice, but the wing on the nose had brought it back down with a thump. All in all the run had been easy.

Art's speed was 575 mph. The practice run, if it had ever been that, now became official. One more like it would give him the record. For the return leg Art would use a run-up of only one-and-three-quarter miles so as not to reach his peak speed too soon. He wanted to accelerate all the way up to and through the measured mile, then shut down; to set the record, in other words, while covering the least possible distance.

The *Monster* was ready to go at 12:23. "I said goodbye to the world again," Art related afterward to fellow Akronite Harvey Shapiro. "The crew fired the engine and I crept forward, then blasted off. The acceleration was so great I thought I was going through the back of the car. I kept going faster, faster and faster, realizing this was my chance and I'd better do it now."

His airspeed indicator was reading well over 500 when he passed the first clock. It had taken just 20 seconds to get there from a standstill. The tire was still holding. It was as hot as a sauna now in the cockpit, the J-79 radiating heat through the metal sheet pressed against Art's shoulder. He had been urged to put a thick steel plate between himself and the engine. He hadn't bothered. If the engine blew, he figured he'd be dead just the same. The tire was still holding.

There was the exit marker, the big green-and-black checkerboard Bud had painted. The tire was still holding. Airspeed 625 now. The tire was still holding. He throttled back the J-79. The tire was still holding. The car gave its usual shudder as the engine came out of burner. The tire was still . . .

Boom.

An explosion rocked the *Monster*. The car dropped down in the rear and toward the right. Art knew instinctively what had happened: his right rear tire had blown again, this time at 600-plus mph.

But things were coming at him too fast for the thought to form clear in his mind. He could feel the *Monster* straining to veer off course. He tightened his grip on the steering yoke and hit the chute-release button. There was no answering tug. The exploding tire had blown the main chute clean off the car. At the same time the cockpit was filling with smoke. It was from the front right tire burning up as it rubbed against the body panels with the car now atilt. Art couldn't see through the choking blackness, couldn't see that he was careening off course. And without an oxygen mask, he couldn't breathe. "That's when I began to feel uneasy," was how he would put it.

Steering blindly with one hand, he felt for the canopy latch. It wouldn't open. It was the tape he had used to keep the latch from vibrating. He clawed it off and turned the lever and pushed up on the Plexiglas cover. It went up only a couple of inches before the air stream caught it and slammed it against the side of the car and smashed it to pieces.

The wind was blasting straight into his face, mashing the flesh of his cheeks back toward his ears. The smoke was gone now, whipped away in a flash. He could see. But all there was coming at him was whiteness. The black line was gone and he wasn't slowing. His main chute hadn't worked. He hit the release button for Jim's backup and at the same time saw a speck up ahead. There was no time to react. He saw it and was passing over it in almost the same instant. There was a jolt and the sound of rending metal and pieces coming off the car and flying back past his head.

Art almost lost it. The *Monster* slewed to one side and very nearly went into a roll before he got it straightened back out. It took all his strength to fight against the dragging rear rim. Then the backup chute was out fully. The straps of Art's harness dug into his chest. But it didn't feel like it should, not the usual brick wall. The chute was being shredded by shards of metal flying off the car. The torn and flapping fabric nevertheless held together long enough to slow the *Monster* to where Art could use his disc brakes. He eased onto a parallel course alongside the dike where Craig Breedlove had

gone swimming and finally came to a controlled, smoking halt. The entire run, start to finish, had taken less than a minute.

The Tooele County sheriff got to the *Monster* just in time to see Art climbing out of the cockpit, mad and swearing. Son of a bitch! he was sputtering. God damn it! Shit!

Are you okay?

For Christ sakes look at my car. Some damn thing's gone through and wrecked the damn engine.

So you're okay . . .

God *damn* it! Son of a *bitch*! And Art gave what was left of his rear wheel a good kick.

He had settled down by the time a crowd started to gather, journalists and speed groupies and families who had driven out with their kids to take in the show. The *Monster* had been something to see before, but now it was even better, a mass of damage. The blowout of the 250-psi tire had acted like a bomb, destroying not just the tire but the body paneling all round the wheel. Fading into the distance you could see the twin furrows the bare aluminum rim had dug in the salt and the bits of debris the car had shed on the way. And look at those chutes. They're torn to pieces.

The rubber-neckers were starting to get in the way now. If fuel was leaking and a fire ignited, the *Monster* would be fully destroyed and people might get burned. "Stay away from the car, please," called out a Speedway official. "Everybody who isn't crew get back . . . Come on, everybody except crew . . . Come on folks, there's no reason for you all to be up this close . . . Come on, just the crew members . . . Come on!"

The *Green Monster* had been badly damaged. The blowout had mangled almost the entire right side and whatever Art had run over had smashed up the left. It had been a metal survey stake, pounded into the salt when officials were measuring the course. Closer examination would reveal ruined instrumentation on the exposed underside

of the engine and four distinct cracks in the car's frame. The one piece of good news was that nothing had been sucked through the engine itself. It was that fear, Art said, that had set him off when he emerged from the cockpit. As it turned out, his J-79 was okay.

Back at the motel in Wendover the telephone was in constant use by the press and the crew and the Firestone people. Word was going out that Art had just set a new land speed record of 576.55 mph, reclaiming the title from Craig Breedlove after only five days. Firestone head office back in Akron had an ad campaign all ready to go and just needed to fill in the details.

There was only one call Art wanted to make. He had to let June know he was okay. She would be worried.

"How is she?" someone asked when he got off the phone.

"She was bawling. She'd heard that I'd crashed the car and that I was all right, but she didn't know for sure."

Ed finished up his phone call a few minutes later and joined them with his glass of nerve tonic. Art's blowout had just about done him in, but he was settling back down. "If we can get out of here early in the morning, I can drive one of the rigs back," he said. "As long as I get back Wednesday, because I got to go to work or I'm in trouble."

"I thought you were going to stay here and run the bus all week," said Jack. It was a little ribbing for Ed's earlier outburst about driving the bus around the circular course for an endurance record just to ruin the salt for Craig.

"I ain't going to be a dirty bastard without him," joked Art.

"Hey, that's a good quote, huh?"

"How about those sandwiches," said Bud. "Where are they at?"

What Jack couldn't get over was how Art had blown away the record so quickly. Half a day and the thing was done and everybody was back in Wendover in time for lunch. It wasn't how Craig did it. With Breedlove, said Jack, "It's a typical Los Angeles production. He makes a Ben Hur out of it. With you guys, it's zip zip and it's over."

"Well, we come out here for business, not to play," drawled Ed, getting mellow. "You know, that car's only made 11 runs in its lifetime."

"You're kidding. The *Green Monster*'s made only 11 runs?"

"Eleven runs, boy."

"So you're going to be in and out of here in one day."

"In and out in a day, yeah."

"Hey Arthur, did you press the car? Did you really push it?"

"Oh shit no. That's just minimum afterburner. That's just a shade over half power. Even with that setting, if we'd backed up two more miles the damned thing would go seven and a half."

"Nobody kissed that car today," said Jack, referring to the supposed ritual that Art made the crew perform for good luck.

"The hell they didn't," said Art, which got everyone laughing.

"I saw you out there kissing it three or four times," somebody said.

"It was three times . . . I love that car. She's good to me. I'm still here, ain't I?"

The guy droning on the phone in the background motioned Art over. He had Firestone head office on the line. Everyone there was ecstatic.

"Hey Art, Jim wants to talk to you."

Art took the receiver and became all business. "Hi Jim . . . Thank you . . . Well, the main thing is, we got 'em shut down for a while . . . Yeah, we got inside dope. Breedlove's car is so near flying I don't think they can do it . . . Yeah . . . I don't know whether they will or not. They said they was, just to confuse us, but I don't think they will . . . Well, see you when we get home then."

So it was in the bag. With *Sonic I* on the verge of flying, there was no way Craig could reclaim the record in the few days of good weather that might be left in the season. That meant that Art was all set to hang onto his speed title for another whole year.

And then June delivered their new baby, mother and child both safe. It was a girl, but Art named her Dusty just the same. Nineteen sixty-five just couldn't get any better.

CHAPTER **22**

Six-Oh-Oh

"Craig, I've got some bad news for you."

Craig and Lee Breedlove had just flown into New York for an appearance on *To Tell the Truth*. It would kick off the publicity harvest from the double records they had just set, making them the world's fastest man and woman and the fastest husband and wife.

It was one of the Goodyear public relations people who had met them at the airport. "Art just went 576," he said. "The weather cleared for a moment, and he was right there."

Art had done it again. He had snatched Craig's hard-won record away the previous year, after *Spirit of America* was wrecked and Craig couldn't respond. This time he had done it at the last moment, when the season was ending. One good downpour and it would be checkmate again.

So much for the publicity tour. And a game show appearance now would be a humiliation. Imagine a picture of Craig's car appearing on TV screens across the nation and host Bud Collyer announcing with his usual pep, "This is the jet-powered *Sonic I*. It held the land speed record for five days last week . . ."

After venting his frustration with his fist on a partition wall in the men's room, Craig made plans for an immediate Bonneville return and phoned George Klass, who had stayed behind with the

car in Wendover. George, in charge of logistics, started reassembling the rest of the team. If they were going to respond to Art's record, it would have to be soon.

Craig and Lee flew back to Utah on Friday, November 12. When they landed at Salt Lake City, the wreckage of a plane that had crashed the previous evening was visible beyond the end of the runway. Forty-three people had died. It was a Boeing 727 out of New York, the same aircraft Craig and Lee were in, flying the same route. There seemed something unlucky about that—particularly in light of how Craig was feeling about climbing back into his racer.

Art's inside dope had been correct: *Sonic I* really was on the verge of flying. The problem, as Craig now realized, was due to its inherent shortcomings. From the standpoint of aerodynamics it was not as good a car as his first *Spirit*. It was easier to drive with its two front wheels, but it was not as well designed to stay on the ground at high speed. "*Sonic I* was more styled than engineered," says project manager Stan Goldstein, looking back. "And some of that styling turned out to be really poor in terms of aerodynamics. The Coke-bottle effect, for example, we didn't totally understand it. The original concept was developed for supersonic flight, this Coke-bottle shape sucked in at the waist to offset the square inches taken up by the wings. But since our car didn't have any wings, that turned out to be more styling than anything else."

Much of the force that was working to lift *Sonic I*'s nose off the ground originated with its 10-foot-high tail fin. Its purpose was to create drag like the feathers on an arrow to make the car stable and keep it going straight. As it turned out, however, the tail fin's position behind the rear axle, combined with the substantial drag it generated at high speed and its lofty height above the engine's tail pipe, was causing the car to pivot up on its rear wheels like a teeter-totter. At just over 600 mph, *Sonic I* was in effect doing a wheelie.

In hindsight, a different tail-fin configuration would have been better, perhaps dual fins set lower and a bit farther forward and a different design for the car's nose. But there was nothing to be done about that now. If Craig was to get back out onto the salt to reclaim the record before the winter closed in, he would have to make do with what he had. And what he had wanted to fly.

It was his turn to wait now, however. Firestone still had the course reserved for the remainder of the second week of November. After Art used only the first half-day of that booking to set his 576-mph record, a second Firestone-sponsored land speed vehicle was wheeled onto the salt to take over, a pencil-shaped car called *Goldenrod*, 32 feet long, four feet wide and two feet high. It was powered by four Chrysler Hemi engines laid back-to-back and generating a total of 2,400 horsepower. The car's builders were the brothers Bill and Bob Summers of Ontario, California. "They built that thing in a chicken coop," marvels Stan Goldstein. "It was a *big* chicken coop, but a coop just the same." Bill and Bob had been trying since the beginning of September to break Donald Campbell's record of 403 mph—what was now known as the wheel-driven record to distinguish it from the unlimited record that had become the preserve of the jet cars. The significance of the wheel-driven record tended to be overshadowed by the glamour of the jets and the runaway speed numbers they were posting. To the land speed aficionado, however, it had at least as much meaning, for getting a vehicle to go extremely fast using internal combustion engines directing power through the wheels was *hard*. It meant meeting all sorts of mechanical challenges—getting multiple engines to work together, for starters— and dealing with the huge problem of wheel spin, something that did not affect the jet cars with their direct thrust.

It finally came together for the *Goldenrod* crew on Friday, November 12, 1965, the second to last day of Firestone's course booking. Driver Bob Summers, lying flat on his back, his face hidden behind a hood that combined oxygen mask and goggles, pushed his hyper-sleek car to a new record of 409.277 mph. It would stand for

26 years. The accomplishment would make the Summers brothers' reputation in the car world and help them launch a successful automotive parts business. But it would bring them nothing in the way of direct financial reward. In lining up sponsors to fund the project, it hadn't occurred to them to ask for a bonus for breaking the record.

Sonic I looked battle-worn as it was towed onto the salt flats two days later. Six weeks of speed runs and repairs and modifications had left their mark. There were the louvers that had been punched through the body panels along the sides and on the top; the extra-large replacement canards sticking out from the sides; the flanges tacked onto the body alongside the rear wheels; the miscellaneous wear and tear all over. And up front, just behind the cockpit, Craig's name remained butchered from the replacement of the air duct back in October. All that was left now was "Craig" and half of the "B."

Things looked grim that first day, Sunday, November 14. It was cold and drizzling and the salt was wet. Land speed records normally weren't set this late in the year for a very good reason: racing conditions tended to be horrid. It had in fact been done only once, nearly 30 years before, when George Eyston went 311 mph on November 19, 1937. But Craig did not have the luxury of waiting for perfect conditions. That would be a sure way to lose the season completely. He would have to be ready to grab the record back whenever the opportunity presented itself; whenever the air was still and it wasn't raining. He would have to get the job done fast, just like Art Arfons.

Craig was up at four that morning. It had hailed during the night and he hadn't gotten much sleep. By daybreak he was out on the salt and the crew had the car ready. It was heavily overcast and the course was damp, but it might just do if the wind would stop gusting. Craig retired to the trailer to drink coffee and wait. He needed only an hour of still air to make his two runs. Only one hour.

At mid-morning Joe Petrali radioed down from the USAC trailer that it was calm in the mile. Craig hurried out and got

Sonic I ready. He was in the cockpit, engine roaring, when Auto Club steward Ben Torres ran over waving his arms to call off the run. The wind down the course had picked up. In another minute the gusts hit them, strong enough to have put the racer in danger of flipping. After a few more hours of waiting Craig gave up and drove dejectedly back to Wendover. The day had been a total write-off.

It was more of the same the next morning, Monday, November 15—another early wake-up; another skipped breakfast; another grim drive out to the salt before daybreak; another drizzly, iron-gray sky with the crew shivering over cigarettes and coffee in disposable cups. They waited at the south end of the course until 8:30. Then the weather started to break. "Joe says it's great in the mile," said Nye Frank, jogging over from where Ben Torres was hunched over his radio receiver. "Let's get it running." Craig immediately climbed into the cockpit and the crew rushed through the engine start-up procedures.

Shafts of sunlight were appearing down the course as *Sonic I* began its first run in a spray of saltwater. Craig went into afterburner right from the start. The car accelerated through the range of severe vibrations that lay below 300 mph, then things smoothed out, then came that tenuous feeling, where the steering became sluggish and it was like you were skating on ice. "You sort of skim over the salt," was how Craig would describe it. "The car drifts. Pretty soon you wonder who's driving who."

Craig was just passing Joe's first clock, his speed indicator hovering near the red line marking 600 mph, when he felt the front end of the car grow alarmingly light. The wheels stayed in contact with the ground, but only barely. He was just hanging on. He remained poised there, holding his breath, on the verge of takeoff, until the mile exit marker flashed past six seconds later. Then he cut the engine and hit the chute-release button. The primary came out. He could feel it. But the tug lacked its usual eye-bulging violence. The canopy had opened and then collapsed after filling with spray

thrown up by the wheels. Craig went to his heavy-duty brakes and was able to slow the rest of the way without trouble.

For practically the first time *Sonic I* survived the run without damage. The aluminum body panels underneath the salt spatter showed no sign of crinkling. Joe's verdict when it came was 593 mph, putting Craig comfortably ahead of Art and within striking distance of his goal of 600. He would need to clock through the mile at around 610 mph on the return run to get it, right around the speed where he expected his front wheels to lift right up off the salt. There was nothing he could do about it in the space of one hour. The front canards were already set at their most extreme downward angle. "Give me 610," he told Walt Sheehan. "Give me 610 and not one mile faster." Walt did some fast calculations, then opened the engine access panel at the back of the car to reset the throttle linkage, easing it ever-so-slightly forward.

It took the crew only 30 minutes to get the car ready for the return trip. At 9 a.m. Craig was back in the cockpit, the weather still holding. After Nye helped him on with his harness, Craig said, "Ask Walt if he really knows what he's doing."

Nye went over to Walt. "The boss wants to know if you know what you're doing."

"I don't have the faintest idea," replied Walt, trying to rub some warmth back into his hands. "Just tell him to get ready to make his run and not to worry."

Craig was in a car that wanted to fly. He had a primary-chute braking system with a propensity for failing. And he was now heading back down the course toward the south, the unlucky direction, back toward the brine pond where he had taken a swim in 1964 and then nearly again in October. In short, it was hard not to worry. "I was sweating bullets," he said.

So why was he out there? Well, it was the way he earned his living—a very good living if he broke the record, what with the bonuses from his sponsors and follow-up endorsements. It wasn't really about the money, however. "Let's face it," Craig would say the

next year. "When you sit down in that cockpit, all the money in the world isn't going to make you drive that car 600 mph if you don't really want that record."

So what was pushing him to do it? It had much more to do with prestige. For Craig, for Art and Walt Arfons, for Doc Ostich and Donald Campbell and Athol Graham and Glenn Leasher and all of the others, the desire for prestige was the primary driver, the prestige of being known as the fastest, the best. It was that more than anything else that motivated them to seek out what Craig would call the "ecstasy mixed with stark terror" of traveling at very high speed.

And then it was over. After six weeks of trials and tribulations, Craig made his return run and for the first time everything went right. The sun came out and the air remained calm. Walt Sheehan's throttle linkage setting took him to the exact speed that he wanted. *Sonic I* once again flirted with flying, but again it barely stayed on the ground. And when it came time to stop, the primary chute deployed correctly. The yank momentarily shot Craig's 150-pound bodyweight up to 1,500 pounds and everything was great. It was so great that in a burst of exuberance Craig alarmed observers by steering the car off the course. Had he lost control of the racer? No, he was taking it back to the pits to park alongside its trailer, just like you park the family Chevy in the driveway after a trip to the store.

Craig had done just over 608 through the mile, giving him a two-way average of 600.601 mph. It was the fifth land speed record he had set in just over two years, a record that was faster than a cruising passenger jet and nearly as fast as a bullet from a .45 caliber handgun. It also made him the first human to reach 400, 500 and 600 mph. After the cheering died down and the hugging was over, Craig laid an arm over Joe Petrali's shoulder and said, "I'm so happy I could kiss you, Joe." Back in Wendover Craig joined his crew for lunch at the Stateline Casino, a swig of Coors his first nourishment in 20 hours, and the celebration continued. "That 600 is about a thousand times better than 599," Craig exulted. "Boy, it's a great feeling."

The sheer pleasure of the memory still stirs Craig today. "We couldn't have cut it much thinner than that," he says with chuckle. "I mean, just look at that record, six hundred point six-oh-one. We just barely squeaked it in."

There was no way Art could respond that year. His car was too badly damaged. The USAC officials packed up their gear and the course was vacated, and soon the salt was under water as the overdue bad weather closed in. That made Craig and in turn Goodyear the surprise ultimate winner for 1965. It was now Firestone's turn to cancel ads and TV commercials and swallow the crowing of Brand X. "Goodyear—The Fastest Tires on Earth," ran the full-page spread in the Akron *Beacon Journal.* "Breedlove Goes 600! Breaks Last Week's Record on Same Goodyear Tires Used to Set Two Previous Land Speed Records—Without a Single Tire Failure."

"Without a single tire failure." That was especially sweet. Out at the Portage Country Club that weekend and for many to follow, there were big smiles as the Goodyear executives rubbed it in deep.

Craig admitted after doing 600 mph that *Sonic I* would never make it to Mach 1. "We thought it would when we designed it," he told *Motor Trend* magazine in March 1966, "but from our experience up there, we know it won't. Parts of it have supersonic capability, but I don't want to say what it lacks. That's my secret." He now estimated that with further modifications a more realistic speed potential for the car would be 675 mph, deep inside the transonic zone but still at least 50 mph short of a boom. But that would come only after Art answered. Until then, Craig's main concern was to make the most of his six-oh-oh.

He had learned an important lesson from his first record in the three-wheeled *Spirit:* that the company hired to haul the car to exhibitions and car shows around the country earned more in trucking charges than he did in appearance fees. For *Sonic I* he therefore made the astute decision to handle the trucking himself, hiring George Klass as his driver. He had it all worked out with Goodyear. For the

two-year period the company allowed him to retain possession of the car, they would pay him commercial trucking rates to haul it to the shows and store openings and other publicity events where they wanted it to appear. Craig would then fill out his schedule by booking additional appearances for himself and the car on his own. Between the Goodyear haulage fees and his personal bookings, he expected to do very well.

It was Goodyear public relations director Bob Lane who threw cold water on his plans. "We don't want to use the car," Lane said blandly when Craig stopped by Goodyear's Akron head office to arrange the appearance schedule for *Sonic I*.

Craig was incredulous. "You don't want it . . . ?"

"That's right. We don't want it. We don't want it anyplace. And another thing, you billed us for the gasoline that the project used, and you were given that gasoline by Shell."

"I did not make one penny on that gas," Craig shot back. "I billed you for the exact cost. Your accountant was there and approved every payment to Shell, because it was a project expense for *your* car. It was part of the cost of building *your* car, to go get parts for it and things like that. That's what you were billed for."

Lane remained adamant. Craig, steaming at the implied accusation, wrote out a check to make a point, reimbursing Goodyear for the gas money it had paid to Shell. "Well, I'm just going to leave the car at home, then," he said, "because I can't afford to let it just sit in between the shows I've got and have a driver on the road and all that. I won't make any profit."

"So, your problem," said Lane, "is that you need something to pay your costs in between the shows that you do have, in the time when it would be down, right?"

"Well, yeah. It's not profitable otherwise."

"Okay, I'll tell you what. We'll use the car at cost. We'll reimburse you for your gas, for your driver's salary and for any out-of-pocket expenses you have in between the shows we want the car at. That way, you won't lose money."

The memory still burns Craig. "I had literally risked my life for them at 608 miles an hour," he says, "and they were running all these ads and all this stuff and Bob Lane was doing this. I just couldn't believe it. I've never seen a guy who was so nuts."

"The Goodyear people were gangsters," concludes Stan Goldstein, general manager of the *Sonic I* project. "It was just the way they operated. They were really rough-and-tumble guys."

Craig had to push himself through the publicity tour that followed. He was sick as he set out, the physical and mental exhaustion of getting *Sonic I* built and running it for the record giving way to full-blown pneumonia. He was forced to cancel a number of public appearances and didn't fully recover for nearly six months. The tour on the whole ended up falling well short of the success he had hoped for.

He still had the bonus and follow-up endorsement deal coming to him for breaking the record, however. It was right there in his contract with Goodyear, a total payout of about $75,000. Craig opted not to receive the money directly. Instead, Goodyear talked him into investing it in one of their company stores, just as famed Indy driver Parnelli Jones was doing with considerable success with his chain of Firestone outlets. Craig's attorney advised him against it, but Craig liked the idea. It seemed like a good long-term investment.

It wasn't.

CHAPTER **23**

Last Stand

"Here's nothing I can do but run again," Art said just hours after Craig went 600. "What determines who goes the fastest depends on which car fails first or which driver gives up first—and I'm pretty stubborn."

It took Art and Ed until Christmas to restore the *Green Monster*. In addition to repairing the extensive damage caused by the blowout and running over the survey marker, they enlarged the bulb of the sonic probe slightly and added a point to the scoop in the body below it. This, Art believed, would enhance the car's aerodynamics and improve airflow into the engine.

They also added air-over-oil suspension to the rear wheels. Art had come to the conclusion that the engine's rightward torque had blown out his rear tire on that side rather than his front because there was suspension on the front wheels—necessary for the operation of the nose wing—and not on the back. When the engine's torque threw downward pressure onto the car's right side, the strain in front was therefore being more evenly distributed over both tires by the give of the suspension, while in the rear it was all going straight into the right tire. The result: *boom*. The solution: install suspension in back. It would be a significant risk, for if it didn't solve the problem, it would just make things worse. "If anything ever happens now," Art said, "it'll rip the axle right off."

Art was champing at the bit to return to the salt flats. He even spoke of a date in January. No one had ever gone after the record at Bonneville at that time of year, but that didn't deter him. When January rolled around, however, the salt was in hopeless condition and the plan had to be cancelled. Art next said that he would make his attempt in April, still well outside the usual season, but supposedly doable because of below-average precipitation over the winter and because he didn't need a 10-mile course. With the *Monster's* acceleration, he said, six or seven miles would do. By late March that plan in turn had been scrapped. The salt was too wet and there was no chance of it drying out before summer. A week in June was announced next, but that didn't pan out either. It finally came down to August, comfortably back into the LSR season.

Ed Snyder was not happy during these months of waiting. He had been there as Art's best friend and partner from the very beginning, the person Art trusted most to help him build and run his cars, even to make appearances at shows in Art's stead with *Cyclops*, which Ed did that spring. Ed had loved being a part of it all, the satisfaction of making things with his own hands, the excitement of racing, the prestige of being involved. But the fun was all gone now, pushed aside by the stress. Art admitted that the fun was over for him too. But he still had that powerful drive, the "false pride" as he put it. Ed didn't. Ed was worried all the time—worried that Art was going to get killed and that he would have helped make it happen.

Firestone was worried too. The company was dead set against Art trying to grab back the record in only two runs as he had done the previous year. This time they wanted him to proceed with caution, starting out with a series of test passes to monitor the strain on his tires. Art grudgingly agreed. Prior to the return to the salt, he and Ed would accordingly install electronic sensors on the *Monster's* rear wheels. They would serve the same purpose as the front-wheel sensors on *Sonic I* which had warned Craig that he was dangerously close to flying. On the *Monster* they would monitor the opposite problem, excessive downward pressure in back. The sensors were

duly delivered from Firestone and Art and Ed got them mounted, but there were delays and the August date for Bonneville slipped by. They were now looking at a week in the middle of September.

This time they made it out to Utah, Firestone fretting all the way that Art would forget about the agreed-upon tests and bull ahead for the record. "The only way I could leave town was if I would be a good boy and not go out and stand on it like I usually do," Art said. "So we went up to the head boy's office and he said, 'Now, we're taking you at your word that this is going to be a test program.' And I agreed to that. Then they came out behind my back and asked Ed, 'Can we take his word for it?' They asked Bud too. They even asked my kid.

"I'd like to get it over with right now. I don't have the courage to run day after day. I'd just as soon go out and make two runs and forget about it. But I've agreed to make a minimum of five runs now. So that'll give them a good graph and we'll know what to predict, the loads on the car, the speeds we're going to go."

Art made only two runs on the salt in September. His first, a test pass as ordered, was clocked by USAC at 370 mph. The *Monster*'s new sensors checked out. "You didn't get that real crazy, did you?" Ed said after, relieved.

"It was so tempting," joked Art. "My foot was itching." And to the Firestone technicians: "You're lucky I'm a man of my word."

Craig Breedlove was on hand as an observer. His *Sonic I* racer, he told reporters, was ready to go if Art broke his record. All he had to do was reinstall the jet engine, which had been removed to prevent damage while the car was on tour.

The next day, on Art's second run, there was trouble. It was discovered after his 432-mph test pass that both of the newly developed 32-inch tires in the rear—four inches larger than the ones previously used—had been badly gouged. Art had come close to a fourth blowout. The torque of the engine had caused great downward pressure in the rear of the car, 2,800 pounds on the left and nearly 4,000 pounds on the right. It had compressed the new rear

suspension and brought the larger tires into contact with the wheel wells, where there was now little clearance.

There was no alternative but to head back to Akron to make changes. The Firestone engineers meanwhile pored over the data they had collected and came up with the frightening estimate of 6,000 pounds of downward pressure on the *Monster*'s right rear tire, even with the new suspension, when Art hit 600 mph. It was beyond what the company had designed the tires to take, a guarantee of disaster should Art push to that speed. The decision was therefore made to install dual rear wheels to spread out the load. It would mean that the wheels would project out from the body and into the air stream, giving the *Monster*'s rear end a beefed-up appearance. As a further precaution, Art mounted a spoiler on the underside of the car. The idea was that the wind deflecting off it at high speed would lift up the rear end and alleviate some of the downward pressure.

Art's plan now was to run for the record in the third week of October. It didn't happen. The new dual rear-wheel assemblies being prepared by Firestone were held up, forcing another delay, this time to the beginning of November. "Right now it's touch and go," Art said as the season ran out. "They've already had snow in some parts of Utah. All we can do is hope for the best." When the wheels were finally ready Art had trouble getting them balanced. Yet another postponement was required, this time to the week beginning November 13. The weather situation was now critical, with the autumn rains threatening to close Bonneville down for the year. The pressure was getting intense.

It was while he was battling these delays in October that Art first had the nightmare. He was driving the *Green Monster* down the salt, going after Craig's record, when he started tumbling end over end for a terrifying few seconds before lurching awake in a sweat. It was like one of those premonitions his mother had had for as long as he could remember, the future glimpses that could sometimes be spooky.

Art didn't discount the supernatural. He admitted there had been times in the *Monster* when it felt like his dad, dead since 1950,

was there with him in the cockpit. But no, it was nothing. It was probably just his nerves, on edge from all this waiting. It didn't help, either, the way Ed got so anxious and Firestone nagged him. Or maybe it was the death of Charlie Mayenschein that was really on his mind. Charlie had been out on his motorcycle the month before when he was struck by a driver making a careless left turn. He had lingered in the hospital for a week before succumbing.

June knew something was bothering Art as the return to Bonneville drew near. She could tell by the way he was fixing things up around the place, tuning the family car and checking the furnace and even making repairs to their son Timmy's tree house. He finally told her about his dream, but he wouldn't listen when she tried to talk him out of going. Art's sister Lou Wolfe tried to dissuade him too when she heard about it, but encountered only grim determination.

"This is something I've got to do," Art said before leaving. "This is something I want to do. I've made up my mind."

Art and Ed and Bud Groff left Akron on Thursday, November 10 for the drive back to Utah. As they set out the newspapers were reporting what seemed a good omen: the *Columbia*, one of Goodyear's two blimps, had crashed at Long Beach, California. Fortunately, the only injury was to Goodyear's pride when the Akron *Beacon Journal* printed a picture of the collapsed dirigible on the front page.

Out on the salt flats, meanwhile, it had been raining. There were puddles and ponds of water all over, an inch deep in places. According to the mayor of Wendover, it would take at least until Sunday for the International Course to dry out. And that was assuming there wasn't more rain. Otherwise the season was already finished.

The rain was holding off when Art and the crew arrived and set up camp, a large awning off the open back of the bus to shelter the *Monster*, a Firestone flag on a pole just beside it. Art was going to take two test runs on Monday, November 14, to satisfy Firestone,

pushing the car to 550 mph, then immediately go for the record if there was enough daylight remaining. "I hate to make all these test runs," he groused. "It's like playing Russian roulette. The next time you don't have as good odds."

Art was assuming—hoping—that things would go smoothly. They didn't. On his first run both chutes failed to open. He had to stop by using his brakes. Two hours were burned up working on the problem, then he tried again. This time his chute deployed prematurely, robbing him of speed just as he was nearing the end of the mile, clocked at 475 mph. It yanked out a lot of the stitching and necessitated another delay while Jim Deist sewed the canopy back together. It was nearly 4 p.m. before he was finished, but the wind and the rain were holding off. Art decided to go, to seize the record right then. He passed the first of Joe Petrali's photo eyes from a two-and-a-half-mile run-up doing close to 550. Too slow. He tromped down harder. The force of the acceleration knocked his foot off the gas pedal. When he got it back on, the burner faltered before relighting. When it did, it was too late.

Art was clocked at 554 mph. And once again he had trouble with his chute prematurely deploying. It popped out this time when the afterburner was still flaming and the shroud lines were burned through. Art had to use his backup. Fighting discouragement, he and the crew worked under trouble lights through the cold evening to fix the short circuit and reinforce the rear spoiler on the bottom of the car. It had taken a beating from the blast of salt spray and air pressure.

The next day, Tuesday, November 15, proved just as disappointing. The trouble this time wasn't the chute but the burner, which sputtered and died. A thorough flushing of the fuel lines fixed it. On his next run, clocked at 524 mph, the J-79 emitted an unfamiliar shriek in the mile. "The engine's running a lot rougher," Art said, deeply concerned. "It's got an awful lot of vibration."

"I bet you cracked a turbine," someone suggested. But a close examination revealed no damage. As Art and Ed peered and probed in the *Monster*'s tail and crawled underneath, Bud grabbed a nap in

the cockpit. He was the only crew member small enough to find any comfort in the cramped space. Art tried a third run at 1 p.m. and the engine seemed okay. The problem now was that he just wasn't getting enough speed. When he saw halfway through the mile that he was out of record range, he aborted the run.

The *Monster* was performing at least 50 mph below expectations. Art had a good idea why. In modifying the car to make it safer, he and Ed had compromised its speed. First there was the additional drag caused by the dual rear wheels. The original single wheels had fit nicely inside the wheel wells, out of the air stream. Now, doubled up, they extended six inches into the blast. More drag was coming from the spoiler they had attached to the underside of the body. And then there was the increase in the car's overall weight, the extra 800 pounds they had added, most of it in the new rear axle and wheel assemblies. All of it combined to cause the same problem that had confounded Nathan Ostich with his *Flying Caduceus* three years before: too much weight and drag for the thrust. In Ostich's case the problem had been insurmountable because he had reached the limits of his power. Art still had a lot more—and he decided to use it.

Wednesday was much too windy for racing. The morning was spent at Wendover Air Base, fine-tuning the *Monster*'s J-79 on the unused tarmac beyond the abandoned swimming pool that had no shallow end. The afternoon was given up to waiting for extra chute-deployment charges to be flown in from the West Coast. It was another indication of how things weren't going as planned, that Art had used up the charges he had brought from Akron and was still nowhere near to claiming the record. The box didn't arrive until after sundown. Art opened it to find 14 of the shotgun-shell devices packed neatly inside. He intended to use only two.

That evening he quietly told the crew that he would try for the record again first thing in the morning. This time, he said, he was going to start three miles back from the clocks. It would be the longest run-up he had ever used with the *Monster*. And he was going to do it in second-stage afterburner for the first time. That meant that

two nozzles rather than one would spray a double-load of flaming kerosene into the red-hot exhaust blasting out the car's tail pipe. It would mean a lot more power . . . and a lot more torque.

That night Art had the nightmare again and bolted awake in a sweat. It didn't deter him. He was committed now to get back to his center and floor it. He was committed to pulling the trigger and getting the thing done.

They arrived on the salt at dawn on Thursday, November 17. Art wanted to get an early start because high winds were forecast for later that day. He was wearing his white fire suit with red piping up the leg and "Firestone" stitched on the pocket. Over top he had on a winter jacket, gloves and a cap. By 6 a.m. they had the *Monster* out from under its awning and were getting it ready. Then the sun was up and shining in a blue sky, a welcome change after a week of gray. The absence of wind actually made conditions close to ideal, an anomaly this late in the year.

The usual crowd of spectators and reporters and photographers soon gathered. They wanted to know about Art's game plan. "I'm going to stand on the accelerator clear through the mile," he said. Cameraman Dennis Goulden was there too, filming and making sound recordings. It was for a documentary on Art for the local-interest *Montage* series on Cleveland TV station WKYC. Dennis was about to get some gripping stuff.

By 7 a.m. the *Monster* had been towed into position three miles from the measured mile. It was hauled behind a station wagon, tethered by a long strap. The Firestone technicians started wiping down and checking the tires. Then they were giving them a final top-up with nitrogen until they were as unyielding as iron.

It was 7:30. At the rear of the car Ed installed the firing charges and Jim Deist loaded the chutes. The main and backup went into compartments on either side of the tail pipe. It was a tight fit. Some pounding with a toilet plunger was needed to get them in place.

Up front the start cart was backed into position and the drive shaft inserted into the nose of the *Monster*. Art never paced nervously before a run. But right now he was pacing. Off to the side a helicopter piloted by Bob Hosking whined to life and rose into the air. It would fly over the course so that *Sports Illustrated* photographer Eric Schweikardt could take photos.

At 7:55 Art was ready to go. Bud stepped in. He has come to preside over the ritual that followed. He spread a piece of green carpet on the salt in front of the cockpit. Art stepped out of his boots and onto the pad and into his driving shoes, the soles clean of salt. Bud then produced the lucky leather jacket and helped Art get it on. It had had a tear in it that Art had sewn up before leaving Akron. Next came the helmet. Still no ear plugs. Art had to hear the power.

He climbed into the cockpit. It was the usual tight fit in the upholstered red-and-white seat. I guess I've been eating too much, he joked as he snapped on his harness. Ed moved into position beside the start cart up front. He was puffing on a cigarette, haggard around the eyes and visibly nervous. Back at the cockpit Art nodded and said just one word: "Okay." Bud lowered the canopy. When Art clamped it shut from inside it pressed down on the top of his helmet. A coffin with the lid closed would be more comfortable by far. But he would be in it for only a few minutes.

It was 8 a.m. Ed got the Buick V-8 engine of the start cart going. The drive shaft started spinning, turning over the turbine of the J-79. Art opened the fuel line, set the throttle and hit the ignition. When he heard the engine fire he advanced power to 67 percent. Idle. He flashed the signal to Bud. Bud relayed it to Ed with a slashing motion. Ed shut down the V-8 and guided the drive shaft out of the nose cone as the truck hauling the start cart eased forward and pulled off to the side. There was nothing in front of Art now, just the expanse of salt with the black line down the middle and the mauve mountains far in the distance.

It was 8:03. The heat was already coming through the cockpit wall pressed against his right shoulder. He released the brakes and

started rolling, the J-79 in full military power. Then he went into second-stage afterburner for the first time on an LSR run. The tail pipe narrowed and orange and yellow flames shot out and a big cloud of salt was kicked up. No one had ever seen a start like it or heard one so intense. You could feel the noise vibrating your brain. Holy cow, they said, slightly stunned as Art shot ahead down the course. Then there was a scramble to the cars to follow. Humpy Wheeler set out in the official chase car with a photographer and doctor. Dennis Goulden lugged his 16mm camera and sound equipment into the car Ed and Bud were driving. All the vehicles carrying crew and Firestone people had a first-aid kit, fire extinguisher, crowbar and ax in the truck. Up ahead in the helicopter, at an altitude of 200 feet, photographer Eric Schweikardt started clicking.

Fifteen seconds have elapsed. The shaking eases as the *Monster* passes 300 mph. Then it's at 400 and climbing and the ride is smoothing right out. Up ahead Art can now see his giant signboard marking the start of the mile. His body is rigid, his gloved hands locked hard on the yoke. The *Monster* is a challenge to handle. He lets it wander so long as it stays inside the lines on either side of the course. When he does make a slight correction it takes all of his strength. It's like trying to steer a car in deep mud.

He's in the mile.

One . . .

The heat from the engine is getting intense.

Two . . .

The smaller sign for the start of the kilometer flashes past. The distance means a lot in Europe. Art doesn't give it much thought.

Three . . .

There's his second sign marking the mile exit. It's a speck in the distance.

Four . . .

He's almost through. He glances at his speedometer.

Five . . .

It's hovering at 600 mph. He was hoping for better.

Six . . .

He looks up to see the exit marker flash past and the center line off to the right. He is almost off the course, onto the rough salt. He turns the yoke and feels the *Monster* fight back. There is a shudder, like he has run over a big rock. The black line disappears altogether.

He's lost it . . .

He instinctively hits the switch killing the engine and presses the button releasing the chute. There is no time to tell if anything happens. He only notices in the brief flash of consciousness left him that the horizon is rotating.

He's upside down . . .

"Don't go fast," June had told him during his daily call home the evening before. His wife of 19 years flashes through his mind. So do his kids, his eldest Ronnie and young Timmy and his new baby girl Dusty. It bothers him that he hasn't spent more time with them . . .

Then everything goes black.

Pilot Bob Hosking and photographer Eric Schweikardt were hovering overhead in the helicopter and had the best view of what happened. They saw the *Monster* drift to the left of the black line and veer sharply back to the right. Then it started to roll. Eric caught it all in a series of pictures.

"It first flipped over on its right side and then suddenly it was upside down," he said. "There was an enormous puff of flame in the middle of it, and then Hosking began to crank the helicopter down on top of it. The *Monster* came out of the first roll, and it still had all its wheels. But it landed hard, right side up, and suddenly one of the wheels bounced high into the air toward us and almost went through one of the rotors. The wheel was almost as high as we were. The car was exploding in pieces on all sides. Then a parachute blossomed out of the smoke. The car went end over end, twice. It landed

on its side and began to slide, twistingly. It slid forever, kicking up salt."

Bob took the chopper down to land near the biggest piece of wreckage, the battered remains of the engine, Art's cockpit still attached to the side.

Trooper Lamar Melville was the first on the scene. He had set out from the USAC trailer at mid-course as soon as Art rocketed past and the plume of salt and smoke appeared moments later. Ted Gillette jumped into his ambulance to follow. Lamar, the sole trooper with the Wendover branch of the Utah Highway Patrol, had been on hand for countless runs on the salt going back to Athol Graham. He had seen the carnage that occurred when drivers cracked up at speeds much slower than what Art had been doing. He therefore knew Art was already dead. No one could survive a crash at 600 mph.

The *Monster*, what was left of it, was upright when he got there, the J-79 silent and smoking, wires and tubing spilling out like guts. The wheels had been torn off, the nose wing was missing, body panels were torn and twisted, salt encrusted everything like a thick frost. The smell of kerosene filled the air. Thankfully, there was no fire.

The canopy on the left side, Art's side, was long gone, smashed to pieces somewhere back down the course. The inside of the cockpit was frosted white like the rest of the wreckage. Art was still there, strapped in his seat, his left arm hanging out limply. And to Lamar's huge surprise, he was alive. "Be careful of my arm. I think it's broke," Art said weakly. "It scared the hell out of me," Lamar remembers today. The noise of a helicopter landing momentarily drowned everything out.

Bob Hosking was also certain Art was dead. No one could have survived what he had just witnessed. He ran forward, Eric following with his camera, and joined Trooper Melville. He noted

blood smeared on Art's face and spattered inside the cockpit and was equally surprised to see that Art was moving. He was groaning, reaching up to his eyes, which he seemed unable to open. A piece of chromoly tubing from the protective cage around him was bent across his chest, pinning him in. Bob, a big man, grabbed it and yanked it straight up with brute force. The ambulance arrived and Ted Gillette hurried forward.

Art had stopped moving now. He was unconscious.

Humpy Wheeler had now covered most of the distance from the start line, the doctor in the front seat beside him. Art had shot past 30 seconds after they had lit out. The impression from the chase car was of swirling white salt spray and a green-and-red streak. Humpy thought, Jesus, is a human really in that thing? In the time it took for the notion to pass through his mind the white cloud was far down the course.

And then it was rising into the air, much too high, and Humpy knew that the *Monster* had crashed. "I remember slowing down as we entered the wreckage field," he says, "because I didn't want to run Art over. I'd seen my share of racing accidents, but nothing like this. It was complete and total carnage."

Humpy pulled to a stop at the main piece of the car and joined the others already on-site. Art was drifting in and out. The doctor felt for a pulse.

Ed Snyder and Bud Groff were the next on the scene, cameraman Dennis Goulden in the back seat. They had driven down the course at a more sedate speed and didn't realize that something had happened until they saw chunks of black. Dennis immediately hoisted his camera and started filming out the windshield over Ed's shoulder, his microphone picking up the rising alarm.

"There's tons of rubber laying there . . . He blew a tire."

They continued on until they could see the green sign marking the end of the mile. Then they were getting into the main field of debris.

"There's part of the car . . . There's some more."

"Jesus, there's parts of the car all over."

"Oh God," moaned Ed. "I don't even want to go down . . . Oh my God . . ."

There was the *Monster* itself now, battered and smoking, cars and a helicopter in a ragged semicircle around it, people clustered at what was apparently the smashed remains of the cockpit. Bud pulled the car to a stop and got out, saying, "Let's go, let's go." Dennis lurched out the back with his camera. Ed stayed in the front seat, staring ahead.

"Come on, Ed. Might as well get out. There's no sense in holding up any longer."

"I knew he shouldn't a done it," said Ed, his voice breaking. "I knew he shouldn't a done it. Oh my God . . . I knew he shouldn't . . ."

"It's everyplace."

"Oh no . . . Art . . ."

They hurried up to the remains of their *Monster*, their beautiful *Green Monster*. Bud's face was hard. Ed, emotionally gutted, was crying. "Oh Art," he wailed as he stumbled forward. "Oh no, Art . . . Oh Art . . . Oh Art . . ."

The doctor leaning over the cockpit had found a pulse. Art was hanging on, bloodied but still in one piece. There was no telling, however, what the extreme forces he had endured had been done to his brain and his innards. They would have to be careful lifting him out.

As they began to shift him, the sound of Ed's weeping seemed to bring Art to his senses. "For Christ sake's Ed, shut up," he said. "I'm okay." And to the others: "Don't cut off my jacket." Finally they had him out and carefully eased onto Ted's stretcher. An ambulance plane, a little red Cessna, had by this time landed nearby. Ed and Bud helped carry the stretcher to it and loaded Art on board. The doctor and Firestone's Jim Cook squeezed in behind. There

was no more room for anyone else. "I think I'm all right," Art said again before the door was closed. "Will you call June and tell her I'm okay?"

The plane took off and banked toward Salt Lake City.

Back at the crash site there was a mix of hope and despair. Ted Gillette said that he hadn't detected any broken bones and thought that Art would pull through. He'd seen worse, much worse, in highway crack-ups. Some of the others weren't so sure. Athol Graham had been clinging to life too when they pulled him out of his racer. And Glenn Leasher had been killed at a much lower speed.

They were starting now to poke through the wreckage. Look at this, guys were saying, shaking their heads. And: Christ, look at that. The steering yoke was turned completely upside down. Then someone noticed the tattle-tale needle on the *Monster*'s airspeed indicator, the needle that stayed at whatever maximum speed was recorded. It was stuck at 640 mph. At Bonneville's altitude airspeeds tended to read about 30 mph faster than actual ground speed. That meant Art had been going about 610 when he crashed. No one had ever crashed a car at that speed before, let alone survived it.

"He coulda had the record," Joe Petrali was saying. He still had the slip of paper with Art's speed written on it for his first pass through the mile. The scribbled figure was 585.366 mph. Joe knew how records were set, with the second run usually faster. "He would have stepped her up just a little on the return run and he coulda had it."

Down the course the marks in the salt were being examined to determine the trajectory of the crash. The distance from where the *Monster* became airborne to where it hit on its first bounce was measured at 527 feet. At the speed Art was traveling he would have covered it in about half a second. The flying and bouncing and skidding all together covered more than a mile.

Ed, grim now and mentally exhausted, helped with the removal of the wreckage, loading it onto a flatbed. Then he hitched a ride

into Salt Lake City in Don Francisco's light airplane. They were met at the airport by a police car. It was on the drive to the hospital that Ed heard the news over the radio.

Art Arfons, three-time holder of the world land speed record, the announcement began, had crashed his racer that morning on the Bonneville Salt Flats. He had been pulled from the wreckage alive but had died on the way to St. Mark's Hospital in Salt Lake City. He was 40 years old. He was survived by his wife, two sons and a daughter.

Art's oldest son Ron was at Springfield High School in Akron when he heard what had happened. It was noon, right after art class. Ron was in the cafeteria when he ran into an older student he knew who had graduated the previous year.

"Oh man," his friend said, "I didn't think you'd be in school today."

Ron didn't know what he was talking about. "What do you mean?"

"I heard your dad got killed."

The news had been on WAKR, an Akron radio station. Ron, distraught, telephoned home to his mother to find out what had happened. June had heard the news too and had just lived through a few minutes of hell before receiving a phone call that Art was alive. She told Ron not to believe the news reports. Your dad's okay, she said.

Ron was sure that she was lying, that she was just saying that to ease the pain of him losing his father. He had driven to school that morning in the jalopy Art had helped him fix up, but he was too upset now to drive it back home. He left the car in the parking lot and started walking.

Walt Arfons in the meantime was on his way to the airport. He had heard what had happened to his estranged brother. He wanted to see him.

* * *

The attendant at the information desk directed Ed to the fourth floor of St. Mark's Hospital in Salt Lake City. No, she said, Arthur Eugene Arfons wasn't dead. He was definitely alive, in Room 464, listed in satisfactory condition. But when Ed entered the room there was no sign of his friend. For a moment he felt as if he had been played a very cruel trick. Then he heard the sound of running water in the bathroom. He opened the door and there was Art, alive and on his feet and gingerly taking a shower.

Art was in fact in unbelievably good shape, battered and bruised but not a bone broken and no sign of brain damage. Ted Gillette's on-the-spot diagnosis had been right. "It's amazing," said the attending physician. "He's not as bad off as an average driver in a rear-ender." The worst of the damage had been done to Art's exposed face. As the *Monster* tumbled and skidded, a whirlwind of salt had ripped away his goggles and scoured his flesh raw and scraped his corneas badly. It was his eyes, swollen shut and covered with gauze, that were now causing him the most pain, enough to require sedation.

A call was directed to Art's room later that afternoon. It was Craig Breedlove. They had an amiable chat, Craig offering condolences on the wrecked *Monster* and congratulations on Art's miraculous escape. Art hadn't reclaimed the record, but he had beat Craig for having survived the world's fastest crash. Zeldine Graham dropped in next for a visit. Art, she knew, was what her husband Athol had dreamed of being. Had Athol lived, they could have been friends.

Walt arrived in the evening from his rushed flight from Akron. He and Art took each other's hand and spoke and perhaps even hugged. When it mattered, they really did care about each other. They would never again be buddies, not like in the old days with their motorcycles and home-built airplanes. But much of the animosity between them would remain behind in that hospital room, left in the past.

By this time the journalists and TV crews had come and gone. Art, stretched out on his hospital bed, gamely tried to answer their

questions from behind the bandages over his eyes and through the pills he had been given. Were you frightened, Art, they asked him. Were you scared at all? Tell us.

"I was never scared. I just hung on. When I came to in the ambulance plane I could feel my toes and fingers and I said to myself, 'Boy, I'm all together.'"

So how was it possible that you survived?

"I didn't think it *was* possible to survive at such speeds," Art admitted. Then he grinned and raised his bare arms. "My leather jacket saved me, see? Not a scratch."

Does this mean you're done with land speed racing? Is it time to hang up the helmet?

It was very the day of his crash, and still Art didn't hesitate for a moment. "I'll be back," he said. He estimated that it would take a year to build a new racer. He already had some new ideas he wanted to try, including a cockpit ejection system. "My wife's a little worried. She's going to do a little hollering about this. So I'm going to have to square things away at home first."

Ed, off to the side, was still upset and emotionally raw. He wouldn't leave the hospital. He would stay there with Art the whole night. Now he said: Count me out. I've had it. I'm through.

"That's what he said last year," said Jim Cook. Jim figured that Ed would be back once he calmed down, that Art would again talk him around. But this time Ed meant it. He really was through.

Epilogue

Art checked out of St. Mark's Hospital and returned home to Akron the day after the crash. His eyes were still bandaged, but that didn't last long. He ignored the doctor's advice and removed the gauze before getting off the plane. He said, "Don't want to scare June." That weekend he was sitting down to Thanksgiving dinner with his family and watching a football game on TV. Then Ed pulled into the yard with the truck carrying the hulk of the *Monster*. Art gave his recovery another two days, then headed back to the shop to poke through the shattered remains. He wanted to know what had caused him to crash.

He found the answer in the right front wheel bearing. It was totally seized up. The grease-packed ball bearings inside the plum-sized assembly hadn't been able to handle the speed, Art's 600-plus mph. With the *Monster*'s wheels turning at 7,000 rpm, the ball bearings had gotten ahead of the thick grease and started rubbing against each other and against the spindle, superheating to the point where the whole thing welded together. When that happened the wheel tore off in an instant, dropping the racer's right front corner down onto the salt and starting it tumbling end over end.

There was nothing to salvage. "Just junk," was how Art put it. He received an offer to go on tour with the wreck and another to sell it for a good price so that it could be put on display. Having not broken

the record, he had nothing to show for the year and could have used the money. "But I couldn't do it," he said. "I turned them all down. The crew and I cut up what was left of *Monster*. She's piled there now, outside my shop. Looking at that pile I choke up. There was a lot of me in that car . . . an awful lot." Art would sell the remains to a local scrap dealer for just a few dollars, keeping only the tail. It still sits in his Pickle Road workshop, flecked with salt, leaning against the wall behind some dusty old engines.

It took most of the winter for Art to fully recover from the lingering effects of the crash, particularly the eye damage. He spent the time finishing his latest project, a boat, something he had been working on for more than a year. It was actually his old jet dragster *Cyclops*, mounted on pontoons, front wheels still in place. Art knew nothing about boats apart from his experience on a U.S. Navy landing craft in the Second World War. But he had an idea for a quick and cheap shortcut to the water speed record: to literally drive *Cyclops* on water. As he figured it, once he got to around 150 mph, the pontoons would rise up out of the water and the front wheels would start rolling along the surface, which at high speed would be as hard as Bonneville salt. This would eliminate much of the friction associated with a boat's passage through the water, cushion it from ripples and allow him to shoot right past the record.

The idea never panned out. In a series of low-speed test runs in 1967, the unwieldy-looking contraption June called Art's "Green Submarine" displayed a dangerous tendency to plow into the water. He prudently decided to abandon the project.

Art returned to what he knew after that and started building a new *Green Monster* land speed car, just like he said. And Ed, just like *he* said, refused to help. The vehicle, completed in 1968, was similar in outward appearance to its pulped predecessor and equipped with another J-79 engine, but it was lighter and more streamlined and had a better ratio of power to weight. With it Art was confident he could reclaim the record, maybe even go supersonic. But he never got the chance. Firestone was scaling back on its involvement

in racing and no longer wanted to back him. The company in fact would ultimately pull out of motor sports altogether—NASCAR, Indy, land speed, the works—and cede victory to Goodyear. Unable to find a new sponsor to pay the hefty fees for renting the salt and bringing in timers, Art ended up running the car only on drag strips and eventually sold it off in frustration for $100,000. His son Tim still has the receipt. The buyer, California rancher Slick Gardner, rechristened it the *Anderson Pea Soup Monster* and drove it in a bid for the LSR in 1978. He failed.

It was at the wheel of his next creation, a jet-powered dragster dubbed *Super Cyclops*, that Art had by far the worst racing experience of his life. It happened at the Dallas International Motor Speedway on October 16, 1971, Art driving on Goodyear tires for the very first time. In a warm-up run prior to an announced attempt at 300 mph, the car crashed through a guard rail at top speed, killing the local newscaster riding shotgun in the second cockpit and two track workers watching from the side. "Everybody was sure that Art was dead," recalls Bud Groff's son, Ted. "The car was lying on his side and there's just no way he made it. But as Pappy is standing there, waiting for the truck to come to winch the car up, he sees the dirt start moving. He said it was just like a God-damned rat trying to climb out of a hole." Art, knocked unconscious by the impact, had been saved from the resulting fire because his side of the car was buried in mud. He once again miraculously escaped with little more than cuts and bruises. Emotionally, however, the incident was devastating. "I think the man will be lucky if he doesn't end up in a mental institution," said a track spokesman after witnessing how Art wilted upon being informed of the three deaths. A tire blowout was believed to have caused the mishap. Art never returned to drag racing after that day.

Casting about for some other source of income to support his family, Art fell in with a group of franchise developers who wanted to open a chain of Art Arfons Speed Shops. It gave him some nice quiet work for a while, sitting in a shop from nine to five, which he

hated. Then the venture folded and he was once again at loose ends. What he stumbled on next, more fortuitously, was tractor pulling. In 1974 he was back in competition, driving an aircraft engine-powered farm machine called, of course, the *Green Monster*. The sport of professional tractor pulling, where he would be a pioneer of jet turbines, would provide Art with his livelihood for the next 25 years.

It was at this point that he lost Bud too. "Art's crash in '66 changed Ed Snyder a hell of a lot," says Ted Groff, "but it didn't change Pappy. What did it for him was when Art quit running the cars and started running the tractor. Pappy said, 'I ain't into no God-damned tractors. I ain't going with you.'"

Art's failure to get a sponsor for another LSR bid delivered a roundabout blow to Craig Breedlove. As long as Craig held the record, there was no compelling reason for Goodyear to back him for a return to the salt flats. "Any time we want to publicize or talk about the land speed record, we can do it already," reasoned a Goodyear insider. "Why do we need a new record?" It meant that Craig too was out of the game. Without competition, without the back-and-forth dueling with Art, there wasn't enough excitement to stir up interest and attract sponsorship dollars. "Nothing could get me a sponsor quicker than if somebody broke my record," Craig said in 1970. "Everybody's welcome—as long as they leave the sound barrier to me." But there weren't any takers, at least not quite yet. And so the LSR stayed at 600 mph as Craig's life started going downhill.

Strike one was the breakup of his marriage. When ABC aired the special *The Racers: Craig and Lee Breedlove* in 1968, the couple was in fact no longer together. Lee had left to marry Nye Frank, crew chief for both *Spirit* projects. In the divorce settlement Craig lost his Palos Verdes home and a good chunk of his savings.

Then the Goodyear store failed. That was strike two. Everything Craig had coming to him from his 600-mph record had been tied up in the venture. Now it was gone. And then, for strike three,

something a little different: a flood hit LA in January 1969, sub-
merging Craig's garage under four feet of water and mud. Cars,
equipment, paperwork, manuals, engines—everything was a mess
and mostly unsalvageable. And he didn't have insurance.

The biggest losses were the racers he had built as part of a proj-
ect with American Motors, including a streamliner called *American
Spirit* to go after the Summers brothers' wheel-driven land speed
record. Craig had unveiled it at a media event the previous summer
at which Lee's attorney had hugely embarrassed him by showing up
and publicly serving him with divorce papers. Bad weather subse-
quently kept the car off the salt flats that year. Now, in the wake of
the flood, it would never make it. American Motors didn't want to
sink any more money into getting *American Spirit* cleaned up and
restored. Later that spring they pulled the plug on the whole pro-
gram, the best thing Craig had going. It left him adrift. Hope briefly
rekindled when the opportunity arose for him to drive Donald
Campbell's *Bluebird*, on display in a British museum, for the wheel-
driven record. Tonia Campbell, Donald's widow, liked the idea. But
others didn't. The project never came off.

By 1970 Craig had fallen on hard times. He was bankrupt, living
in a room over his mud-spattered garage, driving an old Buick one
clunk away from the scrap yard. It was the lowest point of his life.
And then, on October 23, 1970, he didn't have the LSR either. Gary
Gabelich broke it in a rocket car called the *Blue Flame* with a two-
way average of 622 mph. It seemed at first a lucky break, for it meant
there was once again competition. But Craig was unable to find a
sponsor. Not even Goodyear was interested anymore.

"When Craig set his last record," says George Klass, "Goodyear
ran these full-page ads in magazines like *Life* and *Look* that said,
'We test our tires at 600 so yours will be safe at 60.' That's how they
wanted to promote it. What are they going to do with a new record,
say: 'We test our tires at 630 so yours will be safe at 63'? I mean,
it's just pragmatic. The idea of going 630 mph or whatever had no
benefit to them."

During the 13 years in which Gabelich would hold the record, Craig doggedly struggled back to his feet. Salvation for him would be in sales, a skill that had served him so well in winning over Shell and Goodyear back in the day. This time he applied himself to the housing market, becoming a real estate agent and then an investor, working his way back to financial health and then on to wealth. Finding the way to business success kept his attention diverted from racing throughout the late 1970s and on into the '80s. But the yearning to return to LSR competition stayed with him—especially after Englishman Richard Noble went 633 mph in his *Thrust 2* jet car in 1983. For Craig, that added national pride to the fire. Slowly, methodically, long-dormant plans for building a third *Spirit of America* racer started coming together, one that could reclaim the record for the USA and add "First to 700" to Craig's long list of achievements.

It would take more than a decade to find sponsorship and get the car built and then run it. Like in the old days, Craig would seek out help wherever he could find it, including among his old crew. One of those he approached was Bob Davids, the surfboard-building teen who had done fiberglass work on both *Spirit* racers. Bob, who had become a successful entrepreneur and CEO, turned him down. "Craig," he said, "I've got companies to run. I can't just drop everything and go with you." Craig would also sound out George Klass, who had made those memorable runs in the supply truck through the Watts Riots. "My first thought," George recalls, "was, 'I don't want to work that hard.' We worked 20 hours a day, seven days a week on *Sonic I*. We had no life. We were just passionate. I'm not that passionate about cars anymore. And I sure as hell don't have that kind of energy." Ultimately, Stan Goldstein would be the only member of the old crew to get involved in the new project. He would serve as manager.

Art in the meantime had become a tractor-pulling star with his fire-spewing, twin turbine-powered *Green Monster*. His son "Turbo" Tim and his daughter Dusty, the "Dragon Lady," joined him on the

pull circuit aboard machines of their own, making it a family busi-
ness. But as with Craig, the salt stayed at the back of Art's mind, a
yearning to resume the quest for the record that just wouldn't leave
him, even though he was now in his 60s and running on a heart
patched up with a triple bypass. It finally drove him to begin work
on another land speed racer, *Green Monster* No. 27. He would build
it with Tim's help and, as usual, with his own money. Number 27
would look very different from his previous *Green Monster* jet cars,
small and low and with just two in-line wheels to reduce ground
effects and drag. The wheels, moreover, would be bare metal discs,
an LSR innovation. They freed Art of the need to find a sponsor to
develop and fabricate custom-made tires—and from the worry of
his old nemesis, a blowout. The waist-high machine's overall weight
when it was finished was a scant 1,800 pounds, a quarter that of
Art's Bonneville record-setter. Equipped with a J-85 jet engine gen-
erating 4,500 pounds of thrust, it would have one of the highest
power-to-weight ratios in LSR history.

June was upset when she discovered what Art was doing. It
dawned on her when she came into the workshop one day, three
years into the project, and saw the car there, nearly complete. The
thought of having to again endure all the anxiety of the mid 1960s
was momentarily too much. She picked up a metal bar and threat-
ened to ram it through the engine. Art said that he would have to
mortgage the house to buy a new one if she destroyed it.

He went ahead and finished the car. He also built a centrifuge,
a pod on the end of a rotating arm, to reacquaint himself with the
feel of high speed. He would take many rides in the thing, spinning
around and around in his backyard, until he could handle the Gs.

Art headed back to Bonneville in July 1989 after an absence of
23 years. This time Tim went with him to help. Ed declined to make
the trip and Bud had just died. For Art it was a matter of personal
satisfaction. He didn't have a sponsor like Firestone or the prom-
ise of a bonus and endorsement deals if he succeeded. He didn't
even have a company backing him for a salt booking and timers.

He would be running on the cheap thanks to a cost-sharing outfit called the Utah Salt Flats Racing Association.

There were tears as he set out from Akron. The departure was all the more painful for June because of the shocking death just days before of Craig Arfons, Walt's son, while chasing the water speed record. Walt, 72 and retired, witnessed the whole thing from the pier with Gertrude standing beside him, the horror of the jet boat rising into the air at 370 mph and then coming down and smashing to pieces. Walt had told Craig just before the run that he was uneasy about it, but his son reassured him. "He told me, Dad, if it starts to get airborne, I'm going to do what you always said—shut it off and go back and start again. There's always another day, always another run.'" But for Craig Arfons there wasn't. He was the sixth driver to die since the 1930s trying to break the water speed record.

Out on the salt flats, Art would fly too—at the age of 64 and an estimated speed of 350 mph. "The car had gone over the horizon," says Tim, "and all of a sudden we could just see it pointing straight up like a rocket taking off and there was a bunch of dust. I thought Dad was history. I thought that was it."

The *Monster* was lying on its side when they got there, the canopy blown off. For having flown 30 feet into the air and rolled twice, it was in pretty good shape. And Art was okay. "I think I goosed it too much," he said as he was helped out, bruised but otherwise undamaged. And: "I seen the horizon fall off the windshield and I knew I was in trouble. The first thing that came to my mind was, 'Oh, shit. Not again.'"

Art and Tim repaired and modified the car over the next year, abandoning the two-wheel configuration as unstable and going with four metal wheels: two inside the body up front, side by side, and two in the back projecting out on spindly outriggers. When they returned to Bonneville in 1990, Art managed a top speed of just 338 mph. The acceleration, the brutal vibrations, the salt dust that got in his eyes and blinded him—it all proved too much. The experience left Art feeling disgusted with himself more than anything

else—disgusted with the way his strength and willpower had faded; disgusted with the way his aging body was letting him down.

Art would take the car out to the salt one more time in 1991. When he got there he found a note from June in his suitcase. "This is sort of personal," he said, offering to show it to the film crew that had tagged along to make a documentary called *The Green Monster*. The interviewer urged him to read it on camera. Art shyly took the paper back and put on his glasses.

"'Art,'" he read, "'please don't let anybody influence you to go fast. You've done a lot more now than you ever expected to do in racing. Don't do anything foolish, because I love you.'" When he reached those last words his voice was just starting to break.

Art didn't go very fast on his final Bonneville appearance. When it was done he took a few hours to think things over and then made an announcement. It was nothing grandiose, just a simple statement: "I'm not going to run no more. I think it's time. I owe it to June."

Craig Breedlove was on the salt with Art in 1990 as a spectator. In a quiet moment he gave his old rival some advice similar to June's: Don't try to rush things; don't do anything foolish. "I saw an old friend who was visibly shaken," Craig would say later. "It's the first time I'd ever seen him without an air of confidence about what he was doing. I thought about it before I did it and I told him what I thought. That's all . . . I'm glad he got to build his car, bring it out. He found out something. Now he can retire knowing that he came out and gave it a try. I think that's fine. I'm very happy that he's safe. I love the guy and don't want to see him get hurt."

Craig himself was then in his 50s, no spring chicken by LSR standards but nevertheless working his way back into the game. He was now based in the town of Rio Vista outside San Francisco, in a former car dealership he had converted into a workshop. Here, during the first half of the 1990s, a revolutionary new car would take shape. He called it *Spirit of America—Sonic Arrow*.

Sonic Arrow would be a four-wheeler but laid out in a tricycle pattern like the first *Spirit*, the wheels in front set side-by-side within the body, the ones in back nearly eight feet apart on outriggers. Craig didn't like the idea of metal wheels; he would go with Kevlar tires. The engine would be a modified J-79 producing 23,000 pounds of thrust in full burner, running on Shell Premium Unleaded. The body, an air duct on each side, would be tubular in cross section and set close to the ground. The top of the chassis would be barely waist-high, Craig lying almost flat on his back in a cockpit up front. And at the back there would be no single tail fin like the one that caused the teeter-tottering with *Sonic I*. Instead, *Sonic Arrow* would have three low tail fins, one in the center and one atop each outrigger. When fabrication was complete, Craig once again went with a vaguely American-flag paint job, this time a base of white with subtle red and blue stripes. Sponsorship logos were the final adornment, familiar names like Shell and Goodyear among them. The main sponsor, however, was Craig himself. *Sonic Arrow* ended up costing him personally over a million.

Bringing the car to completion in 1996 was just the first hurdle Craig had to clear on his way to the record. When that was done he had lawsuits to contend with, one filed by an unhappy sponsor, another by a disgruntled project member who had been let go. Obtaining the services of an official timing association was also a problem, USAC's price having risen to a bare minimum of $150,000. Craig eventually got the International Motor Sports Association to provide a bare-bones service for the nominal sum of one dollar. Then there were the environmentalists, a new twist for the '90s. A jet car making noise in the desert was an abomination in the eyes of Gaia, the painting of course lines an ecological disaster that had to be blocked.

Craig finally made it in October 1996, 31 years after his last LSR run. He took *Sonic Arrow* to Black Rock Desert in northwest Nevada, the same place Richard Noble had set his still-standing 633-mph record. It was America's new mecca for ultimate land

speed, with more space than Bonneville, diminished after a half-century of salt mining. Craig's immediate goal was 650 mph, good enough to beat Noble and return the LSR to the States. After that he would cautiously advance toward 700. There was some urgency to get the job done, for Noble had just completed a new car of his own, a twin-engine brute called *Thrust SSC*, and was aiming straight for Mach 1. He and driver Andy Green were about to run on Jordan's Al-Jafr Desert. Another speed duel was in the making.

Noble and Green failed to break the record in Jordan that autumn. Craig also failed, more spectacularly, at Black Rock. The reason wasn't any shortcoming with his racer. *Sonic Arrow* was better designed, lighter and more powerful than *Sonic I* and had definite record-setting potential. What undid Craig was a simple misunderstanding. "One-five" was the wind report that came over the radio prior to his run. He took this to mean that the wind was wafting at mid-course at an acceptable 1.5 knots. It wasn't. It was blowing at a dangerous 15. As Craig entered the measured mile at 675 mph, faster than he intended, a crosswind caught the *Arrow* and tipped it onto its side and sent it arcing off course. Fortunately it righted itself, the chute deployed and Craig escaped unharmed. The car wasn't so lucky: the frame was bent and the left side was damaged. Craig didn't leave Black Rock that year entirely empty-handed, however. He had beaten Art's record for surviving the world's fastest car crash.

Craig returned to Black Rock the next year to try again. This time he would share the desert with Noble, Green and *Thrust SSC*. But Craig's luck had run out when he led off in September 1997. In a preliminary run something got sucked through *Sonic Arrow*'s engine and wrecked it. Craig, undaunted, hauled it back to Rio Vista and installed a second J-79 he had on hand as a spare. "The key," he said, "is persistence."

Before he could regain his momentum, however, the Brits swept the field. On September 25 Andy Green set a new record of 714 mph,

robbing Craig of the first-to-700 distinction he had been hoping for to close out his career. And then, on October 15, Green pushed *Thrust SSC* even faster—and the spectators lining the course heard an unmistakable boom. The verdict after the return run was a two-way average of 763 mph. For the atmospheric conditions that day at Black Rock, that was just under Mach 1.02.

Although the bar had now been raised very high, Craig entertained hopes of mounting a renewed assault on the LSR for another eight years. The main hitch was the difficulty in lining up sponsors. The sport had become so cripplingly expensive that whatever financial advantage there might once have been was now gone. "If you're a sponsor, what good is it?" admits Stan Goldstein. "I mean, when you can spend a third of the money on a NASCAR race and get five times the exposure. It just doesn't make good business sense."

Craig finally made the decision to give up the LSR quest in 2006. He was 69 and had been at it for nearly half a century. He sold *Sonic Arrow* to millionaire adventurer Steve Fossett. Fossett died in a plane crash before he was able to run it.

Craig doesn't see much future left today for the land speed record. Everything about the sport, from building a car to paying for course bookings and timers, has become too expensive. "You might pull it off for 10 million dollars. But offhand, I'd say 15 to 20 million would be a more realistic figure. The thing is, everything costs so much now compared to what we spent in the '60s. Just to go buy an aircraft bolt now, it's really expensive. And another problem is that nowadays the military blows holes in the sides of discarded engines with a cutting torch and you can't fix them. They are literally destroyed so they can only be used as scrap metal. So just trying to find a surplus engine that you can make runnable is really hard to do."

These and other challenges mean that there are few who are now actively chasing the Big Number. Richard Noble and Andy Green, their 1997 record still intact, are the most serious contenders. They have a new machine called *Bloodhound* at the design stage and are seeking funding to build it. Their stated goal is 1,000 mph. "It's not

going to happen," says a former member of the *Spirit of America* team matter-of-factly. That opinion is shared by others in the old land speed fraternity from the 1960s. Now that the record has gone supersonic, the difficulties are too daunting and the costs are too great. The Big Number might be nudged up a bit higher, but for all intents and purposes, the land speed adventure is over. The game has been played.

Craig is in his early 70s now, remarried and content to rest on his laurels. He keeps busy with trips to California and Nevada where he has business interests, but for the most part spends his time quietly in the Mexican resort town of San Carlos with his wife and his dachshund. "You can't do it over, so I'm satisfied," he says of the decade when he pushed the land speed record up through 400, 500 and 600 mph. "Obviously you can look back and Monday-morning-quarterback all your mistakes. And they were numerous. It was a time when basically I was growing up and learning and becoming an adult. The main thing is that I'm content with my life now. I'm happily married and in a nice place. Things are good."

Walt Arfons is still kicking in his 90s as this book goes to press. After many years of retirement in Florida, he and Gertrude have moved back to Akron to be near their remaining son and their daughter. Walt's memory and eyesight are still good, but he has difficulty walking and his hearing is shot. Too much exposure to the roar of jets and rockets, he says.

As for Art, he passed away on December 3, 2007, two years after his old friend Ed Snyder. He was 81. He lies today in a green casket in Akron's Mt. Peace Cemetery, wearing the fire suit he used when he set his three land speed records, the white outfit with "Firestone" and "Art Arfons" in red on the chest. He has a wrench in each hand, his J-79 jet engine manual beside him, and a jar of Bonneville salt at his feet.

Sources

1. The L.A. Hot Rodder

For Craig's early life and the beginning of his struggle to build a jet car, I interviewed Craig Breedlove; his mother Portia Bowman and half-sister Cynthia Bowman; Bill Moore, his friend since elementary school; Stan Goldstein, who first met Craig in junior high; and Art Russell and Mike Freebairn, who got to know him in high school. Craig's autobiography *Spirit of America*, chapters 1–5, co-written with Bill Neely, was the most useful published source. Other books and articles: "Never Scrap a Coupe," *Hot Rod*, Sept. 1960 (about Craig's '34 coupe); Craig Breedlove, "Driving a World's Record 407 Miles Per Hour," *Popular Mechanics*, Nov. 1963; Paul Clifton, *The Fastest Men on Earth*, chapter 22; Hays Gorey, "Cool Run For an Old Hot Rodder," *Sports Illustrated*, Aug. 19, 1963; Peter J. R. Holthusen, *The Fastest Men on Earth*, 136–138; Jim Murray, "Love and Carriage," *LA Times*, June 12, 1964 (includes an account of Craig's crash as a teen); Cole Coonce, *Infinity Over Zero*, 41 (more on the crash); reports on L.A. hot-rodders being arrested in the *Long Beach Press-Telegram*, Sept. 10 and 12, 1952; and Harvey Shapiro, *Man Against the Salt*, chapter 14. Also worth noting is the 1963 documentary *Spirit of America*, which contains footage of Craig's jet car in the early stages of construction with voice-overs by Craig and some of his friends.

For Mickey Thompson's story, I interviewed Mickey's first wife, Judy Creach, and his chief mechanic and partner Fritz Voigt. Other important sources were Mickey's 1964 autobiography, *Challenger*, written with Griffith Borgeson, and Erik Arneson's 2008 biography *Mickey Thompson*.

2. Bonneville 1960

For the story of Athol Graham and the *City of Salt Lake*, I interviewed Zeldine Graham, Athol's son Butch Graham, Otto Anzjon's sister June Rock, and LSR historian Harvey Shapiro, who conducted extensive interviews with Zeldine back in the early 1970s and is now writing a book on Athol. Butch and June also provided a wealth of clippings and photos from their personal collections and, from Butch, copies of Athol's correspondence and letters of condolence to Zeldine. The quoted letter from Firestone regarding tires is S. E. Petrasek to Athol Graham, Dec. 11, 1957, Butch Graham Collection; the press conference telegram is Firestone to Athol Graham, July 12, 1960, ibid.

The most comprehensive coverage of Athol's LSR quest and death is found in the *Deseret News*, 1959–60, in particular Hi McDonald's and Hack Miller's reports, and in Marion Dunn's pieces in the *Salt Lake Tribune*. J. M. Heslop shot a photo of Otto weeping beside the wreck of the car that appeared in the *Deseret News* on Aug. 2; it won a prize at the Utah State Fair later that year. The *East Mill Creek Neighbor*, Athol's neighborhood paper, published a piece on him in Aug. 1960 containing useful background information. Other eyewitness accounts of Athol's crash are in Thompson, *Challenger*, chapter 31 and Hays Gorey, "Death on the Salt Flats," *Sports Illustrated*, Aug. 8, 1960. Other sources: Charles Nerpel, "344.7 Miles Per Hour," *Motor Trend*, Mar. 1960; Griff Borgeson, "Bonneville Newsletter," *Sports Cars Illustrated*, Nov. 1960; Floyd Miller, "Race Against Death," *Reader's Digest*, Oct. 1963; and Doc and Wendy Jeffries, "The City of Salt Lake Liner, Parts I and II," *Bonneville Racing News*, Jan./Feb. and Mar. 1993.

3. The Pickle Road Mechanic

The best published sources on Art's early life and racing career are Frederick Katz, *Art Arfons*, chapters 1–4, and Harvey Shapiro, *Man Against the Salt*, chapters 10, 11 and 25 (recollections by Ed Snyder, Art's sister Lou Wolfe and Art himself). I also interviewed and/or corresponded with Lee Pendleton, a friend of Art and a fellow drag-strip competitor going back to the 1950s; Walt Arfons; Art's son Tim Arfons; Walt's son Terry Arfons; Art's sister Lou Wolfe (given name Gresola); Art's nephew Tom Joswick (Lou's son); and Ed Snyder's widow, Nadine Snyder. Tom Joswick additionally shared with me valuable clippings and photos from his collection on his two racing uncles going all the way back to a feature on the Arfons mill in the *Akron Times-Press* from Dec. 5, 1937, containing a picture of 10-year-old Art. For more on the strained relationship between Art and Walt, see Jack Olsen's two-part feature, "Enemies in Speedland," *Sports Illustrated*, Nov. 29 and Dec. 6, 1965. Art's recollection of his first meeting with Donald Campbell is from the Jack Olsen tapes (University of Oregon Library Special Collections and Archives, Collection Number Ax322, Series VII, Boxes 12 and 13), reel 100, side A. Also worth noting are Art and Walt Arfons, "How to Build a Championship Rod," *Rod Builder and Customizer*, July 1956, which gives a rundown of the brothers' co-built *Green Monsters*, and Bob Behme, "Jet Age Stopping," *Car Craft*, Aug. 1960, which refers to Art as the first drag racer to use a chute. An earlier reference to Art using a chute, complete with photos, is "Arfons Hits 171 mph for Mark," *Detroit Times*, Sept. 7, 1959.

There is some confusion as to who was first to do 150 mph in the quarter mile. Art claimed that he was—at the National Drag Championships in Kansas City on Aug. 31, 1956. *Hot Rod*, Nov. 1956, bears this out: "Art set a speed of 150.00 mph—E.T. 12.21—to become the initial member in Hot Rod Magazine's new '150 MPH Club.'" It seems indisputable from contemporary newspaper accounts, however, that Lloyd Scott in *Bustle Bomb* was in fact first. He did it at the World Series of Drag Racing in Lawrenceville, Illinois on Aug. 20, 1955, with a top speed of 151.007 mph.

Sources for the continuing story of Mickey Thompson included my interviews with Judy Creach and Fritz Voigt; Thompson, *Challenger*, chapters 31–32; and Arneson, *Mickey Thompson*, chapter 4. Contemporary newspaper accounts of Mickey's 406-mph run state that it was a broken drive shaft that spoiled his return trip. It was Voigt who said that it was actually a blown engine. (Arneson, pp. 110–111. See also the comment by Mickey's son Danny Thompson, pp. 24–25.)

A good day-by-day account of the 1960 Bonneville LSR season is Don Francisco, "Big Boys at Bonneville," *Car Craft*, Jan. 1961. Shapiro, *Man Against the Salt*, chapter 13, includes useful information, including Art's reminiscences of running *Anteater*; Campbell's "for the hell of it" comment is on p. 73. The documentary *The Green Monster* contains footage of Art and Walt in the old dragster days; *The Long Black Line* shows the *Anteater* in action at Bonneville.

The story of Donald Campbell's 1960 attempt was gleaned from reports in the *Deseret News* and *Salt Lake Tribune*, write-ups in *Sports Illustrated* by Hays Gorey (Sept. 26, 1960) and Kenneth Rudeen (Aug. 22 1960 and July 29, 1963), and Leo Villa's eyewitness account in the *Record Breakers*, chapter 9, which includes a diagram of the trajectory of the crash. Controversy would arise over Donald's claim that he was going 365 mph at the time of his crash in light of the fact that he had covered only 1.7 miles. "No [wheel-driven] car could accelerate that fast," an anonymous Bonneville veteran said in *Sports Illustrated*, July 29, 1963. "Its wheels would have been spinning and digging holes in the salt that you could stand in." A more realistic figure would be around 240 mph. The crash was accompanied by wheel spin resulting from loss of traction, which would account for the higher speed recorded by the telemetering equipment.

4. Spirit and Cyclops

The scene of Craig's initial meeting with Bill Lawler is based mainly on Breedlove, *Spirit of America*, chapter 7. For the continuing

story of Craig's struggle to build the jet car, I interviewed Craig Breedlove; Bob Davids; Lee Frank (formerly Lee Breedlove); Mike Freebairn; Stan Goldstein; Bill Moore; Art Russell; and Rod Schapel. Published sources are as cited for chapter 1. *Spirit's* unveiling at the Wilshire Country Club was reported in the *LA Times*, Aug. 5, 1962; film footage of the event appears in the documentary *In Search of Speed: The Battle of Bonneville.*

For Art's second trip to Bonneville with *Anteater*, see "Biggest and Fastest Streamliner," *Hot Rod*, Dec. 1961, and the usual sources of the *Salt Lake Tribune* and *Deseret News*. Sources on *Cyclops* include Katz, *Art Arfons*, chapter 5; Shapiro, *Man Against the Salt*, 191–195; "The Cyclops," *Motor Trend*, June 1962; and Lee Kelley, "The 'Green Monster' Man," *Hot Rod*, Aug. 1968. I also interviewed Tim Arfons and Tom Joswick.

For Walt's role as the pioneer of the jet car, I interviewed Walt Arfons and his son Terry Arfons. See also Griff Borgeson, "It's Still Only Hot Air," *Car and Driver*, Feb. 1962; Griff Borgeson and Wayne Thoms, "World's Fastest Dragster," *The How-To Book of Hot Rods*, 88–91 (includes a photo of a young Craig Breedlove posing with Walt, captioned: "Craig Breedlove has gained unique knowledge of jet land vehicles from GM-16's team"); Keith Thorpe, "Jet Dragsters . . . The Grounded Missiles," *Popular Hot Rodding*, April 1963; "All About the Weinie Roasters," *Modern Rod*, July 1963; "Flame Ranch," *Drag Strip*, Dec. 1967; and Shapiro, *Man Against the Salt*, chapter 16.

5. Doc's Red Racer

For Nathan Ostich and the *Flying Caduceus*, I interviewed and corresponded with Al Bradshaw, the only full-time, paid employee of the project and the only principal *Caduceus* member still living. I also interviewed Joann Brock, Ray's widow, and Bob Merriam, who helped the *Caduceus* team as a volunteer at Bonneville in 1960 and '62. The primary newspaper sources were the *Los Angeles Times*,

Deseret News and *Salt Lake Tribune*. The Firestone-sponsored documentary *The Long Black Line* was also useful, containing a segment on the *Caduceus* with narration by Ostich. Also worth noting is the 1970s film *Chase the Wind*. Other published sources: Robert Hyatt, "Jet Car Aims at 500-MPH Record," *Popular Science*, July 1960; Ray Brock, "The Flying Caduceus," *Hot Rod*, Oct. 1960; Thomas Stimson, "Bonneville's Magnificent Trials— and Errors," *Popular Mechanics*, Dec. 1960; Don Francisco, "Big Boys at Bonneville," *Car Craft*, Jan. 1961; Paul Clifton, *The Fastest Men on Earth*, chapters 18 and 20; Peter J. R. Holthusen, *The Fastest Men on Earth*, chapter 7; Louise Ann Noeth, *Bonneville: The Fastest Place on Earth*, chapter 8; and Robin Richardson, "Medical Records," www.thrustssc.com/thrustssc/Club/Secure/ Medical_Records.html.

6. Zeldine and Otto and Harry

For the reincarnation of the *City of Salt Lake* after Athol Graham's death, I interviewed Zeldine Graham, Athol's son Butch Graham, Otto Anzjon's sister June Rock, and Harry Muhlbach, and I corresponded with Athol's daughter Loie Graham. June and Butch also provided me with material on Zeldine and Otto from their personal collections, mainly clippings from the *Deseret News, Salt Lake Tribune* and *East Mill Creek Neighbor*. The two letters quoted offering Zeldine assistance in rebuilding the car are Van Washburn to Zeldine Graham, Sept. 22, 1960, Butch Graham Collection, and Scott Cheesman to Zeldine Graham, Sept. 22, 1960, ibid. I also spoke with Scott's widow, Zina Cheesman. Other published sources: Floyd Miller, "Race Against Death," *Reader's Digest*, Oct. 1964; Doc and Wendy Jeffries, "The City of Salt Lake Liner, Part III: Otto Anzjon Rebuilds," *Bonneville Racing News*, April 1993 (reprinted in *Goodguys Goodtimes Gazette*, Nov. 1993); and the write-ups on Otto and on Harry's crash in the "Scorecard" section of *Sports Illustrated*, Dec. 10, 1962 and Oct. 28, 1963.

7. Out of Control

For *Spirit of America*'s first disastrous season at Bonneville, I interviewed Craig Breedlove, Bob Davids, Mike Freebairn, Stan Goldstein, Bill Moore, Art Russell and Rod Schapel. Breedlove, *Spirit of America*, chapter 9, was also an important source, detailing the problems plaguing the car and the tension between Craig and Rod. Film of the car in action in '62 is in the documentary *Spirit of America*. For Art Arfons and *Cyclops*, see Katz, *Art Arfons*, 50–53; Shapiro, *Man Against the Salt*, 194–195; Keith Thorpe, "Jet Dragsters . . . The Grounded Missiles," *Popular Hot Rodding*, April 1963; "All About the Weinie Roasters," *Modern Rod*, July 1963; and the *Deseret News* and *Salt Lake Tribune*, Aug. 10–25, 1962.

8. Infinity

The story of *Infinity* is based primarily on my interviews and correspondence with Vic Elischer and on my extensive e-mail exchanges with Tom Fukuya. Both were immensely helpful in dredging up memories, some of them painful. Tom told me that before sitting down to write responses to my questions, "All was blanketed by a thick fog of tragedy, loss, wasted effort and missed opportunity." Tom Hanna recounted his memories of hanging around with Glenn Leasher in the early days in Wichita, while Bill Kaska shared his recollections of being Glenn's friend after Glenn moved to the West Coast. Bill was also a witness to the crash and still has a piece of *Infinity*'s aluminum body with its name painted on it in red. I also corresponded with Ron Christensen, who grew up in Wendover and spent many hours on the salt in the 1960s watching the racers and taking photos. Ron left the bone fragments where he found them. He took home several pieces of the car as souvenirs, some of the aluminum body and the parachute.

Published sources included reports in the *Oakland Tribune*, *San Mateo Times*, *Deseret News*, *Salt Lake Tribune* and *Los Angeles Times*; "An End to Infinity," *Time*, Sept. 21, 1962; Cole Coonce,

Infinity Over Zero, 111, 139, 148–149 and 156–157; and Ugo Fadini, "The Infinity Jet Car," www.ugofadini.com/omicron-10story.html. Footage of the crash appears in the documentary *The Bold Men*, broadcast on ABC television in 1965, and the later film *The Green Monster*. This is likely the footage shot by Salt Lake City cameraman Gale Boden, who according to the *Deseret News* was covering Glenn's run for CBS. It doesn't appear that the crash was broadcast live on national TV, as has been stated in several LSR books.

With regard to what precipitated the crash, Tom Fukuya speculates that torque caused by the afterburner may have been responsible for veering the car off course in the first place. "I believe the crash was caused by Glenn determinedly holding the throttle down no matter what, and possibly running into an unexpected torque steering effect. After the total load was put on the left wheels when the car rolled leftward, the front wheel bearings failed, fused and burned through the stub axle. The car slammed down and was shattered. From the time the car left the track and began running on the rough salt until it rolled, Glenn had several seconds to throttle the engine down and deploy the chutes, but chose not to do so."

Shortly after Glenn's death, Tom became a conscientious objector when he received his draft notice. "I guess Glenn's death did affect me," he says. "All I knew was that I never, ever, wanted to be involved in another's death again, and nobody was going to get me to do that, especially by threats or by force." He did alternate service instead, working with autistic children at a daycare center in Berkeley. It was here that he developed a conditioning technique using food rewards that he called "M&M Therapy" to help teach the kids under his care. He never published anything about it, but it spread and it is widely used today in the treatment of autism. "So it could certainly be said," concludes Tom, "that Glenn's death contributed obliquely to the now-standard treatment for autistic kids."

The name of Glenn's young wife was reported in the press as both Lynn Bostic and Lynn Bostock. She had evidently been his sweetheart back in Wichita and followed him out to the West Coast, where she found work as a telephone operator. They married in January 1962.

9. "If Some People Want to Play Around . . ."

The news that Mickey was building a rocket car was reported in the *Deseret News*, Aug. 30, 1962. Other sources included my interviews with Fritz Voigt and Judy Creach; Mickey's autobiography *Challenger*; Arneson, *Mickey Thompson*; and James Wright, "2,000-hp Car Poised for New Speed-Record Try," *Popular Science*, Aug. 1969.

10. Goodbye John Cobb

The John Cobb section is based on Charles Jennings, *The Fast Set*, chapters 15–17; David McDonald's firsthand account *Fifty Years with the Speed Kings*; S.C.H. Davis, *The John Cobb Story*; George Eyston, *Fastest on Earth*; David Tremayne, "John Cobb, A Reluctant Hero," www.lesliefield.com; and on contemporary accounts of Cobb's and Eyston's visits to Bonneville in the *Deseret News*, Aug. and Sept. 1938, Aug. 1939 and Sept. 1947. Leo Villa and Kevin Desmond, *The World Water Speed Record* contains a firsthand account of Cobb's death in *Crusader*.

For the birth of the *Wingfoot Express* and its first season on the salt, I interviewed and exchanged correspondence with Walt Arfons, Terry Arfons and Tom Joswick. Walt's recollections of his collapse on the night Chuck Hatcher crashed are from the Jack Olsen tapes, reel 102, side A. Gertrude Arfons' comments are on this tape as well. Walt says today that Chuck was "on dope." For published sources: Shapiro, *Man Against the Salt*, especially quotes by Tom Green on pages 230–231; Bob Clay, "The Fastest Man on

Wheels," *Rod and Custom*, Feb. 1965; Simon Lewis, "Tom Green and Wingfoot Express: Story of a Land Speed Record," www.simon-lewis.com/motorsport/Wingfoot; and contemporary newspaper accounts. The report that Walt canceled his return to the salt due to "a dispute with one of his major sponsors, who also sponsored Breedlove's runs," an obvious reference to Goodyear, appeared in the *Deseret News*, Sept. 28, 1963. Walt bridles today at the suggestion that Goodyear nixed his return because it wanted Craig to hold the record for the rest of the year. "Goodyear and us had a very good relationship," he says.

For Craig's 407-mph record: Breedlove, *Spirit of America*, chapter 10; Breedlove, "Driving a World's Record 407 Miles Per Hour," *Popular Mechanics*, Nov. 1963; Don Francisco, "The Spirit of America," *Hot Rod*, Oct. 1963; and reports in the *Deseret News* and *Salt Lake Tribune*. Additional material came from my interviews with Craig Breedlove, Bob Davids, Lee Frank, Stan Goldstein, Portia Bowman and Cynthia Bowman. I also interviewed Rexford Metz, who was on the salt filming the Academy Award-nominated documentary *Spirit of America*. Rexford, a USC Film School student at the time and coincidentally Jim Deist's brother-in-law, had begun filming *Spirit* in 1962; when Craig failed to break the record, the documentary dragged into a two-year project. The intricacies of the timing equipment were explained to me by Dave Petrali, who worked as a course observer under his father Joe back in the 1960s and is today a head timer with USAC, and were further elucidated by the article "Assault on the Salt" in the Hewlett-Packard company magazine *Measure*, Oct. 1968. Film footage of the record appears in *Spirit of America* (1963), recently re-released by the National Archives, and in the 2004 BBC documentary *In Search of Speed: The Battle of Bonneville*. An audio recording of the record run with commentary is also available on the Fleetwood Records LP *407.45: Craig Breedlove's Spirit of America World Land Speed Record*. Additional bits of color and dialogue came from Leo Villa, *The Record Breakers*, 74 (Malcolm Campbell's outburst); "407.45 mph

Avg. on the Ground!" *Motor Racing and Economy Car News*, Aug. 9–16, 1963; Hays Gorey, "Cool Run For an Old Hot Rodder," *Sports Illustrated*, Aug. 19, 1963; and "A Dream of Speed," *Time*, Aug. 5, 1963.

11. Building a Monster

The story of Art's building of the *Green Monster* jet car is well told in Katz, *Art Arfons*, chapters 6 and 7. Other sources were my interviews with Tim Arfons, Terry Arfons, Tom Joswick, Lou Wolfe, Ted Groff, E. J. Potter, Lee Pendleton, Tom Mayenschein (Charlie's son), Nadine Snyder and Humpy Wheeler; Art's reminiscences in Shapiro, *Man Against the Salt*, 232–234; and the Art Arfons interviews on the Jack Olsen tapes, reel 100, side A and reel 101, side A. Among the wealth of magazine articles touching on the creation of the *Green Monster*: Hays Gorey, "Ugliest, Cheapest and Best in the World," *Sports Illustrated*, Nov. 9, 1964; W. W. James, "Assault on the Salt," *Customs Illustrated*, Dec. 1964; Don Francisco, "World Land Speed Record Cars—1964," *Hot Rod*, Jan. 1965; "World Land Speed Record the Hard Way," *Modern Rod*, Feb. 1965; John Reddy, "Fastest Man on Wheels," *Reader's Digest*, Mar. 1965; Art Arfons, "I Drove Faster Than Any Human," *Saga*, Mar. 1965; and Lee Kelley, "The 'Green Monster' Man," *Hot Rod*, Aug. 1968.

Tom Mayenschein additionally provided me with a copy of a family DVD he has made entitled *Charlie Mayenschein's Accomplishments and a Few Good Friends*, plus a copy of a private interview he filmed with Art Arfons. About the original sketch for the *Green Monster*, Tom says: "Dad said that on the drive back from Florida, he got a pencil and a piece of cardboard and drew a design for the car. He said Art kept trying to look at it and Dad wouldn't let him. When he was done with it, Art was still driving. He glanced at it and pulled the bus over to the side of the road and looked at it and looked at it and said, 'This is exactly what I was thinking.' Boy, I would love to have that piece of cardboard today."

12. Accolades and Acrimony

For Craig's experiences after breaking the record, the publicity tour and the strain of stardom, I interviewed Craig Breedlove and his former wife Lee Frank. Breedlove, *Spirit of America*, chapter 10, was also a valuable source. Craig's "Who the hell . . ." comment is from Cyril Posthumus, *Land Speed Record*, 177. The planned Breedlove movie and the Steve McQueen connection were first mentioned to me by Craig's half-sister Cynthia Bowman. Subsequent research turned up a production announcement in the *Los Angeles Times*, May 25, 1964. Craig filled in the details. Co-producers on the project were Stan Jolley, William Veragas and Roy Seawright. The story of Rod Schapel's lawsuit is based on my interviews with Craig Breedlove, Stan Goldstein, Rod Schapel and Art Russell. According to Craig, Rod sued him for $300,000 and 30 percent of his income.

13. Down to Three

The main source for the rest of the Nathan Ostich story was my interview and follow-up correspondence with Al Bradshaw. I also interviewed Ray Brock's wife, Joann Brock, and interviewed and exchanged correspondence with Bob Merriam, who served on the *Flying Caduceus* crew in 1962. For film footage of the *Caduceus* in action in 1962 and '63, see the Firestone documentary *The Long Black Line*, which includes a portion of narration by Ostich himself, and also *Chase the Wind* from the early 1970s.

Sources for the continuing saga of Donald Campbell were: Leo Villa's firsthand account in *The Record Breakers*, chapters 9 and 10 (includes excerpts from Villa's diary) and Appendix 1 (transcript of Donald's last words); Peter Holthusen, *The Fastest Men on Earth*, chapter 5; Paul Clifton, *The Fastest Men on Earth*, chapters 21 and 23; Cyril Posthumus, *Land Speed Record*, 175; "Race Against Time and Tide in the Outback," *Sports Illustrated*, May 20, 1963; Kenneth Rudeen, "Speed King? Or Just Son of Speed King?" *Sports Illustrated*, July 29, 1963 (deals with the criticism directed at Campbell); the

"Scorecard" section in *Sports Illustrated*, June 10, 1963 and July 27, 1964; "Bluebird to Happiness," *Time*, July 24, 1964; and reports in the *Sydney Morning Herald* and the Melbourne *Age*.

A number of films have been made on the life of Donald Campbell. For his quest for the land speed record, see in particular the documentary Donald himself made in 1964 entitled *How Long a Mile*. With regard to his fatal attempt at the water speed record, see the 1967 documentary *The Price of a Record* and the 1988 BBC docudrama *Across the Lake*, starring Anthony Hopkins as Campbell.

14. Brother Against Brother

Useful published sources for Walt Arfons' and Tom Green's record include Green's reminiscences in Shapiro, *Man Against the Salt*, chapters 15 and 16, and Simon Lewis, "Tom Green and Wingfoot Express," www.simonlewis.com. Green's comments crediting Art with helping get the *Wingfoot* working properly appeared in the *Deseret News*, Oct. 3, 1964; Pat Green's worry for her husband was revealed in the *Deseret News*, Oct. 5, 1964. Unpublished sources included my interviews with Terry Arfons and George Callaway and my correspondence with Walt Arfons, and Art's and Walt's respective comments on their racing and their continuing feud on the Jack Olsen tapes, reel 101, side A and reel 102, side B.

For Art's first trip to Bonneville with the *Green Monster*, I interviewed Ted Groff, Tom Mayenschein, Lee Pendleton, E. J. Potter and Humpy Wheeler. Katz, *Art Arfons*, chapters 8–9, was also useful, as were Hays Gorey's articles in *Sports Illustrated*, Oct. 12 and Nov. 9, 1964; Art Arfons, "I Drove Faster Than Any Human," *Saga*, Mar. 1965; Lee Kelley, "The 'Green Monster' Man," *Hot Rod*, Aug. 1968; Don Francisco, "World Land Speed Record Cars—1964," *Hot Rod*, Jan. 1965; and "World Land Speed Record the Hard Way," *Modern Rod*, Feb. 1965. For a recording of Humpy Wheeler relating the story to reporters of Charlie Mayenschein hitching a ride in the *Monster*,

see the Jack Olsen tapes, reel 97, end of side A and beginning of side
B; see also Harvey Shapiro's account in the Akron *Beacon Journal*,
Oct. 4, 1965 and in *Man Against the Salt*, 237–238. The documenta-
ries *The Long Black Line*, *Challenge* and *The Bold Men* contain footage
of the *Monster*'s 1964 runs. Charlie Mayenschein's son Tom con-
firmed to me the existence of the audio recording Charlie made when
he snuck a ride in the *Monster*. Tom recalls Charlie playing it for his
family around the kitchen table before giving it to Art.

15. To Five Hundred

Descriptive details on Wendover at the beginning of the chapter are
drawn mainly from the oral notes Jack Olsen recorded during his
1965 visit (Jack Olsen tapes, reel 97, side A and reel 98, side A). For
Craig's 468- and 526-mph records, I interviewed Craig Breedlove,
Bob Davids, Lee Frank, Stan Goldstein, Bill Moore and Art Russell.
For newspaper accounts, I relied primarily on the *Deseret News*, *Salt
Lake Tribune*, Akron *Beacon Journal*, and *The New York Times*. Other
published sources: Craig's firsthand account in *Spirit of America*,
chapters 12–14; Devon Francis, "Can They Hit 500 mph?" *Popular
Science*, Aug. 1964; Hays Gorey, "Fast, Wet—and Almost Dead,"
Sports Illustrated, Oct. 26, 1964; C. P. Gilmore, "Speed Carnival at
Bonneville," *Popular Mechanics*, Dec. 1964; Don Francisco, "World
Land Speed Record Cars—1964," *Hot Rod*, Jan. 1965; William
Moore and David Burke, "Jets at Bonneville," *Popular Hotrodding*,
Jan. 1965; Bob Clay, "The Fastest Man on Wheels," *Rod and Custom*,
Feb. 1965; Paul Clifton, *The Fastest Men on Earth*, chapter 24; Bill
Neely, "For My Next Act, I'm Going to Set Myself on Fire," *Playboy*,
May 1972; and Neely, *Tire Wars*, 111.

16. Drowning in the Desert

Eyewitnesses to the crash with whom I spoke included Cynthia
Bowman, Bob Davids, Stan Goldstein, Rexford Metz, Bill Moore,

Art Russell, Rod Schapel, and of course Craig Breedlove himself. Published sources are as in the previous chapter. Film footage of Craig's crash can be seen in *In Search of Speed: The Battle of Bonneville*. Included is the view from a movie camera that had been attached to *Spirit*'s rear wheel fairing. It was thrown 300 yards from the car upon impact. This footage, together with film shot by Rexford Metz, was featured in the Spotlight News documentary *The Wildest Ride*, produced by Goodyear in 1965. Don Francisco (*Hot Rod*, Jan. 1965) writes that Craig had the bad luck of landing right where a deep canal had been excavated beneath what was otherwise a very shallow lake. *Spirit*'s nose sank into the canal, while its rear wheels straddled the sides and thus held the tail up out of the water.

The dialogue in this chapter and the latter half of chapter 15 is taken verbatim from newspaper accounts and from Jim Economides' audio recording of Craig's run and crash, subsequently released by Capitol Records as an LP entitled *Breedlove 500+*. Cole Coonce's *Infinity Over Zero* includes a transcript of this recording. Additional audio of Ted Gillette's voice during a Bonneville run (Art Arfons' record run earlier that month) can be found in the documentary *The Bold Men*.

About Craig's famous quip after the crash, Bob Davids told me the following story. "We had two shops in Gardena, Quincy's main shop and another rented one a couple blocks away where Craig had another of his cars. I had this little Honda and would go back and forth between the two shops. Quince or Nye would say, 'Hey Bobby, go get this part,' and I would shoot over there and run into the shop almost at full speed and do a brody, sliding around so that I'm facing out. So this one time, I go zipping into the shop to pick up a part and I slam on the brakes and slide the bike around—and there's this film crew in there filming Craig. The director yells 'Cut' and he's really pissed at this 18-year-old asshole and he says, 'Really good job, kid. What do you do for your next act?' I said, 'I set myself on fire,' and everybody cracked up.

"Craig used that line after he went into the pond. When he was standing there, nervous as hell because he'd just escaped death, he said, 'For my next act, I'll set myself on fire.' He got that from me."

17. Blowout

Art's candid feelings about being filmed posing with the *Infinity* wreckage for the documentary *The Bold Men* are from the Jack Olsen tapes, reel 100, side A. "It made me so God-damned mad," adds Humpy Wheeler in the same taped conversation; the David Wolper Productions crew "was the craziest bunch of guys in the world." A copy of this excellent film was kindly provided to me by Tom Joswick.

Sources for Art's 536-mph record include contemporary accounts in the *Deseret News*, *Salt Lake Tribune* and *LA Times*; "Riding the Washboard," *Time*, Nov. 6, 1964; Katz, *Art Arfons*, chapters 10–11; Arfons, "I Drove Faster Than Any Human," *Saga*, Mar. 1965; Shapiro, *Man Against the Salt*, chapters 15–16; Don Francisco, "World Land Speed Record Cars—1964," *Hot Rod*, Jan. 1965; and my interviews with George Callaway, Lee Pendleton, E. J. Potter and Humpy Wheeler. Art's description of the blowout and the damage it caused is from Tom Mayenschein's interview with him, portions of which Tom included in his film *Charlie Mayenschein's Accomplishments and a Few Good Friends*. Additional details were gleaned from the films *The Long Black Line*, *Challenge* and *The Bold Men*. Art relates the episode of the old man with the dog in the Jack Olsen tapes, reel 100, side A; his hard feelings toward Walt over the dumped dirt and the *Wingfoot* rocket announcement are from reel 101, side A, along with Humpy Wheeler's explanation.

An excellent and easily accessible source on Paula Murphy is Chip Tatroe's online archive at www.americanjetcars.com. Chip's page on Paula contains a wealth of photos and clippings, notably: "Fastest Woman on Wheels," *Modern Rod*, Feb. 1965; "Paula Murphy: World's Fastest Woman Driver," *Auto Topics*, April 1965;

Karen Nelson, "Personality Profile: Paula Murphy," *Drag Racing*, July 1967; and "Funny Girl," *Hot Rod*, Mar. 1970.

18. Sonic I

The account of the building of *Sonic I* is based primarily on my interviews with Craig Breedlove, Bob Davids, Stan Goldstein, Tom Hanna, George Klass, Bob Koken, Bill Moore and Art Russell. Other sources were Breedlove, *Spirit of America*, chapter 14; Breedlove, "750 MPH, Here I Come," *Popular Mechanics*, Sept. 1965; Eric Rickman, "Spirit of America: Sonic I," *Hot Rod*, Oct. 1965; Dick Wells, "Those Magnificent Men and Their Speed Machines," *Hot Rod*, Jan. 1966; Jerry Kirshenbaum, "A Speed King Without a Kingdom." *Sports Illustrated*, April 27, 1970; and David Samuels, "The Light Stuff," *The New Yorker*, June 9, 2003 (for Bob Lane and the Goodyear blimp). That Craig had secretly booked the salt flats through the firm M-Z Promotions was revealed in the *Deseret News*, Nov. 3, 1965.

My sources for the section on Art Arfons included the documentary *The Green Monster*, which contains footage of Art's 1964 appearance on *To Tell the Truth*; my interviews with Tim Arfons and Humpy Wheeler; comments by Humpy from 1965 on the Jack Olsen tapes, reel 96, side A; Olsen, "My Brother, My Enemy, in Speedland," *Sports Illustrated*, Nov. 29, 1965; and Lou Wolfe's reminiscences in Shapiro, *Man Against the Salt*, 152–153.

19. "All-Out, Blood-Stinkin' War"

Most of the scenes and dialogue in this chapter are from the Jack Olsen tapes. Jack's assurance to Walt that he would erase the tapes after use is on reel 102, side B; his interview with Goodyear president Vic Holt is on reel 94, side A; his conversations with Humpy Wheeler begin on reel 94, side A and continue through to reel 96, side B; his visit to Art's shop is on reel 94, side B; Walt's and Art's

respective accounts of their meeting at the rocket car's unveiling are on reel 101, side A (Art's side of the story, together with his comment on M-Z Promotions) and reel 102, side A (Walt's side); Gertrude and Terry Arfons' comments are on reel 93, side A. Other sources included my interviews with Terry Arfons, Walt Arfons, George Klass and Humpy Wheeler; Bobby Tatroe's letter to June Huff, Oct. 1, 1965, www.americanjetcars.com; reports in the *Deseret News* and *Salt Lake Tribune* for Sept. 1965; Lester Nehamkin, "Bonneville," *Hot Rod*, Dec. 1965 (useful salt flats diary for the month of September); Dick Wells, "Those Magnificent Men and Their Speed Machines," *Hot Rod*, Jan. 1966; James Joseph, "Walt Arfons Lights the Fuse on LSR Rocketry," *Car Life*, June 1966; Don Thomas, "A $60,000 Disappointment at 580 mph," *Wonderland*, May 14, 1967; Alex Walordy, "Jets on Wheels," *Speed and Supercar*, Oct. 1967; Katz, *Art Arfons*, chapter 12; Breedlove, *Spirit of America*, chapter 15; and Shapiro, *Man Against the Salt*, chapters 15–16.

20. "Like a Game of Russian Roulette"

For *Sonic I*'s first trip to the salt flats and its 555-mph record, I interviewed Craig Breedlove, Bob Davids, Stan Goldstein, Tom Hanna, George Klass and Bob Koken. The meeting between Craig and Art is reconstructed from Craig's account in *Spirit of America* and my interview with him. Years later, Art confirmed to USAC historian Donald Davidson that this meeting took place (Shapiro, *Man Against the Salt*, 146). Other sources included Breedlove, *Spirit of America*, chapters 15–17; accounts in the *Deseret News*, *Salt Lake Tribune*, *LA Times* and *The New York Times*; and Sam Low, "Six Hundred at Bonneville," www.samlow.com/speed/sixhundredat-bonneville.htm. Low's account, based on stories he heard from Craig and his *Sonic Arrow* teammates at Black Rock in 1997, mixes events pertaining to Craig's 555-mph record (i.e. the squashed paneling behind the air duct), into the story of his 600-mph record two weeks later.

For the conclusion of the story of the *Wingfoot Express* rocket car, I corresponded with Walt Arfons and interviewed Terry Arfons, who was with his father at Bonneville that autumn. The most useful published sources were write-ups in the *Deseret News* and Akron *Beacon Journal*; Jack Olsen's "Enemies in Speedland, Part II," *Sports Illustrated*, Dec. 6, 1965; Don Thomas' four-part series on Bobby Tatroe in *Wonderland* magazine, April–May, 1967; and Holthusen, *The Fastest Men on Earth*, 133–135.

21. Boom

The opening section on Craig tying up the salt after setting his 555-mph record is based on my interviews with Craig Breedlove, Lee Frank, Stan Goldstein and George Klass, and on Breedlove, *Spirit of America*, chapter 17. The scenes and dialogue concerning Art and his run for the record are drawn primarily from the Jack Olsen tapes. Jack's interview with Art and Humpy Wheeler on the eve of Art's record attempt is on reel 100, side A; the sounds and voices on the salt flats before and after Art's record and tire blow-out and the private gathering afterward in a Wendover motel room are on reel 98, side A. Other sources included my interviews with Tim Arfons, George Callaway, Tom Joswick and Humpy Wheeler; Hi McDonald's report in the *Deseret News* and Harvey Shapiro's in the Akron *Beacon Journal*; Jack Brady's Bonneville report in *Competition Press and Autoweek*, Dec. 4, 1965; Jack Olsen's feature in *Sports Illustrated*, Dec. 6, 1965; Dick Wells, "Those Magnificent Men and Their Speed Machines," *Hot Rod*, Jan. 1966; and Shapiro, *Man Against the Salt*, 64 and 249–250.

22. Six-Oh-Oh

For the story of Craig's 600-mph record, I interviewed Craig Breedlove, Bob Davids, Lee Frank, Stan Goldstein, Tom Hanna and George Klass. Other sources: Breedlove, *Spirit of America*,

chapter 18; Clifton, *The Fastest Men on Earth*, chapter 25; Low, "Six Hundred at Bonneville," www.samlow.com/speed/sixhundredatbonneville.htm; Olsen, "Enemies in Speedland, Part II," *Sports Illustrated*, Dec. 6, 1965; Breedlove, "600 MPH—What It's Really Like!" *Motor Trend*, Mar. 1966; and Shapiro, *Man Against the Salt*, 81. Some later published accounts tend to mix up the particulars surrounding Craig's 555-mph and 600-mph records. Contemporary newspaper reports were particularly useful in helping to pin down what happened when.

23. Last Stand

For Art Arfons' return to the salt in 1966 and his subsequent crash, I interviewed Terry Arfons, Tim Arfons, Walt Arfons, Craig Breedlove, Zeldine Graham, Ted Groff, Tom Joswick, Lamar Melville, Harvey Shapiro, Nadine Snyder, Humpy Wheeler and Lou Wolfe. The documentaries *Arfons: The Man and His Monster* (for the *Montage* series on Cleveland television station WKYC, 1966) and *The Green Monster* (broadcast on PBS as part of the *POV* series, 1999) were also useful. It was from these two hard-to-find films (my thanks to Tom Joswick for copies) that I pieced together the dialogue of a distraught Ed Snyder and other crew members as they arrived at the wreck. Crash footage and audio also appear in *In Search of Speed: The Battle of Bonneville*.

The most useful book on the crash was Harvey Shapiro's *Man Against the Salt*, in particular Art's reminiscences in chapter 17 and the eyewitness accounts of Humpy Wheeler (pages 135–137), Dave Petrali (270–272), Ed Snyder (395–396) and Harvey himself (xvi–xviii). For the reminiscences of Art's son Ron and his wife June, I relied on Shapiro, pages 410–413, and on interviews with same in the film *The Green Monster*. Other major sources included Bob Ottum's firsthand account "Duel With Death on the Salt," *Sports Illustrated*, Nov. 28, 1966, and reports in the *Deseret News*, *Salt Lake Tribune* and Akron *Beacon Journal* (my thanks to Harvey

Shapiro for copies of his features). Additional bits were gleaned from "Nightmare on the Flats," *Time*, Nov. 25, 1966; John Thawley, "Bad Day at Bonneville," *Hot Rod*, Feb. 1967; and Lee Kelley, "The 'Green Monster' Man," *Hot Rod*, Aug. 1968.

Harvey Shapiro mentioned to me that after returning to Akron, he put together a short documentary on Art's 1966 land speed bid and crash from footage he had shot on the salt flats. He screened this film once for a school audience and never showed it again. It has been sitting in Harvey's basement for the past 40-plus years.

Epilogue

For Craig's continuing story, I interviewed Craig Breedlove, Stan Goldstein, Lee Frank, George Klass and Bill Moore. Bill was present when Craig crashed in 1996 and gave me an eyewitness account. Published sources included Breedlove, *Spirit of America*, chapters 19–20; Jerry Kirshenbaum, "Speed King Without a Kingdom," *Sports Illustrated*, April 27, 1970; William Neely, "For My Next Act, I'm Going to Set Myself on Fire," *Playboy*, May 1972; Peter Brock, "Incident at Black Rock," *Popular Science*, Feb. 1997; Richard Hoffer, "The Great Race," *Sports Illustrated*, Sept. 29, 1997; Michael Neill, "Desert Lightning," *People*, Sept. 29, 1997; Michael Mattis, "Craig Breedlove," *Salon*, July 31, 1999; and Bernice Yeung, "Magnificent Obsession," *SF Weekly*, Nov. 15, 2000.

In 2007 Nye Frank, Craig's old *Spirit* crew chief and Lee's new husband, died at the age of 68 after a fight with a 27-year-old neighbor. No charges were laid as it was deemed a case of mutual combat. Lee, who witnessed the incident, contends it was murder. "Nye was standing there with his hands down at his sides and this kid slugged him in the mouth and then got him in a headlock and bent him in half and choked him to unconsciousness. My husband was lying on the ground like he was dead and the kid beat him and I couldn't get him off." Lee and her daughter Dawn Breedlove are still seeking justice.

For the rest of Art's story, I interviewed and/or corresponded with Tim Arfons, Walt Arfons, Ted Groff and Tom Joswick. The documentary *The Green Monster* contains interviews with Art and his wife June and their son Tim and footage of Art's three trips to Bonneville in 1989, 1990 and 1991. This film also includes footage of Craig Arfons' crash and interviews with Walt. For newspaper accounts on Craig Arfons' crash, I used the *St. Petersburg Times* and Lakeland, Florida's *The Ledger*. Accounts of Art's 1971 crash in Dallas and the subsequent investigation were found in the *Denton Record-Chronicle*. Other sources on Art: Oscar Fraley, "And Now . . . Arfons Goes After the Water Speed Record!" *Mechanix Illustrated*, Dec. 1966; "Art Arfons and His Green Monster," *Hot Boat*, April 1967; Lee Kelley, 'The 'Green Monster' Man," *Hot Rod*, Aug. 1968; Woody Hatten, "Art Arfons," *Pulling Power*, Fall 1981; Shapiro, *Man Against the Salt*, chapters 21–23; Richard Noble, "Art Arfons' Last Stand," www.thrustssc.com/thrustssc/Club/Secure/Arfons_Last_Stand; and Mike Tobin, "Hungry for Horsepower," www.racingcampbells.com/content/campbell.archives/art.arfons.

Bibliography

Books and Articles

"All About the Weinie Roasters." *Modern Rod*, July 1963, 9–13ff.

Arfons, Art, as told to Devon Francis. "How I'll Drive Faster Than Sound." *Popular Science*, July 1965, 46–49 and 168–170.

———, with James Joseph. "I Drove Faster Than Any Human." *Saga*, March 1965, 25–27ff.

———, and Walt Arfons. "How to Build a Championship Rod." *Rod Builder and Customizer*, July 1956, 12–15 and 64.

Arneson, Erik. *Mickey Thompson: The Fast Life and Tragic Death of a Racing Legend*. Osceola, WI: Motorbooks, 2008.

"Art Arfons and His Green Monster: He'll Try to Roll Up a New Water Speed Record While Riding on Wheels at Over 300 mph!" *Hot Boat*, April 1967, 26–31.

Behme, Bob. "Jet Age Stopping." *Car Craft*, August 1960, 22–25ff.

Borgeson, Griffith. "Bonneville Encore." *Hot Rod*, February 1960, 34–35ff.

———. "A Jet Car for the Ages." *Hot Rod*, April 1960, 42–45.

———. "Bonneville Newsletter." *Sports Cars Illustrated*, November 1960, 20–22.

———. "It's Still Only Hot Air." *Car and Driver*, February 1962, 74–76.

———, and Wayne Thoms. "World's Fastest Dragster." In *The How-To Book of Hot Rods*, 88–91. Fawcett Books, 1961.

Breedlove, Craig. "Driving a World's Record 407 Miles Per Hour." *Popular Mechanics*, November 1963, 87–92ff.

———. "750 MPH ... Here I Come." *Popular Mechanics*, September 1965, 88–92ff.

———, as told to Charles Maher. "600 MPH—What It's Really Like!" *Motor Trend*, March 1966, 46.

———, with Bill Neely. *Spirit of America: Winning the World's Land Speed Record*. Chicago: Henry Regnery Company, 1971.

Brock, Peter. "Incident at Black Rock." *Popular Science*, February 1997, 54–58.

Brock, Ray. "The Flying Caduceus." *Hot Rod*, October 1960, 24–29ff.

———. "'60 Bonneville National Speed Trials." *Hot Rod*, November 1960, 30–39ff.

———. "Bonneville Preview." *Hot Rod*, August 1961, 76–79.

Clarke, R. M. *The Land Speed Record, 1940–1962*. Cobham, Surrey: Brooklands Books, 2000.

———. *The Land Speed Record, 1963–1999*. Cobham, Surrey: Brooklands Books, 2000.

Clay, Bob. "The Fastest Man on Wheels." *Rod and Custom*, February 1965, 22–25ff.

Clifton, Paul. *The Fastest Men on Earth*. New York: The John Day Company, 1966.

Coonce, Cole. *Infinity Over Zero: Meditations on Maximum Velocity*. La Crescenta, CA: Kerosene Bomb Publishing, 2002.

Davis, Sydney Charles Houghton. *The John Cobb Story*. London: G. T. Foulis, 1953.

Diamond, David. "The Fast American Hero." *Wired*, November 1996, www.wired.com/wired/archive/4.11/breedlove.html.

Eyston, George. *Fastest on Earth*. Los Angeles: Floyd Clymer, 1946.

———. *Safety Last*. Spalding, Lincolnshire, England: Vincent Publishing, 1975.

Fadini, Ugo. "The Infinity Jet Car." www.ugofadini.com/omicron-10story.html.

Formoyle, Ken. "Green Monster #5." *Rod and Custom*, September 1955, 46–49.

Fraley, Oscar. "And Now . . . Arfons Goes After the Water Speed Record!" *Mechanix Illustrated*, December 1966, 68–70ff.

Francis, Devon. "Can They Hit 500 mph?" *Popular Science*, August 1964, 70–73ff.

Francisco, Don. "Big Boys at Bonneville." *Car Craft*, January 1961, 38–43ff.

———. "The Spirit of America." *Hot Rod*, October 1963, 26–33.

———. "World Land Speed Record Cars—1964." *Hot Rod*, January 1965, 38–43ff.

———. "Save the Salt!" *Popular Hotrodding*, January 1965, 62–63.

———. "Bonneville '65." *Motor Trend*, December 1965, 77.

Gilmore, C. P. "Speed Carnival at Bonneville." *Popular Mechanics*, December 1964, 69–73ff.

Gorey, Hays. "Death on the Salt Flats." *Sports Illustrated*, August 8, 1960, 16–19.

———. "Cool Run For an Old Hot Rodder." *Sports Illustrated*, August 19, 1963, 46–51.

———. "Two Old Shoestringers Jolt the Jet Set." *Sports Illustrated*, October 12, 1964, 66–67.

———. "Fast, Wet—and Almost Dead." *Sports Illustrated*, October 26, 1964, pp. 72–74.

———. "Ugliest, Cheapest and Best in the World." *Sports Illustrated*, November 9, 1964, 24–25.

Griffin, Mike. "The Arfons Legend." *American Rodder*, June 1990, 68–73.

Hatten, Woody. "Art Arfons." *Pulling Power*, Fall 1981, 25.

Hoffer, Richard. "The Great Race." *Sports Illustrated*, September 29, 1997, 60–66.

Holthusen, Peter J. R. *The Land Speed Record: To the Sound Barrier and Beyond*. London: Guild Publishing, 1986.

————. *The Fastest Men on Earth: 100 Years of the Land Speed Record.* Stroud, Gloucestershire, UK: Sutton Publishing, 1999.

Houlgate, Deke. *The Fastest Men in the World—On Wheels.* New York: World Publishing, 1971.

Huntington, Roger. "Looking Through the Sound Barrier." *Hot Rod*, July 1965, 42–44ff.

Hyatt, Robert. "Jet Car Aims at 500-MPH Record." *Popular Science*, July 1960, 94–95.

James, W. W. "Assault on the Salt." *Customs Illustrated*, December 1964, 12–15.

Jeffries, Doc, and Wendy Jeffries. "The City of Salt Lake Liner, Parts I, II, and III." *Bonneville Racing News*, January/February 1993, 4–5; March 1993, 4–5; April 1993, 4–5. (Also published in *Goodguys Goodtimes Gazette* later in 1993 as part of Doc Jeffries "Flat Out" column.)

Jenkins, Ab and Wendell J. Ashton. *The Salt of the Earth.* St. George, Utah: Dixie College Foundation, 3rd edition, 1993 (originally published 1939).

Jennings, Charles. *The Fast Set.* London: Little, Brown, 2004.

Joseph, James. "Walt Arfons Lights the Fuse on LSR Rocketry." *Car Life*, June 1966, 70–74.

Katz, Frederic. *Art Arfons, Fastest Man on Wheels: The Complete Life Story of the World's Land-Speed Record Holder.* New York: Thomas Nelson and Sons, 1965.

Kelley, Lee. "The 'Green Monster' Man." *Hot Rod*, August 1968, 52–55.

Kirshenbaum, Jerry. "A Speed King Without a Kingdom." *Sports Illustrated*, April 27, 1970, 64–76.

Low, Sam. "Six Hundred at Bonneville." www.samlow.com/speed/sixhundredatbonneville.htm.

Mattis, Michael. "Craig Breedlove." *Salon*, July 31, 1999, on-line at www.salon.com/people/rewind/1999/07/31/breedlove.

McDonald, David ("Dunlop Mac"). *Fifty Years with the Speed Kings.* London: Stanley Paul, 1961.

Miller, Floyd. "Race Against Death." *Reader's Digest*, October 1963, 140–146.

Moore, William A. and David Burke. "Jets at Bonneville." *Popular Hotrodding*, January 1965, 16–19ff.

Neely, William. "For My Next Act, I'm Going to Set Myself on Fire." *Playboy*, May 1972, 136–182.

———. *Tire Wars: Racing with Goodyear*. Tucson, Arizona: AZTEX Corporation, 1993.

Nehamkin, Lester. "Bonneville." *Hot Rod*, December 1965, 84–85.

Neill, Michael. "Desert Lightning." *People*, September 29, 1997, 97–98.

Nerpel, Charles, "344.7 Miles Per Hour." *Motor Trend*, March 1960, 44–45.

Noble, Richard. "Art Arfons' Last Stand." www.thrustssc.com/thrustssc/Club/Secure/Arfons_Last_Stand.html.

Noeth, Louise Ann. *Bonneville: The Fastest Place on Earth*. Osceola, Wisconsin: Motorbooks, 2002.

Olsen, Jack. "My Brother, My Enemy, in Speedland." *Sports Illustrated*, November 29, 1965, 80–96.

———. "Enemies in Speedland, Part II: Duel on the Salt." *Sports Illustrated*, December 6, 1965, 110–138.

Ottum, Bob. "Duel With Death on the Salt." *Sports Illustrated*, November 28, 1966, 28–31.

Pearson, John. *Blue Bird and the Dead Lake: The Story of Donald Campbell's Land Speed Record at Lake Eyre in 1964*. London: Collins, 1965.

———. *The Last Hero: The Gallant Story of Donald Campbell and the Land Speed Record, 1964*. New York: D. McKay Co. [1966].

Post, Robert C. "The Machines of Nowhere." *American Heritage of Invention and Technology*. Volume 7, issue 4 (Spring 1992), 28–36.

———. *High Performance: The Culture and Technology of Drag Racing, 1950–2000*. Baltimore: Johns Hopkins University Press, 2001.

Posthumus, Cyril. *Land Speed Record: A Complete History of the*

Record-Breaking Cars from 39.24 to 600+ mph. Reading, Berkshire: Osprey Publishing, 1971.

"Race Against Time and Tide in the Outback." *Sports Illustrated*, May 20, 1963, 20–21.

Reddy, John. "Fastest Man on Wheels: Meet Art Arfons and the Incredible Homemade Contraption With Which He Broke the World's Speed Record." *Reader's Digest*, March, 1965, 94–98.

Richardson, Robin. "Medical Records." www.thrustssc.com/thrustssc/Club/Secure/Medical_Records.html.

Rickman, Eric. "Spirit of America: Sonic I." *Hot Rod*, October 1965, 46–51.

Ross, Frank. *Car Racing Against the Clock: The Story of the Word Land Speed Record*. New York: Lothrop, Lee & Shepard, 1976.

Rudeen, Kenneth. "Speed King? Or Just Son of Speed King?" *Sports Illustrated*, July 29, 1963, 56–61.

Russell, James. "The Sound Barrier—Can Walt Arfons Break It?" *Auto Topics*, August 1965, 44–45.

Scalzo, Joe. *City of Speed: Los Angeles and the Rise of American Racing*. St. Paul, Minnesota: Motorbooks, 2007.

Scott, Jeff. "The Last American Hero." *Cars*, March 1980, 68–74.

Shapiro, Harvey. *Faster Than Sound: The Quest for the Land Speed Record*. Cranbury, New Jersey: A. S. Barnes and Co., 1975.

———. *Man Against the Salt*. London: Minerva Press, 1997.

Smith, LeRoi. "The Jet: A Short-Fused Bomb?" *Hot Rod*, August 1963, 84–85ff.

St. Antoine, Arthur. "Mach My Day!" *Los Angeles Magazine*, August 1996, 50–52.

Stambler, Irwin. *The Supercars and the Men Who Race Them*. New York: Putnam, 1975.

Stimson, Thomas E. Jr. "Bonneville's Magnificent Trials—and Errors." *Popular Mechanics*, December 1960, 101–106ff.

Talbot, John. "Breedlove-Tatroe-Cobra Set 23 New Records." *American Rodding*, June 1966, 24–25.

Thawley, John. "Bad Day at Bonneville." *Hot Rod*, February 1967, 96.

Thomas, Don. "The Man Who Would Be World's Fastest on Land." *Wonderland: The West Michigan Magazine* (weekend insert with the *Grand Rapids Press*), April 30, 1967. (This feature on Bobby Tatroe continues in *Wonderland* on May, 7, 14 and 21, 1967.)

Thompson, Mickey, with Griffith Borgeson. *Challenger: Mickey Thompson's Own Story of His Life of Speed*. Englewood Cliffs, New Jersey: Prentice-Hall [1964].

Thorpe, Keith. "Jet Dragsters . . . The Grounded Missiles." *Popular Hot Rodding*, April 1963, 46–52.

Tobin, Mike. "Hungry for Horsepower." www.racingcampbells. com/content/campbell.archives/art.arfons.asp.

Tremayne, David. *The Land Speed Record*. London: Shire Albums, 1999.

Villa, Leo and Tony Gray. *The Record Breakers: Sir Malcolm and Donald Campbell, Land and Water Speed Kings of the 20th Century*. London: Paul Hamlyn, 1969.

———, and Kevin Desmond. *The World Water Speed Record*. London: B. T. Batsford, 1976.

Walordy, Alex. "Jets on Wheels." *Speed and Supercar*, October 1967, 19–23ff.

Wells, Dick. "Those Magnificent Men and Their Speed Machines." *Hot Rod*, January 1966, 50–57ff.

"World Land Speed Record the Hard Way." *Modern Rod*, February 1965, 27–29ff.

"World Series of Drag Racing." *Speed Age*, January 1955, 60–62.

Wright, James. "2,000-hp Car Poised for New Speed-Record Try." *Popular Science*, August 1969, 90–91ff.

Yeung, Bernice. "Magnificent Obsession." *SF Weekly*, November 15, 2000, on-line at www.sfweekly.com/2000-11-15/news/ magnificent-obsession/.

Jack Olsen Tapes

University of Oregon Libraries, Special Collections and University Archives, Jack Olsen Papers, Collection Number Ax 322, Series VII: Sound recordings, Boxes 12 and 13, Reels 93–102.

Audio-Visual Material

Arfons: The Man and His Monster. Documentary written and produced by Jon Boynton, filmed and directed by Dennis Goulden for the *Montage* series on Cleveland television station WKYC, 1966.

Behind the Headlights: The Spirit of America. Documentary, Speed Channel, 2004.

Breedlove 500+. Audio recording and commentary of Craig Breedlove's 1964 LSR. Los Angeles: Capitol Records, LP, [1965].

Challenge. Documentary written and produced by Don Frankman and Betty Skelton, directed by Don Frankman, 1965.

Charlie Mayenschein's Accomplishments and a Few Good Friends. Documentary by Tom Mayenschein. Privately made; for family use only.

Chase the Wind. Documentary produced and directed by Al Blanchard. Allend'or Production, [early 1970s].

407.45: Craig Breedlove's Spirit of America World Land Speed Record, Bonneville Salt Flats, Utah, U.S.A. Audio recording and commentary of Craig Breedlove's 1963 LSR. Lynn, Mass.: Fleetwood Records, LP, 1963.

In Search of Speed: The Battle of Bonneville. Documentary produced and directed by Iain Scollay. BBC, 2004.

Spirit of America. Documentary produced by Algernon G. Walker, directed by W. A. Blanchard, Spotlight News, 1963. (Re-released on DVD by the National Archives, Washington, D.C.)

The Green Monster. Documentary produced by David Hess, A. C. Weary and Robert Moses, directed by David Finn. Salt Flat Films, 1999.

The Bold Men. Documentary produced by David Wolper, directed by William Friedkin, for ABC television, 1965.

The Long Black Line. Documentary produced by Firestone Tire and Rubber Company, [1964].

The Racers: Craig and Lee Breedlove. Documentary aired on ABC television, June 8, 1968.

The Wildest Ride. Documentary produced by Spotlight Films for Goodyear Tire and Rubber Company, 1965.

Index